NO LONGER INNOCENT

NO
LONGER
INNOCENT

BOOK ART

IN AMERICA:

1960–1980

BETTY BRIGHT

GRANARY BOOKS

NEW YORK CITY

2005

Book design by Philip Gallo
Cover design by Emily McVarish
First edition
Printed and bound in U.S.A.

No Longer Innocent: Book Art in America 1960–1980
is published with the generous assistance of
Furthermore: a program of the J.M. Kaplan Fund.

Library of Congress Cataloging-in-Publication Data
Bright, Betty.
 No longer innocent : book art in America, 1960-1980 / Betty Bright.-- 1st ed.
 p. cm.
 Includes bibliographical references and index.
 ISBN 1-887123-71-7 (alk. paper)
 1. Fine books--United States--History--20th century.
 2. Private press books--United States.
 3. Artists' books--United States. I. Title.
 Z1033.F5B75 2005
 709'.73'09046--dc22
 2005018232

Granary Books, Inc.
 www.granarybooks.com

Distributed to the trade by D.A.P./Distributed Art Publishers
 155 Avenue of the Americas
 New York, NY 10013-1507
 Orders: (800) 338-BOOK
 Tel.: (212) 627-1999 Fax: (212) 627-9484
 www.artbook.com

Also available from Small Press Distribution
1341 Seventh Street
Berkeley, CA 94710
 Orders: (800) 869-7553
 Tel: (510) 524-1668 Fax: (510) 524-0582
www.spdbooks.org

FOR VERA AND JAY

CONTENTS

LIST OF ILLUSTRATIONS

(Unless otherwise indicated, all dimensions are for a closed work,
measured in inches, with height preceding width.)

LIST OF COLOR PLATES

(following page 76)

We still lack a generally accepted and workable definition of artists' books in spite of many perceptive commentaries by American, British, French, and German scholars who may not have always dealt with the same subject matter. We may even wonder to what extent we can define artists' books in terms of genre or classify them according to categories. Indeed, resentful librarians have considerable difficulty in finding a place for them, so much so that the Bibliothèque Nationale has arbitrarily relegated many of them, and particularly the offset multiples, to print collections!

Whereas paintings, whether mimetic, abstract, or even minimal, can hardly conceal their various filiations, artists' books seem to arise from nowhere even though they flaunt a multiplicity of ingredients and can hardly deny their complex origins. Book workers as a rule show affinities with the avant-garde movements of their time, such as Futurism, Dadaism, Surrealism, Fluxus, and Pop Art. Outstanding revolutionary artists, such as Duchamp, Schwitters, and Warhol, who negate the boundaries confining the various arts, have produced at least one work that can qualify as an artist book.

Modern artists' books came into being in the latter part of the nineteenth century in France. Manet's graphic treatment of Charles Cros' *Le Fleuve,* of Mallarmé's translation of Poe's *Raven* (1875), and of his own *L'Après-midi d'un faune* (1876) introduced the *livre de peintre,* a limited edition boasting of original engravings or lithographs by a well-known artist. Mallarmé's *Un coup de dés* (1897) was the first artist book in which a readable text assumed the visual functions of imagery. Manet's *livres de peintre* encouraged but hardly influenced subsequent developments, such as William Morris's Kelmscott Press, or German expressionist painters' more modernist return to the past both in typography and woodcut illustrations. The remarkably original Russian futurist books owe many of their innovative qualities to economic constraints. Influenced by Mallarmé's typography, Blaise Cendrars and Sonia Delaunay's *La prose du transsibérien et de la petite Jehanne de France* (1913) unfolds vertically as though in reaction to the codex form. And in any attempt to charter the zigzag course of the artist book we have to take into account the masterpieces created by William Blake.

As the term itself indicates, artists' books undoubtedly have a dual, not to say schizoid, nature: textual/verbal and visual/pictorial.

As art works they belong in museums and galleries; as books they belong in libraries and book stores; as collectibles, they require both the privacy of reading and the public display of exhibitions. Following Manet's example, the French *livre de peintre* maintained a strict division in space and labor between text and image. In this respect, it marked a retreat from the progressive nineteenth-century practice of printing together and interweaving letterpress and woodcuts. In any case, the engravings or lithographs by famous artists in these limited editions function as direct reactions to, and embellishments of, the text. Unfortunately, dealers often remove them, whether signed or not, from the loose-leaf volume and sell them as prints. Works such as *Un coup de dés, La prose du transsibérien,* Russian Futurist, and most German Expressionist books escaped this dire fate, and, for obvious reasons, later offset and computer-produced artists' books will never be pillaged in this manner.

The revolutionary use of typography initiated by Mallarmé established a collaborative rapport between text and image. Moreover, new techniques became increasingly important. Ceasing to function as documentation, photography became a means to surprise readers and viewers, while photomontage produced even more shocking effects. And the many kinds of manipulation characteristic of bookwork reduced painting, drawing, and typography to a subordinate position. This sort of leveling coincided with the putting into question of traditional art by Cobra school painters in Northern Europe, by Tàpies in Catalonia, Arte Povera in Italy, Pop Art in America, and Fluxus. In book art, this revolt against tradition also benefited from economical methods of production and the increasing sophistication of computers.

In spite of this revolution, so-called elitist book art survived in France with the help of American expatriates such as Woolworth and Shirley Sharoff, while thriving in America thanks mainly to the inventive bookwork of artists and publishers. Vincent Fitzgerald and Granary Books in New York City, Brighton Press, Lapis Press, and Arion Press, among others, have produced limited editions rivaling the best Gallic *livres de peintres*. Somewhat cruelly and subversively, Tom Phillips in England, Buzz Spector and John Eric Broaddus in America altered existing books, thus creating one-of-a-kind works of art. Broaddus and Timothy Ely hand-made one-of-a-kind skillfully bound and painted volumes.

Although artist books, especially in the thirties and forties, might best be described as elegant portfolios, the reader could turn their loose-leaf pages and treat them as offshoots of the codex. In those days, enterprising publishers, such as Kahnweiler, Skira, and

Maeght, functioned as matchmakers who would bring together, on equal terms, a poet and a compatible painter. In recent years the codex has undergone radical transformations that it no longer resembles a portfolio or requires an equal partnership between writer and artist but rather the grand design of a single planner. Bookwork has become all-important, as demonstrated by Bertrand Dorny's pleated pyramids, Susan King's telescoping accordion in *Women and Cars,* Ronald King's built-in puppet show in *Ananzi and Company,* and an assortment of pop-ups and cutouts derived from children's books by a variety of artists. Flatness can also be avoided by engraving, as we can see in Paoli Boni's relief aquatints for Georges Perec's *Métaux* (1985) and Étienne Hajdu's for Pierre Lecuire's *Règnes* (1961), a white volume with sculptured embossings. Moreover, the extendable accordion fold allows for the construction of perfectly readable objects, as Shirley Sharoff has shown in her *Great Wall of China* (1991) and Julie Chen in her *Octopus* (1992) peepshow. As Betty Bright has stated it, these sculptured volumes move into another art form.

Artists' books have developed in so many ways and have generated so much creativity that we can hardly wonder why so much scholarly work has been devoted to them, particularly in the last few years. Unfortunately, most of the major exhibition catalogues feature almost exclusively limited editions with graphics by major artists, a major exception being the exposition of inexpensive artists' books, many of them American, curated by Anne Mœglin-Delcroix at the Bibliothèque Nationale in October 2000. Professor Mœglin-Delcroix had actually persuaded the reluctant French National Library to purchase these strange books. Moreover, Florence Loewy's specialized bookstore in Paris and Printed Matter in New York have by means of exchanges and exhibits bridged the gap between American and European artists who produce affordable books. In *Esthétique du livre d'artiste, 1960/1980* (Paris: Place, 1997), a state doctoral dissertation in philosophy, Anne Mœglin-Delcroix covers the same period and some of the same books as Betty Bright but from a totally different perspective and with a different emphasis, for she stresses the conceptual rather than the historical and technical ramifications of artists' books.

If we have discussed some artists' books produced long after 1980, it is to show the seminal importance of the period on which Betty Bright has focused. The books published in the United States between 1960 and 1980 established book art as a worthy and viable field of endeavor and made possible all the bookworks that have been produced since then. Betty Bright's scholarly and critical study is like no other. Johanna Drucker's *The Century of Artists' Books* (New York:

Granary Books, 1995) provides a valuable survey of the genre. Other studies in the field are either a gathering of essays, cover a different period, or suggest ways of reading and viewing artists' books. Betty Bright shows that it is far more rewarding to study these books in context rather than as isolated works of art. *No Longer Innocent: Book Art in America, 1960–1980* provides a thoroughly researched historical framework while avoiding a mechanical reliance on chronology. It also takes into account the development of printing and the complications of publishing original bookwork in the United States. Betty Bright explains the designs of printers and publishers as different from one another as Harry Duncan and Walter Hamady. And she is no less interested in the book as a finished product and in the means of its production. This approach appears all the more timely now that the survival of letterpress has become a problem. Whereas in France L'Imprimerie Nationale has been privatized and skilled typographers can no longer replace the worn parts of their equipment, private presses continue to thrive in the United States. The creators of offset multiples and of computer-generated images will hardly show concern over this situation, but only the artists involved with limited editions.

—RENÉE REISE HUBERT AND JUDD D. HUBERT

ACKNOWLEDGMENTS

I owe my discovery of book art to Jim Sitter, founding director of Minnesota Center for Book Arts, who hired me in 1984 when MCBA was still in the planning stage. Jim began my interview by dramatically opening *Self-Portrait in a Convex Mirror* by the Arion Press. *Self-Portrait,* was, fittingly, a circular book housed in a brushed stainless steel case, whose lid was crowned with a convex mirror. Within the case, circular pages of handmade paper carried the John Ashbery poem along with imagery by leading artists. That first artist's book— unwieldly and compelling—served as a metaphor for my experience of helping to start MCBA. As Jim foretold, a dream could move from a mere reflection into vibrant reality with a lot of hard work and a little luck.

About ten years later, this history began with the research that I conducted for a Ph.D. in Art History from the University of Minnesota (2000). Throughout the ensuing six years, I thank Professor Rob Silberman for his encouragement, patience, and insight. I also acknowledge the thoughtful contributions of my dissertation committee members: Professors Jane Blocker, Michael Hancher, Barbara Martenson, and Patricia McDonnell. I am grateful for the generous grant from the Getty Center for the History of Art and Humanities that supported my November 1995 research trip, and, once there, I thank Marcia Reed and her staff in the Rare Books Department for their tireless assistance. In addition, a grant from the National Committee for the History of Art allowed me to attend the International Congress of the History of Art in Amsterdam in September 1996. I also wish to thank Janis Ekdahl and her staff at the Museum of Modern Art Library in New York for their assistance during my research trip in 1997.

In the last few years I have pulled apart, cut back, and reconfigured this manuscript to better tell the story of artists and books. I have also pursued earlier leads. For example, I thank Mary Phelan and Lois Johnson, who brought me out to The University of the Arts in Philadelphia in 2001 to meet with students. During that trip I met with Rosina Feldman, who devoted several hours to introducing me to the work of her late husband, Eugene Feldman. I also thank the Society for the History of Authorship, Reading and Publishing for a travel grant that enabled me to attend and present a paper at its July 2001 conference, held at the College of William and Mary in

Williamsburg, Virginia. My paper discussed the work of three key artists who made books in Philadelphia during 1964: Eugene Feldman, Claire Van Vliet, and Dieter Roth.

Because book art has occupied me for a professional life of twenty years, it would be impossible to assemble a full listing of the artists, curators, collectors, and booklovers who have contributed to my understanding of artists' books, although I try to acknowledge key writers and curators in my Introduction. I can only extend heartfelt thanks here for the hundreds of encounters with the artists and their books—many of whom I met at Minnesota Center for Book Arts—that have delighted and challenged me, and helped to shape my own aesthetic over the years.

However, I do wish to especially acknowledge the several artists and arts professionals who patiently submitted to lengthy interviews related to my research. Their contributions helped me in my efforts to bring the field and the time period to life. Those interviewed include: Richard Bigus, Betsy Davids, Judith Hoffberg, Susan King, Richard Minsky, Keith Smith, and Claire Van Vliet. Several people generously provided materials from the 1960s and 1970s, in particular Betsy Davids, Judith Hoffberg, Joan Lyons, John Risseeuw, and Susan King. In addition, I interviewed professionals in 1993 in relation to an independent research project for Professor Timothy Blade, that examined the differences between collecting art and collecting artists' books (Professor Blade, since deceased, was to have served on my dissertation committee). Those who graciously participated in those interviews included: Sally Alatalo of the Flaxman Library, the School of the Art Institute of Chicago; Steven Clay of Granary Books, New York; Jay Dillon of Sotheby's Book Department; Rosemary Furtak and Liz Armstrong of Walker Art Center; Priscilla Juvelis of Priscilla Juvelis, Inc., Boston; Clive Phillpot, former director of the Library at the Museum of Modern Art, New York; Betsy Pittman of Virginia Commonwealth University, Richmond, Virginia; Nancy Princenthal of *Art On Paper*; and Ruth Sackner. My sincere thanks to Renée Riese Hubert, Professor Emerita at the University of California, Irvine, and Judd D. Hubert, Professor Emeritus at the University of California, Irvine, for their erudite foreword. I also thank the artists who have provided me with reproductions of their books.

I appreciate the review of sections of the manuscript by Rosemary Furtak and Rob Rulon-Miller, and I have benefited greatly from the thoughtful commentary and suggestions of Terry Belanger, Betsy Davids, Walter Hamady, Joan Lyons, Richard Minsky, Marvin and Ruth Sackner, Keith Smith, and Claire Van Vliet, all of whom

generously took time out of their busy schedules to read the manuscript or sections from it. I thank Tim Johnson, Librarian of Special Collections and Rare Books at the Andersen Library, University of Minnesota, for facilitating my photographing of a few key books. My thanks for help in contacting artists for permissions, to Rosemary Furtak and her staff at Walker Art Center Library, and to Steven Leiber.

My heartfelt thanks to Jay P. White and Karen Chernyaev for their careful edits. Any inconsistencies or inaccuracies that may remain are my responsibility.

I complete this book with two artists in mind, Jim Trissel and Karen Wirth, whose friendships sustained me in my research and writing.

— BETTY BRIGHT

INTRODUCTION

There is something impossibly difficult in the written assessment of books others may not have seen, like reports from deep space or from the sensual life reporting back a summary of its own existence. Most valuable things are complex; good criticism is very difficult indeed.[1]

—JIM TRISSEL, 1996

The story of book art in America in the 1960s and 1970s is a story of persistent identity crises and of fierce allegiances as well as dissensions. Much to the chagrin of critics and the frustration of artists, the enduring debate over the years has turned on the most basic of questions: What is and what isn't an artist's book? In his essay "The Rise of the Book in the Wake of Rain," printer Jim Trissel laments that too often the critics of artists' books have resorted to an "effort to segregate kinds of books into categor[ies] and to proclaim something now called the 'artist book' the emergent and superior species." By this, Trissel refers to writers who claim for art one kind of artist's book to the exclusion of all others. To the uninitiated, such hair-splitting may appear confusing, even mean-spirited. Why the polemic?

A preoccupation with definition is perhaps understandable given the diversity in artists' books, which appear in dramatically different forms and with radically divergent content. Such books can appeal to entirely separate audiences. Let me offer a story from my own experience as curator of the nonprofit organization Minnesota Center for Book Arts (MCBA). In 1992, the respected book collector and critic Abe Lerner arrived in Minneapolis to speak at the annual dinner hosted by the Ampersand Club, a local book art group. Before the dinner, Lerner visited MCBA and toured its exhibition, "Completing the Circle: Artists' Books on the Environment." The show would soon begin a national tour, accompanied by an illustrated catalogue and funded by a grant from the National Endowment for the Arts (NEA). Lerner later departed from his opening remarks to Ampersand members to rail against the exhibition and MCBA for sponsoring it. One got the impression that he felt a need to identify an infestation that was threatening the health of the book world itself.

What had prompted Lerner's wrath? Certainly not fine press books such as Claire Van Vliet's *The Tower of Babel* (1975, fig. 1), a set of unbound folios of haunting lithographs accompanied by letter-press-printed texts by Franz Kafka about the imagery and myths of Babel. Or on a more intimate scale, not the elegant typographical design of Gray Zeitz's *Sabbaths 1987* (1991, fig. 2), in which seven poems by Wendell Berry either rage against prodigality or meditate upon a

1. *JAB* [*The Journal of Artists' Books*] 5 (Spring 1996): 26–27.

FIG. 1. Claire Van Vliet.
The Tower of Babel
12¹/2 x 10

FIG. 2. Gray Zeitz.
Sabbaths 1987
10 x 7

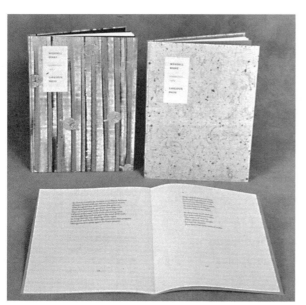

longed-for balance with a changing earth. No, Lerner reacted to the blight he believed had afflicted sculptural bookworks such as Richard Minsky's gaping *Geography of Hunger* (1988, fig. 3) and Doug Beube's *Tar Spill* (1987, fig. 4). These books are not pretty, and they do not follow the rules of typography or binding or, for that matter, reading itself. They capture attention by amusing or disturbing a reader, who often responds by nervously searching for a label to explain the work's transgressions. No wonder that Lerner took umbrage with the cohabitation of such works alongside the well-proportioned page designs of fine printing. Abe Lerner rightly recognized the challenge delivered to booklovers by the sculptural bookwork. Imagine, then, a critic's dilemma: How does one place a consciously repellent book into a proper context? Principles of typographical and structural integrity that have guided booklovers in the past do not apply to these practical objects transformed into a purely expressive role. In fact, the clash between typographical and sculptural artists' books is only one conflict out of several that have thwarted an even-handed discussion of artists' books, from fine press books of poetry to fetid bookworks.

To compound the difficulties of placing such works into a proper curatorial context, I could find no history that identified precursors for the full spectrum of book art. When I asked book artists in the late 1980s about their influences, they vaguely acknowledged works from the 1960s and 1970s. Over time, my questions grew more persistent. Where did these different

books originate from? Are their histories related? What drew so many artists to the book form, and why did some artists alter it into such unrecognizable manifestations? Finally, I posed the question: Is it possible to encompass such diversity within one history?

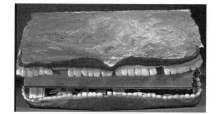

FIG. 3. [CP11] Richard Minsky. *Geography of Hunger* by Josué de Castro. 9 x 7

I tamed diversity through definition. I traced the rise of three distinct categories of the artist's book: the fine press book, the deluxe book, and the bookwork. I also identified the

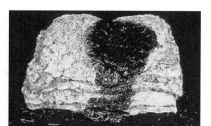

FIG. 4. Doug Beube. *Tar Spill* 12 x 20 x 8. Size varies

appearance of hybrid artists' books, in which characteristics of one kind of book merge with another. This process results, for example, in a fine press–deluxe hybrid or a deluxe-bookwork hybrid. Second, I explored a number of issues concerning the production, distribution, and reception of the artist's book. Most of these issues stem from two conflicting perceptions of the artist's book: Is it a book, or is it art?

What exactly is an artist's book? Simply stated, an artist's book is a book made by an artist. To create it, an artist either executes each step of a book's production or works closely with others to give form to a vision. But mere artistic involvement does not make an artist's book. Every aspect of the book—from content to materials to format—must respond to the intent of the artist and cohere into a work that is set in motion with a reader's touch.

Sounds simple, doesn't it? The reality is much more complex, even labyrinthine. General terms such as "artist's book" or "book art" actually convey radically different meanings to various groups in the field. As will be detailed below, some critics adopted the term "artist's book" in the early 1970s to identify only the multiple bookwork. For these writers there was simply no other valid kind of artist's book, and in steadfastly arguing that point of view, they succeeded to a great extent in dismissing art world identities for fine press, deluxe, and sculptural bookworks. Although today more writers use "artist's book" as a general term, these earlier definitions, with the resulting confused perceptions, linger.

In contrast, the term "book art" has escaped such partisanship. It has faithfully continued to indicate a range of practices conducted within a community of nonprofit arts organizations that first appeared

in the mid 1970s. Perhaps because of the clarity of the term, some multiple bookwork writers have avoided or belittled it in order to dissociate their books from the craft-based disciplines related to the production of fine printing. I use "artist's book" and "book art" as umbrella terms, while recognizing that "book art" implies a broader meaning that encompasses related arts such as hand papermaking and bookbinding.

The proliferation of book art begins around 1960, when recurring differences in content, format, and material begin to distinguish the three categories of artists' books.[2] The terms "fine press book" and "fine printing" remain generally unchallenged, and for sympathetic writers those terms continue to reflect an aesthetic based in a British heritage and associations of literary content and letterpress production. Fine press books celebrate the demands and rewards of craft: of pulling a mould and deckle from a vat of paper pulp, of sewing the signatures of a binding, or of printing on a hand press.

"Deluxe book" evokes associations with star artist and high-cost collectibility rather than with aesthetic innovation. In truth, "deluxe book" has never been used consistently as a term, perhaps because of its elitist associations. More common has been the use of *livre de peintre* or, less commonly, *livre d'artiste*. While those terms accurately reflect the French patrimony of the deluxe book, the terms are inaccurate when translated into the too-narrow "painter's book" or the too-broad "artist's book." The French heritage of the deluxe book utilizes printmaking (usually) and induces the pleasures of sight, touch, and even smell from a close attention to vivid imagery, fine papers, and rich leather bindings. "Deluxe" describes the expensive materials and meticulous production of the traditional deluxe book and also indicates the issues that complicate and enrich that aesthetic — for example, in the homely look of Richard Tuttle's *Story with Seven Characters* (1965, fig. 5), discussed in chapter 7, which he adopted in ironic contradiction to the deluxe canon. Both strategies inform the deluxe aesthetic.

The term "bookwork" first appeared in 1975 with *Artists' Bookworks,* an exhibition curated by Martin Attwood for the British Council.[3] The compound term indicates a reflexive stance: This is an artwork about books, one whose content may subvert conventional book design or deliver provocative artistic or social significance. Two influential writers, Ulises Carrión and Clive Phillpot, used the term regularly in the late 1970s to describe an artist's book that relies on avant-garde strategies, content, and formats. Their regular usage, however, should not suggest unanimity over the use of that term or any other for the multiple bookwork. In fact, passionate debates over definition

2. Other terms that have vied for prominence concerning each type of artist's book are discussed in the following chapters, at the point in time in which they appeared in the literature.

3. The date of 1975 is based upon the chronology reported by Clive Phillpot in "Twentysix Gasoline Stations that Shook the World: The Rise and Fall of Cheap Booklets as Art." *Art Libraries Journal* 18, no. 1 (1993): 4–5. There is no listing of "bookwork" in the *Oxford English Dictionary* (Oxford: Clarendon Press, 1989).

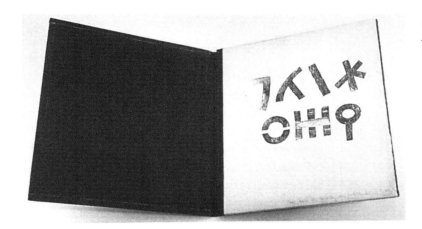

FIG. 5. Richard Tuttle.
Story with Seven Characters
12 x 11

dominated the 1970s as artists and writers called the multiple book-work by different names while arguing its case as an artwork.

The bookwork in that period developed into two subcategories: the multiple bookwork and the sculptural bookwork. "Multiple bookwork" was actually coined by Phillpot in 1982. He intended that the term indicate an artist's use of a contemporary commercial print-ing technique (such as mimeograph, copier, or offset printing) in books of relatively large editions. Artists who made multiple book-works often priced them low to indicate a populist intent. They hoped that the multiple bookwork's large numbers and low prices would result in more books being sold directly to the public, thus by-passing the traditional gatekeepers of the museum or the gallery.

In addition to the term multiple bookwork, I add "sculptural bookwork." A sculptural bookwork designates works such as those by Richard Minsky (*Geography of Hunger*) and Doug Beube (*Tar Spill*), discussed above. The two terms of multiple and sculptural bookwork indicate their shared avant-garde intent to defy the norms that govern the ordinary book. One kind of intent is directed toward producing unconventional content (in multiple), and the other intent expresses itself through sculptural means and is generally a one-of-a-kind work. In the 1970s sculptural bookworks were described by a number of terms (most often, "book object"). The sculptural bookwork, how-ever, was not always a static object, but occasionally emerged as a performance piece or an installation. Its varied manifestations had in common the artist's intent to embody ideas about the book as an ob-ject and as a concept in its form and materials. Its content often re-sponded to the associations that have grown up around books over the centuries, such as the religious identity of the Bible. An artist might work with just such a concept to dramatize the content of a bookwork and so heighten the response of a reader. Such an encounter occurred

for me with *The Crisis of Democracy* (1980), another work by Richard Minsky. Minsky bound the book in leather and then wrapped it in barbed wire. The content of *Crisis* concerned the author's fears of the impending collapse of democracy. As I cautiously opened it for display, I experienced a number of conflicting ideas. Reading the book (a risky enterprise, but possible) would contribute to its eventual shredding, symbolically enacting the warning of the author and so implicating the reader in the political crisis that is the book's subject. The powerful effect of guilt-by-association created by *The Crisis of Democracy* engages the associations or aspects of the book in order to transcend gimmickry and succeed as art.

Several issues have arisen from the confusing dual nature of the artist's book as art and book. One issue concerns whether the artist's book has helped to enlarge our sense of what constitutes art and art-making. Book characteristics align it (even define it) with the ordinary book (as in trade publishing, small press publishing) or with technology (its printing method). Artists have recognized the advantages of invoking these associations. Most agree that books can be seen as carriers of knowledge, even guardians of culture. Because of that, an artist's book can operate like a "Trojan horse of art," [4] as printer Walter Hamady put it: It can insinuate itself into a reader's consciousness while it delivers content that may be unexpected or disturbing. In being associated with the trade book, however, the artist's book is then inextricably linked to the fate of trade publishing.

Additional debates concern the difference between a unique work of art and an artwork produced in multiple; the uneasy relationship of high art with popular culture; and the awkward intersections of fine art with craft and commercial printing technologies. Questions about distribution arise from the different expectations for books and art. For example, book distribution assumes publication in large edition sizes with a goal of reaching a broad audience. But the traditional view of fine art distribution suggests hushed conversations in galleries or bidding at auctions, where the goal is to sell artworks produced in limited numbers to a wealthy audience.

Artists in the 1960s and 1970s confronted such issues when they brought art and populism together, as independent publishers who sought a means for direct address to a wide audience. The timing of this populist fever was not coincidental to the dramatic growth in the production of artists' books—the two developments were interdependent. But the means of printing a book also determined what audience it reached. To a critic or potential collector, hand lithography

4. Walter Hamady, "Pre/Face, in Lieu Of," *Two Decades of Hamady and The Perishable Press Limited* (Mt. Horeb, Wisconsin: Perishable Press, 1984), n.p.

usually suggested a fine art, deluxe context, while copier printing communicated an avant-garde, bookwork context.

Finally, the book form has always posed special reception issues in its display. Unlike most art, an artist's book requires touch to unlock its evocative "otherness." The restrictions of exhibition in display cases force readers and critics to judge and articulate a book's success based on a single page opening. But a book is much more than pictures and text, much more than any one page. Reading a book involves the tactile, even emotional experience of paging through it. How, then, have the aesthetic complexities of the book form affected its acceptance as an art form? Put another way, what do the problems that the artist's book poses to the art world tell us about the limitations of that very world?

The conflicts over definitions of artists' books and the issues that these books raise for the art world are crucial to the story of the artist's book as a vital cultural artifact which underwent tremendous change in the period from 1960 to 1980. As I weighed key artists and artworks out of the many that emerged from that period of growth, I discovered early writers who raised questions about the disappearance of the ordinary book. These questions influenced the development of the artist's book as early as the 1960s, when the ordinary book's 500-year rule first faced diminishment from electronic and digital interlopers.

No history has been written before now that charts the development across the full spectrum of book art activity in the United States. A review of the key historical texts for each kind of artist's book reveals a breadth and depth of writings that vary widely with the type of book under discussion. (A selection of key texts is included in the bibliography.) Writings about the fine press book, for example, reflect longstanding efforts by American writers to understand the relationship of their own fine printing to that of their British predecessors. In addition, early historical writings on fine printing often appear in books under the subject of "books about books." These histories actually concern the common book and its printing technologies as they contributed to the spread of information and learning. But book history shifts into the history of book art in the many writings that celebrate the books of William Blake and the books of William Morris's Kelmscott Press in England.

Some early designers such as Stanley Morison of England exerted influence through their writings and, in the case of Joseph Blumenthal of the United States, also through curating. Joining them in America

from about 1950, the writings of printer Harry Duncan provided a voice and a model for the next generation of fine printers who were equally committed to achieving a similar literary farsightedness, mastery of craft, and attention to a book's artistic holism. In 1983 *The Private Press,* by Roderick Cave, surveyed a rich heritage of fine printing whose international selections included contemporary U.S. presses and their books. Journals such as *Fine Print* (1975–90) and later *Bookways* (1991–95) framed and fostered that dialogue, in which the related arts of papermaking, bookbinding, and calligraphy also gained a profile.[5]

Today, the lack of a substantive national journal for fine printing has to some degree muted that dialogue. The fine press book needs venues and criticism that do not eschew its typographical and literary past but rather come to grips with art-world influences and its own increasing visual, material, and structural enrichments. Although the recent history of fine printing and book art is relatively well documented through a scattering of catalogue essays, articles, and chapbooks, this history integrates the developments of hand papermakers and bookbinders into the larger story of fine printing and book art.

The deluxe book, unlike the fine press book, has benefited from the documentation and celebration of its books in a parade of glossy European surveys. In fact, success for the U.S. deluxe book was gauged early on by the degree of America's ingress into Europe's pantheon, as tracked in exhibitions here and abroad.[6] But publications of mere documentation or tributes to imagery and printmaking expertise often ignore the crucial role of "book" in these works. This omission is evidence of a critical vacuum that has not been helped by the relative unavailability of the deluxe book. That unavailability derives from its small edition sizes, from its sequestration in private and institutional collections, and from its display behind glass. Museum visitors who understand that "don't touch" is a necessary restriction for the protection of a museum's treasures still find the admonition irreconcilable with the expectations of touch that they bring to a book.

Discussions of the deluxe book must address the related contexts of a book's production. An essential resource is the essay by Robert Rainwater for the catalogue *The American Livre de Peintre* (1993). Rainwater examined the form and content of the deluxe book, the collaborative efforts of deluxe publishers, the contributions of early U.S. exhibitions, and the influence exerted by ateliers and dealers. The following year, *A Century of Artists Books* appeared, a lavishly illustrated catalogue accompanying an exhibition at the Museum of Modern Art [MoMA], authored by Riva Castleman,

5. In addition, book art organizations in California have published *Ampersand* (from the Pacific Center for the Book Arts) and *AbraCadaBrA* (from the Alliance for Contemporary Book Arts, ACBA, until 1999) for several years and in varying publication schedules. A shared U.S.-British journal, *Parenthesis*, appeared in 1998 from the newly christened Fine Press Book Association. All of these journals publish reviews of books and general interest articles on book art that primarily concern the fine press and deluxe book; *Ampersand's* scope extends to the sculptural bookwork.

6. Catalogues that marked that progress included Monroe Wheeler, *Modern Painters and Sculptors as Illustrators* (New York: the Museum of Modern Art, 1936); Philip Hofer and Eleanor Garvey, *The Artist and the Book: 1860–1960 in Western Europe and the United States* (Boston: the Museum of Fine Arts; Cambridge: Harvard College Library, 1961); and Breon Mitchell, *Beyond Illustration: the Livre d'Artiste in the Twentieth Century: an Exhibition* (Bloomington: Lilly Library, Indiana University, 1976).

Chief Curator of the Department of Prints and Illustrated Books. The exhibition contained mostly deluxe books, interspersed with a few bookworks—such as those by Ed Ruscha and Dieter Roth—that had by then entered the canon of the art world.

Twenty years earlier Susi Bloch wrote an essay for the catalogue *The Book Stripped Bare: A Survey of Books by 20th Century Artists and Writers* (1973). In it, Bloch provided a critical model that not only assessed compelling imagery but engaged the book form itself. Her essay will figure into my discussion of the 1970s. Not long after Bloch's essay was reprinted in *Artists' Books,* an anthology edited by Joan Lyons (1985), the writings of Renée Riese Hubert appeared, which outlined an aesthetic program in essays and in her definitive *Surrealism and the Book* (1988). In 1999 Renée Hubert joined with Judd D. Hubert in an in-depth consideration of a variety of contemporary works in *The Cutting Edge of Reading: Artists' Books.* This substantive writing is relatively recent; only Monroe Wheeler (*Modern Painters and Sculptors as Illustrators,* 1936) confronted issues of format and media pertinent to the deluxe book before Bloch's essay appeared in 1973.

The multiple bookwork generated the greatest number of debates during its rapid growth in the 1970s. Most arguments established an historical lineage that was reflective of (and thus validated by) the art world. But most of these writers displayed little knowledge of the bookwork's avant-garde history. Susi Bloch's essay in 1973 was one exception among the early catalogue essays that circulated in the book art community. Most writings postdate 1980, such as those by Renée Riese Hubert, as well as the catalogue essay by Jaroslav Andel for Franklin Furnace's *The Avant-Garde Book: 1900–1945* (1989), and Anne Mœglin-Delcroix's *Esthétique du livre d'artiste, 1960/1980* (1997).

The critical discourse of the multiple bookwork crystallized before 1980 in catalogues and journals.[7] From France, Stéphane Mallarmé wrote the earliest and perhaps most influential essay, "The Book: A Spiritual Instrument" (1895). In it, Mallarmé described type as marks that inhabited the white space of a page and contributed equally to the expressive meaning of a text. From Germany, Walter Benjamin wrote "The Work of Art in the Age of Mechanical Reproduction" (1936), in which he observed the mass media's ability to dissolve the elitist "aura" that contrived to hold art separate from the masses. Benjamin's essay circulated among American artists in the late 1960s, when it was translated into English.

Beginning in the mid 1970s, a small circle of contemporary writers set the parameters of the discourse specific to the multiple bookwork. Ulises Carrión, Clive Phillpot, Lucy Lippard, and others depicted its

7. In particular, see the catalogues *Artists Books* (Philadelphia: Moore College of Art, 1973) and *Artwords and Bookworks: An International Exhibition of Recent Artists' Books and Ephemera* (Los Angeles: Los Angeles Institute of Contemporary Art, 1978), both of which figure into my discussion later in this history. See also two alternative journals whose special issues focused on the alternative multiple: *Art-Rite* (no. 14, Winter 1976–77), and *The Dumb Ox* (no. 4, 1977). As for ongoing journals, only *Umbrella* (Judith Hoffberg, ed.) has consistently tracked the field since 1978.

various artistic and social characteristics. In the period after 1980 the influence exerted by *Artists' Books: A Critical Anthology and Sourcebook* (1985), edited by Joan Lyons, cannot be overstated. Recently joining Lyons's anthology in importance, *The Century of Artists' Books* (New York City: Granary Books, 1995), by Johanna Drucker, acknowledges avant-garde precursors and then examines over three hundred multiple bookworks within book-specific contexts. Drucker identifies a "zone of activity, rather than a category into which to place works by evaluating whether they meet or fail to meet certain rigid criteria."[8] For the most part, the fine press and deluxe book, as well as sculptural bookworks, fall outside of Drucker's zone of activity. Anne Mœglin-Delcroix analyzes more than five hundred artists' books from Europe and the United States that share conceptual content, in her copiously illustrated *Esthétique du livre d'artiste, 1960/1980*.

The sculptural bookwork, the fourth and last kind of artist's book, was not investigated by an American writer before 1980, except for a brief celebration or dismissal. An in-depth history of the U.S. sculptural bookwork remains to be written, beyond the few works noted in this study. Only in the mid 1980s did the sculptural bookwork attract sustained critical attention here, seen in the writings of Renée Riese Hubert and Buzz Spector. Hubert characterized the sculptural bookwork in oppositional terms as a "*livre détourné* [that] produces an almost systematic clash between the book as object and its intellectual, aesthetic and cultural dimensions. It plays art against functionalism" and "reading against looking."[9] Such "deviant books" interrupt, redirect or even refuse a reader's movement from image to text or from page into sequence or back again, even as they "invite us to read them in their own deviant way."[10] Hubert identified the combustible mix of fascination and repulsion that such works can inspire, since, when confronted with them, readers react personally, even viscerally.

For artist and critic Buzz Spector, Hubert's concept of the deviant book was intensified by the interplay between nostalgia and desire that is stimulated when a reader encounters a sculptural bookwork.[11] Spector writes with the authority that comes with making altered bookworks as well as installations of found books, such as *Library of Babel* (1988, fig. 6). These works assumed nearly iconic status among book artists. They excelled at triggering viewer emotions that collide with memories of reading as an intimate and protected activity: of a book opened in one's lap, or reading while reclining in bed, the book suggestive of a pivot point at the intersection of a reader's public and private lives. Such subliminal residues lurking within a reader resulted in profound associations attached to the common book that Spector and others readily engaged. For example, a book's

8. Johanna Drucker, *The Century of Artists' Books* (New York City: Granary Books, 1995), 2.

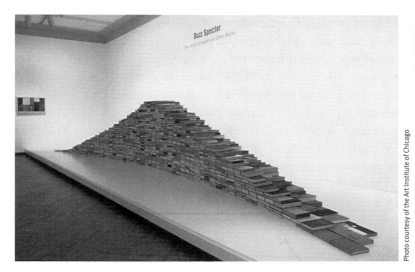

FIG. 6. Buzz Spector.
Library of Babel, 1988.
Installation of found and stacked books. Approximately 4' x 30' x 5' (HxWxD).

Photo courtesy of the Art Institute of Chicago

openable codex format suggests oppositions of containment and release, interior and exterior, surface and depth, covering and exposure, invitation and rejection. Now imagine those associations subjected to the theatrics of Lucas Samaras, whose sculptural bookworks from the 1960s were often pierced by knives and glass shards. Such works can generate an onslaught of emotional suggestions and deflections.

Add to this tense drama the idea that such associations do not exist in stasis but in an object that moves in response to a reader's touch. Within the book, timeframes coexist: that of its original production; that of the completed book's presumed word-by-word reading; and that of each reader's unique experience with it. Such an experience begins with touch to set it into play, and develops along with whatever kind of paged access the reader undertakes. Once a reader becomes aware of the reading experience, this sense of a performance complicates and enriches every encounter with an artist's book. Hubert is particularly adept at alerting a reader to this process, to the choices that he or she makes in following a text or in contemplating an image, and how those choices create a complex response. Such concentrated reading is taxing, since a sensitive reader must open up to an unfolding physical, intellectual, and emotional simultaneity. Book artists understand this sentient quality of reading and hold in mind the expectation of each reader's individual response. In that sense the book artist needs a reader to open the book in order to activate it, and so complete it.

Signs of the critical maturation of the book art field are recent or just emerging. For example, Keith Smith has published textbooks since 1984 that examine issues of aesthetics and production in his own multiple and sculptural bookworks as well as in the bookworks

9. Hubert notes that the term was first used by Caroline Corre. Hubert, "Readable-Visible: Reflections on the Illustrated Book," *Visible Language* 19, no. 4 (Autumn 1985): 521.

10. Ibid., 522.

11. In 1995 Spector's collected writings appeared in *The Book Maker's Desire* (Pasadena: Umbrella Editions, 1995).

of other artists. His writings were crowned by *200 Books* (Rochester, New York: keith smith *BOOKS,* 2000), an extensively annotated bibliography of Smith's artists' books up to that time. Other book art writers to whom I owe a debt for their insight into the book's cultural identities include Frances Butler, Susan Compton, Betsy Davids, Susan King, and Gerry Lange. *The Journal of Artists' Books* (known popularly as *JAB* 1994–2003), edited by Brad Freeman with the strong involvement of Johanna Drucker, published a number of interviews and essays that often featured the multiple bookwork. In addition, *Speaking of Book Art: Interviews with British and American Book Artists* (1999), by Cathy Courtney, held a series of lengthy interviews with leading artists on both sides of the Atlantic. There are not many interviews with multiple bookwork artists of the 1960s and 1970s beyond those with Ed Ruscha, Lawrence Weiner, and a few others. An exception is found in Thomas Dugan, *Photography Between Covers: Interviews with Photo-Bookmakers* (Rochester, New York: Light Impressions, 1979), which captured a sense of the time for artists, including Joan Lyons, Keith Smith, and Syl Labrot. To supplement this material, I have conducted several interviews with leading artists and others in the field.

Collected writings are also a sign of critical maturity, and Drucker's own *Figuring the Word: Essays on Books, Writing, and Visual Poetics* (1998) brings many of her journal and catalogue essays together in one volume.[12] Despite these publications, relatively few in-depth retrospectives and monographs on book artists have appeared; those that have belong to prominent artists, such as Ed Ruscha, Sol LeWitt, Dieter Roth, and Lawrence Weiner.

Another sign of a maturing art world is bibliographical documentation, a nightmarish prospect in such a wildly diverse and marginalized field. Scholars and collectors of fine press and deluxe books have long produced bibliographies, but for the multiple bookwork, the reading lists produced in the 1970s soon gave way under the flood of articles and small catalogues that appeared in the 1980s. To date, only Stefan Klima has attempted to assemble and interpret a bibliography for (primarily) the multiple bookwork, in *Artists Books: A Critical Survey of the Literature* (1998). Klima considers a mountain of literature in journal articles, reviews, and exhibition catalogues, but he does not examine the multiple bookwork within its larger book and art contexts or within a consistent chronological framework.

The variety of writings suggests a number of difficulties that the artist's book poses to an historian intent on establishing definitions, boundaries, and interpretations. The most important point to be made here is that the book art community itself is not comprised of a

12. In addition, see Jerome Rothenberg and David Guss, eds., *The Book, Spiritual Instrument* (New York City: Granary Books, 1996), a reissue of *New Wilderness Letter* #11 from 1982. See also *A Book of the Book, Some Works and Projections about the Book and Writing* (New York City: Granary Books, 2000), a compilation edited by Jerome Rothenberg and Steven Clay of over ninety writings from all time periods.

discrete set of makers and viewers, nor sites for art-making and exhibiting. In the book art world, artists and critics and sites of production and exhibition may shift in and out of the book and art worlds as interests and opportunities provide.

This bibliographical summary captures the complexities and limits of not only this particular history but of the book art field itself. Let me end with six points that tell what this history will include and what it must leave aside.

First, my priority lies in assembling a broad-based U.S. history in which book art's own institutional development, along with the related worlds of art, typography and graphic design, trade book publishing and independent publishing, are considered together with the discussions of specific books and artists. To that end, *Art Worlds* (1982), by Howard Becker, has proved invaluable. Becker proposes a sociology of art production, whose players range from institutions that anchor "culture industries" such as film or book publishing, to minor art worlds vying for recognition, to the rebels of emerging "maverick" art networks.

My second point is that this history reflects that book art can translate into fine press or deluxe books as well as the multiple and sculptural manifestations of the bookwork. As I alluded to above, I came to this research from within the book art world: I helped to start Minnesota Center for Book Arts in 1984, and stayed there for nine years, during which time I curated about fifty exhibitions and handled thousands of artists' books. After a career of exhibiting radically different kinds of artists' books, and learning about the varieties of book and art from those juxtapositions, I am able to let the differences as much as the likenesses inform and illuminate the story of the book's continuing appeal to artists.

Third, I have adopted a chronological approach to this history in order to address an amnesia that has long afflicted the field. As a curator I felt that I operated in a vacuum, since no history existed that examined the crucial time period in the United States when the artist's book came to life, from 1960 to 1980. My research, then, was meant to answer my longstanding questions about an art form that had matured to the point where it was "no longer innocent" and yet had no sense of its own history, its own heritage. This amnesia has produced an increasing number of artists' books in the last twenty years whose content or strategies were long ago exhausted by unacclaimed innovators.

Fourth, in keeping with my focus on the United States, European artists' books appear here only selectively. I have chosen a few books made in Europe before 1960 as key precursors, to illustrate specific

strategies or content that proved attractive to American book artists. In addition, I include selected contemporary European artists' books from the 1960s and 1970s which were for the most part made by artists who had unarguably established a U.S. presence by that time and which in the following years exerted significant influence over American book artists.

Fifth, this history is limited by its use of terminology. Any selective lineage cannot escape the confusions and even the unwitting deceptions perpetrated by terminology. After all, it is a fact of any history that to define is to separate, to assign an identity, and even (by extension) to control a reader's perception of a work, a kind of work, or even of an entire field. But for the purposes of telling this story, I have sorted work into three categories that are distinguishable in artistic intent, content, and format especially in their early manifestations. Note, however, that part of the story also lies within the increasing overlap between the fine press book, the deluxe book, and the bookwork, an overlap which only hints at the plurality that awaited the artist's book in the 1980s. Even so, the use of terminology (despite its deficiencies) is necessary to sort through the kinds of books that embody this history.

Sixth, writing a history about a marginalized art form poses special questions regarding emphasis. Book art has been permeable to influences from the book and art worlds that surround it, but to a great extent book art has also been held separate from the attentions and resources of both the art and book worlds. This disregard is being redressed to some degree as the more recent art movements concurrent with the rise of artists' books receive attention. But then, the contributions of the book to these movements are hard to ignore. For example, books played a crucial role in the Fluxus movement, where their sequential structure enlivened content that often concerned chance and performance. And Conceptual interests in an idea-based, "dematerialized" art outside of the museum and the gallery, as well as Conceptual involvement with time-based and sequential art-making, contributed to a flood of artists' books.

As a site and source of art-making, the book undoubtedly affected those art movements sympathetic to its properties and potential. My challenge has been to capture the importance of works and actions that took place within the book art world, while not overstating its influence on the surrounding trade book and art worlds. The paradox here is that for all of its modest influence as recognized by those on the outside, to those within the book art world, an artist's book holds the power to demand and deliver nothing less than a new way of seeing, through the simple act of picking up a book.

What is left is to tell the story, which will begin with a discussion of the precursors for each type of artist's book produced in Great Britain and Europe in the early twentieth century. That context will lead in later chapters to the period when U.S. artists' books came to life, between 1960 and 1980. To best describe the changing nature of the book as an artifact, only a few books and artists must represent the hundreds that appeared. Many books have been left out, and the pain of such necessary omissions has been heightened by the knowledge that this history can only do so much and must await other voices to respond, enlarge, and deepen the discussion.

I

BOOKS FOR THE NEW CENTURY

Therefore, granted well-designed type, due spacing of the lines and words, and proper position of the page on the paper, all books might be at least comely and well-looking: and if to these good qualities were added really beautiful ornament and pictures, printed books might once again illustrate to the full the position of our Society that a work of utility might also be a work of art, if we cared to make it so.[13]

—WILLIAM MORRIS AND EMERY WALKER, 1893

William Morris has sworn a terrible oath against me for daring to bring out a book in his manner.... The truth is that, while his work is a mere imitation of the old stuff, mine is fresh and original.[14]

—AUBREY BEARDSLEY, 1893

EUROPE'S LEGACY

THE FINE PRESS BOOK

The story of the rise of book art in America actually begins with
books from Europe that emerged with the twentieth century. This
chapter steps back a hundred years to consider precursors that have
come to characterize the fine press book, the deluxe book, and the
bookwork. For many booklovers, William Morris, poet, illustrator,
and book designer, is considered the founding father of fine
printing.[15] In the 1890s, Morris was nearing the end of a life devoted
to art-making and activism. He began his last enterprise, the Kelm-
scott Press, in 1891, and produced books that asserted an emphatic
graphic and material presence. Such books embodied Morris's Arts
and Crafts belief in history as a source for holistic design and quality
production. Morris's magnum opus was the Kelmscott *Chaucer*
(1896, fig. 7). Bound in white pigskin leather, *Chaucer* opens to reveal
capacious pages. Morris designed borders of vines that twist and spill

FIG. 7. [CP2] William Morris.
The Works of Geoffrey Chaucer
Woodcut title, borders, frames,
initials by Morris. 87 woodcut
illustrations by Edward Burne-Jones.
17 x 11 3/4

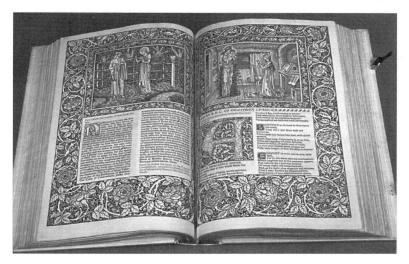

around the illustrated pages and the decorative capitals, as in a
botanical riot.

Morris's frustration as a writer served as the catalyst for his
founding of the Kelmscott Press. A published poet since 1858, Morris
had become painfully aware of the trade-offs in quality made by com-
mercial publishers eager to produce larger and cheaper editions. Before
he founded the Kelmscott Press, Morris was appalled when, in judg-
ing a book design competition for the first Arts and Crafts Society

13. From "Printing," in *Arts
and Crafts Essays by Members
of the Arts and Crafts Exhibition
Society* (1893); reprinted in Will
Ransom, ed., *Kelmscott, Doves
and Ashendene* (Los Angeles:
The Typophiles, 1952), 33.

14. Quoted in William Peterson,
*The Kelmscott Press: A History
of William Morris's Typographical
Adventure,* (Berkeley: The University
of California Press, 1991), 283, 285.

15. This statement is debatable.
Booklovers may argue the merits,
for example, of the open designs of
John Baskerville (1706–1775), or the
more dramatic pages of Giambattista
Bodoni (1740–1813), both of whom
designed books where the text, not
the illustrations, remained primary.
For the purposes of this history of
book art, which examines the involve-
ment of artists in bookmaking, Morris
will serve as our model. Sources
cited in the introduction note several
survey histories of printing.

exhibition in 1888, he acknowledged that none of the trade books of his own writings met standards of good design.[16] The design of some trade books had fallen prey to industrialization; specifically, the requirements of the high-speed presses of the time. These presses required that printers dilute their ink in order to print the thin and narrow typefaces efficiently. In some cases unskilled printers produced a page of overall grayness rather than the crisp printing that such typefaces required. Uneven printing was a problem as well, as was the wood pulp or bleach in many of the papers. There were those who were conscious of book design, even though, as historian Susan Otis Thompson notes, "There was as yet no profession of book designer, while the practicing printer was more noteworthy for his technical than his artistic knowledge. [A book's] illustrations might be by several different hands, reproduced by several different processes. In any case, no one saw the advisability of relating the lines of the type to those of the drawings or imposing any kind of unity on the decoration of the book."[17]

As a writer, artist, designer, and lively bibliophile, Morris believed that books were essential to life; he once famously compared their creation to the building of a house. Morris viewed type as analogous to the mortar that holds a building together. He designed the smaller *Chaucer* type to fit this book's double borders. Even an all-text page, punctuated by smaller foliated caps and type ornaments, is as much picture as text.

Despite the stature that the Kelmscott Press attained with collectors and other printers, Morris's books were never free from detractors. One critique was telling. In 1934, long after Morris had died, Holbrook Jackson excoriated the Kelmscott books, in a dinner speech, as "typographical curiosities from birth, and so far removed from the common way of readers that they have become models of what a book should not be....The Kelmscott books are overdressed. They ask you to look at them rather than to read them."[18] Granted, a Kelmscott page demands careful attention from a reader. Type and picture were meant to cooperate in the effect. As a poet and voracious reader Morris felt no need to justify exuberant designs that he believed celebrated a text. The point was not simply to read a story in a book but to enter into a world. To critiques aimed at his admiration for Gothic book design, he retorted: "You may say that you don't care for this result, that you wish to read literature and to look at pictures; and that so long as the modern book gives you these pleasures you ask no more of it, well, I can understand that, but you must pardon me if I say that your interest in books in that case is literary only, and not artistic, and that implies, I think, a partial crippling of the faculties; a misfortune which no one should be proud of."[19]

16. Susan Otis Thompson, *American Book Design and William Morris* (New York, London: R.R. Bowker Company, 1977), 20.

17. Ibid., 2–3.

18. Quoted in Roderick Cave, *The Private Press* (New York and London: R. R. Bowker Company, 1983 [2nd ed.]), 111.

Unlike the *Chaucer*, whose grandeur suggests a deluxe book aesthetic, most of the Kelmscott Press books (and the Arts and Crafts' books in general) projected a less commanding presence. *Hand and Soul*, by Dante Gabriel Rossetti (1895, fig. 8), is more typical of the Kelmscott Press. Morris's own Golden type, which was inspired by a fifteenth-century roman type by Nicholas Jenson, is the primary visual element here, accompanied by occasional foliate borders. *Hand and Soul* caters to its literary content, true to what became the heritage of the fine press book.

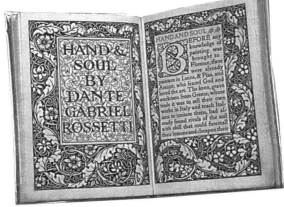

FIG. 8. William Morris. *Hand and Soul.* 5³⁄₄ x 4¹⁄₄

Even though a history of early typography is beyond the scope of this discussion, a brief summary will set the stage for later developments that affected American fine printers and trade publishers. At the time of the founding of the Kelmscott Press in 1891, the typography emerging from British presses had begun to alter. The reign of the old-style Caslon typeface since 1720 had accustomed printers and readers to a robust letter carrying the slight irregularities of thicks, thins, and serifs characteristic of the edged pen and of early printing. The first modern typeface was cut in 1784 at the foundry of Firmin Didot, and by 1787 Giambattista Bodoni had designed his interpretation of Didot. These modern-face romans and other typefaces were introduced into England by John Baskerville and Robert Thorne in the late eighteenth century, and this kind of typeface slowly supplanted Caslon. The modern-face types mimicked the minute hairlines of engraving, with vertical shadings that created dramatic thick-to-thin contrasts. The modern style projected the cool, rationalist character of Industrial Age efficiency while also meeting the technical needs of the new high-speed presses.

Long before the 1870s, the industrial revolution in England had transformed publishing from the "mechanization of the graphic chain"[20] that multiplied the speed and size of its huge print runs. Woodpulp paper supplied high-speed letterpresses. These letterpresses were replenished by linotype and monotype machines capable of the rapid setting and casting of large amounts of metal type, supplied in turn by punchcutting machines.[21] Technological developments allowed a greater presence of imagery, and the look of the trade book subtly evolved throughout the nineteenth century. Still, wood engravings printed with type remained a cost-effective and popular option for illustrating books and magazines—at least for a time—since they could be locked into the press bed along with the type, although stereotypes were often used to speed up printing.[22] In

19. Morris, "The Woodcuts of Gothic Books," quoted in William Peterson, ed., *The Ideal Book: Essays and Lectures on the Arts of the Book by William Morris* (Berkeley: The University of California Press, 1982), 37.

20. Henri-Jean Martin, *The History and Power of Writing* (Chicago and London: The University of Chicago Press, 1994), 406.

21. Peterson identifies these steam-driven presses as contributing to the "bland, undistinguished" pages that characterized some nineteenth-century trade printing. The presses necessitated types cast in harder metal, which in turn could sustain letters with thinner strokes and serifs. Thinner types allowed more letters and words per page, and so reduced printing costs. Peterson, *The Kelmscott Press*, 11–19.

the late nineteenth century, lithography combined with the emerging photographic technologies increasingly dominated trade printing. But, as Peterson notes, "probably the ordinary reader a century ago paid no more attention to such matters than readers nowadays do; the most appalling woodpulp paper, when it is new, may seem decent enough to the unpracticed eye."[23]

With mass production came the inevitable commercialization that Morris believed had contributed to a fundamental dishonesty of bookmaking, where "modern book papers...frequently masqueraded as something better, with fake wire and chain lines (to suggest that they were handmade) and adulturants (to add weight and shininess). In certain kinds of books and periodicals, [Morris] suggested, cheap paper was acceptable, but only if it frankly acknowledged its own cheapness and made no effort to disguise itself."[24] Trade books could not compare to the incunabula that Morris admired. These books, which were printed in the first fifty years after the invention of movable type (1450–1501), conveyed a strong typographical presence on crisp white papers, with sturdy bindings. Morris also insisted that only books printed by hand could achieve his desired aesthetic because hand-printing allowed the printer the ability to manipulate ink density along with the type's impression on the page.

The influences that shaped Morris's Arts and Crafts aesthetic provide an artistic heritage for the fine press book, but of equal importance to Morris were his social convictions. Morris found inspiration, in his student days, in the writings of John Ruskin. In *The Seven Lamps of Architecture* (1849), Ruskin denounced the dehumanizing effects of industrialization on Victorian England. In *The Stones of Venice* (1851–53), Ruskin championed the Middle Ages for its Gothic art and its (presumed) moral superiority integral to the hand production of goods, since such products were untainted by mass production. Morris secularized Ruskin's credos by blending a Pre-Raphaelite[25] faith in a unity of the arts with a socialist commitment to each individual's need to integrate life with art, based in the control of production.

Morris's socialist writings from the late 1870s and 1880s denounced the barriers that separated craft from art and everyday life from art-making. He believed in the dignity of the worker and in each person's inherent creativity, and proposed that art held the power to enact social change. By exercising one's creativity in the hand production of goods of beauty and use, the dehumanizing systems of mass industry could be thwarted.

Morris's socialism and art-making illuminate his convictions about craft and art, about the social and political impact of art, and

22. The stereotype was made by a variety of processes from the 1700s forward. Originally, a cast was made in metal from pages of set type; around the 1830s the cast began to be made in plaster of paris. From this mould, fresh metal plates could be produced as needed, thus reducing publishing costs. Lithography was not often used in books because of its inability to be printed alongside text; instead, it usually illustrated current events in editions of prints. Chromolithography (basically a hand process due to its requirement for the registration of multiple color plates) was used less frequently in books, but was capable of handsome effects. Between the two world wars, photogravure was used in advertising for high-quality color illustrations and in plates for art books and high-end magazines.

23. Peterson, *The Kelmscott Press*, 14.

24. Ibid.

about the role of the artist in society. He was adamant in his aversion to the trappings of modern-day living: "Apart from the desire to produce beautiful things, the leading passion of my life has been and is hatred of modern civilization."[26] Morris justified his historicism not as a retreat into nostalgia but as the mining of artistic and social wellsprings in order to replenish the "arts of life."[27] If art enabled life to flourish, then art's banishment from capitalism—where daily objects had taken on the appearance of neutral, mass-produced tools—had the opposite effect: "if you dispense with applying art to articles of utility, you will not have unnoticeable utilities, but utilities which will bear with them the same sort of harm as blankets infected with the small-pox or the scarlet-fever, and every step in your material life and its 'progress' will tend towards the intellectual death of the human race."[28] Faced with this, Morris stated that the craft worker could play a vivifying role by challenging the deadening forces of industry on behalf of the dignity and autonomy of a worker. Making art would be no less than "the expression of reverence for nature, and the crown of nature, the life of man upon the earth."[29]

Morris infused the tangible process and product of craft with the creativity of art, and then elevated them both into a single powerful force for social, artistic, and even spiritual improvement: "What is an artist but a workman who is determined that, whatever else happens, his work shall be excellent? Nothing can be a work of art which is not useful; that is to say, which does not minister to the body when well under command of the mind, or which does not amuse, soothe, or elevate the mind in a healthy state."[30] Morris's legacy argues for craft-as-art, an argument that remains unwelcome in some quarters of today's art world. From Morris, the book emerged as an everyday object that could transform society. If later fine press artists and writers seemed unaware of (or uninterested in) Morris's social ideals, they did respond to his writings on artistic integrity, as demonstrated in unified book design and production.

The Arts and Crafts under Ruskin and Morris decried industrialization (which had resulted in dreary factory towns in England) and the loss of hand production. Morris claimed that abandoning modern manufacturing for small-scale ventures would not produce an economic decline, but rather the attainment of an ideal. However unrealistic, Morris simply believed that mass production hampered society more than helped it. His socialism envisioned an activist art worker whose products were not just beautiful, but socially restorative. Morris, however, struggled with the paradoxes inherent in such convictions, such as when his detractors pointed out that his decorator's business (and, to a lesser extent, his publishing) depended on a

25. Pre-Raphaelitism was originated by the Pre-Raphaelite Brotherhood, a group of English artists active between 1848 and 1853, whose members included Dante Gabriel Rossetti. The group wished to infuse British art with the color, clarity, and subject matter associated with Italian painting before the era of Raphael. Edward Burne-Jones emerged as the leader of the late Pre-Raphaelitism.

26. Morris, "How I Became a Socialist" (1894), in *On Art and Socialism: Essays and Lectures* (Paulton [Somerset] and London: John Lehmann, Ltd., 1947), 277.

27. Morris, "Art and Its Producers" (1888), in *On Art and Socialism,* 208.

28. Morris, "The Arts and Crafts of To-Day" (1889), in *On Art and Socialism,* 230.

29. Morris, "The Prospects of Architecture in Civilization" (1881), in *On Art and Socialism,* 250.

30. Morris, "Hopes and Fears for Art," in *On Art and Socialism,* 172.

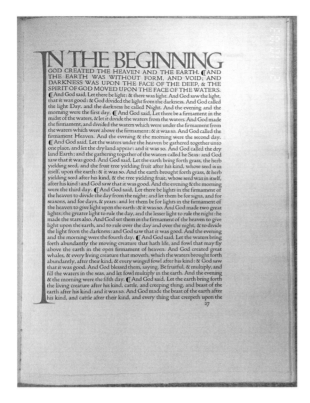

IN THE BEGINNING

FIG. 9. T. J. Cobden-Sanderson.
Doves Bible
13³/₈ x 9¹/₂

31. In 1861, in reaction to the poor
quality design and manufacture of
England's household furnishings,
Morris founded the firm to be known
as Morris & Co. The enterprise was
a great success, and its wallpapers,
tapestries, rugs, and furniture
created the "Morris look" sought
after by middle-class and wealthy
customers.

wealthy clientele.[31] Morris did not deny the paradoxes, but lived through them, as an activist, a self-described "decorator by profession," and perhaps even an eccentric, who was committed to beauty and whose ideals recast medieval society as a present-day option to a capitalist society. Although Morris's design influence in America did not touch upon his socialism, his valorization of craft as art and craft as a force for social change comprised an equally profound contribution. His activist spirit will reemerge, albeit transformed, in some of the fine printers of the 1960s and 1970s.

The Arts and Crafts movement espoused an ethics of creativity whose underlying moralism left little doubt about what had been lost with England's industrialization: the title *Hand and Soul* could have served as its rallying cry. The Arts and Crafts book embodied that ideal in the use of quality materials and integrated design. Every book was to be hand-crafted, *honestly,* "not that books should sometimes be beautiful, but that they should generally be beautiful."[32] A respect for literary content and the ideal of involvement in, if not the execution of, every aspect of book production offered a compelling model of creative control centered in the artist-publisher. But what will also become clear is that the conservatism underlying Morris's rejection of industry contributed to a complicated heritage for fine printers.

Morris's aesthetic was not the only one that appeared in Arts and Crafts books. In fact, some later printers accord a more enduring legacy to the typographical "chaste simplicity" sought by the Doves Press.[33] T. J. Cobden-Sanderson, "visionary, idealistic, and humorless,"[34] founded the Doves Press with Emery Walker, in 1900 in England. The two chose their book design models from sixteenth-century France and Italy. The page designs of their books reflect an elegant restraint, as seen in the Doves Press Bible (1903–05, fig. 9), which was meant to embody "the supreme Book Beautiful or Ideal Book, a dream, a symbol of the infinitely beautiful in which all things of beauty do ultimately merge."[35]

The books of Morris and Cobden-Sanderson demonstrate the room for variety within the Arts and Crafts aesthetic for fine press books. Other distinctive styles of book design also existed in 1890s

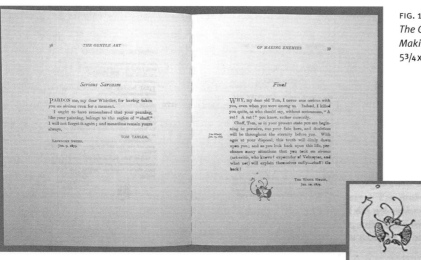

FIG. 10. J. M. Whistler. *The Gentle Art of Making Enemies*. 1890. 5³/4 x 7¹/8

England. For example, Aesthetic book design arose from several neo-classical styles. From its beginnings in the 1860s and into the 1880s, the Aesthetic book took its historical cue from Renaissance models as opposed to the medieval inspiration of the Arts and Crafts. The page design of the Aesthetic book displayed generous margins, old-style roman type (often Caslon) or italic types, and centered running heads set in caps. Often smaller in size and cloth-bound, Aesthetic books were usually printed on laid paper with a deckle edge. But widely differing designs co-existed even within the Aesthetic approach. One kind of design is exemplified in the pages of James McNeill Whistler's *The Gentle Art of Making Enemies* (1890, fig. 10). It displays an open look, with blocks of Italic type set off-center, and a whimsical use of butterfly devices. The book's contents are equally unconventional. Whistler painstakingly recorded every dismissal and diatribe from his "enemies," those critics who had disliked his art. The detractors began with none other than Ruskin, hero of the Arts and Crafts, who described Whistler's paintings as "works...in which the ill-educated conceit of the artist so nearly approached the aspect of wilful imposture."[36] Ruskin wrote the essay in 1877 for his own monthly publication. Whistler sued Ruskin for libel, won the suit, and included all of the related court documents and correspondence in *Enemies*.

Although Whistler did not pursue book design beyond this volume, *The Gentle Art of Making Enemies* influenced book design. A. J. A. Symons claimed in the journal *Fleuron* (1923–26) that Whistler's undecorated, asymmetrical typography offered a lively and workable alternative to the Arts and Crafts style. Symons dismissed the Arts and Crafts as reflecting an "expansive, impractical opulence [that] was in itself no solution to a printer's problems, nor did it indicate the

32. Morris, "The Woodcuts of Gothic Books," 37.

33. Ibid., 16. Other printers preferred the designs of the Ashendene Press (1895–1935) of C. H. St. John Hornby, whose books, Ransom determined, "fall somewhere between Kelmscott exuberance and Doves severity." 17.

34. Peterson, *The Kelmscott Press*, 119.

35. Cobden-Sanderson, "The Ideal Book or Book Beautiful" (1902), quoted in Ransom, *Kelmscott, Doves and Ashendene*, 71.

36. Whistler, *The Gentle Art of Making Enemies* (London: William Heinemann, 1892. Republished in 1967, New York: Dover Publications, Inc.), 1.

direction of reform," whereas *Enemies* demonstrated that, "by taking care, by the exercise of taste and judgment, the ordinary materials of the printer could be made pleasing both to the eye and to the mind."[37]

In the same essay Symons cited the influence of the famously shocking drawings of Aubrey Beardsley. Beardsley's success in launching the English Art Nouveau book aesthetic can be traced, ironically, to his rejection by Morris as an illustrator for the Kelmscott book *Sidonia the Sorceress,* to which Beardsley refers in the statement that begins this chapter. Dismissed by Morris, Beardsley instead executed illustrations for the Dent edition of Malory's *Le Morte D'Arthur* (1893–94, fig. 11) that resemble ironic caricatures of Kelmscott medievalisms. Much to Beardsley's delight, his fluid, elongated, slightly naughty style, "rarified as hothouse orchids,"[38] caught on. Beardsley was impatient with past printing techniques, and used line blocks that photographically reproduced his ink drawings—a striking departure from the Arts and Crafts wood-engraved aesthetic. His drawings in *Salome* and in the journal *The Yellow Book* provoked public furor and (so Symons claims) magnified the influence of Art Nouveau. Art Nouveau had lost much of its momentum by World War I, but its influence and that of the Aesthetic book represent the different styles in book design in 1890s England, all of which contributed to the fine press aesthetic.

Even though Morris defended his plans for a press as restricted to a personal "typographical adventure,"[39] the growing number of requests from collectors for books soon convinced him to enlarge print runs up to about 300 copies. Nowhere near the size of a trade edition, the decision to increase his press runs nonetheless placed Morris's private operation into a public context. The public-private balancing act of the Kelmscott Press forced Morris to confront a number of issues about aesthetics and rarity that continued to haunt fine printing in the 1960s and 1970s. Critics attacked him for elitism in printing books by hand, even though iron handpresses were still in use in the late 1800s. Revisionists such as Roderick Cave have since retorted that, even though "many of [Morris's] prices were certainly high (the velum [*sic*] *Chaucer* cost 120 guineas)...others were low. His own lecture *Gothic Architecture,* printed at the Arts and Crafts Exhibition in 1893, cost half a crown,"[40] and Cave added: "That the Kelmscott Press was successful enough to cover the very heavy production costs of its books was no slur on its amateur status."[41] Note the portrayal by Cave of Morris as an amateur. The term amateur, or private printer, was the way in which fine printers distinguished themselves from trade printers.

37. A. J. A. Symonds, "An Unacknowledged Movement in Fine Printing: The Typography in the Eighteen-Nineties," *Fleuron* 7 (1930), 110.

38. John C. Lewis, *The Twentieth Century Book: Its Illustration and Design* (New York: Van Nostrand Reinhold, 1967, 1984), 16.

39. William Morris, from a letter to William Bowden, March 1, 1891; Peterson, *The Kelmscott Press,* 7.

40. Cave, *The Private Press,* 110. The average price of most Kelmscott books was just two guineas, affordable to those with a "comfortable" income. Robin Kinross, *Modern Typography, an Essay in Critical History* (London: Hyphen Press, 1992), 35.

The books of the Kelmscott, Doves, and Ashendene Presses were generally welcomed by book collectors who shared in the valorization of literature and the finely made book. Thus, the collecting environment for the early fine press book was relatively congenial, especially when compared to the avant-garde's adversarial relationship to collecting, and even compared to the difficulties encountered by deluxe book publishers in convincing art collectors to buy books and print portfolios.

41. Cave, *The Private Press,* 106.

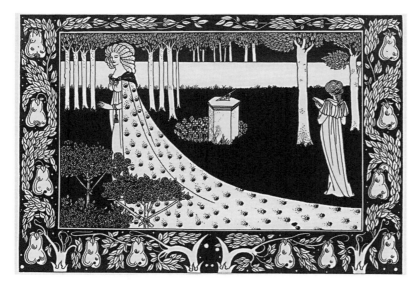

FIG. 11. Aubrey Beardsley.
Le Morte D'Arthur
by Sir Thomas Mallory.

The private printer in the Arts and Crafts was expected to follow a creative muse free from commercial constraints. That freedom presumed that printers pursued a purity of intent focused upon meticulous standards of production and the use of quality materials. Such goals were reasonable when printing books in small editions. In 1929 American Will Ransom suggested that, "The simplest and perhaps the truest type of private press is that maintained by one who is, at least by desire, a craftsman [who] finds a peculiar joy in handling type, ink, and paper, with sufficient means and leisure to warrant such an avocation. His literary selection may leave something to be desired and art may be disregarded or amazingly interpreted, but he has a good time."[42] Boundaries soon blurred between the hobbyist printer and the emerging occupation of the professional book designer.

Was the Arts and Crafts book merely another Victorian revival, or did it embody true innovation? In their belief in art's transformative powers, Arts and Crafts' printers anticipated the ideals of some avant-garde movements in the late nineteenth and early twentieth century in Europe, such as Futurism and Russian Constructivism, discussed below with the bookwork. But the Arts and Crafts' conservative utopianism, which idealized the Middle Ages in some ways as a morally superior culture, allowed for only an uneasy alliance with the avant-garde, and one that many writers denied altogether.

The character of the Arts and Crafts as Morris defined it is complicated by the dual roles of stylistic renewal and social imperative. Whether or not the Arts and Crafts movement was truly innovative is a question whose answer lies beyond this discussion. For our purposes, Morris's continuing influence over U.S. fine printing is undeniable. His

42. Will Ransom, "What is a Private Press," *Private Presses and Their Books* (New York: R.R. Bowker Company, 1929), reprinted in *Books and Printing, a Treasury for Typophiles* (Paul A. Bennett, ed., Savannah: Frederic C. Beil, Publisher, 1951), 177.

rejection of late nineteenth century commercial book design was vindicated in the popularity of the Kelmscott "look," mimicked for a time (often to excess) in the trade books and on the title pages of literary journals in Europe and the United States. With its popularity, the Arts and Crafts achieved a new public presence and stimulated discussions about book design, with Morris as the protean model of the artist-writer-publisher. The Kelmscott Press also served as a catalyst for the transatlantic study and adaptation of historical types to early twentieth century design in Britain and America. Its practitioners included leading commercial book designers, fine press historians, and printer-teachers who nurtured the growing U.S. fine press movement.

The enduring legacy of Morris for the United States was less his ornate aesthetic or even his radical social agenda, but rather the gestalt of his life's philosophy, which spanned the gulf between artist and society, between isolation and activism, between issues of quality and commercialism. His books integrated decoration and imagery in fine materials and execution, and embodied an ethics of the book intended to inspire others to seek such a synthesis. Fine printers of the 1960s and 1970s emulated Morris's belief in the artist as a creator of worlds fashioned after great literature.

After a flurry of designs in the early twentieth century that emulated the Kelmscott Press, most European designers adopted a less ornate aesthetic and used imagery more sparingly, so as not to detract from the typographical presentation of literature. Morris remained a complicated figure. His books marked an opening salvo in a periodic conflict over imagery in fine press books. Many later fine printers avoided the use of imagery because they believed it distracted from a book's typographic integrity. Morris's influence, however, remains undeniable. Fine printers in America embraced a tradition that symbolically began with Morris, who embodied the Arts and Crafts movement. His personable writings and lectures articulated a belief in the integrity of handwork and the importance of fine materials and design.

THE DELUXE BOOK

When [the book Gaspard de la Nuit, *with wood engravings by Armand Seguin] came from the press of the Imprimerie Nationale, where they had made a veritable typographical gem of it, a bookseller went to offer it to one of his customers—a true blue in the way of bibliophiles, M. Béraldi himself. The latter, to begin with, could not find praise enough for the book. But all at once: "Who is the publisher?" "Vollard." "The man who published* Parallèlement *and* Daphnis et Chloé? *Ah, no! That would be letting the Devil into my library."*[43]

—AMBROISE VOLLARD, 1936

Parallèlement, published in France just four years after *Chaucer,* is often recognized as the quintessential deluxe book. Compare the magnificent size and foliate glories of the Kelmscott *Chaucer* to the red leather-bound *Parallèlement* (1900, fig. 12). *Parallèlement* pairs the lithographs of Pierre Bonnard with the love poems of Paul Verlaine. Symbolists such as Verlaine and Bonnard hoped to evoke rather than describe; their art was made of "guessing by degrees," as Stéphane Mallarmé put it, where, "one gradually conjures up an object so as to demonstrate a state of mind."[44] The type, an italic Garamond, slows the reader with its canted letters and sense of intimacy. The use of ampersands further slows reading and adds a decorative informality, like a handwritten love letter to be savored.

Parallèlement also showcases color lithography, the signature medium of the deluxe book, which was first associated with the popular Paris street posters of the 1890s, and which decorated American cities as well.[45] Lithography offered poster artists such as Jules Chéret as well as proto-modernists such as Henri Toulouse-Lautrec an autographic directness largely new to illustration. This spontaneous aesthetic in turn translated into the images that these artists created for deluxe books. When color lithography was used in posters, the design conventions governing type and image could be ignored. In *Parallèlement,* for example, Bonnard's nudes shift and stretch on the page, in dreams or in an embrace. The boudoir-pink lithographs spill in languorous lines across margins and gutters as if unable to contain the "tender and voluptuous"[46] passions of the poems.

Another factor that differentiated the deluxe book from fine printing was its collaborative nature. The production of the deluxe book generally depended on a collaboration involving many players: publisher (few artists took on a publisher's role), printer, designer, typographer, binder, papermaker, and dealer. Books such as *Parallèlement* were not solely associated with an artist (Bonnard) or a writer

43. Vollard, *Recollections of a Picture Dealer* (Violet M. MacDonald, trans., 1936; New York: Dover Publications, 1978), 254–55.

44. Interview with Jules Huret, "Enquête sur l'évolution littéraire" in *L'Echo de Paris* (March 14, 1891), 2. Reprinted in *Les Interviews de Mallarmé* (1995), quoted here by Sarah Whitfield in "Fragments of an Identical World," in *Bonnard* (New York: The Museum of Modern Art, 1998), 13.

45. Technical developments augmented the appeal of color lithography. The use of photography and the substitution of thin metal plates in place of the stone expanded lithography's potential for the cheap and fast production of commercial ephemera such as posters, invitations, and announcements. Photomechanical color separation was experimental throughout the 1880s and 1890s in the United States and Europe, and was not used regularly until the turn of the century. By 1900

(Verlaine). These publications were also recognized as products of a dealer, who in this case was Ambroise Vollard.[47] Like Morris, Vollard turned to publishing partly in frustration with the poor designs of trade books, although Vollard focused his dissatisfaction on the lifeless designs of the illustrated book. Beginning in the 1850s, trade publishers of illustrated books began to transfer designs onto woodblocks photographically. As a result, an engraver's role resembled that of a copyist, with little interpretive latitude. Photography also could transfer line-block and half-tone illustrations to zinc and copper, which added efficiency but lowered quality.

Vollard chose artists and writers from his Montmartre circle, and he demanded much from them. His artists often completed over 100 images for books that were issued in up to 250 copies, a substantial print run more reflective of Vollard's optimism than of collector interest.[48] Vollard's use of painters rather than professional illustrators was also a calculated wager on the collectibility of the print.

Parallèlement, however, did not sell. Poor sales were partly due to the subject matter. Some of Verlaine's poems celebrate lesbian love, content which resulted in the printer, the Imprimerie Nationale, forcing a recall and reprinting of the title page with the printer's name removed. Vollard's second book, *Daphnis et Chloé,* also with lithographs by Bonnard, did not sell, either. Collectors were disturbed by the freehand nature of lithography, typified by Bonnard's incursions into margin and text—the very characteristics that eventually secured *Parallèlement's* artistic legacy.

The efforts of Vollard should be viewed in the context of a time of flourishing book collecting in France. Nine societies of bibliophiles operated in France up to World War I. The societies were populated by bankers, landowners, doctors, and other bourgeoisie, and their exclusivity resembled social clubs, with group dinners and other events. Their commissions for illustrated books were dictated by conservative tastes that favored literary classics illustrated in an "academic and historicist" style.[49]

Another factor contributing to poor sales was that Vollard's market consisted of the bibliophilic public, which constituted a more conservative audience than art collectors. Collectors looked askance at books of pictures by artists identified as painters rather than illustrators; concerning a later edition, a bookseller admonished Vollard that, "Painters are not illustrators....The liberties they permit themselves are incompatible with the 'finish' which is the whole merit of the illustrated book." Within a generation Vollard received his vindication: with the rise of modernism, the critical respect for (and the value of) his books increased as well.

the three- and four-color halftone process of offset lithography was displacing the chromolithograph, at least in larger print runs. Phillip Dennis Cate and Sinclair Hitchings, *The Color Revolution: Color Lithography in France, 1890–1900* (Santa Barbara: P. Smith, 1978): 5.

Even though color lithography is associated with the deluxe book aesthetic of France in the 1890s, it should be noted that a number of other printing and printmaking techniques created illustrations in trade books, including etching, steel engraving, woodcut, and pochoir. Other techniques that became increasingly available to book illustration included the Woodburytype process, the collotype, the line block, photogravure, and the halftone. Chromolithography was valued because it freed lithography from a dependence on hand-coloring, although it still needed an intermediary (called a *chromiste*) to transfer a composition by drawing it.

46. Ibid., 253.

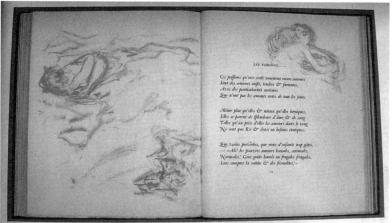

FIG. 12. Pierre Bonnard.
Parallèlement.
11⅝ x 9⅜

While collector resistance to *Parallèlement* was based on its pictures and design, other deluxe books generated questions about format. André Marty, for example, published Toulouse-Lautrec's *Yvette Guilbert* as an album (portfolio) in 1894. Ready to be opened after untying its securing ribbon, *Yvette Guilbert* conveys a sense of invitation, like an entrée to the singer's dressing room. It contains Toulouse-Lautrec's lithographs, which teasingly touch or overlap the text, both printed in olive-green. The presentation of *Yvette Guilbert* marked an ongoing debate concerning the deluxe book. Could a print portfolio be considered a book form?

Collectors' interests played a part in the variety of publishing formats. Many preferred a book to be issued unbound and wrapped in Japanese paper covers, so that the collector could later commission a binding. Unbound portfolios of text and imagery also allowed collectors the option of framing prints for wall display. Nevertheless, some artists viewed the portfolio, then as now, as a format that destroys the cohesion of a work, because collector preference for imagery is served to the detriment of the literary integrity associated with the bound book.

By the 1920s, *Parallèlement* served as standard-bearer for the deluxe aesthetic. It was admired for the affinity that it achieved between its sensuous imagery, its restrained typography, and its luxurious materials. Its overlap of image with type on the page was recognized in time as innovative. In this, *Parallèlement* anticipates deluxe books that depart from convention in content, materials, or format. And yet, many of the books that followed *Parallèlement,* and which also carried modernist imagery, did not achieve such a lasting impact. However much the imagery might innovate in these books, most experiments were directed toward a stylistic end rather than toward an

47. Other publishers of deluxe books who operated from Paris included Iliazd, Daniel-Henry Kahnweiler, Albert Skira, and Efstratios Tériade.

48. Audrey Isselbacher, *Iliazd and the Illustrated Book* (New York: The Museum of Modern Art), 13.

49. John Harthan, *The History of the Illustrated Book: The Western Tradition* (London: Thames and Hudson, 1981), 248.

integrated reshaping of the entire book. The deluxe book's inevitable elitism from costly materials and limited numbers also instilled in them an aesthetic conservatism.

Henri Matisse's *Jazz* (1947, fig. 13), a second example of the deluxe book from later in the century, achieves a cohesive page through methods that were unusual for the time. The book's publisher, Tériade, often followed artists' suggestions on text selection and book design. Matisse created *Jazz*'s jewellike imagery from paper cut-outs. He executed its images and then wrote the text about art and life during a year-long confinement in bed. Tériade chose to print *Jazz* with the pochoir technique in order to unite imagery and text (pochoir is a process of applying color through stencils). The use of this commercial printing technique represented a departure from deluxe books. Matisse's large, calligraphic script spills across the page, evoking the nature of a handwritten journal, an elegant companion to his imagery.

The makers of America's deluxe books faced their own challenges, namely from a conservative artistic heritage and the inevitable taint of economics. The lack of substantive critical discussion of early deluxe books in Europe, then in the United States, did not help, with commentary generally limited to an artist's success with the formal aspects of art: line, shape, color, and image. There was little if any mention of a book's form—book design and a book's physical attributes were not subject to the same investigations expended in mark-making. The deluxe book also required that the art world reconsider the means of determining artistic authorship and intent. Deluxe books are typically identified by the artist only, or by the publisher (as in "a Vollard book"). Traditional notions of connoisseurship did not easily acknowledge and respond to the shared and varying contributions of

FIG. 13. Henri Matisse. *Jazz.* 16 1/2 x 12 3/4

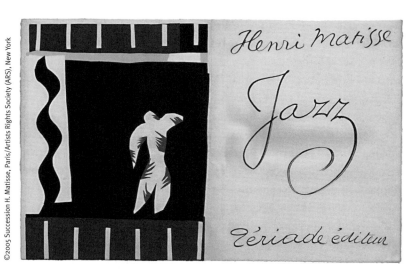

collaboration, especially when they took place at the scale and complexity of the deluxe book. In the 1960s these notions are challenged by some independent artists who execute most of a book's production, publishing free of an atelier.

THE BOOKWORK

> *I rest not from my great task!*
> *To open the Eternal Worlds, to open the immortal Eyes*
> *of Man inwards into the Worlds of Thought, into Eternity*
> *Ever expanding in the Bosom of God, the Human Imagination.*[50]
> —WILLIAM BLAKE

The books of William Blake prefigure the avant-garde books created in Europe a century ago. A handful of books represent myriad avant-garde innovations by artists from virtually every movement, including Symbolists, Expressionists, Cubists (although most Cubist books took on deluxe characteristics), Russian and Italian Futurists, Dadaists, Soviet Constructivists and Productivists, and Surrealists. Avant-garde artists experimented with every aspect of the book as they responded to new technologies and the changing artistic, social, and political milieu of the late nineteenth and early twentieth centuries. No single factor led to the adoption of the book by the avant-garde. Rather, the capacity of a book to carry both image and text, along with its accepted presence within society, propelled its emergence as an artwork.

William Blake poured a vision of the artist as oracle into the poetry and imagery of his Prophetic books. *Jerusalem the Emanation of the Giant Albion* (1804–27, fig. 14) is the culminating book in that series, and it presents his ecstatic vision of reconciliation and unity. Blake described the books that he lettered, drew, printed, and colored as "illuminated printing" to align them with the medieval manuscripts that he admired, and he described himself on his first etched title page as the "author and printer."[51] Blake modeled the role of an independent artist in charge of one's vision from conception to completion, as writer, artist, printer and publisher, a role that later book artists strove to emulate, but few could duplicate. The seamless unity of written text with drawn imagery that he created in his books, represented the ideal of a holistic page to later artists. Many finished prints present text surrounded by Blake's dense marginalia. In this plate of relief etching and white-line engraving, Christ (as Los) tenderly raises up the collapsed, idealized form of the character Albion. Blake's choice to self-publish resulted from economic constraints and aesthetic needs. He avoided the economic burden of publishing a

50. *Jerusalem the Emanation of the Giant Albion*, chap. I, plate 5, quoted in Bindman, *Blake as an Artist* (Oxford, England: Phaidon; New York: E. P. Dutton, 1977), 16.

51. Blake's printing methods are still a matter of scholarly debate. See Robert N. Essick's *William Blake, Printmaker* (Princeton: Princeton University Press, 1980).

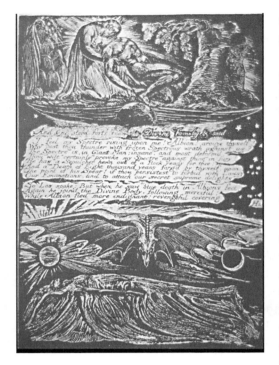

FIG. 14. William Blake.
*Jerusalem the Emanation of
the Giant Albion*

typeset book, even as he freed himself from censorship concer ns.

Blake's handwritten texts comprise a dramatic departure from conventional book design, and even from the flowing calligraphy of Matisse's *Jazz*. Blake's full-text pages do not welcome a reader; instead, they confront him or her with a "wall of words"[52] to ponder. The illuminated pages resemble a scribe's dispatch from one of Blake's mythic lands, where muscular heroes undergo supernal trials and are granted revelations in return.

Blake described revolutions as hydralike, able to spawn new creative possibilities while containing a potential for violence. Revealingly, Blake's mythologies also include the character of Los, the artist as supreme seer who wields the power of prophetic poetry, to act in "Sublime Allegories" that chronicle the weakening of the social fabric from materialism. The operatic scope of his stories matched the cataclysms that marked Blake's own time, such as the French Revolution. Later artists admired Blake's uncompromising artistic and philosophical convictions and found characters such as Los appealing. Blake's books are celebrated as harbingers of the bookwork. His use of printmaking and hand-coloring, and the resulting pages that resemble colorful tapestries of written and drawn communication, suggest instead a hybrid of the deluxe book and the bookwork

EMBODIED SPACES

*Man's duty is to observe with the eyes of the divinity; for if his connection with that divinity is
to be made clear, it can be expressed only by the pages of the open book in front of him.*[53]
—SYMBOLIST STÉPHANE MALLARMÉ, 1895

52. McGann, *Textual Condition*
(Princeton: Princeton University
Press, 1991), 142.

53. Stéphane Mallarmé, "The Book:
A Spiritual Instrument" (1895), in
*Stéphane Mallarmé, Selected Poetry
and Prose* (Mary Ann Caws, ed.,
New York: New Directions Books,
1982), 80.

54. Ibid.

If Blake served as oracle to a visionary artist's book, Stéphane Mallarmé, a second influential artist, served as the bookwork's spiritual advisor. Mallarmé, a Symbolist poet and philosopher, recognized in a book's pages and form the lineaments of a spatial, temporal "distribution of light," a form in which "all earthly existence must ultimately be contained."[54] Mallarmé wrote "The Book: A Spiritual Instrument" in 1895, an essay that would assume heroic stature for late-twentieth-century book artists. Mallarmé, a contemporary of William Morris, shared Morris's contempt for nineteenth-century industrialization. Morris looked to medieval art for inspiration and then directed his

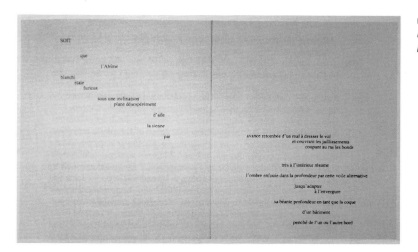

FIG. 15. Stéphane Mallarmé. *Un coup de dés jamais n'abolira le hasard*

art outward to the public in hopes of transforming the design of everyday objects. In contrast, Mallarmé withdrew to write poetry that evoked a reality based not on objective observation but on his private imaginings, full of emotion and possibility. His essay portrayed the page as a living thing where meaning could be affected by type size, style, and placement.

He again demonstrated those interests in his design of *Un coup de dés jamais n'abolira le hasard* ("A throw of the dice will never abolish chance"), first published in an English literary magazine in 1897 (fig. 15), a year before his death, and not in book form until 1914. In it, his poetry is set free from the constraints of columns and margins. The book itself becomes an organic entity whose very form participates in its expressive power, and where turning a page is an act akin to the waving of a magician's wand: "were it not for the folding of the paper and the depths thereby established, that darkness scattered about in the form of black characters could not rise and issue forth in gleams of mystery from the page to which we are about to turn."[55]

For Mallarmé and for the many artists he inspired, the book was about space as much as form, a fluid space responsive to each letter, where "The book, which is a total expansion of the letter, must find its mobility in the letter; and in its spaciousness must establish some nameless system of relationships which will embrace and strengthen fiction."[56] Imagine the radicalism implicit in Mallarmé's call for an inspired reconsideration of the book: to remove cultural assumptions about the look of books, and to re-present the book as a "spiritual instrument" of pure thought, whose pages pulse as if from a breathing, mysterious interaction between mark and space. "We, in turn, will misunderstand the true meaning of this book and the miracle inherent in its structure," he cautioned, "if we do not knowingly imagine

55. Ibid., 82. More than a century before the appearance of Mallarmé's *Un coup de dés jamais n'abolira le hasard,* Laurence Sterne's novel, *The Life and Times of Tristram Shandy,* delineated an expansive internal environment of the book through the use of graphical and narrative devices. The novel, published between 1759 and 1767, altered a reader's pace through the use of blank pages and pages of solid black and marbling. On the page, Sterne inserted semantic cues such as a pictographic curlicue between paragraphs to indicate the swish of a cane, and sets of asterisks as sly stand-ins for profanities. *Tristram Shandy*'s narrator skips forward and backward in time, and admonishes the reader to help interpret the storyline, such as it is. Sterne's book was a popular success in its day as public entertainment, and for later artists, his inventions demonstrated that a book could direct typography, graphical signs, and even a narrative's flow to unsettle and invigorate the experience of reading.

56. Ibid.

that a given motif has been properly placed at a certain height on the page, according to its own or to the book's distribution of light."[57]

Music was his metaphor. Mallarmé's awakening to space transformed typography into an equivalent of sight, sound, and spirit, in which the placement of symbols across a score indicated notes, stresses, or rests: "Let us have no more of those successive, incessant, back and forth motions of our eyes, traveling from one line to the next and beginning all over again. Otherwise we will miss that ecstasy in which we become immortal for a brief hour, free of all reality, and raise our obsessions to the level of creation. If we do not actively create in this way (as we would music on the keyboard, turning the pages of a score), we would do better to shut our eyes and dream."[58] The mindless "back and forth" of conventional reading removes the reader from the potency of language. Mallarmé opens up the page for poet and reader to explore together.

The text of *Un coup de dés* is mutable and nonlinear, resistant of a single narrative thread. It juxtaposes the absurd, chance-driven act of tossing dice, to the meaningless bedlam of the world, although at least the dice thrower can participate in a potential for understanding by taking action amidst the chaos.[59] Mallarmé engages the page as a field on which the words, those chosen constellations of letters, can respond to one another and to the surrounding space. In that exchange, illustration depends not on pictures but on a typographical design, where "A tremendous burst of greatness, of thought, or of emotion, contained in a sentence printed in large type, with one gradually descending line to a page, should keep the reader breathless throughout the book and summon forth his powers of excitement. Around this would be smaller groups of secondary importance, commenting on the main sentence or derived from it, like a scattering of ornaments."[60]

As he imagined it, a voice or voices appear and subside throughout one long sentence that rhythmically modulates across page openings and among eddies of white space. The large and small roman and italic types invite a number of readings. One may scan down a page, or follow a single distinctive typographic "voice" across several page openings. Mallarmé insists upon an interrogative approach to reading, one that is active, dynamic. "I am not asking for any servile obedience. For, on the contrary, each of us has within him that lightning-like initiative which can link the scattered notes together."[61]

Mallarmé's aesthetic reaches beyond graphic and narrative page design, to require the touch of a reader in order to enact its "flowering totality."[62] Mallarmé even personified the book form as a sexual alter-ego, in which uncut pages evoke metaphors of intimacy and desire, and [in which] the "folds [of the pages] will have a mark which remains

57. Ibid.

58. Ibid., 82–83.

59. There is no scholarly unanimity on the interpretation of *Un Coup de dés*. My simplified interpretation is adopted from John Porter Houston's detailed discussion, *Patterns of Thought in Rimbaud and Mallarmé* (Lexington, Kentucky: French Forum Publishers, 1986). See also Drucker, *The Century of Artists' Books*, 33–37.

60. Ibid., 83.

61. Ibid., 82–83.

62. Ibid., 82.

63. Ibid., 83.

intact and invites us to open or close [them] ac-
cording to the author's desires."[63] The book's
metaphorical potency led later artists to con-
sider the opened book and the cut page as sug-
gestive of exposure and desecration. Symbol
and metaphor, interior and exterior, content
and form: Mallarmé's embodied spaces invest
textual presentation with innuendo in the
environment of the opened book.

Embodied spaces on the page resonate
with color in a later collaboration by Blaise
Cendrars and Sonia Delaunay-Terk, *La prose du
transsibérien et de la petite Jehanne de France*
(1913, fig. 16), published in 150 copies. The stan-
zas of the 445-line poem by Cendrars are
printed letterpress in several different type-
faces and colors. *Transsibérien* resembles a long
vertical banner when opened, one that appears
to ripple with fields of color. On close inspec-
tion, the areas of color resolve into three dis-
tinct categories. One category is composed of
the dense patterns of typefaces printed in
color and that become legible as the reader
draws in close. A second color field resolves

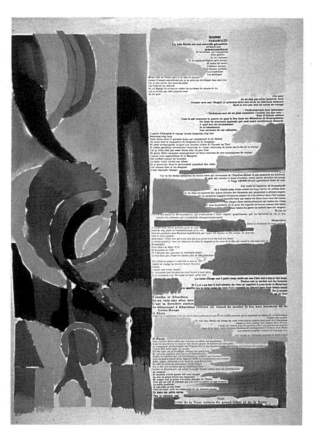

FIG. 16. Blaise Cendrars and
Sonia Delaunay-Terk.
*La prose du transsibérien et
de la petite Jehanne de France.*
Detail. 78¼ x 14¼ (open)

into loose washes of color that Delaunay-Terk painted around the
type on the unprinted surfaces. A third expanse of color extends
down along the left edge in a vertical panel animated by the arcing
shapes of Delaunay-Terk's painted pochoir. Most of the shapes are
abstract or suggestive, except for the silhouette of the Eiffel Tower,
recognizable at the base. Unfolded, the sheet undulates with color.
The washes of color animate the negative space around the blocks of
type like a refraction of the painted design on the panel opposite.
Transsibérien represents Mallarmé's ideal of a "flowering totality"
now opened into blossom, its colors fresh and vital, an invigorated
design adapted by Cendrars and Delaunay-Terk to serve the needs of
this extraordinarily long poem.

Transsibérien was touted by Cendrars and Delaunay-Terk as the
"first simultaneous book." Neither poet nor artist was allied with the
Futurists, but both had connections and sympathies with the inter-
ests of the time; for example, Delaunay-Terk with her husband,
Robert, developed Orphism, in which they investigated the striking
effects of placing discordant colors in close proximity to one another.
The actual experience of simultaneity in *Transsibérien* was meant to

occur with the work opened out, when a reader took in all at once the effect of the type and the imagery, and then carried that initial impression into the reading of the poem.

There is another way to read *Transsibérien,* however, which is suggested by the book's unusual format. Folded up, the book is tall and narrow. On its cover, a Michelin railway map locates the setting of the poem, the Trans-Siberian railway, which crosses Russia from Moscow to the Sea of Japan. The narrator of the poem is on that train, traveling across Russia with his sixteen-year-old mistress, Jehanne. The appropriated format of a map announces his journey and also serves to represent the unsettling back-and-forth movement in the poem. On his way East, the narrator struggles with ruminations over his life. Periodically, Cendrars reverses the direction of the action by interjecting into the poem the image of troop trains heading West, carrying the wounded back from battles in Manchuria. The repetitive motion and sound of a train also suggests a physical correlation to the means of reading the poem. A reader may choose to open the work out consecutively, unfolding it to reveal stanza after stanza to trace the story of the poem like a traveler recalling a journey while pouring over a map. The use of the map format may also stimulate in a reader the mix of emotions that accompany any journey, emotions that can include anxiety and a desire for change or escape. The reader is more likely to identify with the narrator's own turmoil, as the written journey overlaps with one's own remembered or imagined journeys.

BOOK DISSEMBLINGS

I oppose the decorative, precious aesthetic of Mallarmé and his search for the rare word, the one indispensable, elegant, suggestive, exquisite adjective.... Moreover, I combat Mallarmé's static ideal with this typographical revolution that allows me to impress on the words (already free, dynamic, and torpedo-like) every velocity of the stars, the clouds, aeroplanes, trains, waves, explosives, globules of seafoam, molecules, and atoms.[64]

—FUTURIST F.T.MARINETTI, 1913

...what I regard as objective, more or less deliberate manifestations of my existence are merely the premises, within the limits of this existence, of an activity whose true extent is quite unknown to me.[65] —ANDRÉ BRETON, 1937

Books by three more artists, F. T. Marinetti, Alexander Rodchenko, and André Breton, demonstrate the range of subversion that the avant-garde readily employed in order to undermine conventions in book typography, materials, and illustration. F. T. Marinetti, with Tullio d'Albisola, embodies the Futurist fascination with industry in *Parole*

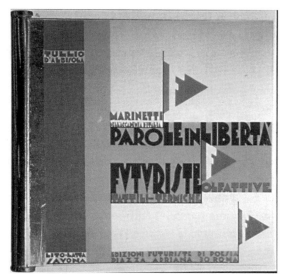

FIG. 17. F. T. Marinetti.
*Parole in libertà futuriste
tattili-termiche olfattive.*
9³/₈ x 9¹/₄

FIG. 18. Alexander Rodchenko,
Vladimir Mayakovsky.
Pro Eta (About This)

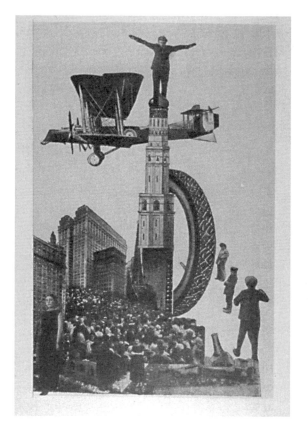

in libertà futuriste tattili-termiche olfattive (Futurist Tactile, Themic, and Olfactory Words in Freedom, 1932, fig. 17). Light reflects off the book's stiff and shiny tin-plated metal pages, which carry lithographed sans-serif type and imagery. The words describe noises and smells—the detritus of a contemporary industrial society. The metal, cool to the touch, and the sounds that accompany the turning pages (the soft clack of metal sheets and the rattle of ball bearings held by parallel wires in the tubular spine) re-situate a reader within the materials and insistent sounds of that industrial moment.

Parole in libertà was produced twenty years after Marinetti's manifesto, which called for a "dynamic and torpedo-like" assault on reading and the book, and whose targets included Mallarmé's "spiritual instrument."[66] Marinetti and d'Albisola created *Parole* as a transformed ordinary book, an embodiment of revolutionary ideals heralded by its recast typography, materials, and form. Futurists called their new language "words-in-freedom," in which syntax was abandoned to emphasize synesthetically the optical and phonetic qualities of text.

Parole in libertà remade the material and typographical presence of the book, but avant-garde artists more often undermined book conventions through the use of photography. The photomontage exemplified the avant-garde as the ultimate in appropriation, manipulation, and distortion. Artists noticed how business exploited photographic

64. "Typographical Revolution" (1913), in *Futurist Manifestos,* Umbro Apollonio, ed. (New York: Viking Press, 1973), 104–5.

65. *Nadja,* Richard Howard, trans. (New York: Grove Press, Inc., 1960), 12.

66. Marinetti acknowledged his awareness of Symbolism, but dismissed what he described as Mallarmé's "decorative, precious aesthetic." *Futurist Manifestos,* 105.

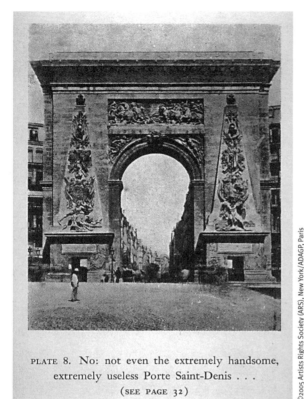

PLATE 8. No: not even the extremely handsome,
extremely useless Porte Saint-Denis . . .
(SEE PAGE 32)

©2005 Artists Rights Society (ARS), New York/ADAGP, Paris

FIG. 19. André Breton.
Nadja.
8 x 5³/₈

67. Ades, *Photomontage* (London:
Thames and Hudson, 1986), 13.

68. In the 1920s, artists, including
Rodchenko, broke from the "new realism" of Suprematism to promulgate
Constructivism. Their hero was the
artist-constructor, equally at ease
with meeting artistic or technological
needs, in service to the October Revolution. See Christina Lodder, *Russian
Constructivism* (New Haven: Yale
University Press, 1983), 251; and German Karginov, *Rodchenko* (London:
Thames and Hudson, 1979), 87.

69. Quoted in Ades, *Photomontage*, 83.

70. See Renée Riese Hubert,
Surrealism and the Book (Berkeley,
Los Angeles, Oxford: University of

technology in advertising, and in response artists engaged in their own playful or perverse "dismembering of reality."[67] For example, Alexander Rodchenko's *Pro Eta* (*About This,* 1923, fig. 18), by Vladimir Mayakovsky, epitomized Constructivist photomontage.[68] Rodchenko combined drawing with collaged engravings and photographs to suggest both the narrator's intense concerns for individual freedom ("I am only poetry / only the heart"),[69] as well as the larger climate of revolutionary Russia. He did this by juxtaposing personal and public imagery. One photomontage presents the narrator atop a tower, his arms outflung, an airplane passing incongruously nearby, while in the milling crowd below stands his beloved, Lili, who gazes not up at her lover but out at the reader.

Photography dominated the visual milieu of the twentieth century after a series of related developments enabled it to be mass printed. Halftone photoengraving was quickly adopted in the early twentieth century and applied to large-run newspapers, books, and magazines. Photoengraved blocks allowed the printing of images alongside type on high-speed presses, and so displaced woodblock engraving. Along with the halftone plate, other improvements opened photography to a mass public in the 1880s. Line photogravure first appeared in 1875, and by 1891 shading and middle tones were possible. Dry plates, a flexible film, better color-sensitive emulsions, anastigmat lenses, and the Kodak box camera in 1888—which now included a photo-finishing service for its owners—expanded photography's range of subjects and eased its access and use.

The Surrealists were equally drawn to photography as a subversive medium. The Surrealist leader André Breton used photographs as found material in his novel *Nadja* (1937, fig. 19).[70] The book operates just below the veneer of the commonplace, as an "interplay of absence and presence"[71] that insists, deadpan, on normality. For example, *Nadja*'s photographs are accompanied by captions that are comprised of excerpts from the text, some of which include the helpful directive, "see page...". Sometimes this system holds, but in a few instances the statement is mysteriously missing from the indicated page. In another tease, a Parisian landmark—the "extremely handsome, extremely useless Porte Saint-Denis"—is pictured, but only

(one checks the text) to record what the narrator says he did not see on his walk. Documents appear, such as a handwritten letter from an actor of the Théâtre Moderne, and a printed program for a film, and yet they are reduced to such a small size as to be nearly illegible, and hence inaccessible. The text and images of *Nadja* conspire to create a rhythm in the reader in which they repeatedly refer to one another, but only to veer apart again in "anti-mimesis."[72] *Nadja* prefigures the multiple bookworks of the 1970s, as an illustrated book that refuses to illustrate consistently, and a book that uses photography's presumption of reality to trip itself up in the act of presentation, thereby undermining all credibility of words or images as purveyors of truth.

California Press, 1988), 263. Surrealism originated in a Paris group of Dada writers and developed into a major international movement between the two World Wars. Surrealists rejected rationalist concepts of art to seek a reflection of the incongruities of reality, and to that end used the unconscious and absurd subject matter.

71. Ibid., 285.

72. Ibid., 258.

THE READYMADE BOOK

> [Art] is a product of two poles; there's the pole of the one who makes the work and the pole of the one who looks at it. I give the latter as much importance as the one who makes it.[73]
>
> —MARCEL DUCHAMP

Marcel Duchamp, our last bookwork precursor, created *Unhappy Readymade* in 1919, four years after coining the term "readymade." A readymade was an industrially produced object that Duchamp selected at random, then christened as art. That act challenged the art world's assumptions about art-making and originality. Duchamp wrote from Buenos Aires to his sister Suzanne and her husband, Jean Crotti, in Paris, sending instructions to hang a geometry textbook outside their Paris balcony until it was destroyed by the weather. Duchamp named the work *Unhappy Readymade* (fig. 20), and later described it to Pierre Cabanne: "It was a geometry book, which [Crotti] had to hang by strings on the balcony of his apartment in the rue Condamine; the wind had to go through the book, choose its own problems, turn and tear out the pages. Suzanne did a small painting of it, 'Marcel's *Unhappy Readymade*.' That's all that's left, since the wind tore it up. It amused me to bring the idea of happy and unhappy into readymades, and then the rain, the wind, the pages flying, it was an amusing idea."[74]

Duchamp called the work a readymade, but its alteration by the elements and the fact that it is a book complicate its identity more than that of Duchamp's earlier readymades, such as his bicycle wheel (1913). For our purposes, *Unhappy Readymade* can be described as one of the first altered books; further, it can be termed an installation bookwork—and perhaps even an environmental bookwork. As a readymade, the geometry textbook was one among many identical

FIG. 20. Marcel Duchamp. *Unhappy Readymade.* Original photograph possibly by Jean Crotti or Suzanne Duchamp.

73. Pierre Cabanne, *Dialogues with Marcel Duchamp,* Ron Padgett, trans. (New York: Viking Press, 1971), 70. Quoted in Thierry De Duve, "Echoes of the Readymade: Critique of Pure Modernism," *October* 70 (Fall 1994): 77.

74. Cabanne, *Dialogues,* 61.

copies, a quotidian book, its contents not meant to give pleasure but to serve for reference or rote learning. Duchamp's anthropomorphic title suggests how this work differs from other readymades. Buzz Spector commented recently that one distinguishing factor of *Unhappy Readymade* is that, as a book, the identity of its author was withheld from the viewer in a "lack of disclosure."[75] Any curiosity or frustration generated by that concealment is overshadowed by the second decision, to set into play the work's planned disintegration. In addition, the book's alteration occurred at a distance from the artist, in an expression of the indifference that Duchamp emulated in his choice of readymades.[76] Unlike the other readymades, the exposure of *Unhappy Readymade* ensured its eventual disappearance, with only memories of its bookish incongruities lingering on.

Rather than the artist separating from life in order to create, Duchamp immersed his art in the transformation of everyday objects. To alter common objects was at once constructive and destructive, meant to enact the demolition of the assumed preeminence of "high art." Duchamp joined Mallarmé in assigning significance to the audience: its role was to interpret, and so contribute to, the transfiguration of a work of art. *Unhappy Readymade* objectified and conceptualized the book in its long-distance enactment. Duchamp dismissed the inviolability associated with books; he revealed them as vehicles whose cultural and religious associations only raised their value to artists as objects ripe for appropriation.

This act of "naming," and hence creating, a work of art from a book would alone have altered thinking about the ordinary book, an object whose cultural identity had remained largely unquestioned until that time. Duchamp returned to ideas about the book in two later works, the readymade constructed objects *Boîte verte* (Green box, 1934) and *Boîte-en-valise* (Box in a Suitcase, 1936–41, fig. 21). The book, the box, and the suitcase are related, since all are objects of containment. Duchamp's intrusions into box and suitcase are not directed so much toward destruction (as in *Unhappy*) as toward displacement. *Boîte verte* is a box used like a book. It consists of a green box containing a painstakingly produced set of facsimile of notes on scraps of paper, drawings, and reproductions of Duchamp's works. Like a book, *Boîte verte* relates the story of artistic process, here communicated through material evidence. A strength of its boxed format is that it allows access to its contents and also embodies the circularity inherent in artistic process, rather than submitting to a book's linear structure.

75. Buzz Spector, "The Book Alone: Object and Fetishism," in *Books As Art* (Boca Raton, Florida: Boca Raton Museum of Art, 1991), 40. The surviving documentation of *Unhappy Readymade* consists of a photograph and the depiction of the work in a painting by Suzanne, *Le Ready-made malheureux de Marcel* (1920). The book's title and author are discernable neither in the photograph nor in the painting.

76. Cabanne, *Dialogues*, 48.

77. Jaroslav Andel, *The Avant-Garde Book: 1900–1945* (New York: Franklin Furnace, 1989), 66.

Boîte-en-valise is a suitcase used like a book. It tells another story, that of Duchamp's artistic life. Inside the suitcase, tiny reproductions of Duchamp's artworks are mounted in a gallery setting, like a retro-spective-in-miniature. *Boîte-en-valise* brings to mind Walter Benjamin's "The Work of Art in the Age of Mechanical Reproduction," which will be discussed in chapter 3. Briefly, that essay notes the diminished impact (which Benjamin calls "aura") art exerts when it is mass produced. When an image of a work of art is removed from a particular art world context, and multiplied in flattened re-productions, Benjamin believed that the art grew overly familiar, its expressive power neutralized. Like *Boîte verte, Boîte-en-valise* pursues reproduc-tion with a vengeance. Duchamp at once celebrates his own artistic output even as he slyly undermines its value from his use of reproductions.

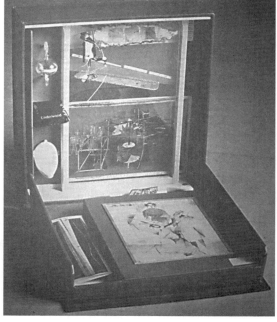

©2005 Artists Rights Society (ARS), New York/ADAGP, Paris/Succession Marcel Duchamp

FIG. 21. Marcel Duchamp. *Boîte-en-valise* (Box in a Suitcase). 15¼ x 16¼ (closed)

Duchamp's ultimate solution—to mount his own retrospective—is above all eminently practi-cal, if offered partly in jest. With this work, a suit-case joins the box as book hybrids, "a new category of book."[77] Only booklike, *Boîte-en-valise* taunts the cultural eminence of the book by supplanting it with the suitcase, a workaday conveyance for Duchamp's visual auto-biography. Duchamp realigns identities for sculpture and the book, and he transforms notions of authorship and the roles that were open to artist, object, and viewer. The influence of *Boîte verte* and *Boîte-en-valise* can be linked to a flood of altered books and boxes that ap-peared in the 1960s and 1970s. Duchamp's two works also relate to the interests of multiple bookwork artists in using commercial tech-nologies to print their books cheaply and in large numbers.

Avant-garde experiments met relatively few roadblocks in the late nineteenth and early twentieth century. Avant-garde artists investi-gated and promoted books along with other art forms. These artists reinvented the book for art in all of its manifold contexts and dimen-sions, but many of these works only gained their dramatic profile from the passage of time and the critical regard of art history. By the 1960s, bookwork artists in America unconsciously investigated paths that had first been explored by their largely unheralded ancestors. We will consider next how some of those influences arrived and devel-oped in the United States in the early twentieth century.

II

THE UNITED STATES: ASSIMILATION AND CHANGE

From the first at The Cummington Press we were aware of great typographical traditions. That is to say, we had them on the brain. For none of us was trained in even the most elementary disciplines of the craft itself. And we couldn't find, at the beginning of the 1940's, anywhere at all in this country to learn how to print type in the traditional way, on damp paper with a handpress — it was rumored that no one here had done so for at least a generation, a lapse of time long enough to superannuate the art.[78]

—HARRY DUNCAN

I spoke [in an earlier essay] of the need to return to the attempts of the 1920s to try to produce [books] like the Grahhorn Whitman or the Nash Dante. I rather arrogantly proclaimed to my fellow printers that we were not carrying through. We were being diverted by printing slick little keepsakes and things like that, but we were not offering ourselves to the greatest. I proclaimed a noble failure is greater than many trivial successes. When I began the Psalter I was taking that challenge up myself.[79]

—WILLIAM EVERSON

People like me...who care about printing, constitute the tiniest lunatic fringe in the nation.[80]

—LEONARD BASKIN

THE FINE PRESS BOOK

THE ROYCROFT PRESS: ART AND BUSINESS

Beginning in the mid twentieth century, Harry Duncan, William Everson, and Leonard Baskin helped to shape the character of the fine press book in America. But the fine press book as these printers envisioned it did not leap from the press fully mature. Its story begins decades earlier with the efforts by American designers to emulate British precursors, and then with the herculean efforts on both sides of the Atlantic to fashion an aesthetic responsive to the needs of both fine printing and trade publishing.

The Arts and Crafts movement (1861–1914) exerted the greatest early influence on America's fine press book.[81] The Arts and Crafts was an established, international art movement infused with a revivalist spirit that accepted the book as an expressive partner equal to other art forms. From 1901 to 1916 Gustav Stickley's popular *Craftsman* journal carried the Arts and Crafts to a U.S. audience, in articles that promoted the values of craftsmanship. Many Americans embraced the Arts and Crafts style, along with William Morris as its colorful embodiment.[82]

The Arts and Crafts aesthetic reflected its trademark foliates and "blackened" pages, but it also embodied, for William Morris at least, the socialist belief in raising a worker's quality of life through a respect for handwork, thus dignifying the process, the product, and the creator. Once on U.S. soil, however, the activist undercurrent of the Arts and Crafts and of Morris's antimodernism gave way to an awkward embrace of art and business: "American craft leaders were hampered from the outset by their class interests and anxieties, their individualist and idealist assumptions about the nature of social reform, and above all by their own underlying ambivalence toward modern culture and its progressive creed."[83] Craft was not viewed as a means toward the revitalization of work and society, but as an escape from both, neutralized into a hobbyist's retreat.

81. The bibliography of early American printing is voluminous. Joseph Blumenthal's *The Printed Book in America* (Boston: David R. Godine, Dartmouth College Library, 1977) provides an excellent introduction to the subject.

82. See Thompson, *American Book Design and William Morris*. This should not suggest, however, that Arts and Crafts book design was embraced by every American designer. Otis Thompson notes that some opinions of the Kelmscott Press, such as those expressed by Theodore Low DeVinne, "the most famous printer in America," comprised equal parts praise and disfavor. Thompson described DeVinne's mixed opinion on the Kelmscott style as one comprised of an approval of Morris's bold typefaces, quality materials, and presswork, along with a disapproval of the closely spaced type and decorative fleurons that characterized his page designs. *American Book Design*, 145–55.

83. T.J. Jackson Lears, *No Place of Grace: Antimodernism and the Transformation of American Culture, 1880–1920* (Chicago and London: University of Chicago Press, 1994), 64–65.

78. Harry Duncan, "The Technology of Hand Printing," in Harry Duncan, *Doors of Perception: Essays in Book Typography* (Austin: W. Thomas Taylor, 1987), 21.

79. William Everson, in *Printing as a Performing Art,* Ruth Teiser, comp., Teiser and Catherine Harroun, eds. (San Francisco: Book Club of California, 1970), 105–6.

See also Michael Peich, "William Everson: Fine Printer," *Printing History* 18, no. 2 (1998): 36–48.

80. Leonard Baskin interview with Colin Franklin, in Lisa Unger Baskin, comp., *The Gehenna Press: The Work of Fifty Years,* 7.

For better or worse, Elbert Hubbard in East Aurora, New York, came to personify the Arts and Crafts in America. Among his many enterprises, Hubbard founded the Roycroft Press in 1895 to publish his writings and those of a few other authors.[84] The quality of book design and production of the Roycroft Press varied widely. At the positive end, the vellum-bound *As It Seems to Me* (1898) incorporates rubricated capitals and whimsical marginalia. At the negative end, some Roycroft productions seemed determined more by economics than by aesthetics. For example, Hubbard soon realized that evidence of handwork could translate into higher prices. Ever the assiduous marketer, he offered his books in a variety of bindings and added color in print runs and from hand illumination. The books sold for anywhere from $2 to $100. Vilain dryly notes that this sort of handwork "outdid the competition, and it compensated for some of the flaws evident in the incunabula of the press—the uneven inking, the inconsistent presswork, the hesitant page make-up, the poor second-color registration."[85]

In the business world, trade printers around 1900 occasionally indulged in "artistic printing," producing a dizzying mix of typographical and decorative motifs. Other influences in the early twentieth century arrived primarily from Great Britain. European influence, as embodied in the "New Typography" of Tschichold and others, was held at bay until émigré typographers arrived in the United States in the 1920s and 1930s.

The Arts and Crafts movement helped to establish the importance of fine book design. Booklovers recognized the importance of quality typographical design in the fine press book, even though Americans seemed content to avoid debate over the implications of Morris's socialism or his conviction that craft and fine art should enjoy equal status. After its initial impact, the wood-engraved aesthetic of the Arts and Crafts soon waned, and by World War I the popularity of the Arts and Crafts movement had diminished. America was now held in thrall to the machine, and fine press printers sought to design books that displayed an affinity with the trade book, rather than the elitism implied by the materials and scale of a deluxe book. The bookwork remained for now a European phenomenon, largely invisible to America. Interest shifted toward typefaces and page designs that developed out of England's Aestheticism, which were promoted by the new leaders in typographical reform from Britain and the United States.

84. See Jean-François Vilain, "The Roycroft Printing Shop: Books, Magazines and Ephemera," in *Head, Heart and Hand: Elbert Hubbard and the Roycrofters* (Rochester, New York: University of Rochester Press, 1994).

85. Vilain, *Head, Heart,* 25.

BETWEEN BRITAIN AND AMERICA

Type design moves at the pace of the most conservative reader.[86]

—STANLEY MORISON, 1936

The typographic style of the British printed book was scarcely touched by the cold, bony finger of the Bauhaus which put so many dismal sans-serifs on so many Continental title-pages.[87]

—BEATRICE WARDE

Book design owes its twentieth-century evolution to a generation of typographical reformers on both sides of the Atlantic. Their crisp, clean type designs fit the demands of modern trade printing, and their thinking came to dominate and define America's maturing fine press community. Stanley Morison and Beatrice Warde promoted those design ideals at British Monotype Corporation, where Morison served as its typographical advisor from 1922 to 1954, after a decade of work in printing and publishing. His influence grew as Monotype released a number of typefaces that embodied historically sound designs. In his writings Morison espoused the need for reason to govern type design, which he summed up in his *First Principles of Typography* as, "typography is the efficient means to an essentially utilitarian and only accidentally aesthetic end."[88]

Beatrice Warde began work as an assistant librarian for the American Typefounders Company in New Jersey, and under the pseudonym Paul Beaujean wrote on typographical history. She moved to England and the Monotype Corporation in 1927, and stayed until 1960, directing her efforts toward reform in the pages of the company's journal, *The Monotype Recorder,* which she edited from 1900 to 1969. Morison led the effort at Monotype to revive historical type designs. Warde's lecture in 1932, "Printing Should Be Invisible," wittily invoked the etiquette governing the new traditionalist typography in epigrams such as "Type well used is invisible as type, just as the perfect talking voice is the unnoticed vehicle for the transmission of words, ideas."[89] Warde equated the modernist "transparent page" with a "crystalline goblet which is worthy to hold the vintage of the human mind."[90] Wine, reading, and reflection commingled in her association of books of "invisible typography" with a civilized, modern life. The views of Morison and Warde remained integral to the fine printer's lexicon well into the 1960s and 1970s.

Warde's droll directives were undergirded by a reformer's fervor that required the expurgation of the ego in service to a text. Morison and Warde wielded considerable influence in promoting that vision

86. Morison, *First Principles of Typography* (New York: The Macmillan Company, 1936), 6.

87. Warde, *The Crystal Goblet: Sixteen Essays on Typography.* (London: The Sylvan Press, 1955), 130.

88. Morison, *First Principles,* 1.

89. Beatrice Warde, "The Crystal Goblet," in *I am a communicator. The Monotype Recorder* 44, no. 1 (Autumn 1970), 24.

90. Warde, "The Crystal Goblet," 25.

of a well-designed, machine-printed book made affordable from mass production. Robin Kinross summarized their stance:

> The vulgar extremes of 'printer's typography' were eroded by the teachings of the printing reform: typefaces had a historical pedigree and should not be illegitimately (ahistorically) combined, nor used in too many sizes, nor with too much bold type; [second,] the nineteenth century was a dark period typographically...; [and, third,] typography should not get in the way of the reader and the text, but should...be a transparent and civilizing container. This apparently invincible philosophy was bestowed on and accepted by all sectors of the printing world: the trade and its publications; printing education in the technical colleges and design education (so far as it existed) in the art schools; the newly emerging sphere of the 'typographic designer.'[91]

England did not monopolize typographical reform; in fact, it is difficult to determine U.S. or English precedence, due to the busy exchange of influence from writing and design carried on in both countries.[92]

U.S. designers followed a parallel path toward reform. They benefited from the Arts and Crafts in an awareness of the book as a designed artifact, but eventually they came to prefer the streamlined, historical prototypes of the Aesthetic book. This reform movement did not include the voice of the modernist avant-garde in Europe, because those designs did not gain a foothold in the United States until the 1930s—in truth, sans-serif typography remained uninteresting to most fine press printers until later in the twentieth century. Instead, a mix of the Arts and Crafts and Aesthetic styles enlivened the fine press book in the early twentieth century, after which the simple and restrained Aesthetic style took precedence. The ultimate acceptance of the Aesthetic style was due in part to a concerted campaign that touted its superiority on commercial, historical, and educational grounds.

William Morris's legacy in America was primarily a stylistic one and not about his socialist convictions. His trademark foliates or robust typography were adopted—with varying success—by "artistic" publishers in Chicago, Boston, and New York.[93] More important, his work and writings awakened American type and book designers to an awareness of the design potential of the book, a respect for and a sensitivity to a book's presentation and materials, and an integrity conferred upon historically based typefaces.

Designers and fine printers increasingly directed their reformist zeal to support new traditionalist typography at the expense of the foliated Kelmscott aesthetic. Stanley Morison made his preference

91. Kinross, *Modern Typography*, 65–66.

92. See Kinross, 57.

93. Examples include Bruce Rogers's design in 1895 of *The Banquet of Plato* (trans. Shelley), for Way & Williams of Chicago; and a design by D. B. Updike in 1892 of F. Hopkinson Smith's *A Day at Laguerre's and Other Days: Being Nine Sketches*, at the Riverside Press, for Houghton Mifflin of Boston.

clear in *Four Centuries of Fine Printing* (1924). Morison praised Morris's "passion for perfect craftsmanship and his whole-hearted application to detail," along with his "energy, [which] by focusing interest in the craft, has made possible much of the variety and excellence which characterise present-day typography."[94] However, he also stated that

> it is infinitely to be regretted that his enthusiasm for the Middle Ages led him to go behind the roman letter [that is, in his use of an earlier typeface as a model]. The Golden type is his single contribution to its development, for which he might have done so much had he not been under the spell of the incunable. The Golden type is a barren achievement because the Kelmscott master had not realised that, though black is the ideal colour for a gothic age, the roman letter with its finer contour demands a different colour, and can be brought into conformity with gothic standards only by compromising its essential grace and form.[95]

Morison, whose type design and historical acumen was respected if not revered by the reformers, had passed judgment on Morris. The reformers in America—Susan Otis Thompson called their endeavors "fine commercial presses"[96]—comprised a small but vital cadre of enlightened publishers. These publishers employed designers committed to a revitalized type design, and in so doing, the publishers and designers forged ties between trade publishing and fine printing that invigorated both worlds.

Several book designers belonged to the collecting clubs that flourished in most cities. The clubs provided a meeting place for designers, hobby printers, and collectors to discuss fine printing aesthetics with scholars, who were often printers themselves. The clubs also sponsored events and publications. More than any other kind of artist's book, the positive reception of the fine press book was helped by such informal networks for review, discussion, and promotion.

Chief among the clubs, the prestigious Grolier Club (1884–) will be discussed below with the deluxe book, even though its sphere of influence included the fine press world. Joining the Grolier Club in New York was the Typophiles (1930–), which published chapbooks, fine press books that were "informal in approach, small in format, and big in substance."[97] On the West Coast, The Book Club of California (1912–), provided support for printing commissions even as it nurtured an educated audience for those books. Throughout America, these circles of involvement for patronage, education, collecting, and review developed like a "minor art world,"[98] increasingly directed by aesthetics, and tested by the rigors of a book's practical use.

94. Morison, *Four Centuries of Fine Printing* (London: Ernest Benn Limited, 1949, second edition), 44.

95. Ibid.

96. Thompson, *American Book Design and William Morris*, 220.

97. Lehmann-Haupt, *The Book in America: A History of the Making and Selling of Books in the United States* (New York: R.R. Bowker Company, 1951), 294. See also Deoch Fulton, "The Typophiles," *The New Colophon* 2, Part 6 (June 1949): 143–62.

98. Howard Becker defines a "minor art world" as one where "artist-craftsmen develop a kind of art world around their activities....The world contains much of the apparatus of full-fledged major arts: shows, prizes, sales to collectors, teaching positions, and the rest." Becker, *Art Worlds* (Berkeley, Los Angeles, London: The University of California Press, 1982), 278.

The emerging graphic design profession further encouraged a close relationship between fine printing and trade publishing. In New York City the American Institute of Graphic Arts (AIGA) was founded in 1914 and soon attracted more than a thousand members. In 1923 AIGA inaugurated its annual, juried "Fifty Books of the Year" competition and traveling exhibition. Especially early on, fine press books were often displayed alongside trade books at the AIGA competitions, and this juxtaposition was, in itself, a celebration of the typographical revival fostered by the scholarly and printing community.

A NEW AMERICAN FINE PRINTER: HARRY DUNCAN

I never dreamed that a dirt-cheap mid Victorian relic would become the key to my future. Certainly none of us at Cummington understood that the influence of William Morris remained so strong. If no longer the book designer whose style we most aspired to emulate, he nonetheless prevailed backstage as the great liberator who redeemed the art of typography from mercenary industrial toils; after half a century his exploits (abetted by Thoreau's civil disobedience) could still libidinally champion our cause and rally us to unarmed rebellion against the status quo.[99] —HARRY DUNCAN

By the mid twentieth century, Harry Duncan had become the most respected fine printer of his generation. His press, the Cummington Press, produced *The Good European,* which AIGA selected in 1947 for its "Fifty Books" competition. In doing so, the AIGA gave early recognition to Harry Duncan. Two years prior, Duncan had established his fine printing leadership with *Esthétique du Mal* (1945, fig. 22), a book he produced with Paul Wightman Williams, who also worked with him to print *The Good European. Esthétique du Mal* contains a sequence of poems by Wallace Stevens, interspersed with pen-and-ink drawings in brown by Williams which subtly activate the page, their semi-abstract character an uncommon fine press choice. The overall effect is of a friendly book, gracefully designed, waiting to be perused.

Harry Duncan began printing while on a teaching scholarship at Cummington School of the Arts in Massachusetts. Practical instruction unavailable, Duncan had to search out his resources, and solicited advice from Ward Ritchie, Will Ransom, Frederic Goudy, and others; he later recalled the difficulties that inexperienced printers faced in the 1940s:

> At that time it was still not impossible to find in the back room at The Hampshire Bookshop a Nonesuch Press or Officina Bodoni edition or an old *Fleuron* priced so low that

99. Duncan, "Cross-Purposes," *Bookways* 1 (October 1991): 17.

even we could afford it. We held a running debate with the *First Principles of Typography* according to Stanley Morison. Our copy of J. Luther Ringwalt's *American Encyclopaedia of Printing* had its broken back and foxed pages further defaced by inky fingerprints. And we ransacked every neighboring library trying to learn how printing was done before the industrial and electrochemical revolutions ruined it.[100]

By the time Duncan began to print in the 1940s, America's book community had undergone tremendous change. At the end of the eighteenth century the workaday Colonial book designs had been replaced by modern-face typefaces paired with wood-engraved designs. The look of the trade book remained constant until around 1880. By the 1880s, publishing shifted from family-run businesses to the corporations that dominated the next century, joined by paperback publishers after World War II. The book world coalesced. Trade publishing adopted mass-production techniques, including some machine-driven finishing for binding. Power-driven letterpress cylinder presses, machine-made papers, and linotype or monotype composing machines printed newspapers for a largely literate, expanding population. The arrival of a new array of machinery, however, did not insure a higher standard of quality in bookmaking. For example, the crisp finish of calendered papers showed off an engraving's fine lines to advantage, but the use of wood pulp for paper, and the use of mechanized bookbinding that substituted glued for sewn bindings, contributed to the shortened lifespan of a book.

100. Duncan, "The Technology of Hand Printing," 22.

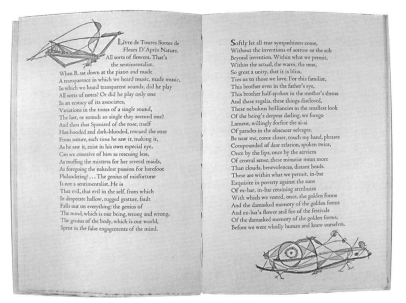

FIG. 22. [CP3] Harry Duncan. *Esthétique du Mal* 6 1/4 x 9 5/8

Joseph Blumenthal recalled those decisive years of transition in the early twentieth century as a time when the first generation of American designers, scholars, and publishers articulated principles applicable to both trade books and fine printing.

> During the first twenty years of [his own press,] The Spiral Press [1926–46] the book designers and printers who had been responsible for the renaissance in American printing were still active. They had begun their work before machinery wholly replaced the hand, before offset printing had become a dominating factor, before photoelectric composition had been conceived. They lived through the transition and meshed the standards of manual craftsmanship with the gears of the machine. With relatively small and comprehensible machinery, this was practicable in what was, only a few decades ago, a much less complex world.[101]

The pace and impetus of reform and revival, influence and cross-fertilization, was greatest up through the 1920s, and then slowed during the Depression and World War II. Only in the late 1940s could designers and scholars build on their foundation of typographical history, although many of those resources remained scattered and informal.

Although Duncan's books generated admiration almost from the start, it was his writing that gave American fine printers a voice and a model. Duncan delineated in his essays an aesthetic that participated in the spirit of typographical reform, but one that remained on his own terms. In 1949 he responded to Morison's epigram, "Typography is the efficient means to an essentially utilitarian and only accidentally esthetic end, for enjoyment of patterns is rarely the reader's chief aim," by claiming that, in truth, "one essential aim of a reader of poetry (and of imaginative prose, too), should be, precisely, enjoyment of patterns; and…a typographer is enjoined to bring his copy to typographic form."[102] Duncan, however, was equally quick to distance himself from a purely decorative intent: "Nor did [our texts] provide a field for the self-expression of a printer's personality, whatever that is. An appropriate book, we thought, should become the text, and therefore exist as it communicates."[103]

Historian Roderick Cave later described Duncan's books as embodying the "severe restrained classical style that…shows clearly the line of descent from presses such as the Doves Press."[104] Duncan's lineage was more complicated than that. In his essay "The Art of the Printed Book" (1980, 1981), Duncan began by invoking Martin Buber's definition of the artist as one who, "exceed[s] the needed for

101. Blumenthal, *The Spiral Press: An Exhibition of Selected Books and Ephemera Designed and Printed at the Spiral Press in New York from 1926 to 1968* (New York: Joseph Blumenthal, 1968), 23.

102. Duncan, "The Cummington Press," in *Doors of Perception,* 14.

103. Ibid.

104. Cave, *The Private Press,* 255.

the sake of the intended." From this premise he remonstrated with the Warde aphorism that "printing should be invisible," by cautioning that her call for typographical clarity "does not mean that typographers must strive to become indistinguishable flunkies whose duties are discharged in self-effacement." Instead, Duncan asserted that for past masters of the book, "Each was expressing, in terms of type, paper, and format, the text at hand; and incidentally, being so great a master, [each] brought his deepest character to bear on the graphic elucidation of his copy."[105]

Ultimately, Duncan judged a book's success by its balance between content and form, directed by a printer's editorial astuteness in which a thoughtful and educated treatment of the whole book revealed a "basic plan which sustains every page."[106] Without that sustained impact, no matter what its strengths, a book would "look wrong, singular, desultory, [and] altogether unconvincing...."[107] Duncan accepted Warde's ideal, that a typographical design must serve the text, just as a crystal goblet acts as a container for a fine wine. At the same time, Duncan maintained that the best printers infused their books with a personal style. In closing, Duncan ingeniously linked Buber with Warde in an aesthetic that honored Morison while also asserting an expressive impetus to fine printing:

> Let us exceed the needed for the sake of the intended whenever possible, taking personal responsibility for any assignment we accept, reading the copy sensitively in awareness of our tradition's bounty and our present resources' limitations, keeping ourselves open to unexpected inspiration by refusing to be hidebound by routine or the prodigies of technology or our own expertise, and finishing it as perfectly as we can. Then we may, as Mrs. Warde hoped that we would, "spend endless years of happy experiment in devising that crystalline goblet which is worthy to hold the vintage of the human mind."[108]

The influence that Duncan exerted over the fine press book derived from his twin interests in the practical and the theoretical. He learned from the designs and writings of Morison and other printers, and he leavened the precepts of the historical typographical revival with the pragmatism of a hand printer and the literary inclinations of a poet. Duncan's unerring eye for literary gifts led several New York publishers to remain on his standing order list simply to see who he published; his authors included writers such as William Carlos Williams, Robert Lowell, Wallace Stevens, and Marianne Moore. Duncan's astute editorial convictions inspired the next generation of

105. Duncan, "The Art of the Printed Book," in *Doors of Perception*, 56.

106. Ibid., 59.

107. Ibid.

108. Ibid., 62.

109. Duncan, "The Cummington Press," 9. Duncan's influence in Iowa City and at the University of Nebraska–Omaha (as of 1972) will reemerge in later chapters. Also in 1956, Kim Merker began his studies at the poetry workshop at the University of Iowa. Merker later discovered printing and studied with Duncan at the handpress, and then started The Windhover Press at the University of Iowa in 1967.

110. John M. Harrison, "A Confirmed Typomaniac: Carroll Coleman and the Prairie Press," *Books at Iowa* (no. 62, April 1995): 68–69. See also Michael Peich, *Carroll Coleman and the Prairie Press* (Tuscaloosa, Alabama: The University of Alabama Parallel Editions, 1991).

printers to embrace his "peculiar urgency" to publish contemporary writing, a mission more typically aligned with small presses or little magazines.[109]

Six years before Duncan printed the first Cummington Press book with some friends, a subtle, sober book emerged from the Prairie Press in Iowa City: the anthology *Contemporary Iowa Poets* (1935), printed by Carroll Coleman. The book's restrained design emulates traditional typography in its Bulmer roman type set unadorned between comfortably wide margins. Ruled lines mark a centered rectangle on the title page, within which a feather is pictured, its only imagery. Its effect, Emerson Wulling quipped, produced a book whose look was "neither kick nor sock, but even and firm."[110] In 1945 Coleman founded the Typographic Laboratory at the University of Iowa School of Journalism, which he ran until 1956. That same year Duncan's partner, Paul Wightman Williams, died in a car accident. Despondent, Duncan sought change, and with Coleman's retirement, Duncan relocated to Iowa City to take over the Typographic Laboratory.

FINE PRESS AUGURIES: LEONARD BASKIN

Confronting Blake plain and unexpected was like being struck by a locomotive. Here was model, praxis, paradigm and example, an artist and poet coupled.[111]

—LEONARD BASKIN

111. Leonard Baskin, in Lisa Unger Baskin, *The Gehenna Press,* 28.

112. Ibid., 29. After serving in World War II, Baskin returned to Massachusetts and taught graphic arts at Worcester Museum School. By 1956 he was teaching at Smith College and living in Northampton, Massachusetts.

As Harry Duncan embarked on his first printing forays, Leonard Baskin experienced a bookish epiphany when as a student he encountered William Blake's books in a library at Yale University. Inspired, Baskin tracked down a campus press and produced his first printed piece in 1942, his own verse in sheets, titled *On a Pyre of Withered Roses*. Baskin proved to be a key figure in shaping a fine printing aesthetic that integrated imagery on equal terms to text. In 1959 Baskin produced *Auguries of Innocence* (fig. 23), an homage that paired Blake's text with his own imagery. The book was commissioned by the Print Club of Philadelphia and in 1968 was reissued in a trade edition. Baskin printed his Gehenna Press and Eremite books fired by a bibliophile's love for the printed page, and allied with a dramatic visual presence. He understood the challenge of integrating his commanding imagery with typography: "It is odd that the press' first book was entirely free of images and that its second had no words. Was it prophetic of an insight I later had in re Blake, that when his poetry is at its greatest, the art is at its weakest...and the opposite."[112]

Baskin's example serves as a counterpoint to the elegant restraint of the books by Harry Duncan. Baskin did not adopt the identity of a

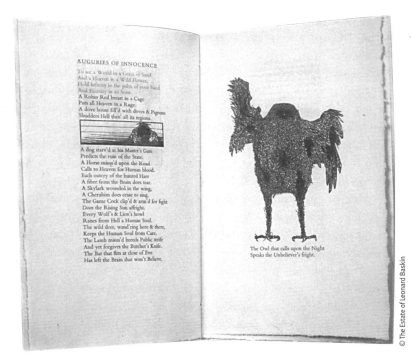

FIG. 23. Leonard Baskin.
Auguries of Innocence
Printed for the
Print Club of Philadelphia.
9 x 5³/4

hand printer and publisher as did Duncan. Baskin came to fine print-ing as a printmaker and sculptor; indeed, the dynamic imagery in his books also testifies to the growing presence of printmaking in the America of the 1950s. Ever the individualist, Baskin did not follow the trend of Abstract Expressionism, but instead explored the figure in his prints. Baskin's literary tastes led him to publish contemporary writers, especially in later years, but he did not maintain a distinctive publishing profile as did Duncan. Baskin's eclectic tastes often led him to publish writings that had long been languishing. His books in-creasingly defined one kind of a fine press–deluxe hybrid, where a strong literary presence is joined to forceful imagery, and produced with high-quality materials.

Baskin, like Duncan, first encountered printing in an educational setting. The integration of fine printing into academia helped to fos-ter a more appreciative audience, as well as indoctrinate some of its practitioners in the aesthetic of the new traditionalist typography. Over the years campus printing instruction appeared and disappeared, often at the whim of a department head or dean. These "bibliographic" presses were usually located in libraries or English departments; the move by fine printing into art departments occurred at a later date.[113]

Unlike Leonard Baskin's fortuitous encounter of fine printing at Yale, artists interested in reviving hand bookbinding and hand papermaking suffered from a lack of teaching venues in the United

113. The term "bibliographic press" was used by Philip Gaskell in his 1965 survey of campus fine presses. In a later survey, David Farrell defined the bibliographical press as: "A [hand] press used to demonstrate the princi-ples of descriptive bibliography and the history and technique of hand-printing. These presses...are found... in libraries, library schools, and English departments." David Farrell, *Collegiate Book Arts Presses: A New Census of Printing Presses in American Colleges and Universities* (San Francisco: Fine Print, 1982), 11.

Education also took place outside of academia. For example, neither Gaskell nor Farrell mention the studio in book design and printing set up by Joseph Blumenthal in the early 1930s at The New School for Social Research in New York. Organi-zations began in Boston, Chicago, and San Francisco in the 1890s, inspired by the Arts and Crafts movement, the Guild of Book Workers (1906–) chief among them.

114. Tom Conroy, untitled article, *Guild of Book Workers Journal* 28, nos. 1–2 (Spring–Fall 1990): 2. Two issues of the *Guild of Book Workers Journal* expand on Conroy's research: Spring 1995 (vol. 33, no. 1) and Fall 1995 (vol. 33, no. 2).

115. Dard Hunter, "Peregrinations and Prospects," *The Colophon* (Part 7, 1931): n.p. See also the discussion of the contributions of Hunter in Blumenthal, *The Printed Book in America*, 104–8.

116. In 1939 the Dard Hunter Paper Museum was established in Cambridge, Massachusetts, at the Massachusetts Institute of Technology. In 1954 it moved to the Institute of Paper Chemistry in Appleton, Wisconsin. It currently resides in Atlanta as the Institute of Paper Science and Technology.

States.[114] England exerted the greatest pull for binders during the Arts and Crafts movement. In the early 1900s, most U.S. binding students were "women of means" who traveled to England to study with T. J. Cobden-Sanderson at the Doves Bindery. Americans later gravitated to Paris to study, until World War II. Despite the high profile of French designer binding, American binders demonstrated relatively little curiosity about French methods. Few French binders taught in America, and few American binders sought training in France. Only the Allen Press in San Francisco (from 1945) was known for its strong ties to a French binding aesthetic.

Much as with hand binding, after industrialization the skills of hand papermaking were kept alive by a few dedicated individuals. Dard Hunter, born in 1883, recalled watching his father print when Dard was ten, at what Hunter mused might have been "the first instance of a private press in America."[115] In 1913, shortly after the founding of the Guild of Book Workers, Hunter built his first paper mill at Marlborough-on-Hudson in New York, and in 1914 he cast type at the site. He opened a second paper mill in Lime Rock, Connecticut, for commercial hand papermaking. Hunter's labors, research, and writings (in particular, his *Papermaking: The History and Technique of an Ancient Craft*, 1943) mark a pioneering effort to promote papermaking as an acceptable area of artistic practice. His advocacy of handmade paper will bear fruit in the 1960s with the crafts revival.[116]

Douglass Morse Howell also sought the recognition of handmade paper by the art world, and to some extent he succeeded. Howell, like Hunter, studied in Europe in the 1910s. He returned and made paper in the 1940s, conducted research at the New York Public Library, and solicited advice from a variety of conservators and binders regarding the limitations of wood pulp papers. In 1946 Howell established (perhaps the first) New York studio that included a Washington hand press and a beater for preparing paper pulp. He printed on his own papers and made papers for others.

CALIFORNIA'S "SMALL RENAISSANCE"

In 1920 the Grabhorn Press was started by the Grabhorn brothers, Edwin and Robert, soon after their arrival in San Francisco. Their books influenced fine printing for more than forty years.[117] With *The Song of Songs* (1922), the Grabhorns found their own style. This small vellum-over-boards book resembles the Doves Press in its clean lines and crisp color, its close-set Goudy Antique type, and the lively lines of the woodcuts by Valenti Angelo. The Grabhorns preferred to use forceful press-work, leaving a deep impression on the hand-made paper that invited readers to explore the topography of the page ("Your type should become a part of your paper," Edwin once said [118]).

In style and scale, the Grabhorn Press *Leaves of Grass* (1930, fig. 24) is another precursor of the fine press–deluxe hybrid. The book's pages have been so widely reproduced as to achieve "virtually canonical" status. For some critics, *Leaves of Grass* also represents a questionable alliance of a fine press with a trade publisher (the project was a limited-edition joint venture by the Grabhorns and Random House publishers, then represented by Bennett Cerf). Megan and Paul Benton suggested that the prominence of the commission may have led the brothers to treat the project in an uncharacteristic manner: "In their correspondence, neither [Cerf nor Ed Grabhorn] showed any inkling of having read the book, much less of being inspired by it. Grabhorn rightly saw the book and its extravagant budget as a great chance to show their stuff. [It]...was thus one of the first in which a beautiful, or lavishly expensive, or typographically significant book was the primary goal; Whitman's poems merely offered suitably broad shoulders on which to hang their bookmaking artistry." [119]

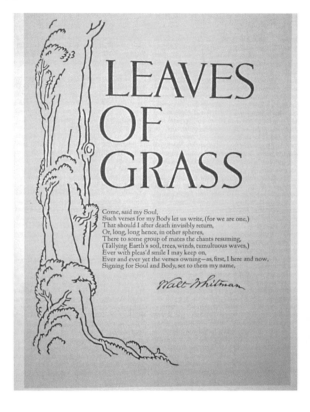

FIG. 24. Edwin and Robert Grabhorn. *Leaves of Grass* by Walt Whitman, Random House, Inc.
14¹/₂ x 9³/₄

117. They were joined by Jane Grabhorn, who married Robert. Jane Grabhorn's own printing will be discussed in chapter 4. Like many printers, the Grabhorns executed job printing along with fine printing. Many of their commissions came from the Book Club of California.

118. Teiser, *Printing as a Performing Art,* 18. The correct amount of printing impression was purely subjective. Harry Duncan described his own printing impression as "a hard, penetrating strike [that] expresses type in its essential virtue, sculptural as it is in construction and application." Duncan, "The Technology of Hand Printing," 29.

Other printers sought to have their inked type lightly "kiss" the paper and not leave any impression.

119. Megan and Paul Benton, "Typographic Yawp: *Leaves of Grass* (1855–1992)," *Bookways* (October 1994–January 1995): 29.

More than just a book, this was book as symbol, and symbols can cost dearly. At $100 a copy (the Bentons add), "Apparently, no one squirmed at the thought of [Walt] Whitman yawping his democratic song from the pages of a book that cost more than common folk earned in a month."[120] Edwin Grabhorn later temporized, speaking in the third person, that "the printer knew that the limited edition was not a racket as long as he had honesty and sincerity, and reverence for the best traditions of the craft."[121] As an early fine press–deluxe hybrid, *Leaves* courts paradox: it straddles the two book types of fine press and deluxe, along with its sponsor of a trade publisher.

Despite the criticism, *Leaves* undeniably achieved a fusion of its parts. The calligraphic Goudy New Style typeface, considered dubious by some type purists, captures Whitman's ebullient voice. The inked type (with just a few hints of red) is closely leaded and tightly spaced to create a strong text-block pattern counterpointed by wide margins. The Grabhorns printed on dampened handmade paper, and the tactility invited by the deep impression of the type enriches the sense of Whitman's own celebrated sensuality. Overall, the book drew more praise than criticism, and the participation of Random House helped to raise the public's awareness of fine design. As printer Andrew Hoyem later commented:

> One can hardly write of this great American press book as representative of a California style of printing. It set a national standard not to be imitated by the Grabhorns, their competitors, or emulators (though other books of the Grabhorn Press did establish an identifiable regional style). *Leaves of Grass* is informed by the grandeur of the earliest printed books and influenced by volumes of the English presses from the turn of the century. But the Grabhorn brothers also took inspiration from Whitman's freedom, escaping momentarily from tradition to create their masterpiece, a book singing the song of its poetic contents.[122]

The Grabhorns passed the torch to Hoyem himself in 1966, after Edwin retired, and Hoyem entered into partnership with Robert. In 1975, after Robert's death, Hoyem rechristened the enterprise the Arion Press.[123]

120. Benton, "Typographic Yawp," 22.

121. Edwin Grabhorn, "The Fine Art of Printing," in Bennett, ed., *Books and Printing, A Treasury for Typophiles,* 232.

122. Andrew Hoyem; Sandra Kirshenbaum and Kenneth Karmiole, eds., *California Printing, a Selected List of Books Which are Significant or Representative of a California Style of Printing* (San Francisco: Book Club of California, 1984), 6.

123. For more on California printers, see Oscar Lewis, "The California School of Printing," *The Colophon* (part 3, no. 9, 1930), n.p.; A. M. Johnston, "Jack Werner Stauffacher, Typographer," *Fine Print* 5, no. 1 (January 1979): 1–6; James Hart, *Fine Printing: The San Francisco Tradition* (Washington, D.C.: Library of Congress, 1985), 50–51; Ward Ritchie, *Fine Printing, the Los Angeles Tradition* (Washington, D.C.: Library of Congress, 1987); and Kirshenbaum and Karmiole, *California Printing.*

PRINTING AS SPIRITUAL DEVOTION:
WILLIAM EVERSON (BROTHER ANTONINUS)

There will be harvest, harvest. We freighted the handpress
Out of the hills. Mounted at last in the little room
It waits for the black ink of its being;
And the rich paper, drawn out of Europe, it too hand-fashioned;
The work of the hand, all; the love of the hand in its sure sweep
When the bar pulls over; all about it the touch of a hand
Laid on it with care. And borne like fruit, a perfect page,
That testament to the heart's abundance
All work of wholeness executes in the enlivened eye: a godly issue.[124]

—WILLIAM EVERSON

William Everson is revered in California fine printing for his superb printing, his evocative poetry and essays, and his larger-than-life personality. As Brother Antoninus, his calling as poet, printer, and monk fed into a resolution to print the *Novum Psalterium PII XII* (ca. 1954, fig. 25), which he viewed as a "bridge between two ages....a Renaissance, rather than a Medieval book," where, "the preliminaries follow certain effects of incunabula, but the text pages are quite close to those of modern poetry."[125] Before joining the Dominican Order, Antoninus (as William Everson) suffered, as a poet, from poorly designed books. In a letter to his publisher his sentiments echoed those of William Morris from sixty years earlier: "I believe I have the distinction of placing my work on the market in about the worst piece of composition I have ever seen in a serious book of poems."[126] Everson had also printed while he was interned (with another young printer, Adrian Wilson) in an Oregon camp for conscientious objectors during World War II. While there, Everson published his anti-war poems in a mimeographed camp publication, *The Untide* (1943).

When Pius XII approved a new Latin translation of the Psalter in 1945, Antoninus devoted himself to the colossal undertaking of designing and printing it. He chose Goudy New Style, partly for its calligraphic flavor and partly because of his admiration of it in the Grabhorns' *Leaves of Grass* (1930). He printed on handmade paper and added a second print run in red for the titles. Antoninus's typography venerated the spoken poetic line and focused on each vowel and breath. His description of the design of *Novum* recalled Mallarmé:

> Language, like music exists primarily in time. All the artifice of the typographer may be seen as the fundamental problem of adapting an elusive temporal medium to the rigid restrictions

124. Lewis Allen, *Printing with the Handpress* (New York: Van Nostrand Reinhold Company, 1969). Everson's poem is the book's epigraph. *Handpress* was first issued in a limited edition by The Allen Press, and then in a trade edition in 1969 by Van Nostrand Reinhold Company.

125. Brother Antoninus, "Novum Psalterium PiiXII" (1954), in Lee Bartlett, ed., *William Everson: On Writing the Waterbirds and Other Presentations: Collected Forewords and Afterwords, 1935–1981*, 127.

126. Letter to the author, dated September 18, 1942, Michael Peich, "William Everson: Fine Printer," 37.

of space. Nor will we ever see the problem more acutely posited than in the printing of poetry. The invention of printing was one of the turning points in the history of verse, for it definitely took poetry out of the mouth and out of the ear and fastened it on the page, gave it up wholly to the eye....Today the fate of a poem may be decided by nothing more than its appearance as it is lifted to be read. I know of no critic who will judge a poem on hearing alone: it is not assumed to exist until actually seen.[127]

Antoninus, however, did not reshape the page to reflect the interplay between mark and space that Mallarmé described as a "distribution of light." Antoninus instead responded to the "aural reality" of a stanza by avoiding line breaks or, if required, by breaking a line at a semi-colon or at some other pivot point to indicate the inhalation of breath. The acute attentions Antoninus paid to the poetic experience, and to its simultaneous voicing and apprehending, added a reverential dimension to poetry and printing. In the wake of delays and the persistent demands of monastic life, Antoninus set the book aside in 1954 to be published by Muir Dawson as a seventy-two-page fragment. Although uncompleted, *Novum Psalterium* was esteemed in the California book world.

The keen awareness that California printers developed for their own fine press heritage intensified with their geographical isolation from the printing activity in the East and Midwest. Oscar Lewis suggested in 1930 that,

Because of that isolation, the printers of the Coast have been less influenced by transient fashions in book design than those in close touch with the production centers; their books, hence, are not so definitely dated as those of many other presses....But [Western designers] have also occasionally been woefully behind the times....the Roycroft school of design continued to flourish on the Coast fully a decade after its vogue has passed in the East....[as well as] the still persisting influence of both William Morris and the fifteenth-century Italians.[128]

An openness to visually innovative designs helped to revitalize fine printing in California, distinct from Harry Duncan's restrained page and Leonard Baskin's dramatic imagery. Writing in 1984, Sandra Kirshenbaum and Kenneth Karmiole attributed California's book aesthetic to several factors, from "the inspiration of the California landscape reflected in the graphic qualities of California books,"[129] to

127. Antoninus, "Novum Psalterium PiiXII," in Bartlett, *William Everson: On Writing the Waterbirds*, 129.

128. Lewis, "The California School of Printing," n.p.

129. Kirshenbaum and Karmiole, *California Printing*, vii.

130. Ibid., ix.

131. Lewis, "The California School of Printing," n.p. Lewis adds that, "Before there was a California school, a book printed on the Pacific Coast was something of a problem....California books and California printers received very little attention in books and essays on American fine printing published, say, before 1925. The invention of the phrase 'California school' changed all this. That device enormously simplified the problem of how to classify a book produced on the Pacific Coast." n.p.

the scale and drama of the "exhibit format" books of landscape photography published by the Sierra Club and others. A mix of global influences arrived from Europe (seen in books by Saul Marks and Jack Stauffacher, who studied there), the Pacific Rim, Asia, Latin America, and from California's own Mexican heritage, and contributed to the distinctive look of California's fine printing.

Kirshenbaum and Karmiole suggest that the bohemian culture in 1890s California, the Beats in the 1950s, and the protest poets of the 1960s all encouraged an oppositional stance detected in contemporary books by California fine printers. They conclude by suggesting that "in California, more than in any other region, printing has come to be a creative, even a spiritual act," as epitomized by William Everson's *Novum Psalterium*.[130] That link of a spiritual devotion to a life of printing is unique to U.S. fine printers (often a curmudgeonly group), as it offered permission to invest printing with one's own myths, desires, or sense of play.

The visuality of books printed by the Grabhorns and Allens did not undermine their literary content, but placed literature on a par with a book's optical and experiential properties. Oscar Lewis added in 1930 that if there was such a thing as a "California School of Printing," its characteristics included "a leaning toward the grand manner" with "large page sizes and a common liking for color."[131] Many of these books refused to adhere to the purist constraints of the new traditionalists, and blurred the boundary between what constituted a deluxe or a fine press book. But what an invigorating confusion, what a rich mix of local literature and contemporary imagery and materials! Geographic and aesthetic insularity proved to be a creative benefit for California's young and ambitious fine press community.

FIG. 25. William Everson.
Novum Psalterium PII XII
15 1/2 x 10 1/4

Chapter Three

The Deluxe Book

My great interest, my real passion, had always been books, books with visual images. I had just read a lovely book that inspired me very much, a book by Monroe Wheeler called "Modern Painters and Sculptors as Illustrators," in which he spoke about artists doing graphic work to illustrate books of poetry...and he said that the ideal thing would be for an artist and a poet to work together on a book. The idea seemed very beautiful to me.[132]

—TATYANA GROSMAN

PRINTMAKING'S CHANGING PROFILE

Four contributors were crucial to the development of America's deluxe aesthetic in the 1960s and 1970s: two print ateliers that encouraged the making of innovative books; an exhibition that broadened the definition of what could be constituted as deluxe; and a fine press whose books embraced the traditional French aesthetic, but only as a means to enhance decidedly American content. The first development was heralded by Tatyana Grosman, Universal Limited Art Editions (ULAE), an influential atelier, and *Stones* (1957–60, fig. 26). Grosman helped to introduce a generation of artists to the spontaneity possible with lithography. This began with *Stones*, a project she began in a converted studio space at her home on Long Island.

Stones, comprised of twelve unbound sheets, evolved from a collaboration between poet Frank O'Hara and artist Larry Rivers. Rivers and O'Hara pushed collaboration into improvisation, as the friends passed the crayon back and forth between them, drawing and writing in the moment, with O'Hara reversing his text to accommodate printing from the litho stone.[133] Their improvisational approach created a strikingly different page from, say, the studied entrancements of *Parallèlement*. In *Stones* there is no separation between image and text—both come from the same crayon in a sketchbook style. This was the milieu of the Beats, who operated in the realm of immediacy and serendipity, worlds away from Bonnard's boudoir.

Grosman not only published innovative deluxe books, she also expanded awareness on the part of artists and collectors to the aesthetic of handmade paper. Rivers and O'Hara performed their duet on paper made by Douglass Morse Howell. Howell labored to produce the linen rag paper in his New York studio, and could "make a few sheets at a time 'only if it wasn't raining' [along with] the portfolio cover [that] came from blue jeans, the uniform of its creators."[134] Grosman recognized the expressiveness of paper as stratum more

132. Calvin Tomkins, "Profiles: The Moods of a Stone," *The New Yorker* (June 7, 1976): 45.

133. Robert Rainwater, *The American Livre de Peintre* (New York: The Grolier Club, 1933), 58.

134. Pat Gilmour, *Ken Tyler, Master Printer, and the American Print Renaissance* (New York: Hudson Hills Press, Inc., 1986), 25.

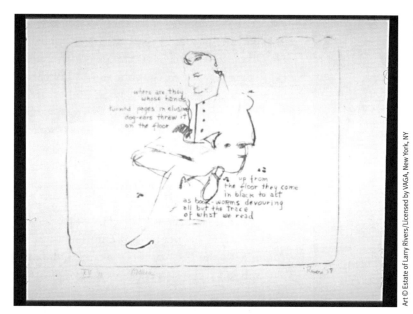

FIG. 26. Larry Rivers, Frank O'Hara
Stones
18³/₄ x 23¹/₄

than as surface. Her singular commitment was exalted into "something of a mystical choice...if there were only five sheets of a certain paper, Mrs. Grosman would publish an edition of five...."[135]

Did *Stones* innovate in its design? Other pages in *Stones* reflect a more fragmented, collaged effect, but overall the work maintains a readable text and discernible imagery. Still, it was far removed from deluxe conventions. The immediacy that Rivers and O'Hara brought to their process produced pages of an unconventional distribution of picture and text, pages meant to appear unfinished and sketchy; in fact, O'Hara's literary circle sought to emulate the Mallarméan notion of the creative act as a "lightning-like initiative which can link the scattered notes together."[136] If it did not refute the deluxe aesthetic absolutely, *Stones* departed radically from the fluid page design of *Parallèlement* and the holographic seamlessness of *Jazz*.

Just before *Stones* appeared, a New York press, Atelier 17, released *21 Etchings and Poems* (1951–60), a collaborative portfolio whose genesis preceded that of *Stones* by a decade. Stanley William Hayter opened Atelier 17 in Paris in 1927. From 1940 to 1946 he operated the intaglio atelier out of New York's New School for Social Research, then returned to Paris in 1950. Hayter demanded the direct involvement of an artist in all aspects of printing, and experimented with different papers and inks. Atelier 17 was recognized as a leader in experimental intaglio printmaking in America, and attracted European Surrealist artists-in-exile such as Max Ernst.[137]

Unlike *Stones*, which was the first offering from ULAE, *21 Etchings* marked the maturity of Atelier 17, but the overlap between the

135. Calvin Tomkins describing paper selection at ULAE. Tomkins, *Off the Wall, Robert Rauschenberg and the Art World of Our Time* (New York: Penguin Books, 1980), 204.

136. Mallarmé, "The Book: A Spiritual Instrument," in, Mallarmé, *Selected Poetry and Prose*, 82–83.

137. Turner and Skiöld, *Handmade Paper Today*, 225. Peter Grippe took over from Hayter in 1951, and Atelier 17 in New York finally closed in 1955. Grippe continued working on the portfolio and released it in 1960. The work generated immediate interest; Lanier Graham even claimed that it inspired *Stones*. Lanier Graham, *The Spontaneous Gesture: Prints and Books of the Abstract Expressionist Era* (Canberra: Australian National Gallery, 1987), 20.

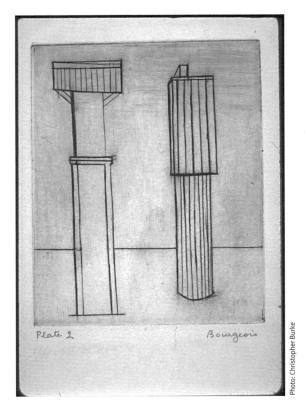

Plate 2 Bourgeois

Photo: Christopher Burke

FIG. 27. Louise Bourgeois. *He Disappeared into Complete Silence* (Plate 2), 1947, Suite of 9 engravings with text. Each 14 x 10 (35.5 x 25.3cm)

138. Rainwater, *The American Livre de Peintre,* 10.

139. See D. Scott Atkinson and Charlene S. Engel, *An American Pulse: The Lithographs of George Wesley Bellows* (San Diego: San Diego Museum of Art), 1999.

two ateliers is felicitous for their shared interest in experimentation. In 1947, Atelier 17 published *He Disappeared into Complete Silence,* by Louise Bourgeois (fig. 27). At the time of its publication little notice was taken of the book. Robert Rainwater notes that only twelve to fourteen variant copies were printed of the book, which may be why it did not elicit a wider response, and why it was omitted from a major 1961 exhibition in Boston. Rainwater has since hailed it as "the most important book created by an artist in America."[138] In the book are nine brief prose works that explore states of mental and emotional unrest. Along with the text, twenty-seven unnumbered and unbound folio sheets carry engravings of unsettling images that appear to have issued forth unbidden from the subconscious. The texts refuse to connect with the images, although suggestions of loneliness and despair resonate in both, like parables that predict the impossibility of union.

The fact that the earlier Atelier 17 printed intaglio and the later ULAE printed lithography illustrates the changes that overtook printmaking in the preceding decades. In the late nineteenth century, printmaking had been associated primarily with etching, with the prints of Old World masters such as Rembrandt, or more contemporary artists such as James A. M. Whistler's etchings and lithographs. Few etchings by American artists were shown, although there were exceptions in galleries such as 291, where Alfred Stieglitz showed prints by Max Weber and John Marin. In the new century, popular interest waned.

The artistic profile of lithography in America suffered from a lack of the positive associations that had popularized it in the poster craze of France in the 1890s, or that had legitimated it as an avant-garde medium by the Futurists in Italy and Russia. A few U.S. artists were intrigued by the ability of lithography to convey drawn gesture—especially George Bellows, who created nearly 200 lithographs between 1916 and his premature death in 1925.[139] For the most part, however, art students studied printmaking more as an exercise, and reserved their serious consideration for painting. At the same time, painters occasionally made prints for extra income—such as Bellows, who produced lithographic illustrations for periodicals.

Lithography's business and popular profile had grown rapidly over the preceding decades. The first commercial U.S. lithographic

press began operation in 1819, and by 1890 more than 700 printing establishments employed 8,000 people, the expansion aided by the invention of offset printing on the cylinder press.[140] The general public associated lithography not with art but with the lithographs published by Currier and Ives that recorded every facet of early America. (From the beginning of the firm in 1834 until its sale in 1907, Currier and Ives made between 7,000 and 8,000 prints.[141]) The quality of offset printing improved in the new century, but America still lagged behind Europe.[142] That changed during World War II with the development of high-speed offset machinery and photocomposition, and in the 1950s the post-war production economy further accelerated offset's expansion. By the 1960s, phototypesetting permeated the printing industry.

Back in the 1920s, Bellows was prescient in his recognition of lithography's expressive potential. By the 1930s, a small number of artists viewed photolithography and serigraphy as viable art media and not just as cheap commercial printing methods. The changing perception was fueled by the Federal Art Project, which supported the creation of prints in all media. Still, many of the lithographs that did gain popular support were not modernist but representational, such as those by Regionalist painters Grant Wood and Thomas Hart Benton. By the 1940s, the commercial profile of offset lithography exacerbated the prejudice directed against it by an art world enamored with the gestural paintings of Abstract Expressionism.

Trade publishing was thriving by the 1950s in the revitalized economy that followed World War II. Art books, magazines, and exhibition catalogues appeared in increasing numbers, sparkling with crisp color reproductions. Their graphic character was emulated by Pop artists in a conscious effort to blur the lines between art and commerce. Offset's clean, reproducible look was exactly what Pop artists wanted, and so offset lithography finally gained an artistic identity, even though that identity was predicated on mimicking its commercial look.

Others investigated offset's expressive rather than simply reproductive potential, such as Tatyana Grosman, who insisted that each artist directly engage with the lithographic stone. June Wayne founded the Tamarind Lithography Workshop in Los Angeles with Ford Foundation support in 1960, as a center for research, education, and production.[143] Higher education provided a refuge in which printmaking continued to develop in the 1950s.[144] Professional organizations appeared, such as the International Graphic Arts Society in 1951 and the Print Council of America in 1956. By the early 1960s, art world attention reawakened to focus on prints by Pop artists and the younger painters of the New York School.

140. Gilmour, *Ken Tyler*, 13.

141. Fritz Eichenberg, *The Art of the Print* (New York: Harry N. Abrams, Inc., Publishers, 1976), 419.

142. Warren Chappell, *A Short History of the Printed Word* (Boston: Nonpariel Books, 1980), 225.

143. Wayne's contributions to lithography and collaborative printmaking are undisputed (and include her training of Ken Tyler), but do not specifically focus on bookmaking.

144. Art schools and college art departments were expanding to accommodate World War II veterans who were applying the GI Bill toward tuition. Printmakers moved into academic positions, and some founded programs, such as the influential intaglio Graphics Workshop at the University of Iowa begun by Mauricio Lasansky (1945), and the teaching of lithography, etching, and woodcut at the University of Wisconsin founded by Alfred Sessler (1946). James Watrous observes that until the founding of the programs in Iowa and Wisconsin, "Printmaking had been an occasional or minor offering at most art schools and was too often ineptly taught." Watrous, *A Century of American Printmaking, 1880–1980* (Madison, London: The University of Wisconsin Press, 1984), 165.

MODERN PAINTERS AND SCULPTORS
AS ILLUSTRATORS

*Where art is concerned, we Americans are a timid and idle people....Feeling a natural patriotism
I wished to make the showing of American material as large as I could. But I found scarcely
anything that one would patriotically choose to have compared with the best foreign work.*[145]

—MONROE WHEELER, 1936

The proliferation in the 1950s of art books from trade publishing
helped to develop a more visually sophisticated reading audience, but
pictures in books were only an indirect influence on deluxe bookmak-
ing. Most American museums and collectors had yet to accept contem-
porary printmaking as a fine art, and with the deluxe book, they also
had to confront a prejudice against books as an art form. A key exhi-
bition in 1936 marked the beginning of a decades-long process toward
the art world's recognition of the deluxe book. *Modern Painters and
Sculptors as Illustrators* at the Museum of Modern Art (MoMA) in
New York, curated by Monroe Wheeler, marked the acknowledgment
by the art world of the deluxe book in a museum context, and also
broadened the definition of what was considered deluxe material. Over
200 works created by ninety-nine artists filled the galleries, with books
by European modernists such as Bonnard, Picasso, and Toulouse-
Lautrec, as well as Barlach, Grosz, and Ernst. Wheeler, however, could
not claim significant U.S. participation in the show, since out of ninety-
nine artists, only eleven were American: "There are few original Amer-
ican artists; and those few are rarely asked to illustrate anything. Only a
handful have troubled to master the various hand-processes of graphic
art....Generally cheapness and easiness seem to be the passwords."[146]

In his catalogue essay Wheeler proposed a deluxe book aesthetic:

> The highest type of illustrated book is the joint work of au-
> thor and artist who are contemporaries, working as in equal
> collaboration; inspired by similar feeling; approaching the
> same subject-matter from opposite directions; dealing with it
> twice within the covers of the one volume. Ideally speaking,
> the work of either author or artist would be complete with-
> out the other....As they appear on equal footing, our sense of
> the greater importance of one or the other will depend on
> which of the two arts we are most sensitive to. Neither
> should seem to take precedence.[147]

Note that Wheeler described his show's participants as illustrators, a
term that could carry a pejorative meaning but was meant to empha-

145. Wheeler, *Modern Painters*, 22.

146. Ibid., 22.

147. Ibid., 16.

size their book-based endeavors. However unfair the judgment, the illustrated books of trade publishing were still generally perceived as poor cousins to the deluxe book, as simple (read = affordable) picture books that served a text more through simple distraction than innovation, far below the lofty (and limited) realm of the deluxe book. Back in 1936, Wheeler attempted to mollify the art and book worlds by linking them, in "modern painters and sculptors as illustrators."[148]

Wheeler made curatorial decisions about media and format that effectively widened the circle of books he could include in the exhibition. First, he exhibited trade books alongside limited editions, since "the by-products of a career of high art are not necessarily superior to the result of humbler specialization in work for publishers," although he hedged that "they generally are, at least at present."[149] With this wider mandate, Wheeler included books with reproduced drawings by realists George Bellows, Thomas Hart Benton, Rockwell Kent, and Grant Wood. A few limited edition books involved Americans, such as John Sloan, and Wheeler even added original (unpublished) watercolors by Charles Demuth for *The Turn of the Screw,* by Henry James. The sense is that Wheeler was laboring to establish a U.S. deluxe presence.

The courageous welcome that Wheeler gave to a few commercially printed books could only enliven a book type that had to guard against pretension. Still, the drawings in these books mostly inhabited a realistic, illustrated-book realm, and so stood in stark contrast to the books from Europe. A second, longstanding issue for deluxe books concerned whether "album-type" print portfolios should be considered on a par with bound books. Wheeler deplored some of these portfolios because they often resembled "arranged marriages" between a text and imagery by an (often deceased) artist. Even so, he admitted a number of them into the exhibition, justifying his decision in that although they "make a second-rate book...the drawings may be superb."[150] Wheeler would have helped the deluxe book more by following his aesthetic inclination consistently. The strengths of *Modern Painters and Sculptors as Illustrators,* however, far outweighed this flaw in the deluxe book's official U.S. debut. Only later, after World War II, with the appearance in the United States of a few key ateliers (especially ULAE), were books and prints nurtured in an environment that encouraged the use of innovative art world media, content, and format.

Collecting was just as important as exhibiting to the acceptance of the deluxe book, and the Grolier Club of New York inhabited the apex. Founded in 1884, fifty years before Monroe Wheeler curated his MoMA exhibition, the Grolier Club served both the deluxe and

148. William Cole, "The Book and the Artist: Rethinking the Traditional Order," *Word and Image* 8, no. 4 (October–November 1992): 378–82.

149. Wheeler, *Modern Painters,* 10.

150. Ibid., 19.

fine press communities. Later in its first year, the thirty Club members met to view an exhibition of etchings, examples of color-relief printing, and other materials related to fine bookmaking. The Grolier Club exerted lasting influence in the book art world due to the public demeanor of its exhibitions, beginning with that first showing: in the three days that the Club opened the exhibition to the public, it attracted an astounding 600 visitors. In some quarters at least, Americans were eager to understand the nuances of printing and binding the handmade book.

AN AMERICAN HYBRID: THE ALLEN PRESS

In the better French books, there is a spirit of freedom, a sort of casualness — I mean thoughtfully planned, but appearing casual. It looks unstandardized, unregimented, not done with a slide rule. So many printers today, I think, design books so that they look mechanical. Everything — the margins, the illustrations and so forth — is done to a certain rule, and as a result they look rather sterile.[151]

—LEWIS ALLEN

The Allen Press of California represents the third key development for the deluxe book: the appearance of a fine press–deluxe hybrid. Lewis Allen and his wife, Dorothy, issued their first book in 1945, then moved into full-time publishing in 1951, thirty years after the Grabhorns set up shop. Lewis Allen's *Printing with the Handpress* (fig. 28, 1969) introduced generations of future printers to the machinery, materials, and methods of hand printing, such as the proper method of dampening paper. Allen argued that hand presses (as opposed to motor-driven presses) afforded greater control for the printer in the "direct and stimulating intercourse with ink, paper and press."[152] The Allens shaped an aesthetic inspired by European models, even as they resituated that tradition within an American fine press perspective

Books by the Allens represent the fine press–deluxe crossover prefigured by the Grabhorn Press's *Leaves of Grass* in 1930. Like the Grabhorns, the Allens combined a commitment to literature with a celebration of the visual and sensuous potential of a book. But even though both presses made hybrid deluxe books, they differed from one another in emphasis. The literary emphasis of the Grabhorn books ultimately determined their character as suited more to fine printing, despite the commanding scale and sumptuousness of the exception, *Leaves of Grass*. In contrast, books from the Allen Press suggest a deluxe designation because in them every aspect celebrates visuality and tactility, from printing in multiple ink colors on handmade papers to bindings of imported fabrics. Admittedly, terms such

151. From a 1968 interview. Teiser, *Printing as a Performing Art,* 72.

152. Allen, *Printing with the Handpress,* 10.

as "fine press" or "deluxe" remain subjective. It is simply that, as a whole, even *Leaves of Grass* remains first and foremost identified with its literary content, while deluxe books such as those made by the Allens are strongly associated with their visual art content.

The Allens' *Youth* (1959), by Joseph Conrad, displays this visual character to great effect. The robust proportions of the Goudy Modern type embody the spirit of adventure in the story, and vibrant multi-colored woodcuts invigorate the assertive bite of the type. Headings in blue announce "Conrad" (on the verso, the left-hand page), "Youth" (on the recto, the right-hand page), and then run across the top of each page, further enlivened by the broken wavy lines of a rough sea. The energetic page design of *Youth* embodies the best of California's printing, where a strong typographical character is matched by its pictures—here, in the magnificent woodcuts of Blair Hughes-Stanton. At the end of the book a final woodcut sets the narrator adrift on the sea, dwarfed by the sun, his arms raised toward it in supplication. In this last image the dazzling sun now resembles a huge eye gazing at man and boat, both just barely suggested.

FIG. 28. Lewis Allen. *Printing with the Handpress.* Device. 1³/₄ x 1

While Allen Press books contributed to the deluxe book aesthetic, their use of woodcut aligned them with a fine press heritage. The art identity of the woodcut and wood engraving had long been restricted to the realm of fine printing. Back in the late nineteenth century, wood engraving had stagnated in Europe and America. This was partly due to the demands of the craft itself, and partly due to the improved quality of photomechanical reproduction, which had displaced the commercial usefulness of wood engraving, although it continued to appear in illustrated trade books and advertisements. Woodcut and wood engraving also remained in demand because of their strong graphic character, and because as a relief printing medium the wood blocks could be locked up in a press bed alongside of type. In the early twentieth century, woodcut and wood engraving diminished in commercial printing use, but appeared in the illustrations of artists such as Rockwell Kent.

When offset took over trade printing at mid-century, woodcut and wood engraving experienced a modest revival in fine press books and in the fine press–deluxe hybrids of Leonard Baskin, Antonio Frasconi, and the Allens (*Youth* was printed in 1959). These artists and their collaborators created representational imagery (the abstract, expressionistic woodcut was nearly absent from fine printing and from the U.S. print world). The Allens cited their models from the world of British fine printing, in the Kelmscott, Doves, and Ashendene Presses, and from the United States in the Grabhorn Press.[153] They also enthusiastically recounted the year spent in

153. Teiser, *Printing as a Performing Art*, 65.

France from 1951 to 1952 as crucial to their understanding of the deluxe book's heritage. In essays published in 1962 and 1981 Lewis Allen reflected on that heritage as he enumerated a deluxe book aesthetic that was also amenable to fine press literary content:

> The ideal press book, we think, should consist of eight virtues: significant text; graphic work by a major artist who sensitively interprets the text without dominating it; a pleasing natural typography to harmonize and act as a framework for ingredients 1 and 2; impeccable hand-craftsmanship; materials of superior quality for permanence and for their intrinsic beauty; suitable use of color to relieve the monotony of the dominating black; an appropriate and durable binding or box; [and] a final ingredient that could be likened to a seventh sense: it is the sum of the other seven [ingredients] wherein they are combined with delicacy, restraint, and apparent casualness without evidence of sterile formula—all in harmony to subtly interpret the text, like a handsome well-constructed bridge between author and reader.[154]

The French deluxe book gained some exposure in the West, primarily in California, and only after a considerable delay following its 1936 debut at the Museum of Modern Art with *Modern Painters and Printers as Illustrators*. Thirteen years later, the California Palace of the Legion of Honor in San Francisco hosted *The French Art of the Book,* in 1949. With *The French Art of the Book,* France reasserted its dominance of the deluxe book at mid-century. The next large-scale showing of Vollard's books had to wait until 1961, with *The Artist and the Book, 1860–1960.*

Admittedly, the early twentieth century represented a period of small but momentous beginnings, where a few artists explored printmaking techniques and a few visionaries founded ateliers, encouraged greater artist participation, and curated exhibitions. As for a deluxe book aesthetic, to a great degree, and especially in the case of recognized artists, critics still tended to review their books in terms of the artist's stylistic development, and so the focus remained on imagery, divorced from form. The voices of Monroe Wheeler, the Allens, and Tatyana Grosman offered a starting point for crafting an integrated deluxe book aesthetic; that discussion resumed in the 1970s.

154. Lewis Allen, Introduction, *The Allen Press Bibliography, MCMLXXXI: Produced by Hand with Art Work, Sample Pages from Previous Editions* (Greenbrae, California: The Allen Press, 1981), 9.

THE MULTIPLE BOOKWORK

Man can make art with a machine; offset press and hand press alike can be his brushes.
I try to use machines as a painter does his brushes. My inks are my paints and the paper my
canvas. In graphics, as in any other craft or art, respect for the materials is necessary. I think
this respect leads to a desire to learn what the juxtaposition of type, line, color, space and
photograph can create.[155] —EUGENE FELDMAN, 1964

MAKING OFFSET'S MARK: EUGENE FELDMAN

Before 1960, a few avant-garde artists experimented with commercial printing techniques in noncommercial ways. Developments in printing, typography, and graphic design, in independent publishing, and, finally, in photography encouraged artists to experiment with a graphic page. Taken together, these influences led to the appearance and rapid growth in the late 1960s and early 1970s of the multiple bookwork, a term that gained currency at that time as this kind of book proliferated.

Eugene Feldman is unmatched in his early role of liberating offset printing from its workaday character. In 1948 Feldman opened the Falcon Press in Philadelphia as a commercial offset printing house. He also designed trade books and taught typography at the Philadelphia College of Art and in the Graduate School of Fine Arts at the University of Pennsylvania. In conventional offset printing, unlike in hand lithography (as seen in *Parallèlement*), the image is transferred from a zinc or aluminum plate fitted around a cylinder in the press, onto an intermediate rubber blanket wrapped around another cylinder. It is from this blanket that the paper receives the image, which has thus been twice reversed. The offset plate can be drawn upon directly, but is most often sensitized to receive a photographic image.

When Feldman worked off-hours at the Press, he shifted roles from printer to artist. He worked as if in a "private laboratory" in which conventions were set aside.[156] He began with bits of film or multiple separations of 35 mm. slides: a single transparency, enlarged and separated several times, could yield up to twenty printing images or components. He might further transform those images by blocking out areas, by combining negatives, or by adding colors and textures from a variety of papers and differing ink densities, film coatings, and filters. Like a choreographer, Feldman imagined, altered, manipulated, and repeated, and his images overlapped and multiplied in response.

155. Feldman, "Statement." *Exposure* 21, no. 3 (1983): n.p. Special Issue.

156. Ruth Fine, "Eugene Feldman (1921–1975): An Appreciation," *Exposure* 21, no. 3 (1983): n.p.

Feldman also employed a technique later used by Dieter Roth, Joan Lyons, and others, where he photographed objects directly in the copy camera as a means of production rather than reproduction. This technique contributed to his first book, *Doorway to Portuguese* (1957), a collaboration with Brazilian artist Aloísio Magálhaes. Magálhaes later recalled the process:

> Sometimes I had to control Gene a little bit because of that fantastic thing with him that he treated the technology like a brush. He was never interested in the fact that the sheets would be reproduced many, many times. Instead, he was always introducing new things. He was forever changing a plate or introducing a new element to the offset process right in the middle of a run. He treated a high, sophisticated technology with complete liberty, complete freedom. His use of the medium was paradoxical because he kept on making changes even to the point of going against the technology. He used the technology of offset reproduction as a tool for making unique images out of materials and methods that had nothing to do with the usual materials and methods of the technology.[157]

For Feldman, offset printing was not only the transparent medium of commercial printing, but also a malleable and inherently fluid art medium in league with photographic imagery. The printing process was itself an art. Feldman improvised at the press. He printed on waste sheets from his commercial jobs–college catalogues, advertisements, calendars, and brochures–to add an unexpected texture or underlying hue. Feldman's interest in the use of ephemera was shared by Beat and then Fluxus artists. Feldman did not use the halftone screen, preferring instead to layer successive ink colors one atop another, shaping tone rather than following a halftone's artificial screens. Under his eye, photographs surrendered their representational function to reemerge as pattern. He also experimented with "blanket" printing, where in place of a plate the printer laid cut-out shapes under the press blanket; inked, their forms were transferred to the paper like offset collage.[158]

Doorway offered Feldman an entrée into an "[exploration of] the full use of this art form," so that "in the years to come the photo-offset process [could] become one of the important creative tools of an artist." [159] But far from a simple analysis, the contents of *Doorway* multiplied mysteries for the reader. To begin with, each page opening carries words in Portuguese, which to most Americans appear as teasing typographical patterns. Even when a reader discovers the

157. *Books by Eugene Feldman* (Philadelphia: Institute of Contemporary Art, University of Pennsylvania, 1977), 7.

158. Alan Fern, in *Eugene Feldman, Prints* (Philadelphia: Philadelphia Museum of Art Print Department and Falcon Press, 1966), n.p.

159. Colophon, Eugene Feldman, *Doorway to Portuguese*, n.p.

English translations at the back of the book, their meanings reveal only associative fancies, like poetic Rorschachs in response to unidentifiable images. Line splashes into abstraction in a palm leaf directly exposed to the plate, in a roller's impression, or from drawing on glass exposed to the plate. Compared to line and shape, color appears sparingly, as inflection or as a means to balance a few sans-serif words against forceful graphics on a predominantly black and white page.

The title page of *Doorway* is dominated by an image that looms over the type, its shapes created from a—greatly enlarged—photograph of a government building in Rio de Janeiro. Across another page spills a striated, crumpled surface like a rockface; its text, "passaro de pedra" (stone bird), suggests a paradoxical heaviness in flight. Only at the colophon is the image source revealed as a drawing "using aluminum foil." Feldman's striking pages also resulted from his choice to ignore the limits inherent in the single page and the gutter except as boundaries to cross. Within the two-page spread, he interrelated white and black space, shape and texture, and large serif capital letters with small, sans-serifed words and phrases. Each page opening was radically decentered, as in the page described above, where a capital "P" stands crisp against a white vertical band, the Portuguese phrase below it, all elbowed into a corner by a rocky landslide.

Feldman generally made books in collaboration with another artist or a writer. *West Side Skyline* (1965, fig. 29) is the only book that carries his name alone, and the only book of his that is purely visual. It is extraordinarily long—19 feet long by 17.5 inches high—as if to suggest that Feldman literally could not let go of it; he wanted to surround himself with the book, to embrace the New York City skyline. To make it, he photographed the cityscape successively, moving his camera along the horizon line while releasing the shutter, as one would construct a panorama view. The skyscraper shapes repeat, barely discernible, in the blacks that are printed repeatedly above the skyline, to comprise the brooding sky overhead.

Feldman retained a modest art world profile in his twenty years of work. His prints and books showed regularly, most often in Philadelphia but also in New York and elsewhere. His dense, repetitive imagery and patterned abstractions later led José Gómez-Sicre to identify his work as a precursor to Op and Pop Art.[160] Feldman's death in 1975, just at the inception of the rise of the multiple bookwork, impeded wide recognition of his influence beyond the later generations of offset book artists who respected his work.

During Feldman's career, offset lithography and photography gained ground in the business world. In 1950 letterpress still continued

160. José Gómez-Sicre, in *Eugene Feldman, Prints*. Other resources on Eugene Feldman include Peter Brattinga, "Eugene Feldman's Creative Experiments in Photo-Offset Lithography," *Artist's Proof*, no. 4 (1962); and Louise Sperling and Richard S. Field, *Offset Lithography* (Middletown, Connecticut: Davison Art Center, Wesleyan University, 1973).

FIG. 29. [CP4] Eugene Feldman.
West Side Skyline.
17 1/2–inches x 19–feet (opened)

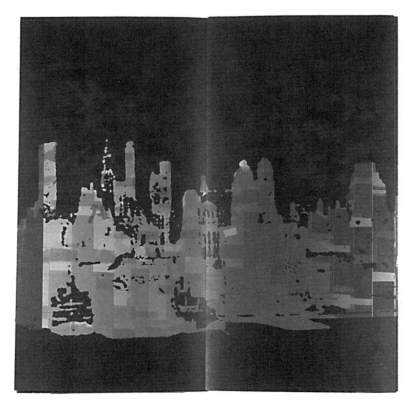

as a viable printing option, as it adapted to higher speeds and color printing. But offset, having been improved during World War II, quickly made inroads into commercial printing, and huge web presses carried continuous rolls of paper that rushed over the more durable bi-metallic plates in multiple color runs. Printers could photograph a page and print from camera-ready copy rather than rely upon electrotyping or metal composition. Blurriness still marred some unprofessional camera-ready work, but the efficiency and savings of photocomposition over electrotyping contributed to its growing popularity.

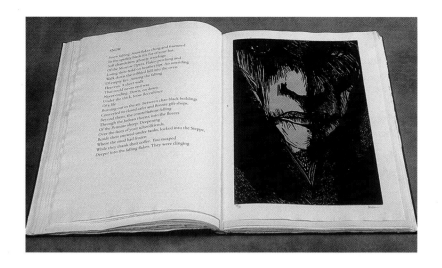

CP1. (left)
Leonard Baskin.
Capriccio

CP2. (below)
William Morris.
*The Works of
Geoffrey Chaucer*

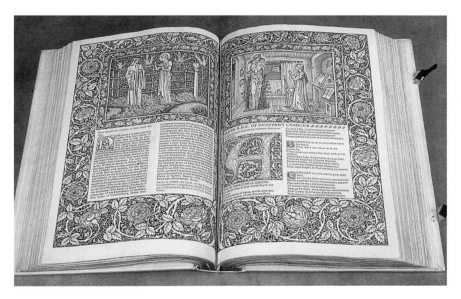

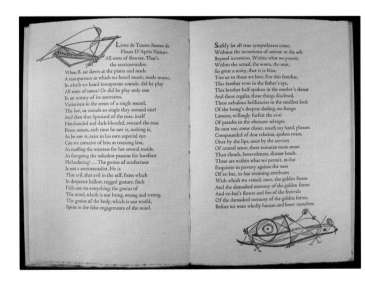

CP3. (right)
Harry Duncan.
Esthétique du Mal

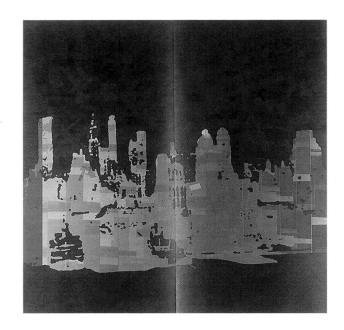

CP4. (left)
Eugene Feldman.
West Side Skyline

CP5. (below)
Conrad Gleber.
Chicago Skyline

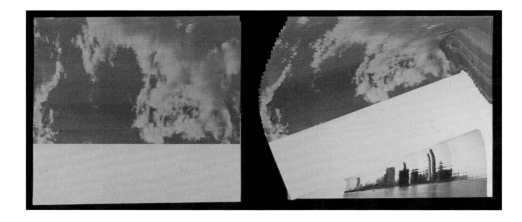

CP6. (right)
Claire Van Vliet.
Sun, Sky and Earth

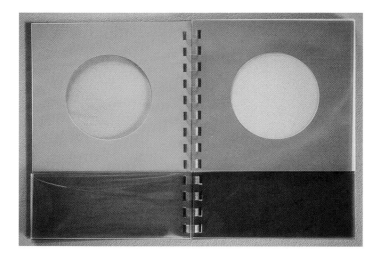

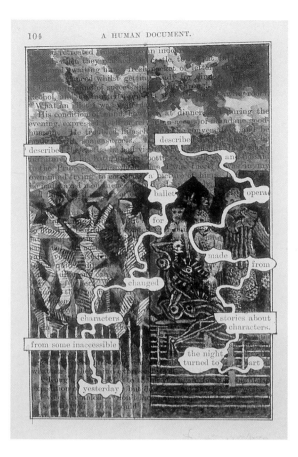

CP7. (left)
Tom Phillips.
A Humument

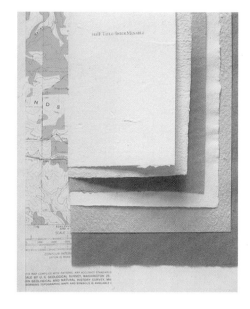

CP8. (right)
Walter Hamady.
The Interminable Gabberjabbs

CP9. (below)
Hedi Kyle.
April Diary

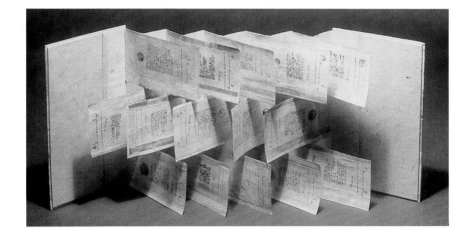

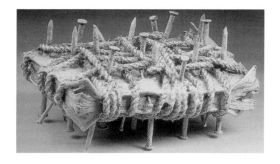

CP10. (above)
Barton Benes.
Censored Book

CP11. (right)
Richard Minsky.
Geography of Hunger

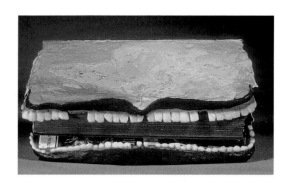

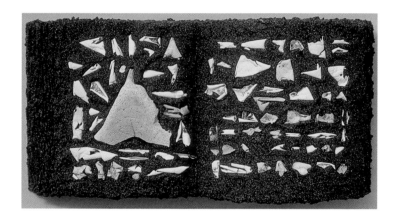

CP12. (above)
Basia Irland.
Endangered Wilderness Series: Costa Rica; Black Sand and Tortoise Egg Shells, Vol. I

CP13. (left)
Gary Frost.
Tracts of Moses David

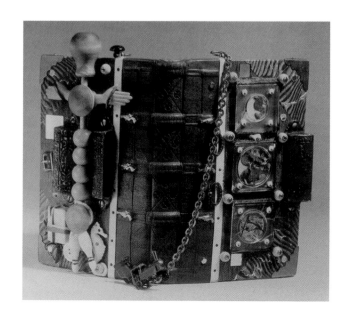

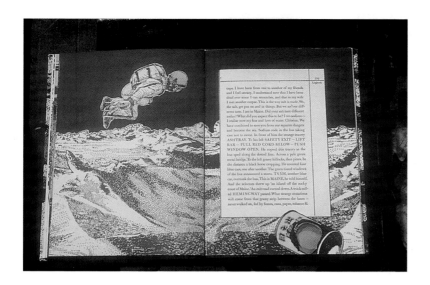

CP14. (left)
Frances Butler,
Alastair Johnston.
Logbook

CP15. (below)
Todd Walker.
*for nothing
changes...*

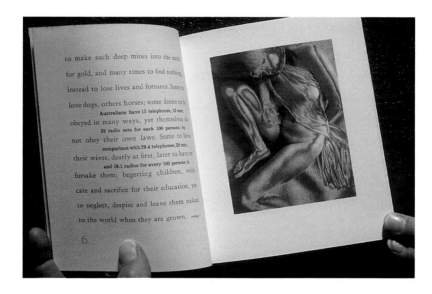

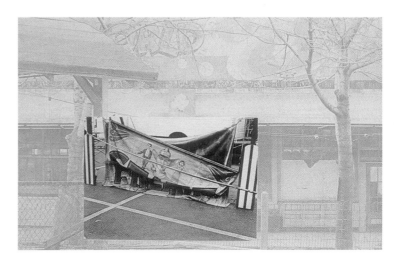

CP16. (right)
Syl Labrot.
Pleasure Beach

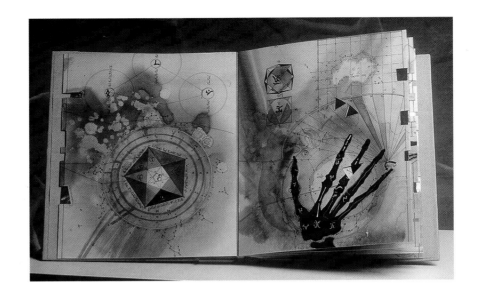

CP17. (right)
Timothy C. Ely.
*The Open Hand
Discovers*

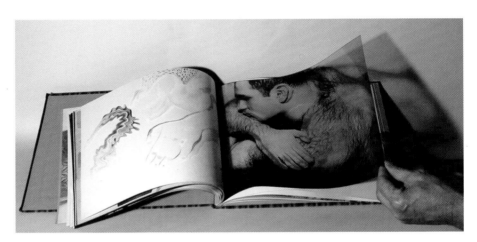

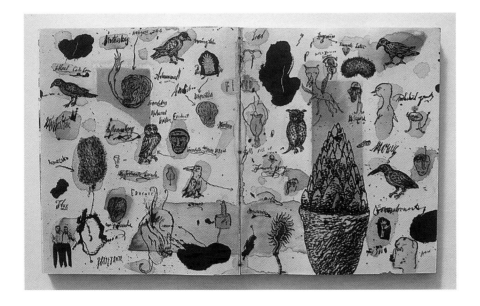

CP18. (above)
Keith Smith.
*A Change in
Dimension*

CP19. (left)
Henrik Drescher.
Too Much Bliss

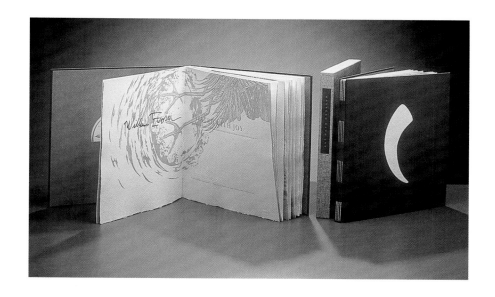

CP20. (left)
Robin Price.
Ravaged with Joy

CP21. (below)
Claire Van Vliet.
Aura

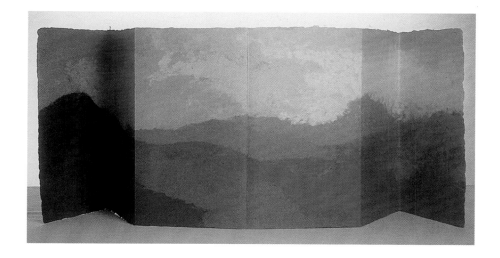

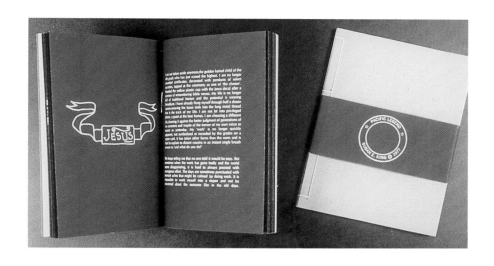

CP22. (left)
Susan King.
Pacific Legend.

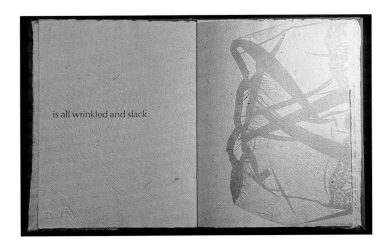

is all wrinkled and slack

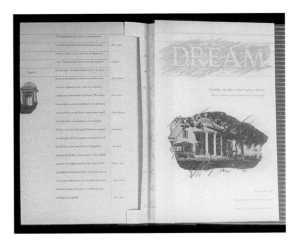

CP23. (above)
John Risseeuw.
The Politics of Underwear

CP24. (left)
Susan King.
Lessonsfrom the South

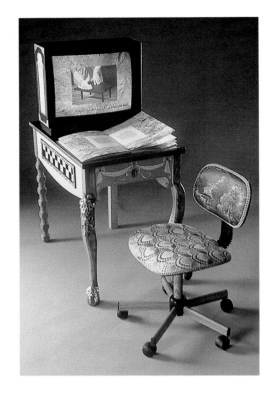

CP25. (right)
Karen Wirth, Robert Lawrence.
How to Make an Antique

BOOKS FOR OUR TIME

The book designer of today conceives of the book as an extra-dimensional form existing in time as well as in space. The various parts are not merely consecutive but continuous, and their relative position in time is considered in the design. The unprinted area of a page is conceived as space, rather than as background or frame. The whole area becomes a dynamic composition in which every square inch functions, whether covered or not. In such a composition no part can be altered without necessitating a revision of the whole.[161]

—MARSHALL LEE, *BOOKS FOR OUR TIME* 1951

Although a history of typography is beyond the scope of this discussion, the influence of modern typography should be noted because it demonstrated a new way to conceive of type and pictures on the page. Modern typography entered the United States from Europe through the graphic design community. A few Americans helped in its dissemination, such as Paul Rand, who visited Europe in the late-1920s. Journals and publications also helped, including the anthology *Circle: The International Survey of Constructivist Art* (1931), which published the first English translation of *The New Typography,* by Jan Tschichold. European émigrés, however, exerted the greatest influence, arriving in the 1930s to work as designers and educators. They carried with them the ideas of the early avant-garde as promulgated by El Lissitzky, László Moholy-Nagy, and others.[162] These émigrés viewed the designer as no less than an intermediary between industry and art whose designs could improve society.

Only after World War II, however, were modernist design principles championed for American book design. One occasion was *Books for Our Time,* an exhibition in 1951 at the New Art Circle gallery in New York, under the auspices of AIGA. In a catalogue essay, Marshall Lee promoted the Bauhaus style (New Typography was a related style) for the use of new technologies and materials (photography, offset printing, coated papers, color), in designs that responded "to the significant influences of modern art."[163] These designs welcomed a vigorous if not dominant role for visual material, and used "typography [that] respects the intrinsic design instead of historical, but graphically insupportable, classification."[164] So, which books illustrated the organizers' manifesto? Not surprisingly, most of them embraced a modern, sleek, image-dominant look similar to that of magazines, with sans-serif type and photographs on coated paper organized into columns and highlighted by bold headlines, bullets, bars, and ruled lines that sought graphic contrast instead of balanced restraint. The modernist designers did not completely ignore

161. Marshall Lee, ed., "What is Modern Book Design?" in *Books for Our Time* (New York: Oxford University Press, 1951), 18.

162. In fact, Moholy-Nagy himself arrived (with Gyorgy Kepes of Budapest) to transplant Bauhaus principles onto U.S. soil in the New Bauhaus school of 1937 in Chicago. See Hans M. Wingler, *The Bauhaus: Weimar, Dessau, Berlin, Chicago* (Cambridge, Massachusetts, and London, England: The MIT Press, 1969). Lorraine Wild notes that modernist design was also taught in the U.S. at Black Mountain College from 1933 to 1956 and at Yale University in the early 1950s, as well as at the New School for Social Research in New York City. "Europeans in America," in *Graphic Design in America: A Visual Language History* (Minneapolis: Walker Art Center, 1989).

163. Lee, *Books for Our Time,* 18.

164. Ibid

77

the wider book world; they also included a few books that used roman type, such as *Time Machine* (1931), designed by W. A. Dwiggins, and even Harry Duncan's *Esthétique du Mal* (1945) appeared, without comment on its new traditionalist typography or letterpress printing.

The extravagant claims by Lee and others was more a case of wishful thinking than true book-design dominance. Advertising seemed the more natural home (at least in America) for such sleek, "typofoto" designs. Eventually many multiple bookworks displayed an assertive page created from typographical contrast and photographic immediacy, such as Andy Warhol's *Index* (Book), in 1967. Beyond graphic design, however, in the early twentieth century American trade book design and fine printing remained largely unaffected by modernism. Restraint and readability still ruled the printed page. When Joseph Blumenthal described this period in *The Printed Book in America* (1977), Lee and the European émigrés received scant (if complimentary) notice.[165] Historian Robin Kinross later agreed that, "the new typography was...fed into the world of American corporate culture, without much effect on existing printing trade practice, nor on the world of the traditionalist typographers."[166]

<div style="margin-left:2em">

165. Blumenthal, *The Printed Book in America,* 138.

166. Kinross, *Modern Typography,* 111.

</div>

THE ARTIST AS INDEPENDENT PUBLISHER

No longer is it possible for modern man, individually or collectively, to live in any exclusive segment of human experience or achieved social pattern....There are no more remote and easy perspectives, either artistic or national. Everything is present in the foreground.[167]

—MARSHALL MCLUHAN 1951

Modern graphic design appeared in an America transformed by a booming post-war economy, which in turn propelled an unending stream of advertising into the foreground of daily life. With that stronger economy, the printing industry's locus of power shifted away from publishing and into a burgeoning advertising industry eager to promote America as a global center of innovation and growth. This was an environment foreign to the niceties of fine printing. It was a visual environment transformed by advertising, movies, and then television. But in its midst, a new kind of independent artist-publisher emerged. Some of the factors that contributed to this growth in independent publications were identified by Marshall McLuhan in *The Mechanical Bride* (1951). In the book, McLuhan analyzed advertising to educate consumers to the industry's subliminal messages (which he termed its commercial "folklore") in order to "assist the public to observe consciously the drama which is intended to operate upon it unconsciously."[168]

<div style="margin-left:2em">

167. Marshall McLuhan, *The Mechanical Bride: Folklore of Industrial Man* (New York, Vanguard Press, 1951), 87.

168. Ibid., v.

</div>

McLuhan identified two shifts underway. First, assuming that the dominant means of communication affected how a society perceived itself, a shift in a communication vehicle radically altered society's values. Second, technology had effectively dissolved social and geographical boundaries, and so, "As the unity of the modern world becomes increasingly a technological rather than a social affair, the techniques of the arts provide the most valuable means of insight into the real direction of our own collective purposes. Conversely, the arts can become a primary means of social orientation and self-criticism."[169] McLuhan's books were read by a public eager to understand and embrace the change brought with new technologies, even as society was growing increasingly aware of technology's own mechanisms for communication and coercion.

What effect did this media revolution have on the artist's book? McLuhan's empowerment of the artist to direct media toward his or her own creative ends supported a burgeoning interest in independent publishing. Artists increasingly put printing, pictures, and type together to produce books, pamphlets, and journals. The range of production was enormous. For example, *Wild Raspberries* (1959, fig. 30), by Andy Warhol, wittily targeted the collectible book market. It emulates an illustrated nineteenth-century French cookbook, but only at first glance. Within it, Warhol's drawings accompany Suzie Frankfurt's amusing faux recipes for Pop meals such as "A and P Surprise," made with a sponge cake bought at the A and P store, and "Seared Roebuck," baked with a saddle of roebuck and served with stewed Macintoshes.

Warhol executed his simple "blotted line" drawings like a monoprint: he copied a pencil sketch in ink onto tissue and pressed the still-wet tissue onto watercolor paper.[170] Then, Warhol's (non–native speaking) mother gamely copied out the covertly risqué captions which sometimes emerged amusingly altered from her inadvertent misspellings. Along with the blotted line technique, Warhol used rubber stamps, stencils, offset-printing, and silkscreen. He and his friends often hand-colored the books, but their work is stripped of individual emphasis, in a strategy that neatly circumvents a fine art focus on gesture or on the individual mark. Ironically, this parody of

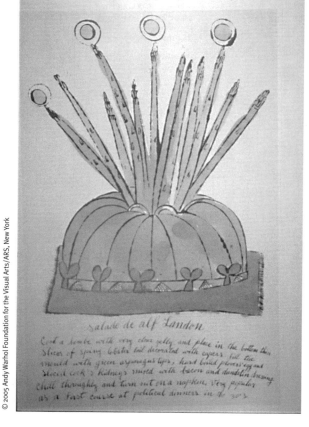

FIG. 30. Andy Warhol. *Wild Raspberries.* 12 x 7½

169. Ibid., 87.

170. Rainer Crone, ed., *Andy Warhol: A Picture Show by the Artist* (New York: Rizzoli, 1987), 12. See also Andreas Brown, comp., *Andy Warhol: His Early Works 1947–1959,* (New York: Gotham Book Mart Gallery, 1971). Warhol's slick graphic style did not appear until later.

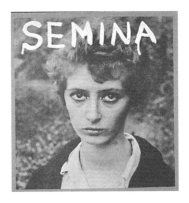

FIG. 31. Wallace Berman.
Semina.
Dimensions vary.

the collectible book did not sell; *Wild Raspberries* was given away to friends.

In striking contrast to *Wild Raspberries, Semina* (1955–64, fig. 31) by Wallace Berman, reflects the flickering emanations from the avant-garde jazz world along with the explorations of·sex and drugs that were part of the Beat culture. Although a journal, *Semina's* design and production foreshadows the idiosyncratic nature of independent publishing in the 1960s. The collaged, all-over page treatment may also reflect the admiration that the Beats held for William Blake, the Symbolists, and the Surrealists. The materials of *Semina* convey a non-precious immediacy. Berman used papers that varied from news-print, acidic cover stock, kraft papers, and imitation parchments, and made collages that incorporated printmaking and the Verifax, an early copier.

The method of printing *Semina* (on a small table-top platen press), as well as its presentation, resulted from limitations in time, money, and materials, but it also represented an ephemeral aesthetic that eschewed the slick finish of mainstream art and publishing. Berman mailed the 200 to 300 copies of the journal to friends and other art people, free, an offering in a spirit akin to Fluxus or mail artists—in an act that demonstrated that his aesthetic was literally not for sale, in direct opposition to the intent of the early "Factory" productions of Warhol. Limited, yet nonconformist, "political" in its marginalized content and distribution, free-spirited and even rude in its intermedia eccentricities, *Semina* reflected the spirit of the alternative publishing movement of little magazines and small presses, allied with the handwork of some West Coast printers.[171]

171. Little magazines perenially battled precarious financing, small subscription lists, and short lifespans. Only a few could be viewed as artist-driven publications, like *Semina.* Although these journals were not artists' books, they acted as conduits for cutting-edge art and literature. See *The Little Magazine in America: A Modern Documentary History,* Elliot Anderson and Mary Kinzie, eds. (Yonkers, New York: Pushcart Press, 1978); and Howardena Pindell, "AlternativeSpace: Artists' Periodicals," *The Print Collector's Newsletter* (September-October, 1977): 96–109, 120–21. Small presses also generally followed a literary bent, but the Jargon Press of Jonathan Williams was an exception. See Steven Clay and Rodney Phillips, *A Secret Location on the Lower East Side, 1960–1980* (New York: The New York Public Library and Granary Books, 1998).

Another emblematic figure in alternative publishing was d.a. levy of Cleveland, Ohio, a "printer, publisher, writer, artist, guru," according to Marvin Sackner (Sackner email to the author, August 31, 2003). The prolific Levy published in mimeograph, silkscreen, and letterpress printing under several imprints, includ-ing Renegade Press (later, 7 Flowers Press). Much of his own writing was concrete poetry. Levy was arrested on charges of distributing obscene material, and, even as his supporters organized in his behalf, he committed suicide in 1968, at the age of twenty-six.

PHOTOBOOKWORK PRECURSORS

Photographic imagery appeared in a growing number of offset printed books, and some of them, whose designs engaged the book form as an expressive entity, were later called photobookworks, as noted earlier. Photography was developing its own artistic character in early-twentieth-century America. Alfred Stieglitz founded the Photo-Secession society in 1902 in order to promote photography as a means of pictorial expression, an art medium where handwork on negatives and prints was acceptable. Another photographic aesthetic comprised "straight photography," which concentrated on the basic properties of camera, lens, and emulsion. Photographers adapted the straight approach to serve their own aesthetic sensibilities, as in the pictures of Paul Strand from the 1910s and 1920s, that could capture a passerby on the street, or organize a rural scene around the pattern of a picket fence.

Although the history of photography is not central to this discussion, mention should be made of books by four photographers—Walker Evans, Weegee, William Klein, and Robert Frank—that prefigure some of the content and the design strategies that diversified further in the photobookworks of the 1960s and 1970s. In *American Photographs,* the pictures of Walker Evans focused on (and so elevated) America's architecture, its anonymous workers, and its everyday objects. His modernist eye could transform a forgettable, hand-painted rural sign into a universal graphic record of human ephemerality. In 1942, books that carried straight photography imbued with a documentary stance had multiplied to the degree that Elizabeth McCausland identified documentary photographic books as a genre for her article in *The Complete Photographer.*[172]

Two early photobookworks used image and text in a manner that departed dramatically from a conventional pairing of image and caption. Photojournalist Weegee created the tabloid-style *Naked City* (1945), about the street life of New York City. The design integrates documents used in policing the street, and photographs starkly lit by the new flash bulb. Weegee himself is present in the voice of a streetwise reporter. He places readers in the moment, behind the camera, and lets them gawk at the riches and privations of city life.

About ten years later, the caustic *New York: Trance Witness Revels* (1956) by William Klein followed *Naked City* in artistic intent. A filmmaker and painter, Klein returned to New York from Paris after World War II, and then, disheartened with the United States, moved back to France and assembled the book. *New York* reflects that self-

172. Elizabeth McCausland, "Photographic Books," *The Complete Photographer* 8, no. 43 (Nov. 20, 1942): 2783. For more on McCausland's article, see Sweetman, "Photobookworks: the Critical Realist Tradition."

imposed isolation in its parody of a travel book whose grainy photographs and distorted views advertise a place that no one wants to visit. Even so, it is hard to resist a book whose pamphlet insert literally reaches out to the reader in display type that cries out, arrow pointing: "This way to Heaven FREE" and, "There is only *one* New York," even sporting a Good Housekeeping seal. This elegy to a culture lost to commercialism was published in Great Britain, Italy, and France—not in America. Klein and Weegee reconfigure the photographic book into a kind of interpretive documentary where content and form conspire to deliver a social critique.

Robert Frank, a Swiss-born photographer, targeted just those inequities that he found in the America of the 1950s. Frank won a Guggenheim Fellowship that funded a road trip across America; from that trip he produced *The Americans* (1959). Frank inherited Walker Evans's uncompromising eye, and chose to picture the reverse side of America's promise. His framing appears casual, his subjects often in shadow, as if photographed on the move, like the immediacy of cinema verité, where portable cameras relay a spontaneous sense of real locales.

Alex Sweetman places *The Americans* into an artist's book perspective, as "a book addressed to the culture of the book, taking its place alongside others, in the classic photobook tradition." [173] Brief captions face Frank's pictures in a conventional photobook presentation, but (as in Walker Evans's *American Photographs*) the content and sequencing of the pictures respond to one another throughout the book. In the 1960s, a younger generation of photographers followed Frank's lead in attempting to reveal to America a truer picture of itself. Books by Walker Evans and Robert Frank delineate the powerful role that the sequential book could play in structuring relationships between pictures, and their books were studied by the emerging photobookwork artists. The books by Weegee and William Klein offer a different vision of books, where a more aggressive voice could be created from pictures, text, and "found" content or structural invention.

173. Sweetman, "Photobookworks: the Critical Realist Tradition," 199.

THE SCULPTURAL BOOKWORK

In France, the young artists of any generation always act as grandsons of some great man—Poussin, for example, or Victor Hugo. They can't help it. Even if they don't believe in that, it gets into their system. And so when they come to produce something of their own, the tradition is nearly indestructible. This doesn't exist over here. You really don't give a damn about Shakespeare, you're not Shakespeare's grandsons. So it's a better terrain for new developments.[174]
—MARCEL DUCHAMP

CORNELL AND DUCHAMP: IMAGINED TERRAINS

Unlike a framed picture on a wall, photographs in a book did not just present views of a world, but they built a world through picture after picture, on page after page. Some artists used the photograph as "found" material, pasted into a box or other container. As content extricated from a former context, photographs aroused in a viewer a mix of curiosity, nostalgia, and even a sense of loss.

The first of three progenitors of the American sculptural bookwork was Joseph Cornell, who excavated vast imagined terrains within the enclosed confines of boxes and books. In these assemblages he often incorporated photographs as well as pages from "found" books. The displacement of page and picture sets them adrift in the context of Cornell's private narratives.

For example, in his Untitled (*Paul and Virginia*) of ca. 1946–48, Cornell papered a Victorian shadowbox with pictures and book pages. In encountering the piece, the viewer gazes into a mirrored door, and, thus committed, opens it to see Paul carrying Virginia across a stream amidst collaged text pages and pictured evidences of their woodland tryst. Across from the couple, robin's-egg blue boxes within cubbyholes frame a peephole to reveal nested eggs. Cornell relied upon collage to construct these idylls. He admired Europe's avant-garde, in particular the collage novels of Max Ernst. Cornell and Marcel Duchamp, who met around 1934, shared a Dadaist "love for sudden juxtapositions of perfectly ordinary and even vulgar objects." In fact, Cornell had actually helped with the assembly of some of Duchamp's *Boîte-en-valise.* But Cornell's sensibility avoided a Dadaist edge in his own work, and he instead chose to evoke mystery or an odd reverie.

Like Duchamp, Cornell also altered books. Cornell's earliest altered book (ca.1936–40) perches a book on a pedestal along with incongruous companions: a thick twisted wire, from which hang a string and a ball that touch the book, their outlines suggesting a triangular space. The spine of the book reveals its subject to be an infantry

174. Quoted by Tomkins, *Off the Wall,* 13.

officer's memorial, suggesting a Duchampian neutrality. Like the translation of line into form and space in a Giacometti sculpture, the neutralized book shifts into shape, but its shut-away contents add a touch of melancholy to the playful construction.

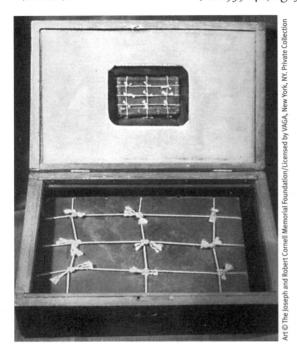

FIG. 32. Joseph Cornell. *Untitled* (Book Box). 3³/₈ x 9 x 6¹/₁₆

Art © The Joseph and Robert Cornell Memorial Foundation/Licensed by VAGA, New York, NY. Private Collection

Cornell later took the altered book off the pedestal and boxed it (ca. 1939–40, fig. 32). The nest reappears here, its progeny not an egg but a book, set into the lid like a miniature mirror image of the book below. Both books wrapped, pre-Christo, their anonymity is secured with knotted cords that deny access and create a decorative (if obsessive) grid that resembles a readymade by Sol LeWitt. In 1945, Cornell actually cut into the book block, transforming a suggestion of constriction into one of overt violence. The altered books of Cornell were not exhibited as often as his boxes, and in fact he did not continue to alter books after the 1940s. Perhaps cutting into them proved too distressing for this self-professed bibliophile, the means of altering so much more invasive than Duchamp's passive destruction of *Unhappy Readymade* through the quiet erosions of weather.

Cornell and Duchamp did not seem to relish their bookish desecrations. But if Cornell's bookworks languished, his other works gained a cult following, despite, or perhaps because of, his reclusiveness. Artists who shared his interests certainly knew of his work by the late 1930s (at least in New York), and over time bookwork artists easily applied his techniques.

175. *Life*, April 28, 1952. 175.

176. Surrealist Mary Reynolds (1891–1950) also deserves note as a prolific American artist of the early twentieth century who invested her bindings with wit and a keen sense of the unexpected. Reynolds studied binding with Pierre Legrain in the 1920s, and responded to Legrain's innovative use of unconventional materials, including reptile skins, precious gems, and metals. Reynolds, a confirmed Parisian, was Marcel Duchamp's lover for two decades, participating in the surrealist circles in Paris and in New York, where she lived for a time at the end of World War II. She occasionally

Another artist crucial to the development of the sculptural bookwork was, once again, Marcel Duchamp, who arrived in New York in 1915 on the heels of the scandal generated by his painting *Nude Descending a Staircase* in the Armory Show. His U.S. visits and his residence from 1942 onward disseminated a varied and iconoclastic influence. His major body of work had been completed, as far as the public knew, between 1912 and 1923, after which he supposedly retired to play chess—only decades later did he reveal his continuing work on the installation *Étant donnés* (1946–66). Despite his low profile, the activities and influence of Duchamp continued to affect American artists, including Cornell. In addition to his involvement in little magazines, Duchamp intermittently reemerged, with his *Boîte verte* (1934), and *Boîte-en-valise* (1936–41, fig. 21). Into the 1950s, Duchamp periodically rereleased his readymades, and enjoyed a recognizable

profile in popular culture, seen in a spread in *Life* magazine in 1952 that featured the *Boîte-en-valise* as his "One Man Show in a Suitcase."[175] If anything, the persistent presence of Duchamp's works in the public eye argues for their influence over the sculptural bookwork.

The infamous catalogue cover that Duchamp made in 1947 must be mentioned as well, as a "nurturing" influence for the altered bookwork. Produced for the 1947 Exposition Internationale du Surréalisme in Paris, which was organized by Duchamp and André Breton, Duchamp purchased latex rubber "falsies," to which he delicately added color, and, working with Enrico Donati, adhered a falsie onto each catalogue's black velvet cover. The catalogue is housed in a box labeled *Prière de Toucher* ("Please Touch"). Duchamp's simple yet shocking transformation of a book, recognized as an object that dictates touch, confronts the viewer with a presumed intimacy even as he or she struggles with varying degrees of attraction and repulsion at the disengaged breast which also, ominously, implies mutilation.[176]

collaborated with Duchamp, as in their binding in of Alfred Jarry's *Ubu Roi*, in 1935. The book's front and back covers are defined by large U's, the two halves joined by a narrow B that served as the spine of the book. Reynolds continued binding until the chaos of World War II forced her relocation to New York for the duration of the war. After her death, Reynolds's brother donated her bindings to establish The Mary Reynolds Collection at the Art Institute of Chicago, where he served as a Trustee. In 1956 the Art Institute published a catalogue of the collection, Hugh Edwards, comp., *Surrealism and Its Affinities: The Mary Reynolds Collection* (Chicago: Art Institute of Chicago, 1973).

BOOK AS ASSEMBLAGE

What Johns loved in his objects is that they are nobody's preference; not even his own.[177]
—LEO STEINBERG

The spirit of the readymade, which could inhabit and transform the everyday book, appeared elsewhere in the American art scene. That readymade spirit was recognizable in *Book,* an early sculptural bookwork by Jasper Johns (1957, fig. 33). Johns exhibited the frozen pages of *Book* amidst the flags, targets, numbers, and alphabets that populated his first solo exhibition at the Castelli gallery. By the end of the exhibition, all but two of his works had sold. The enthusiastic response to the show was all the more astonishing in a time when Abstract Expressionism still ruled the New York art world. In 1956 Johns started to attach everyday objects to canvas, and then painted the object and canvas to form a single, newly convergent surface. He called the works paintings (rather than sculpture), due to their wall orientation and his transforming brushstrokes. In *Book* those fastidious strokes cover the text and all other identifying marks of the opened book with a creamy, semi-translucent skin of encaustic, a pigmented wax that is heated and applied when soft, and then hardens.

From the readymades of Duchamp to the "bound" and nested alterations of Cornell, the book had been increasingly overtaken by artistic incursions. With Johns's brushstrokes, all content, photographic or textual, has been erased, as book confronts fine art, and both painting and book emerged transformed, newly indissoluble in

177. Leo Steinberg, "Jasper Johns: the First Seven Years of His Art," *Other Criteria: Confrontations with Twentieth-Century Art* (New York: Oxford University Press, 1972); reprinted in *Jasper Johns, 35 Years, Leo Castelli,* Susan Brundrage, ed., (New York: Abrams, 1993), n.p.

178. Johns states that when he created his found-object works of the 1950s he was not yet aware of the readymades of Duchamp, although Roberta Bernstein suggests that "he was probably familiar with the tradition of assemblage through the work of Cubist, Dada and Surrealist artists, including Picasso, Schwitters, Miro and Cornell." [31] Bernstein, *Jasper Johns' Paintings and Sculptures, 1954–1974: "The Changing Focus of the Eye"* (Ann Arbor, Michigan: UMI Research Press, 1985), 60.

their forced cohabitation. Before that time America had never encountered a book so exposed and yet removed.[178]

The bright and unreal monochromes of *Book* differentiates its parts: red pages, yellow foreedge, blue binding. It is small (10" x 13") within its boxed frame. Opened at the center, the book's symmetrical, undulating surface mimics the outstretched wings of a bird or a cresting wave, and yet at the same time the book's shape asserts its unassailable identity. Like the altered books of Cornell, the transformation of *Book* effected an odd enshrinement in which Johns displays a devotion to the gesture of an Abstract Expressionist even as his strokes reshape the painting's topography into the sole content of *Book*. In its removal of text, Johns also highlights the dependence of the book on language (and the dependence of the reader on sight) to an almost excruciating degree, as if, in scrutinizing the work, viewers are forced to witness their own failing eyesight. But with the inability to comprehend text, Johns's brushstrokes invite a rediscovery of reading as a purely visual act, one that relies upon an abstract translation from one language into another, both languages comprised of strokes, alphabetic or brushed.

By 1960, bookworks in America had only begun to suggest the emergence of two discrete types, multiple and sculptural. No artist had yet adopted the nomenclature of "book artist," and nonprofit book art organizations were more than a decade away. Fine printers could enjoy a home in the book world, while deluxe and bookwork artists worked largely in isolation from one another. The multiple book-

FIG. 33. Jasper Johns. *Book.*
Mixed media

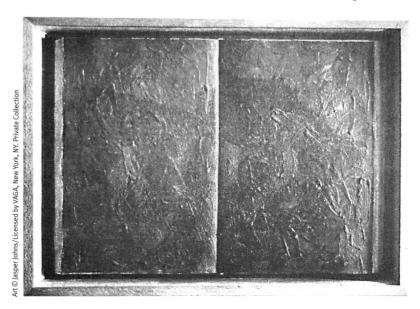

work, still embryonic, was nourished by the fledgling photobook-work's visual narratives, and (more distantly) by New Typography's activation of the page as a graphic field. Two additional ingredients appeared with the innovative use of commercial media, and populist self-publishing, in the painterly printing of Eugene Feldman, and the countercultural journal of Wallace Berman. Their important if largely unheralded efforts did not hint at what soon expanded into a thriving population of mimeo, copier, and offset books. Feldman and Berman deserve credit for claiming the offset press and self-publishing as fit for artistic investigation. These were crucial claims, because they offered another field of activity for offset printing and publishing, away from the world of commerce and in the artist's studio. By this time, American makers of sculptural bookworks had begun to paint, cut, and collage with books, while Europeans were hanging and (soon) burning them. Astonishingly, the 1960s demonstrated that much could still happen to the content and the body of the book.

III

THE 1960S: FERMENT

...Dieter created an exhibition during one month he was [in Philadelphia]—every day he kept adding to it, there was a closing instead of an opening, and everybody at the end of the closing was supposed to dismantle the exhibition and take bits away. I still have a very interesting book he gave me that he did there, that was his more traditional thing of all cut paper, and it was kind of fun for me to see because I'd been working with cut paper images too.[179]

—CLAIRE VAN VLIET

The book as a structure is the Trojan horse of art—it is not feared by average people. It is a familiar form in the world, and average people will take it from you and examine it whereas a painting, poem, sculpture, or print they will not. [180]

— WALTER HAMADY

THE FINE PRESS BOOK

THE JANUS PRESS: A NEW DEMEANOR FOR FINE PRINTING

In the 1960s some fine printers integrated art-making with bookmak-
ing, which resulted in an alternative fine press aesthetic. Two printers—
Claire Van Vliet and Walter Hamady—signaled the changes underway.
From the first, their books were distinctive for their assertive typo-
graphical and visual personalities, which immersed their readers in
whimsy, reflection, and even pathos. Van Vliet and Hamady represent
the artist's increasing involvement with books, on and off campus, as
an alternative lifestyle reflective of the 1960s' desire for independence
and activism.

Claire Van Vliet, trained as a printmaker, was drawn to make
books to present prints in series. Van Vliet printed books as others
had before her—but not by exploring a single, identifiable aesthetic.
Instead, and crucially, Van Vliet approached bookmaking as an artist,
absorbing and improvising with typography, materials, and structures
as the need arose. Van Vliet's books refute the art world's historical
bias against craft. Her books are cohesive aesthetic expressions of
hand production, *and* they also work as art.

For example, in *Sun, Sky and Earth* (1964, fig. 34), when the
reader participates in one cycle—that of paging through the book—
two other cycles are set into play. Van Vliet indicates these other
cycles with a few words: time of day appears periodically in the "sky"
above (morning/noon/evening), and an agricultural cycle is cued by

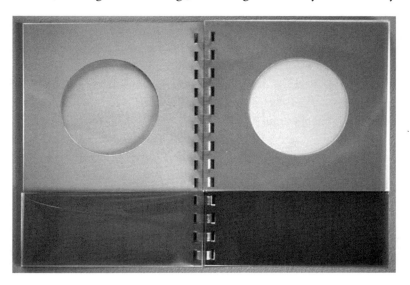

FIG. 34. [CP6] Claire Van Vliet.
Sun, Sky and Earth
7³/4 x 6

179. Author telephone interview with
Van Vliet, February 13, 1997.

180. "Pre/Face, In Lieu Of," in Hamady,
Two Decades of Hamady, n.p.

FIG. 35. Claire Van Vliet.
A Country Doctor.
Typography by James McWilliams.
Sheet size 16 x 12

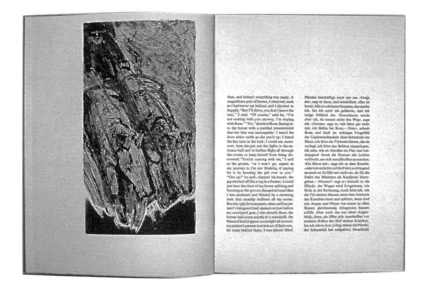

words on the "land" below (growing/harvest/dormant). The cycles are enlivened by color. Van Vliet organizes the transparent pages of colored acetate and cinemoid gels so that the resulting hues alter, page by page, like a changing landscape throughout a day. In addition, since the top and bottom sections of the book can be paged independently, the two together compose a constantly shifting tableau, further compounded by the changing color sequences on the left-hand side that are revealed as the right-hand pages are turned. Van Vliet structures the reading experience of *Sun, Sky and Earth* to evoke the natural world, and the bound structure encourages the reader to enter a contemplative state.

Other books by Van Vliet reveal the more traditional face of her Janus Press, such as Federico Garcia-Lorca's *The Ballad of the Spanish Civil Guard* of 1963, the text printed in Spanish and English, or Van Vliet's Expressionistic paean to *A Country Doctor* (1962, fig. 35), by Franz Kafka. It is *Sun, Sky and Earth,* however, that deserves our attention here, since it alters the reader's experience of the book through its divided pages and unconventional materials, and so represents the changes underway.

In Philadelphia Van Vliet met James McWilliams, who had studied with the respected printer Jack Stauffacher at Carnegie Mellon. McWilliams was the Director of Typography at Curtis Publishing Company. He was also involved in Fluxus (1961–), which emerged out of a group of artists whose anti-formalist acceptance of everyday content and media echoed the interests of Duchamp, Dada, Futurism, and Russian Constructivism. Fluxus was loosely led by George Maciunas, who in turn pointed to John Cage (among others) as an

influence. Cage celebrated chance and the everyday in events such as his 1952 multimedia event at Black Mountain College, in which the musical score consisted simply of "time brackets" to be filled by the participants. Fluxus artists hoped to engage a general audience, rather than the art world clique of critics and collectors, by selling books and other artist publications through mail order (Fluxus "year-boxes," posters, little magazines, and newspapers).

McWilliams and Van Vliet taught at the Philadelphia College of Art, where Fluxus artist Dieter Roth accepted an artist-in-residence position in Fall 1962. In that heady period, Van Vliet remembers visits by Fluxus artists such as Charlotte Moorman and Nam June Paik. Van Vliet, McWilliams, and Roth printed together on the offset press at the school, working with students in an improvisatory investigation of offset printing.

The turmoil of the day fed into bookworks by Van Vliet and McWilliams, such as the Janus Press *Vietnam on a Stick* (1964), *Polyurethane Antibook* (1965), and *Four Letter Word Book* (1964, fig. 36). Their bookwork collaborations reflect a Fluxus celebration of the everyday and of "chance as nature's great forming principle."[181] By the 1960s, the formalist paradigm of Abstract Expressionism was under siege from a number of competing concerns. Joining the assault was Andy Warhol with Pop Art's immersion in consumerist products and pictures; Robert Rauschenberg's juxtaposed detritus of imagery; and, increasingly, anti-war vitriol. In the midst of this chaos that had become the art world, the book was used in every expressive skirmish.

As a period piece, *Four Letter Word Book* represents the growing linguistic interests in the art world of the 1960s, excruciatingly heightened here when "bad" or "inappropriate" language is set into

181. Daniel Wheeler describing the art of John Cage, in Wheeler, *Art Since Mid Century: 1945 to the Present* (New York: The Vendome Press, 1991), 125.

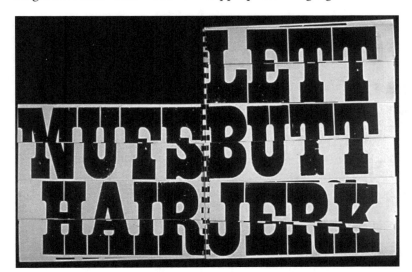

FIG. 36. Claire Van Vliet.
Four Letter Word Book
12 1/2 x 10 1/4

an art or book context. The vigorous, graphically pleasing patterns of the wood type intensify the emotional push and pull between like and dislike. Once the sectioned pages fall into readability, invective shouts out at the reader, who has to negotiate between surprise, amusement, and aversion. The tease continues, as these words collide with non-English other words, all the more titillating for their ambiguity.

Just as children's books invest reading with chance and playfulness, the structure of *Four Letter Word Book* creates in the reader a confused mix of amusement and antagonism. Artists such as Van Vliet and McWilliams recognized that children's book structures invested the reading experience with nostalgia. The presence of nostalgia suggests an unrecoverable past, a sense of loss that might arise with a reader's encounter of such a format from childhood. In *Four Letter Word Book* the sense of lost innocence only intensifies (even if that loss is barely recognized, even subliminal) when the book suddenly reveals its "adult" content.

In 1966, the art department at the University of Wisconsin–Madison hired Van Vliet to teach, on the recommendation of Warrington Colescott, who was leaving on sabbatical. Once on campus, Van Vliet garnered support from the graduate school that eventually resulted in a typographic lab with a Vandercook proofing press, type, and an offset press. Van Vliet innovated further in her second semester with a class on the use of office machines as fine-print media (as she described it).

In that class, student Melissa Gurdus placed copier-printed paper plates on an A B Dick office offset printer to print *Electronic Variations* (1966, fig. 37). The visual appeal of the book is surprising, as it is comprised of fragments from an electrician's language: technical drawings of an engine, the wiring system for a telephone, and an electrical transformer. Gurdus did not use the copier to self-publish pamphlets, as many did in the 1960s and 1970s. Instead, she approached it as a printmaker to collage flat materials and to investigate its signature grainy, high-contrast imagery.

The books and bookworks of Van Vliet remain distinct from the ephemeral Beat and

FIG. 37. Melissa Gurdus. *Electronic Variations* 8 x 100 (when open)

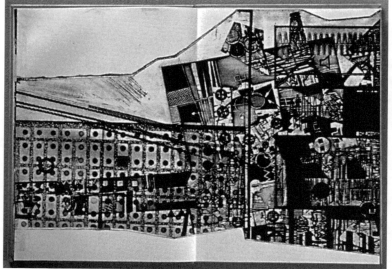

Hippie chapbooks and books of poetry that proliferated in the 1960s "mimeo revolution." Her Janus Press published books committed to an assertive visual presence, whether found in the haunting etchings of *A Country Doctor* or in the graphic variations of the shapes and inking of the wood type in *Four Letter Word Book*. The Janus Press broadens the fine press aesthetic to prize the graphic and material inventions of a book without disregarding its literary and typographical integrity.[182]

While at the University of Wisconsin, Van Vliet served on the search committee that in 1966 hired Walter Hamady to teach drawing, lettering, and typography in the art department. Hamady received a B.F.A. from Wayne State University in Detroit, where he started the Perishable Press Limited as an undergraduate, and received an M.F.A. from Cranbrook Academy of Art. Over time, Hamady exerted considerable influence upon book art as a printer and a teacher. Although Madison never had a formal bookmaking program, Hamady integrated bookmaking into his ongoing teaching. Hamady published his Perishable Press books, many of which incorporated his Shadwell Mill handmade papers, from a studio set up at his home in rural Mount Horeb, Wisconsin. From the first, Hamady modeled the role of poet-artist-printer in books that displayed a mastery of printing in league with an iconoclastic subversion of book design norms. Like Duncan, Hamady published living writers: in the 1960s they included Paul Blackburn, Robert Creeley, Robert Duncan, Loren Eisely, Denise Levertov, and Diane Wakoski. Hamady's playfulness emerges in eccentric, chatty colophons, whose witty expressions reveal him as a sleight-of-hand memoirist guided by a love of food, his children, and other domestic pleasures.

Two early books embody an awareness of handmade paper and subtle color relationships. In *Plumfoot Poems* (1967, fig. 38), the title appears in three lines, as "PLUM-/FOOT/POEMS," a plum-colored hyphen tenderly separating the first word in the otherwise black-inked title page. Touches of brown, red, and purple surface later in the book, and the plum color quietly reasserts itself in the blind-stamped leather spine of the binding. Hamady likes to mix in bits of life's randomness in his books: in collaged maps whose boundaries reconfigure into pattern (as in *The Reardon Poems,* by Paul Blackburn, 1967, fig. 39); in his amusing colophons; and in his incognito appearances. In *Plumfoot Poems,* for instance, Hamady uses a line-cut of a self-portrait photograph superimposed on the reflection from a palm reader's plate glass window on Coney Island, his face overlapping with the psychic's image of a hand.

182. From Madison, Van Vliet relocated to rural Vermont, where she works among the rolling hills pictured in her books, paperworks, and prints. Her story and influence will continue to unfold in chapter 10.

FIG. 38. Walter Hamady. *Plumfoot Poems* 7³/4 x 6

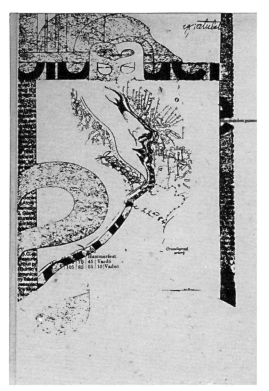

FIG. 39. Walter Hamady.
The Reardon Poems.
Silk screened cover from
a collage by Hamady.

10 x 7

183. Gaskell, "The Bibliographical
Press Movement," *Journal of the
Printing Historical Society* I (1965): 1.

184. Farrell, *Collegiate Book Arts
Presses,* 6. Farrell suggested that,
had Gaskell included other campus
presses, Gaskell could have
identified at least forty presses.

185. H. Richard Archer, "The
Private Press: Its Essence and
Recrudescence," in Archer and
Ritchie, *Modern Fine Printing*
(Los Angeles: William Andrews
Clark Memorial Library, University
of California, 1968), 10.

186. Ibid., 12.

By the 1960s, fine printing included printers with fine arts backgrounds, but they were still in the minority. The restrained page designs praised by Stanley Morison and others remained the ideal of design for many booklovers. In 1965, bibliographer Philip Gaskell noted that fine presses were increasing on campuses in the United States and England, and he located them in libraries and English departments, not in art departments. Gaskell found that, "There is at present something of a boom in bibliographical presses in the universities of the English-speaking world. From 1927 (when the first or them was founded, in America) until 1957, nine such presses were established. In the four years 1960 to 1963, however, another sixteen have sprung up, and more seem certain to follow." [183] Gaskell's numbers reflected presses which curator David Farrell later described as those concerned with the "typographical exposition of works of literature." [184]

Just two years after Gaskell's study, H. Richard Archer discussed a change underway, in a talk at the Clark Library, University of California–Los Angeles, titled "The Private Press: Its Essence and Recrudescence." [185] Archer welcomed the growing interest in fine printing since 1959, but expressed concern that within this "lively, expanding" market there were books that reflected extremes in "artistic printing." Archer tied the growth in artistic (as opposed to typographical) emphasis to Marshall McLuhan, suggesting that McLuhan's influence encouraged printers to embrace "instant culture." Archer despaired that such printers "use jargon, do your best to shock, and [as a result do] whatever is creative [which] may be hasty, confused, and downright vulgar, so long as it attracts attention and makes some money." [186]

Concurrently, letterpress was increasingly being left behind as the business world turned to photocomposition and offset printing. Even so, many commercial printers continued to use hot metal typography for several years, and those used presses often ended up in artists' studios, as Claire Van Vliet asserted: "I got my first press in 1967 [from a trade printer], when letterpress was not an obsolete technology." [187] Both Van Vliet and Hamady printed letterpress on the Vandercook proofing press, which is a flat-bed cylinder press in which a moving flat bed holds the form (with type) while a fixed, rotating cylinder holding a sheet of paper rolls over the form. Then the cylinder is raised, the sheet is removed, and the form is re-inked, ready to print the next sheet. In the 1960s the proofing press was still

considered an "upstart" printing method by Lewis Allen and other printers devoted to the laborious art of printing on an iron hand-press. For the most part, the irrevocability of the technological shift from letterpress to offset in commercial printing did not yet register concern on the increasing number of artists attracted to a relief-printed aesthetic and to the independence of self-publishing. Most fine printers reveled in the more immediate satisfactions of setting up shop relatively cheaply, benefiting from the booming market in used cylinder proof presses and metal type.

Fine printing settled into higher education, and elegant typo-graphical books by Harry Duncan and others continued to be printed. For many booklovers these books represented the best in fine print-ing. Claire Van Vliet and Walter Hamady epitomized a new fine printer, one equally at home with the demands of printing literature as with inventive imagery, materials, and formats. David Farrell's own survey (published in 1982) documented that diversification, as more campus presses found a home in art departments rather than in Eng-lish departments.

187. Claire Van Vliet, "Where We've Been, or Another Turn of the Screw," the author's notes from Van Vliet's presentation (with Terry Belanger), at the Fifth Council of Book Arts Programs Conference, the University of Alabama-Tuscaloosa, February 25, 1999. Betsy Davids made the same point in *Conference Summary: Book Arts in the USA* (New York: Center for Book Arts, 1991), 32. For more on the shift in U.S. fine printing technology, see Gerald Lange, "Edition Printing on the Cylinder Proof Press: A Histori-cal Perspective," *Parenthesis* (May 1999, no. 3): 22–23.

BOOK ART AS AN ALTERNATIVE LIFESTYLE

While campus fine presses multiplied, book art benefited from the rise in popularity of crafts, and the counterculture recognized the satisfactions of handwork. Outside of academia, an increasing num-ber of printers formed informal groups, called Chappels, that met in members' homes. Like the contemporaneous environmental move-ment, the craft movement supposedly stood for both a withdrawal from capitalist society and a participation in a more authentic life's work. *The Whole Earth Catalog*, the bible of the counterculture, in-cluded in its first (1968) edition a review of Marshall Lee's *Bookmak-ing* (1965); that category expanded in the Spring 1969 supplement to include J. Ben Lieberman's *Printing as a Hobby* (1963).

In 1966, public consciousness of the book as a perishable artifact was dramatically heightened with the disastrous Florence flood, as hundreds of students and conservators worldwide rushed to treat damaged books and art. The rise of the mass market paperback at home produced books that cost less, but that suffered from glued spines that cracked apart. The resulting concern with book structure led to a reevaluation of nonadhesive binding and encouraged the inves-tigation of other innovative structures and materials. The profession of the binding conservator emerged, and a few binding conservation initiatives began, notably in Chicago, where Paul Banks established a conservation laboratory at the Newberry Library.

188. Sam Ellenport, "The Future of Hand Bookbinding," *Guild of Book Workers Journal* 31, 1–2 (Spring/ Fall 1993): 40.

Fledgling binders struggled to improve their skills, often operating in small or even solo operations. They occasionally sponsored workshops on technique, although Sam Ellenport reported that, at this early stage, "in most cases the quality of the actual work remained poor."[188] Networking improved in 1962 with the Guild of Book Workers' Journal (its newsletter began in the late 1970s), but several years elapsed before an infrastructure of training and criticism supported quality bookbinding. Commercial hand bookbinding had declined after World War II, due to cheaper machine-made bindings and the postwar economy. By the 1960s, however, a stronger economy generated some commissioned bindings. Occasionally fine binding achieved public notice, as in the show "Contemporary French Bookbinding" of 1965, organized by Polly Lada-Mocarski, which appeared, tellingly, at the Museum of Contemporary Crafts in New York.

Alongside the growing interest in hand binding, hand papermaking generated renewed interest among a few deluxe and fine printers, thanks to efforts by Dard Hunter and Douglass Howell, among others. The printmaking ateliers of William Hayter and Tatyana Grosman (and later Ken Tyler) sought out handmade papers. From 1964 to 1968 Laurence Barker (who had studied with Howell) taught papermaking at Cranbrook Academy to Walter Hamady and Aris Koutroulis (with whom Kathryn Clark of Twinrocker later studied). Printer Henry Morris inaugurated his Bird and Bull Press in 1961 with the first of many titles on the subject, *Papyrus,* by Father Imberdis. Few printers made their own paper, however, and Henry Morris himself did not open his own paper mill until 1978. Walter Hamady provides the strongest early example of an integrated printing and papermaking effort through his Shadwell Mill, which he founded in 1966 after his move to Madison, Wisconsin, to teach.

FINE PRINTING ON CAMPUS

Harry Duncan began to teach and print in the School of Journalism at the University of Iowa in 1956, and his books soon epitomized the best in American literary fine printing. Duncan's *Four Early Stories by James Agee* (1961, fig. 40), for example, is an ambitious book of prose in handset type accompanied by the intaglio etchings of Keith Achepohl. Its design demonstrates Duncan's approach to problem solving. The etchings appear full-page, as in the first story, or they occupy the upper half of a page, as seen here, their width matched to the double columns of text.

189. Irving Sandler, *American Art of the 1960s* (New York: Harper and Row, Publishers, 1988), 82–83.

Like bridging a river, Duncan crosses the gap by running the first sentence in small caps across both columns in a subtle Cloister Old

Style type that sets off the evocative etchings. Duncan animates the typographical texture of the page by replacing "and" with ampersands. At first intrusive, the ampersands season the reading experience by removing the reader from the story, thus enlivening one's progress from story to sign and back again in split-second transitions.

Duncan taught during a rosy economy, with rising student enrollment augmented by new government financial aid programs. Studio art and art appreciation classes multiplied, while out in the community, museum memberships grew and art centers opened to accommodate the expanding interest. Irving Sandler noted that 600 arts institutions were in operation by 1974, over 85% of which opened after 1960.[189] Government patronage began with the National Endowment for the Arts (NEA) in 1965, which acted as a standard-bearer to sanction institutional and corporate arts funding (Harry Duncan received his first NEA grant in 1967, for $10,000). Trade publishing changed course as well. Literacy continued to rise, but the book world lost many family-run publishing houses to corporate buy-outs in the 1960s. Small presses sprang up on the margins of society to fill the void and offer experimental literature to small, devoted audiences.

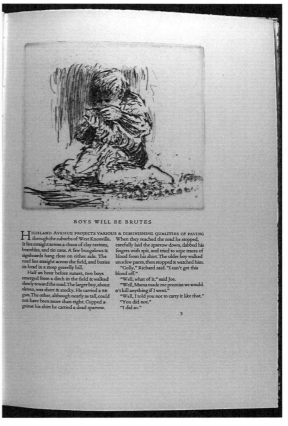

FIG. 40. Harry Duncan.
Four Early Stories by James Agee
8 x 11 3/4

CALIFORNIA'S PRINT ACTIVISTS

Not every fine press book emulated the designs of Harry Duncan or innovated along the lines of Claire Van Vliet or Walter Hamady. Fine printing could also serve countercultural writing printed in the spirit of a small press publisher, as it did with *Dark Brown,* printed by Auerhahn Press in 1961. In it, Michael McClure proclaims in capitals: "CLEAR AS THE IRIS OR MACKEREL. / BREATHE BRIGHT FUCKING AIR!!! / STAR!/CHILD!! / IMAGE."[190] The book's uneven printing quality cannot restrain its visceral literary voice. Its lovely Palatino type, in a (more or less) centered design, is obliged here to pronounce Beat verse, "flowing and billowing from the gut." The book also includes a detailed colophon, in a surprising mix of Beat inspiration and fine press protocol.

The series of printing affiliations by Andrew Hoyem, who joined Dave Haselwood at Auerhahn Press in 1961 and helped to print *Dark*

190. McClure, *Dark Brown*, n.p.

Brown, demonstrates the fluidity of the fine press world. In 1965 Hoyem left Auerhahn to publish independently as Andrew Hoyem/ Printer, and, as was noted earlier, within a year Hoyem entered into partnership with Robert Grabhorn (as the Grabhorn-Hoyem Press), after the Grabhorn Press closed. Grabhorn died in 1973, and Hoyem's shop absorbed Grabhorn's extensive facilities and typefaces. In 1975 Hoyem reemerged, again independent, as the Arion Press. The Arion Press has since distinguished itself by publishing fine press–deluxe book hybrids; its *Moby-Dick* (1979) will be discussed in chapter 11.

Presses (such as Auerhahn) that published Beat writers were the exception in the fine press community. In the 1960s and 1970s, Beat and then Hippie and anti-war poetry appeared in letterpress chapbooks and broadsides across the United States. For some print activists, a countercultural stance, fused with the activism of an independent publisher, prompted them to make books in which message was prized over purist typography. Some of these publishers migrated to offset or copier printing as those technologies became accessible.[191] Other publishers produced books that successfully merged fine printing with contemporary poetry, such as the books by Clifford Burke, and the books by Holbrook Teter and Michael Myers of Zephyrus Image. Hoyem himself published *Howl,* by Allen Ginsberg, in 1971 at the Grabhorn-Hoyem Press.

As has been noted earlier, the bohemian and then the countercultural community in California invested fine printing with an individualism unmatched elsewhere in the country. Sandra Kirshenbaum and Kenneth Karmiole later noted that writers often described the entire range of printing in California in the 1960s (not just the books produced by the print activists) as "colorful" or "highly individualistic" —terms applied "not without a hint of condescension."[192] Still, condescension never turned into outright exclusion. As early as 1961, the Grolier Club showed *Fine Printing and Bookbinding from San Francisco and its Environs.* Books by the forty printers included historical exemplars as well as contemporary work by the Grabhorns, William Everson, the Allens, and others. Although the books by the print activists may not have been praised as epitomizing to the fine press aesthetic, they were understood to represent small press publishing at its essence: bringing voices into print. When viewed from today's perspective, such books demonstrate that the rich diversity in California's fine printing ultimately granted every printer permission to compose a personal fine press aesthetic.

191. For more on Beat printers and the "mimeo revolution," see Clay and Phillips, *A Secret Location on the Lower East Side*; Alastair Johnston, "Literary Small Presses Since World War II in Europe and America," *American Book Collector* (May–June 1981): 13–19, as well as other writings by Johnston noted in the bibliography.

192. Kirshenbaum and Karmiole. *California Printing*, viii.

THE DELUXE BOOK

Thus today there are many remarkable "modern books" that are not "illustrated," but "created"
or decorated, and many that are hardly books at all except in their format. One need not applaud
these developments, but one must recognize them.[193] —PHILIP HOFER 1961

Nobody ever heard of printing on Plexiglass, but he wanted to try it, and we did, and it worked.[194]
 — TATYANA GROSMAN ON ROBERT RAUSCHENBERG'S *SHADES*, 1961

SHADES

Just as the fine press aesthetic was enriched from artistic and activist intentions, the deluxe book was being transformed. Books with the traditional configuration of prints facing text still appeared, but the deluxe canon was soon broached by unorthodox interlopers. Plexiglass took over the page, and rubber-stamp or stains left their mark. Even the woodcut shed its fine press refinement to startle a reader with a looming fantastical creature or the urgency of a wartime news photo.

Shades (1964, fig. 41), by Robert Rauschenberg, epitomizes the new face of the deluxe book as published by a U.S. atelier.[195] Printed in twenty-four copies, *Shades* combines the unorthodoxy of a bookwork with the imprimatur of an atelier, and so exerted influence on both book art and art worlds. The title of *Shades* suggests the pictures in the work that shift in and out of focus depending on the sequence of its pages. Those six lithographed, foot-square Plexiglass pages sit within a slotted aluminum frame, the front "title page" (which carries the only text) affixed, the other pages interchangeable, rotatable, even reversible. The dominance and clarity of any image can be changed by reordering the pages within the frame, and the cast shadows of the blinking lightbulb mounted within it add another level of visual emphasis, true "shades" that appear and disappear. The transparent pages suggest a Mallarméan object, its imagery lit and floating on crystalline sheets. The book's content extends beyond its imagery and text. A reader must look at the book by looking through it; whatever or whomever is behind the book at that moment becomes a another image moving in and out of view.

Shades joined in the challenge to "high art" that Pop Art posed. Printmaking no longer limited an artist to relief or intaglio; artists were increasingly experimenting with media formerly dismissed as commercial, and with imagery from popular culture. Pop artists such as Andy Warhol favored silkscreen (or screenprinting, which derives from stencilling), because of its commercial associations, its cool visual

193. Hofer and Garvey, *The Artist and the Book*, 7.

194. Quoted by Mary Lynn Kotz, *Rauschenberg, Art and Life* (New York: H. N. Abrams, 1990), 148.

195. Tatyana Grosman, of Universal Limited Art Editions (ULAE), stated that Rauschenberg called *Shades* his "book" when it appeared in 1964. Kotz, *Rauschenberg, Art and Life,* 148. Rauschenberg repeatedly used a structure similar to *Shades*, and sometimes he termed the resulting work a book, sometimes not. In 1976, *Shades* was described as "a lithographic object in the format of a book," and later in the catalogue, *Opal Gospel* (1971–1972) is described as, "like *Shades*...meant to function as an unbound and illuminated deluxe book." Smithsonian Institution, *Robert Rauschenberg* (Washington, D.C.: Smithsonian Institution, 1976), 155, 162.

demeanor, and its direct and inexpensive method of reproduction.

The pictures in *Shades* were transferred to lithographic stones by inking photomechanical halftone engravings of images from *The New York Times*; a New York Stock Exchange report, a crossword puzzle, and other images accompany Rauschenberg's marks and drawn letters.

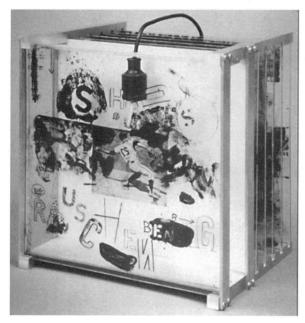

FIG. 41. Robert Rauschenberg.
Shades
15 x 14 x 11¾ (12 x 12 each sheet)

Art © Robert Rauschenberg and ULAE/Licensed by VAGA, New York, NY

Shades relies on Plexiglass for its effect, and thus it also promotes the artistic use of new materials, interests that Rauschenberg furthered through his involvement with the nonprofit organization Experiments in Art and Technology (E.A.T.). *Shades* also demonstrates how the properties of the book form could transform an artist's concerns. Compared to Rauschenberg's other works of the period, *Shades* resembles a Combine sectioned and projected into depth. Its changeability reflects a delight in chance and disjunction that characterized the happenings, while at the same time its transparency creates a diminutive version of the environmental works of the 1960s. *Shades* is art, but on a book's metaphorical terms.

In addition to its Plexiglass pages, *Shades* reinterpreted the rules governing the book form. Such iconoclasm wasn't new; by 1964 other radical alterations had appeared, including *Book* (1957), by Jasper Johns, from Rauschenberg's own circle. But Rauschenberg did more than use books as found objects; he reconfigured the book, and so created a work that, because of its originality, as well as Rauschenberg's artworld profile (he won the Venice Biennale in June 1964, and *Shades* was released in April of that year), raised public and art world awareness of a reinterpreted book-as-artifact. *Shades*'s welcome by the art world did not translate, however, into a widespread relaxation of the deluxe book canon in the book world.

Even if *Shades* did not transform the deluxe book canon, it represented a striking departure. In the 1960s, printmaking was evolving, gaining strength from a mix of economic, artistic, and social factors. International attention fueled the reputations of the Abstract Expressionists, and by the 1960s America was bursting with new artistic directions. The nation's strong economy encouraged collecting and produced an educated middle class eager for culture and inclined to support an emerging and affordable print market. Printmaking continued to solidify its presence in higher education, as taught by Leonard Baskin and others.[196] Art journals demonstrated renewed interest in

196. A few nonacademic printmaking sites also opened in the 1960s, such as the Lower East Side Printshop, founded in 1968 by artist and educator Eleanor Magid and others, to provide arts education for public school students. *Album: Thirty Years at the Lower East Side Printshop, 1968–1998* (New York: Lower East Side Printshop, Inc., 1998). In addition, printmaking clubs began, such as the Philadelphia Print Club, which exhibited and commissioned work. These clubs were later supplanted by museum print clubs, whose purchases generally followed each museum's curatorial interests. Lisa Peters, "Print Clubs in America," *The Print Collector's Newsletter* 13, no. 3 (July–August 1982): 89.

prints, in particular those by Pop artists, and a handful of galleries supported contemporary work. Handmade paper attracted advocates in the ateliers—seen, for example, in the growing interest of Ken Tyler, who added a handmade paper workshop to his studio in the 1970s.

STAMPED INDELIBLY: INDEPENDENT DELUXE BOOKS

[The artist does] not merely reflect the life he perceives about him, [but] rather he communicates his experiencing of life in terms of opinion and point of view, with a conscious political bias.[197]

—ANTONIO FRASCONI

Outside of the atelier, artists published when they had access to equipment. Their books integrated a wide variety of styles and strategies from the 1960s art world, creating hybrids not only of deluxe and fine press, but of deluxe and bookwork. Of the latter, *Stamped Indelibly* (1967) uses the rubber stamp, a printing technology that defied convention in both the fine art and printmaking canons. Access to printing equipment translated into what could be unearthed from a desk drawer or a child's playroom. To make *Stamped Indelibly,* Pop artist Bill Katz gathered designs by fellow artists Red Grooms, Marisol, Claes Oldenburg, Andy Warhol, and others. After having the rubber stamps fabricated, Katz created the prints, whose inking and impression produced the familiar softened gray mark, oddly resituated from an office to an art context. The supposedly neutral mark of the rubber stamp removes evidence of each artist's signature: after all, the artists' involvement ended with their designs—Katz made the marks. Such a strategy blurs the lines of authorship, true to the Pop spirit. The playful connotations of the rubber stamp conjure up childhood pursuits, and thus their use in an art context, Pop artists believed, deflates the pretense that permeated the art world.

Katz used the rubber stamp as a playful printmaking surrogate. Two years later, Ed Ruscha extended that strategy to a perverse extreme with his infamous *Stains*, self-published in 1969 (the photographic books of Ruscha are discussed below with the multiple bookwork). Typically for Ruscha, the title and contents of the book state the obvious, but with a Pop detachment. The seventy-five sheets in the portfolio are stained with substances such as candlewax, olive oil, coffee, Coca-Cola, and semen, each page fastidiously protected from the next by a glassine sheet. These unpalatable contents are safely tucked away within a faux-leather box. The title and contents appear in a gothic blackletter typeface often associated with the self-conscious importance of newspaper mastheads, Bibles, and government

197. Frasconi, "11 Graphic Artists Write," *The Tiger's Eye* 1, no. 8 (June 15, 1949): 59.

documents. The luxurious presentation and portentous typeface promise that something precious is held within, and Ruscha seems to revel in his parody of the discarded evidence of living that comprise the aftereffects of consumption, like a Fluxus artist's dream. But Ruscha did not simply make his point and move on. With the determination of a Conceptualist, he expects the viewer to endure through seventy-five pages of daubs and smudges.

Confronted with these maverick publications, it would be easy to overlook the ongoing developments that distinguished the other deluxe book, the fine press–deluxe hybrid. These hybrids were characterized by literary content and imagery from woodcuts. Some artists used the woodcut to pursue traditional ideals of beauty, as in *Dialogues of Creatures, Moralized* (1967), by the Allen Press, which published the English translation of a series of Dutch morality tales from 1480. The Allens printed it in several ink colors on handmade paper, and for the illustrations they used reprints of the original woodcuts (from zinc cuts by the Allens).

The woodcut was in fact undergoing transformation as a print medium. After World War II, Japanese handmade papers were again available to U.S. printmakers. *Viet Nam!* (1967, fig. 42), by Antonio Frasconi, reinterpreted the content of the fine press–deluxe book along the lines of a bookwork. *Viet Nam!* has no text—nothing relieves its searing images of war. Frasconi based some of his twenty woodcut images of suffering Vietnamese and of the B-52 bomber on newspaper photos, and a sense of journalistic authenticity is translated through the incised and striated surface of the woodblock, its effect eerily

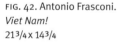

FIG. 42. Antonio Frasconi.
Viet Nam!
21³/₄ x 14³/₄

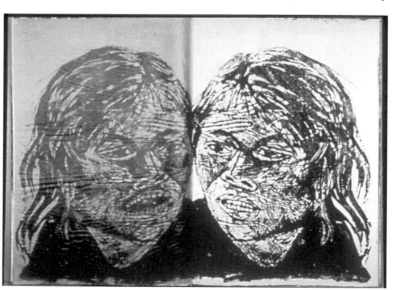

similar to that of burned skin. At the touch of the reader, red and black pages interrupt the full-page images; these rigid, glassine sheets add rattling, visceral interruptions "like bombs"[198] to a reader's paging through the portfolio.

The stunning impact of *Viet Nam!* represents an anomaly among deluxe books. But Frasconi did not so much open the deluxe canon to political content as recognize the inherent populism of the print. Eighteen years before *Viet Nam!* Frasconi defended the woodcut as a political medium in *The Tiger's Eye*. He aligned it with "art [that] must be like bread, like the sun—the intimate of people, all people," where it "must interact with people in every phase of their lives," including "their struggle and their victory."[199] Frasconi recalled that the low cost of the woodcut had endeared it to activist artists such as Francisco Goya, Honoré Daumier, and Käthe Kollwitz, who recognized in the visual staccato of the veined and excavated wood a metaphor for pictures about loss and revolution. By adapting that medium to appropriated news photos, Frasconi resituated the woodcut within the activism of the 1960s.

The social content of Frasconi's books anticipates that of later multiple bookwork artists, whose offset-printed books are meant to deliver artistic and political insurrections into the unsuspecting hands of their readers. So what did Frasconi's claims mean for the deluxe book, a format with which he would perhaps resist association? Frasconi returned printmaking's essentially multiple character to itself, with the book a willing collaborator in its activist program.

RICHARD TUTTLE'S BOOKS OF "OBSTINATE HUMILITY"

Antonio Frasconi infused the deluxe book with unsettling political content. Richard Tuttle challenged the deluxe book's premise of rarity, in books of "obstinate humility."[200] Tuttle self-published his first book, *Story with Seven Characters* (1965, fig. 5), two years after he moved to New York as a student, which was the same year as his first one-person show at the Betty Parsons Gallery. Hardbound in an edition of just seven copies, the letterpress-printed book holds nine folded sheets with eight woodcuts.

The production of *Story with Seven Characters* epitomizes Tuttle's disinterest in producing a typically sumptuous deluxe book made from commissioned papers and adorned with rich bindings. The printed impression in the book is neither crisp nor imbedded in the paper, ignoring the tenets of fine printing. Instead, Tuttle creates a gray zone of uneven inking. The effect may disconcert printing enthusiasts, but it

198. Marilyn Symmes, "Other Languages, Other Signs," in *The Books of Antonio Frasconi* (Purchase: Neuberger Museum of Art, State University of New York at Purchase, 1992), 21; quoted by Rainwater, *American Livre de Peintre,* Item 18: n.p.

199. Frasconi, "11 Graphic Artists Write," 59.

200. Nancy Princenthal, "Numbers of Happiness: Richard Tuttle's Books," *The Print Collector's Newsletter,* 24, no. 3 (July–August 1993): 81.

201. Rainwater, *American Livre de Peintre,* Item 51, n.p.

202. Corinne Robins, *The Pluralistic Era: American Art, 1968–1981* (New York: Harper and Row, Publishers, 1984), 21.

203. Carrión, "The New Art of Making Books," in Joan Lyons, ed., *Artists' Books: A Critical Anthology and Sourcebook* (Rochester, New York: Visual Studies Workshop Press, 1991), 35.

does visually integrate the paper surface with the ink and image laid upon it. Still, Tuttle's books are far from off-handed creations—the evident concentration behind his placement of a line and shape suggests a purity of execution large in thought and focused on follow-through.

The seven characters of the book are actually suggestive but not readable signs that reappear in evocative, even whimsical arrangements. Tuttle's title implies a narrative, and some writers have obliged by interpreting it in this manner. For example, Robert Rainwater describes the effect of the characters as suggesting a "non-linear narrative" comprised of "fragments of an abstract alphabet," and enacted by Tuttle's "playful shapes."[201] Tuttle himself has said of his installations that he seeks to create a "translation into objects of a kind of interior space,"[202] and that he withholds directives so that each viewer may follow his or her own muse. Perhaps Tuttle wants the reader's desire for narrative to permeate the reading so that, desire unmet, the reader projects his or her own stories onto the characters, making, as Ulises Carrión wrote ten years later, "The space [into] the music of [our] unsung poetry."[203]

Several of the books discussed here—*Shades, Story with Seven Characters, Viet Nam!* and *Stains* among them—sit awkwardly within the deluxe canon; in fact, they challenge it. Plenty of deluxe books appeared in the 1960s, where pictures and text faced one another on opposing pages, each demurely remaining in place. As lovely as the traditional book appeared, however, it is the iconoclasts that deserve our interest, for their attempt to liberate (or at least to broaden) the deluxe book aesthetic with uncommon formats, materials, or means of production. As a related point, some writers have discussed these books as bookworks, but to do so would negate that tension between expectation and presentation that they generate, just as, in a different way, the fine press–deluxe hybrids of the Allen Press invigorate both of those types of books by combining traits from each. So, how does one draw the line between deluxe and bookwork? Perhaps these books suggest that a book art context is best defined by the issues that a book raises. Prints can result from the lowly rubber stamp, and letterpress rules can be ignored to visually integrate a mark within a paper's surface. A deluxe book can even spoof itself as a silk-lined box holding a bizarre bounty of stains.

EUROPE IN AMERICA

The United States produced several deluxe books in the 1960s that broke ground in content, media, format, and materials, and in so doing stretched the deluxe canon nearly beyond recognition. Europe's

influence prevailed, however, in the greater art and book worlds: in exhibitions, in its own growing number of deluxe book publishers, and in the continuing stature of its Vollard-era books. Prime among U.S. exhibitions was a 1961 showing at the Museum of Fine Arts in Boston, in collaboration with the Harvard College Library. *The Artist and the Book, 1860–1960, in Western Europe and the United States* was accompanied by a catalogue acknowledged in 1993 as a "still-indispensable reference [that] established for collectors, curators, and dealers the critical listing of books judged the most significant at the time."[204] Europe dominated the enormous show: out of 324 entries, France numbered 182 books to America's 47, which still represented a substantial increase for America over its paltry showing in the 1936 *Painters and Sculptors as Illustrators.*

In his essay, curator Philip Hofer discarded the term "illustrator" used in the 1936 exhibition because he associated it with a "classic tradition" in which a book (or perhaps a portfolio) achieved "a harmonious combination of textual and pictorial elements, each significant, and each of relatively equal importance."[205] In so doing, Hofer formalized the gulf that separated illustrations from the supposed innovations of fine art. Hofer saw his mission as the conversion of the uninitiated or prejudiced, "to demonstrate to the English-speaking world that during the last century *the book has, in fact, become a major vehicle of artistic expression.*"[206] But Hofer's English-speaking world still recognized France as the undisputed leader of the deluxe book. Hofer identified his selections as "livres de peintres," which he described as a recent French term used to designate books with "*original* graphic work" (note his emphasis).[207]

Taken as a whole, the deluxe creations of the 1960s displayed four kinds of intent. The first kind of intent was literary, in which a text played an integral part, such as in *Creatures Moralized.* The second kind of intent was visual, in books with pictures that shimmered on new materials (*Shades*) or wittily misbehaved (*Stamped Indelibly, Stains*). Yet other books carried content that inspired contemplation (*Seven Characters*) or activism (*Viet Nam!*). These vibrant books embodied a "flowering totality"[208] different from the deluxe norm. More than in any other decade, the deluxe book aesthetic of the 1960s changed with books that incorporated fine press typography as well as bookwork transgressions. Not until the 1980s, beyond the range of this study, did the deluxe book again generate such an array of hybrids.

204. Rainwater, *American Livre de Peintre,* 9.

205. Hofer and Garvey, *Artist and the Book,* 7. Eleanor M. Garvey assisted Hofer with curating the show.

206. Ibid., 8 (his emphasis).

207. Boston's exhibition was the most influential U.S. showing of the French canon in the 1960s—but not the only showing. In 1967 Eleanor M. Garvey with Peter A. Wick curated *The Arts of the French Book, 1900–1965* (Dallas: Southern Methodist University Press, 1967), which showed at Dallas Public Library, and then at Sterling Memorial Library at Harvard.

208. Mallarmé, "Spiritual Instrument," in *Stéphane Mallarmé,* 82.

THE MULTIPLE BOOKWORK

...I wanted somehow to think of the press as love letters to the future.[209]

—DICK HIGGINS, ABOUT SOMETHING ELSE PRESS

DONT CORRECT, DONT TOUCH UP, throw the films on the printing plate quickly and carelessly and develop and print....the INTERFERENCE of the halftone of the shooting and the halftone of the pasteups doesn't matter, it will be nice.[210]

—DIETER ROTH, *246 LITTLE CLOUDS*

If there is any facet of my work that I feel was kissed by angels...I'd say it was my books. My other work is definitely tied to a tradition, but I've never followed tradition in my books. The books are just neuter gender, and that's what I like about them. That's why I feel so free when I do them. They're the easiest things to do, and sometimes the best. I like the idea of spending $2,000 on something that's totally frivolous and spontaneous. When I start on one of these books, I get to be impresario of the thing, I get to be majordomo, I get to be creator and total proprietor of the whole works, and I like that. It's nice. And I'm not biting my nails over whether the book is going to hit the charts or not.[211]

—ED RUSCHA

SOMETHING ELSE IN INDEPENDENT PUBLISHING

The multiple bookwork emerged on several fronts in the 1960s, propelled by the expanding phenomenon of independent publishing and by art movements committed to populist principles. Its content was often photographic, and it was printed from offset or from printing media found in the studio, office, or playroom. Three artists advanced the multiple bookwork's potential, specific to photography and to Conceptual concerns; those artists were Dieter Roth, Ed Ruscha, and Sol LeWitt.

Dieter Roth is arguably the most inventive and influential book artist in the twentieth century. In the book art field alone, Roth (aka Diter Rot, Diterrot, Karl-Dietrich Roth, Dieterich Roth) worked with little magazines, multiple bookworks, and sculptural bookworks. Roth's influence was global: he was born in Germany and later lived in Switzerland, Denmark, and Iceland. In America, he exhibited and published books from the 1960s forward, while also lecturing and teaching. Over time, he influenced both the multiple and sculptural bookwork.

Roth's early graphic design work in the streamlined Swiss style earned him international respect. With his encounter of Fluxus art in the early 1950s, he abandoned a geometrical design system for Fluxus serendipity. For Roth and for Fluxus, the possibilities of the ephemeral

209. Dick Higgins interview with Nancy Princenthal, *The Print Collector's Newsletter* 22, no. 4 (1991): 147.

210. Dieter Roth, Addendum, *246 Little Clouds,* which reproduces Roth's instructions to the printer of the book.

211. David Bourdon, "Ruscha as Publisher [or All Booked Up]," *Art News* (April 1972): 32.

constituted inexhaustible content and formats for art-making that embodied life's surprises and absurdities.

Roth's aesthetic is expressed in *246 Little Clouds* (1968, fig. 43) in a book design that courts opposition. The cover portrays sketched heads and the title, along with the handwritten instruction to the printer that the artwork "should be printed NEGATIVE." On the first page the numeral one is followed by "here should __ big pictures," the verb disappearing behind a black scribble, the pictures absent, the statement floating without a period, the point being no point, literally. A point designates an end, a cessation, and Roth wishes to avoid all indications of closure or finish. Roth ordered that the pages be photographed under a raking light to reveal the paper's bumps and wrinkles. Overexposure also produced musty grays that occasionally obscure his scrawled aphorisms. Turning pages that appear wrinkled and yet are not and deciphering the handwritten texts of Roth (and editor Emmett Williams) transforms the reading experience into an attempt at translation by a baffled reader.

The texts themselves do not behave. They are evocative, yet obdurately non-narrative. They comment on the somatic (bladders, excreta) or engage in wordplay. Roth desired to avoid consistency, summed up in text ninety-six as "to name a thing: to turn away from it." Roth's page designs also reflect his contempt for convention. His drawings on cut and torn bits of paper appear taped onto the pages (floating, cloudlike), with cartoony doodles that only sometimes relate to the adjacent text. It is as if Roth gleefully shattered Beatrice Warde's crystalline goblet of traditionalist typography and scattered its shards throughout the pages, each piece revealing a fragment of

FIG. 43. Dieter Roth.
246 Little Clouds
$9^1/4 \times 6^1/4$

thought or an off-center observation. Sometimes Roth's pages display a collage of random slips of paper from his desk, such as a blank daily-planner page from August 30, 1967, taped next to another scrap that carries a drawing of a hand and an arrow—the text next to it, number 100, says simply, "see: august 30th," thus adding to the perceptual play: what to see, this page? the day pictured in one's memory? Other pages carry blottings and corrections. This is anti-illustration, just as the handwritten text and taped typewritten scraps comprise an anti-typography.

In *Clouds* Roth engages time on several levels. Much of the text and imagery of the book is about process, evidenced by the vagaries of paste-up and editing and in the scribblings of Roth and Williams documenting its genesis. Time also means the time undertaken to view the finished book. But Roth further stage-manages time into a diurnal cycle, as noted in his instructions to the photographer: "the little clouds should be shot—not as usually under glass and illuminated from everywhere—but not under, so that the pieces of paper, as well as any un=smoothity within the pencil frames, can stick out and cast their shadows, as clouds do." The angle of the raking light subtly shifts, shot by shot and page by page, across an arc, so that the shadows cast on each page follow daylight's trajectory to chart a day for each reading of the book. However, the aim is not to evoke the embodied space of Mallarmé, but to suggest a compressed and airless vacuum. The wrinkly page creates a flattened space at odds with the shadows produced by the taped clouds, and the cloud motif conspires in a linkage that marches the reader along with the numbered statements. Roth defeated the book form's inherent sense of closure or completion, for implied within every sunset is the next sunrise or the next reading.

Roth was not an American, but his books and his presence were a part of the U.S. art scene from the 1960s forward. His influence was given a boost in 1968 with the publication of *Clouds* by Something Else Press. Among the many independent publishers in the 1960s, Something Else Press (1966 to 1973), run by Richard (Dick) Higgins, brought several international Fluxus artists to a U.S. audience;[212] it was the most influential small press in the U.S. artist's book community.

In launching his press, Higgins published the essay "Intermedia" in his *Something Else Newsletter,* and so provided a defining term for artistic investigations whose "location [lies] in the field between the general area of art media and those of life media."[213] The book form offered a perfect vehicle for disseminating such material. But despite a Fluxus affinity for ephemeral art-making, Higgins wanted books that endured. A background in bookmaking helped him to select

212. 1966 to 1973 were the years that Higgins directed the Press.

213. Dick Higgins, "Intermedia," *Something Else Newsletter* 1, no. 1 (1966). Higgins added to the essay in 1981 and noted that Samuel Taylor Coleridge had coined the term "intermedia" in 1812.

quality materials and to design books that could be distributed through bookstores, as were the books of another small press, the Jargon Press.[214]

Considering the number and variety of its books, Something Else Press undeniably influenced the multiple bookwork, although the extent of that influence is arguable. Nancy Princenthal later mused that, "Its legacy, for all its power, is hard to assess. The press was never self-supporting and despite infusions of Higgins's personal income, it failed financially."[215] But such was the fate of nearly every small press, in which influence accrues slowly. In 1968 Jud Yalkut cited the Something Else Press in "Towards an Intermedia Magazine" as a champion for low-cost, large-editioned art: "Art is taking advantage of the advances in paper and plastics technology. Less affluent art-lovers, already partially diverted by the lower costs of prints and posters, eagerly anticipate the appearance of inexpensive art objects in the limited editions which increase their desirability for 'collectors.'"[216] The influence of Something Else increased along with the growing reputations of its artists. Not all of its books were artists' books, but those that were embodied Yalkut's ideal of books published by an artist-run press, that were distributed along trade-book channels to reach the general public. As for its book art influence, Peter Frank asserted that, "The surge of activity in artists' books and bookmaking that was felt so emphatically in the American art scene in the latter half of the 1970s was set in motion by, among other things, the model of [Something Else] Press and its specific achievements."[217]

214. That is not to say that the formats of Something Else books never departed from convention. For example, Higgins's own *foewandombwhnw* (1969) emulated the *Anglican Book of Prayer* in its typography, onion-thin pages, and demure black leatherette binding. Inside, double columns held a miscellany of Higgins's personal reflections, critical writings, poetry, photographs, and drawings. See Peter Frank, *Something Else Press, an Annotated Bibliography by Peter Frank* (Brattleboro, Vermont: McPherson and Company, 1983), 32.

215. Nancy Princenthal, "Artist's Books Beat," *The Print Collector's Newsletter,* 22, no. 4 (1991): 146.

216. Jud Yalkut, "Towards an Intermedia Magazine," *Arts Magazine* (Summer 1968), 14.

217. Frank, *Something Else Press,* 85.

MEDIA VERSUS AURA: McLUHAN AND BENJAMIN

An age in rapid transition is one which exists on the frontier between two cultures and between conflicting technologies. Every moment of its consciousness is an act of translation of each of these cultures into the other. Today we live on the frontier between five centuries of mechanism and the new electronics, between the homogeneous and the simultaneous. It is painful but fruitful.[218] —MARSHALL McLUHAN

For the first time in world history, mechanical reproduction emancipates the work of art from its parasitical dependence on ritual. To an ever greater degree the work of art reproduced becomes the work of art designed for reproducibility.[219] —WALTER BENJAMIN

The phrase "media versus aura" sums up a decisive confrontation in the art world of the 1960s, which was infiltrated by media with commercial associations (used to create Pop art), as well as with art made with everyday materials (seen in Fluxus art). In the midst of the media tumult the writings of Marshall McLuhan and Walter Benjamin became essential critical reading because of the way they addressed the consequences of media's pervasiveness. By this time, McLuhan himself was becoming a celebrity, variously labeled as "the most talked about intellectual in the art world of the 1960s" and "an intellectual charlatan [or a] visionary prophet."[220] In *The Gutenberg Galaxy* (1962), McLuhan charted the changing status of the book by recalling its "scribal culture" beginnings, and the consequences from the increasing dominance of the "electric galaxy." He concluded in *Understanding Media, The Extensions of Man* (1964) that society needed to transcend the book's restrictive organization of thought: "Perhaps there are better approaches along quite different lines; for example, consciousness is regarded as the mark of a rational being, yet there is nothing lineal or sequential about the total field of awareness that exists in any movement of consciousness."[221] McLuhan was prescient in recognizing the (what later emerged as) digital medium's inherent strengths of referentiality over the book's "outdated" linear format, although he ignored the fact that readers could also explore a book in nonlinear ways. Books were cast aside in McLuhan's global village, where the artist served as seer and interpreter to wield new technologies for social betterment.

Walter Benjamin addressed the fundamental shift underway two decades before McLuhan, in Benjamin's "The Work of Art in the Age of Mechanical Reproduction" (1936), first published in English in *Illuminations* (1968). Benjamin distilled his sense of the impending transformations into an opposition between reproductive technologies

218. Marshall McLuhan, *The Gutenberg Galaxy: The Making of Typographic Man* (Toronto: University of Toronto Press, 1962), 172–73.

219. "The Work of Art in the Age of Mechanical Reproduction," in Walter Benjamin, *Illuminations* (Hannah Arendt, ed., New York: Schocken Books, 1968), 220.

220. Sandler, *American Art of the 1960s*, 78–79; Mark Petr, "Prints, Politics, Polemics," in *Hot Off the Press: Prints and Politics*. Linda Tyler and Barry Walker, eds. (Albuquerque: The University of New Mexico, 1994), 90.

221. Marshall McLuhan, *Understanding Media: The Extensions of Man* (New York: McGraw-Hill, 1964), 84–85.

and what he called the "aura." Aura was Benjamin's notion of originality that encompassed a work's "authenticity" or "cult value," the elitist associations conveyed by a work's uniqueness and an impression of its distance gained from history. Despite the thirty-year delay in its translation, the article was soon recognized as prophetic in its understanding of the paradigm-altering effects of technology.[222] Benjamin believed that although a photographic reproduction of a painting could conceivably reach a wider audience, the effects of that multiplication led to a loss of aura. Reproduction played a heroic role in draining away aura, since "the technique of reproduction detaches the reproduced object from the domain of tradition." This loss of the "authority" of an object was irretrievable; gone forever was "its presence in time and space [and] its unique existence at the place where it happens to be."[223] The effects of aura's "decay" reached beyond art into the social realm to alter the fundamental "manner in which human sense perception is organized."[224]

Benjamin understood the tradition-shattering effects of such "mass" art forms as film. Freed from the confines of cult value, the presence of an artwork was magnified with the limitless access of exhibition value. Benjamin's essay was referenced by book artists—especially the makers of multiple bookworks—to proclaim themselves as change agents in contemporary life. It is questionable, however, whether Benjamin would have extended his argument to include books at all, at least those books in his own collection. Five years before he wrote "The Work of Art...," he authored "Unpacking My Library," a paean to the joys of book collecting. In the essay, Benjamin rhapsodized over the pleasures of building a collection, where the acquisition of each book with its history (we can assume, its aura), slowly inscribed a "magic circle" drawn by the collector in an effort to assemble a self-inscribed world. Benjamin viewed his own books as revered objects. Perhaps Benjamin believed that the book form's tactile and intimate character differentiated it from the predominantly visual nature of film. Or perhaps he would have differentiated between the public realm of art and his private passion for book collecting. His thoughts about books and aura remain ambiguous at best. These questions point out a paradox of the artist's book: In multiple, it supports the ideals of Benjamin's belief in unfettered access to mass art forms. But in reading a book, its status alters into one of a personal, auratic object of cult value.

Benjamin and McLuhan both recognized that art is embedded in history and reflective of economic as well as cultural norms. Benjamin believed that reproductive technology would sweep away the hierarchy of the art world, crowned as it was by the influential concepts of

222. The 1968 publication of Harry Zohn's translation in *Illuminations* brought Benjamin's writings to the attention of the English-speaking world. Benjamin began to be cited by writers such as Martin Jay, who discussed "The Work of Art" in *The Dialectical Imagination; a History of the Frankfurt School and the Institute of Social Research, 1923–1950* (Boston: Little, Brown, 1973). By the 1980s, Benjamin's writings were widely recognized as significant to the visual arts. Benjamin's "The Author as Producer," for example, was reprinted in *Art after Modernism* (Brian Wallis, ed., New York: The New Museum of Contemporary Art, and Boston: David R. Godine, Publisher, Inc., 1984), and "The Work of Art..." was cited in the book's bibliography.

223. Benjamin, "The Work of Art," 220.

224. Ibid., 221, 222.

the connoisseur and the original. McLuhan welcomed the new face of reproductive technology for art in media formats and content. He embraced the ideal of interdisciplinarity as reflective of the potential of mass media to advance global egalitarianism. He just didn't recognize that the book could still serve those ends. Paradoxically, later book artists cited Benjamin to justify their publishing—even though Benjamin had not mentioned books—just as artists embraced McLuhan for his pro-technological stance, his vision of the heroic artist, and his recognition of the properties of the book (portable, sequential), while ignoring McLuhan's outright dismissal of the book as an outdated format.

Art made in the name of pluralism generated confusion in traditional art lovers: How could one recognize "art" if it was so seamless a product of everyday life? Harold Rosenberg commented on what he saw as art's disappearance into "the archetypal creation of the media [as] the package" in his 1969 essay, "Art and Double." Rosenberg responded to the prophecies of McLuhan in which "the book or the canvas is simply a tool of communication that has been largely rendered obsolete by the new electronic media." Rosenberg imagined an unforgiving future as described by McLuhan, in which whole populations would be set adrift in an "eye culture," where, "even if painting and books were to remain, there would be no one...physically capable of perusing them—the eye would no longer follow the contours of a form or the rows of type." [225] Rosenberg may have criticized McLuhan's inflated prose, but he agreed with him that art could no longer exist as in a cocoon, protected from the mechanisms of life that surrounded it (as if it ever had): "whether art is made as a package or as an antithesis to the package, it takes on the character of the package in its mode of transmission to the public, that is, through the communications system of the press, including the art press, the museums, galleries and other distribution and educational mechanisms." [226]

A growing number of book artists did not accept McLuhan's dismissal of the book. For them, the artist's book, often intentionally produced *both* as a package and its antithesis, embodied the awkward yet illuminating dualities that resulted from the overlap of art with commerce.

As demonstrated by *246 Little Clouds,* the look of some multiple bookworks suggested a messy and immediate anti-aesthetic. Publishing had become an activity that could happen as quickly as an artist could draw on a mimeograph stencil, demonstrated by Claes Oldenburg in *More Ray Gun Poems* (1960). In *Ray Gun* Oldenburg pictures

225. Harold Rosenberg, "Art and Double," *Artworks and Packages* (New York: Horizon Press, 1969), 20.

226. Ibid., 21.

227. Robert C. Binkley describes the mimeograph as a machine that "multiplies typescript by means of a stencil printing surface on which the letters of the format copy are cut by the typewriter. The stencil is fastened on a cylinder, and as sheets of paper are fed into the machine an impression is produced on the copy paper by the squeezing of ink through the abraded portions of the stencil." Binkley, *Manual on Methods of Reproducing Research Materials* (Ann Arbor, Michigan: Edwards Brothers, Inc., 1936), 46.

What has since been called the "mimeograph revolution" spawned hundreds of little magazines and chapbooks in programs such as The Poetry Project at St. Mark's Church-in-the-Bowery. Located in New York's East Village, the project published on its Gestetner machine from 1966 until the early 1980s. Beginning in the late 1960s, the Coordinating Council of Literary Magazines offered incentives through government support. See Clay and Phillips, *A Secret Location on the Lower East Side.*

the chaos of the city with fragmented words and shifting, stylized images, where a ray gun shoots a "ray of light" that exposes the outrageous social costs of materialism. Here is the book as package and as its antithesis, quickly run off, folded and stapled, out on the street, as ephemeral as the performances and happenings that marked the period. Other independent publishing efforts grew in number as artists used the mimeograph and then the copier and offset to publish.[227] In the late 1960s, much of the content concerned the cataclysms in Vietnam and its repercussions at home. Activism increasingly joined with art-making, such as in January 1969, when the Art Workers Coalition (AWC) organized on a platform of artists' rights, one that soon expanded to include anti-war concerns, racism, and sexism.

In contrast to the iconoclastic ferment of *More Ray Gun Poems*, Andy Warhol's *Index (Book)* (1967, fig. 44) is a cool and flip consumerist send-up. Warhol filled the book with pictures of cultural divas, consumer icons, and his Velvet Underground band. Although Warhol's earlier books display the naive drawing style seen in *Wild Raspberries*'s faux recipes, in *Index (Book)* photography provides the pictures, and playfulness is encouraged in pop-ups that depict scenes

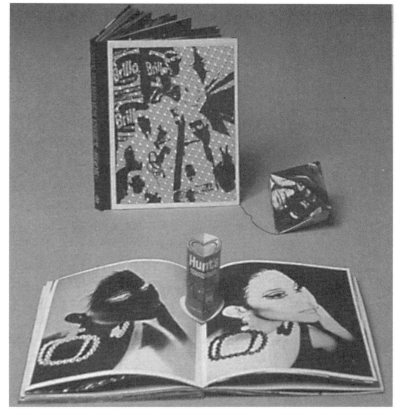

FIG. 44. Andy Warhol.
Index (Book)
11¹/2 x 8¹/2

228. Benjamin, "The Work of Art," 222.

229. Ibid., 220.

or objects, such as his signature tomato can. Beneath its glossy exterior, Warhol evokes the atmosphere of sexuality and rebellion that personified his infamous Factory.

Index (Book) glorifies the package with content that juxtaposed product and myth, equating Campbell's soup cans to Marilyn Monroe and Jackie Kennedy, all of them products produced for the iconography of popular culture (remember Harold Rosenberg). To make his pictures, Warhol used silkscreen in a flat graphic style that refused a personal signature—which of course became his signature. For Warhol, everything is media-created and so equally deserving of artistic appropriation, where, as Benjamin had put it, "To an even greater degree the work of art reproduced becomes the work of art designed for reproduction."[228] Warhol's pretense of aura was stuck onto consumer artifacts in an index that amassed the tokens of an insatiable consumerism. The sensibilities that inhabited Andy Warhol's *Index (Book)* and *Ray Gun Poems* could not be farther apart, the first controlled and cool, the second, chaotic and immediate. Another difference lay in the fact that *Index (Book)* was published in 1967 by the trade publisher Random House in recognition of Warhol's cultural notoriety (and salability). The two books represent an artistic recognition of commercial printing's aesthetic properties, a recognition that also implied the potent denial of the importance of a work's aura believed by Benjamin to assure "its presence in time and space [and] its unique existence at the place where it happens to be."[229]

ED RUSCHA'S "MIMESIS OF AMATEURISM"

Not that I had an important message about photographs or gasoline, or anything like that— I merely wanted a cohesive thing. Above all, the photographs I use are not "arty" in any sense of the word. I think photography is dead as a fine art; its only place is in the commercial world, for technical or information purposes. I don't mean cinema photography, but still photography, that is, limited edition, individual, hand-processed photos. Mine are simply reproductions of photos. Thus, it is not a book to house a collection of art photographs—they are technical data like industrial photography. To me, they are nothing more than snapshots.[230]

—ED RUSCHA, 1965

230. John Coplans, "Edward Ruscha Discusses His Perplexing Publications," *Artforum* 3, no. 5 (February 1965): 25.

If Dieter Roth delineated the evolving multiple bookwork with drawings, the second key artist, Ed Ruscha, did it with photography, beginning with *Twentysix Gasoline Stations* (1963, fig. 45). He conceived of the book while driving back and forth between Los Angeles and his hometown of Oklahoma City. Ruscha chose the book form simply because it best held his idea; in fact, "The first book came out of a play with words. The title came before I even thought about the

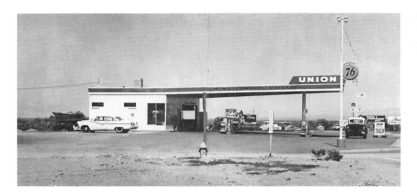

FIG. 45. Ed Ruscha.
Twentysix Gasoline Stations
7 1/16 x 5 1/2 x 3/16

pictures. I like the word 'gasoline' and I like the specific quality of 'twenty-six.' If you look at the book you will see how well the typography works—I worked on all that before I took the photographs."[231] Ruscha's road is the mythic Route 66, identified with the popular television show and song, and his choice of "26" suggests an alphabetic allusion, although that reference isn't followed up by the artist.

The books of Ruscha emerged in the midst of the artistic maturation of photography. Jeff Wall observed that, "It is almost astonishing to remember that important art-photographs could be purchased for under $100 not only in 1950 but in 1960. This suggests that, despite the internal complexity of the aesthetic structure of art-photography, its moment of recognition as art in capitalist societies had not yet occurred."[232] But some in the art world recognized it. In *The Photographer's Eye* at the Museum of Modern Art in 1964, curator John Szarkowski related the works on show to the camera's intrinsic properties, such as "the detail," "the frame," and "time." Szarkowski departed from the chronological "masterpiece canon" that his predecessor Beaumont Newhall celebrated, and from Edward Steichen's mass-media orchestrations such as *The Family of Man* in 1955. Instead, Szarkowski wanted photographic discourse to participate in the modernist aesthetic, but on its own terms, not forced into a traditional painterly mold. He championed the purist vernacular vision of Walker Evans, and showed work by younger photographers such as Diane Arbus, Garry Winogrand, and Lee Friedlander. By the end of the 1960s, photographers pursued as many varieties of expression as did other artists, from the surreal dream worlds of Jerry Uelsmann to the idea-based photography associated with Pop and Conceptualism that were Ruscha's ironic muses.

Ruscha's snapshot aesthetic did not emulate Walker Evans's "poetry of contrast,"[233] or Robert Frank's haunting immediacy. Ruscha came to photography by way of commercial art training at Chouinard Art Institute in Los Angeles. He later declared that: "One of the

231. Ibid.

232. Jeff Wall, "'Marks of Indifference': Aspects of Photography in, or as, Conceptual Art," in Museum of Contemporary Art, *Reconsidering the Object of Art 1965–1975*, (Los Angeles: The Museum of Contemporary Art; Cambridge, Mass., and London, England: The MIT Press, 1995), 251–52.

233. Lincoln Kirstein, "Photographs of America: Walker Evans," in Walker Evans, *American Photographs* (New York: The Museum of Modern Art, 1938), 194.

234. Coplans, "Edward Ruscha Discusses," 25. Ruscha learned letterpress printing from Robert Alexander of Baza Press. Ruscha never took to hand printing, however, and later distanced his books from any fine art connotations.

235. Henri Barendse, "Ed Ruscha: An Interview," *Afterimage* (February 1981), 10.

236. Wall, *Reconsidering the Object,* 264–5.

purposes of my book has to do with making a mass-produced object. The final product has a very commercial, professional feel to it. I am not in sympathy with the whole area of hand-printed publications, however sincere....All my books are identical. They have none of the nuances of the hand-made and crafted limited edition book. It is almost worth the money to have the thrill of seeing 400 exactly identical books stacked in front of you." [234]

Ruscha's flat nonstyle leeches away emotion to leave behind a neutral artlessness that recontextualizes forgettable content in the spirit of the readymades that he had seen at Marcel Duchamp's Pasadena retrospective in 1963. Equally important to Ruscha, the book form remains free of Duchampian associations: "When it's an established thing, and everyone understands it, it's lost its original function. If everyone knew what the books were about, the whole thing would be totally different....Duchamp had already killed the idea of the object on display. After what he did, it would be hard to surprise anyone. So books, conventional books, were a way for me to catch my audience off guard." [235]

Occasionally, "book" for Ruscha migrates into another medium, for example, in his painting, *Standard Station, Ten Cent Western Being Torn in Half* (1964). In this work, Ruscha's gas stations resolve into one monolithic symbol depicted from a low point of view. The picture is organized along diagonal lines, its pumps smartly aligned like guards, the sense of omnipotence, even grandeur symbolized by its "STANDARD" sign sharp and commanding against a flat sky. A viewer might think that Ruscha is touting America's romance of the open road, one in which the gas pumps provide passage. Ruscha undermines a simple message of heroics, however, by a "ten cent Western torn in half"—a book stuck onto the upper quadrant of the canvas. The book's spine is severed (run over?), useless now except in its reuse as collage. Such books of pulp fiction are all that remain of the

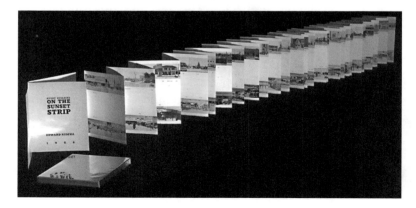

FIG. 46. Ed Ruscha. *Every Building on the Sunset Strip* 7 x 5⁵/₈ x ³/₈, opens to 299¹/₂

myths of the West in a society where gas stations now dominate the "trails West."

Ruscha embraces a "mimesis of amateurism"[236] in his photographic style and subjects. Like Evans, Ruscha seeks the vernacular, but unlike Evans, Ruscha presents a cityscape vernacular to paint an ironic portrait of America. Ruscha's irony is far removed from the social critique of Robert Frank; in Ruscha's books, a city's signage and streets are all reduced to a hip LA neutrality—flat, sunny, and apparently depthless. Still, Ruscha admired the work of both Evans and Frank. He recalled that, growing up in Oklahoma, photographers "were either nerds, or pornographers, or both. Then I saw Robert Frank's *Americans* [around 1958, and]...I also started seeing the work of Walker Evans, which had a profound effect on me."[237] Ruscha found his vernacular in gas stations or empty city streets.

If there is a booklike equivalent to Ruscha's monumental *Standard Station, Ten Cent Western Being Torn in Half,* it extends to the length of *Every Building on the Sunset Strip* (1966, fig. 46). This book does not present a selection of subjects (as in *Twentysix Gasoline Stations*); instead, *Sunset Strip* pictures, building by building and block by block, every bland storefront that lines that mythic street. The title also sets an explicit context of a single street, unlike *Twentysix Gasoline Stations,* where the Route 66 setting was implicit but not stated. In *Sunset Strip,* Ruscha even records the address of every single building in tiny captions.

The format of the book creates a drama at odds with its content. Although it can be examined in one's lap, page by page, if opened out the book stretches to gargantuan proportions (twenty-seven feet). The unfolded accordion sweeps the eye along, as if the viewer were sitting beside Ruscha during his early morning drive along the Strip, the motorized camera mounted on the car, whirring away. More than his static prints and paintings, more even than his other books, *Sunset Strip* projects the multiple bookwork beyond the photographic book and into a sculptural entity, a dumbed-down *tour de force* of the obvious that, when opened, converts the details of a forgettable street into a surprising grandeur of line, tone, and cadence.

Dieter Roth's *246 Little Clouds* and Ruscha's *Twentysix Gasoline Stations* share a mimesis of amateurism in the diligent avoidance of photographic "quality," although their books appear entirely unlike one another. Ruscha views books as a neutral envelope within which his pictures hover, uninflected. The envelope of Roth calls attention to itself, displaying its smudges and bent corners. Ruscha gives book artists permission to use photographs as "nothing more than snapshots,"[238]

237. Ed Ruscha, conversation with Walter Hopps, Yve Alain Bois. Yve Alain Bois, *Edward Ruscha: Romance with Liquids, Paintings 1966–1969* (New York: Rizzoli and Gagosian Gallery, 1993), 100.

238. Coplans, "Edward Ruscha Discusses," 25.

while Roth dismantles photographic reproduction itself, ignoring its rules in a delighted revelation of the page's supposedly-invisible surface.

Without consciously setting out to inaugurate an art form, Ruscha delineated an aesthetic for the art world and book art over the years. The interest that his books generate in the art world continues to fascinate book artists, who also marvel at Ruscha's success in selling them. In 1978 he noted that

> I have an assistant who helps me, handles most of that for me. I sell mainly through two or three distributors, one in NY, one in England. Whenever there is a potential for an exhibition I use it [to sell books]. As for installations of my books I have a pat way of showing them. I suspend them from monofilament from the ceiling. People can look at them without stealing them. The *Sunset Strip* book is shown as an accordion-fold against the wall held up by little push-pins. The more books, the more cohesive the exhibit.[239]

Ruscha kept his books in print and affordable, and as his art profile rose, the books tagged along as his modest artistic alter-egos.

Despite his art world success and the use of the book form by hundreds of artists in the intervening years, Ruscha wryly observed in 1981 that ignorance persisted in the art world concerning book display: "Every year I have at least two shows of my books in galleries and they put [the books] on the walls, because that's what they want. Though it's ok by me, it's not the same thing. They're easy to see, easy to accept because of the context they're in—you know what to think, everything's spelled out for you. It's on a gallery wall so it must be art. The way they're supposed to be seen, of course, is when someone hands someone else just one book at a time and place where they don't expect it."[240] For Ruscha, a gallery's choice to display his books flat, against the wall, underscores the limitations of the art world as much as it demonstrates the book's intractable separateness from that world. (To add insult to injury, the interest that Ruscha has in the form had originally derived from its non-art status.) Ruscha's growing artistic profile (along with the popularity of his books) led to his eventual loss of interest in the format, when, "after a while, the books began to look like a collection, and became too easy to understand."[241]

239. Gary Lloyd, "A Talk with Ed Ruscha," in *The Dumb Ox,* no. 4 (1977): 6.

240. Barendse, "Ed Ruscha: An Interview," 10.

241. Quoted in Barbara Braun, "Artists' Books," *Small Press* 2, no. 1 (September–October 1984): 66.

THE DEMATERIALIZED BOOK

It is Difficult to Bungle a Good Idea.[242] —SOL LeWITT, 1968

Books are a neutral source….Books are 'containers' of information. They are unresponsive to the environment—a good way of getting information into the world. My books are printed in three languages to further global communication, rather than limited and limiting local distribution.[243]

—SETH SIEGELAUB 1969

Photography and Conceptualism, picture and idea, seemed most naturally to occupy the pages of the multiple bookwork. If it cannot be established that the dematerialized art of Conceptualism was best materialized in a book, one can at least argue that books offered a framework that held Conceptualism's sequential progressions. Sol LeWitt explored the expressive varieties of the book as it related to the single trait of a sequential, paginated structure. LeWitt understood that Conceptualism and books belong together. In books such as *Four Basic Kinds of Straight Lines and Their Combinations* (1969, fig. 47), his fascination for unfolding series is perfectly complemented by pagination. The book's title reports the system within. *Four Basic Kinds* begins by visually presenting the full system like a table of contents.

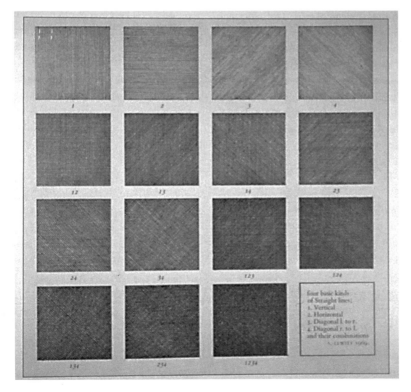

FIG. 47. Sol LeWitt. *Four Basic Kinds of Straight Lines and Their Combinations.* 8 x 8

242. "Sentences on Conceptual Art, 1968," published concurrently in *o.9,* a magazine edited by Vito Acconci; and in *Art-Language* 1, no. 1 (1969); reprinted in Ursula Meyer, *Conceptual Art* (New York: E. P. Dutton, 1972), 175.

243. From interview with Ursula Meyer; reprinted in Lucy Lippard, *Six Years: The Dematerialization of the Art Object from 1966 to 1972…* (Berkeley, Los Angeles, London: University of California Press, 2nd edition, 1997), 126. Seth Siegelaub and John Wendler produced *The Xerox Book,* which was also known by the names of its contributors: *Carl Andre, Robert Barry, Douglas Huebler, Joseph Kosuth, Sol LeWitt, Robert Morris, Lawrence Weiner.*

The reader sees that after the four initial directions, the line patterns lay one atop another in every possible combination, totaling fifteen. Then, like a maestro conducting a performance, LeWitt unfurls each combination, one page at a time, in a progression whose density and color deepens from grayed lines to a blackened square filled by lines from all directions. Despite their controlled appearance, LeWitt's systems do not subscribe to preconceived conclusions. Instead, he leaves them to chance, selecting parameters to put into play, then witnessing their development in line, color, and shape.

Conceptual artist Lawrence Weiner proclaimed, at about the same time as *Four Basic Kinds* appeared, that, "Without language, there is no art," after which he abandoned painting to write terse statements collected in notebooks or in books that began with *Statements* (1968), published by Seth Siegelaub. The book is small, slim, and affordable; each of the 1000 copies cost just $1.95. Within unpretentious covers, texts occupy bold and black masses of sans serif type, and text blocks form through arbitrary line breaks that ignore grammar and readability. The statements do not end with periods, but float on the page, suggesting materiality yet refusing linguistic closure.

Weiner and LeWitt participated in the best-known Conceptual publication of the period, *The Xerox Book* (1968). *The Xerox Book's* seven artists were each allotted twenty-five pages, the only stipulation being that their work somehow engage the copier medium. Line and dot, edge and frame, light and toner: they used deceptively simple means to investigate formal properties. *Xerox Book* diverts the ordinary book's "habit of reading"[244] into a Conceptual byway, where one encounters language but not narrative, imagery but not illustration, in contents that are typically self-referential and inscrutable. Instead, the book's properties of sequence and time, the copier medium's inherent replicated product, and the invented systems of notation that refer to those properties comprise a reconceived "operation and habit of reading" that highlights the awkward intersection of art with commercial technologies.

The *Xerox Book* was also influential as a portable format that could be experienced in other places and times; it was touted as a revolutionary means of exhibiting. The efforts of Siegelaub to bypass galleries and to alter the conventional means of art reception demanded ephemeral or non-art presentations and formats. In 1969 he explained that, "The use of catalogues and books to communicate (and disseminate) art is the most neutral means to present the new art. The catalogue can now act as primary information for the exhibition, as opposed to secondary information *about* art in magazines, catalogues, etc., and in some cases the 'exhibition' can be the 'catalogue.'"[245]

Artists sought out art vehicles embedded in public life because of their potential to affect that public.

The dematerialization of art carried political as well as aesthetic ramifications, although political content in Conceptualism was comprised primarily of a quiet rebellion in its use of non-art formats. As Lucy Lippard later described it, "Communication (but not community) and distribution (but not accessibility) were inherent in Conceptual art. Although the forms pointed toward democratic outreach, the content did not."[246] Books, however material, answered the need for art forms because of their ease at bypassing the museum. Conceptual art is unimaginable without artists' books.

244. Susi R. Bloch, *The Book Stripped Bare: A Survey of Books by 20th Century Artists and Writers* (Hempstead, Long Island, New York: The Emily Lowe Gallery and The Hofstra University Library, 1973), n.p.

245. *Studio International* (London), vol. 78, no. 917 (December 1969): 202. Some critics took issue, however, with Siegelaub's claim of a neutral curatorial stance. Irving Sandler reported that in 1969 Siegelaub mounted a show of conceptual work in rented office space, the installation simply being the artists' catalogues set out on a coffee table. Critic Jack Burnham caustically observed that: "Siegelaub was one of the best artists in it. The others he presented are 'subcontracting to his prime contract as a data organizer.'" Sandler, *American Art of the 1960s,* 354–55.

246. Lucy Lippard, "Escape Attempts," in *Reconsidering the Object,* 31.

THE SCULPTURAL BOOKWORK

[The box] is a form that most of my contemporaries did not consider an important
form. I selected it partly for that reason; that it was virginal, to a certain extent. [247]

—LUCAS SAMARAS, 1972

THE CAPTIVE BOOK: THE BOOK AS BOX

The sculptural bookwork defies Ed Ruscha's expectation that "The way [artists' books are] supposed to be seen…is when someone hands someone else just one book at a time and place where they don't expect it." [248] Sculptural bookworks are seldom handled. In the 1960s, the wildly variable works that fall within this category investigate the artistic possibilities of the book and its related format of the box. In this period few Americans consistently worked with books sculpturally, but one who did was Lucas Samaras.

Samaras is important for his obsession with the altered box and book. Unlike the subtlety of Joseph Cornell's earlier transformations, Lucas Samaras takes the book-as-box captive, invading it in the spirit of a maddened operatic performer. He invests it with autobiographical intimacies, then belies those intimacies with a denial of touch that borders on the sadistic. In 1960 Samaras made his first box, and by 1962 he had altered his first book. [249] His forté was a box engorged with suggestive objects, such as *Box #1* (1962), whose lifted lid suggests an opened book. Opened it may have been, but most of Samaras's enclosures allow access to their arsenals only at the risk of physical harm. For example, *Book 4* (*Dante's Inferno,* 1962, fig. 48) permits only a teasing peek at pages infested with knife, scissors, and razor blade, as if Samaras hoped for them to pierce literary canons.

In 1968 his dealer, the Pace Gallery, suggested that Samaras produce a suite of prints. Instead, he chose to make *Book* (1969, fig. 49), which blooms with ninety-eight colors from screenprinting, offset, embossing, and thermography. The ten pages of *Book* shimmer with silkscreened dots that increase in size and lighten in value toward the back of the book. Biomorphic die-cuts pierce and shape the cardboard-weight pages like those of a children's book. The book begins with two cut-out hands. Lifting the hands reveals Samaras's face in negative, like the manifestation of an unconscious self. In opening the hands, the viewer is implicated, joined (if only through the book as intermediary) in Samaras's desires. Other autobiographical images and symbols proliferate—a thumb, a paintbrush—as if to insist upon his presence. Miniature books printed in tiny six-point type are dis-

247. Barbara Schwartz, "An Interview with Lucas Samaras," *Craft Horizons* 32, no. 6 (December 1972): 41.

248. Quoted in Barendse, "Ed Ruscha: An Interview," 10.

249. Kim Levin, *Lucas Samaras* (New York: H. N. Abrams, 1975), 26, 40.

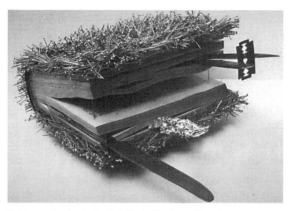
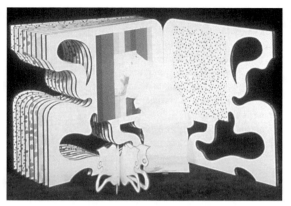

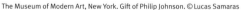

The Museum of Modern Art, New York. Gift of Philip Johnson. © Lucas Samaras Published by Pace Editions, New York. © Lucas Samaras

covered within pockets and envelopes, invoking a nostalgic sense of furtive delight in the reader, like a child sneaking a cookie. Whimsy soon gives way, however, to the uneasy subtexts that lurk within. Samaras's stories are infested with sexuality, obsession, and violence, enacted by characters such as *Dickman* and *Shitman*.

When Samaras made *Book* he had already gained fame for his chilling, pin-covered sculptural bookworks, so perhaps his choice to publish a bound book instead of a suite of prints was not surprising. And what of a connection between Samaras and Joseph Cornell? Samaras's own visual solutions—so tactile and yet so terrifying—could not be further from Cornell's whimsical book alterations, or even Cornell's more unsettling book incisions and confinements. The more likely soulmate for Samaras was John Latham (discussed below), whose dismembered books Samaras encountered in the *Assemblage* show at the Museum of Modern Art in 1961.[250]

The box format could also adopt a bland, workaday character far removed from Samaras's intimidation. Robert Morris made *The Card File* (1962, fig. 50), for example, from a metal file. The cards are indexed and cross-referenced by categories of process and time, their contents describing the making of...*The Card File*. This impression of order is undermined by the contents' digressions, as when a heading, "Decisions," is followed by: "12/3/62, 5:00 a.m. Definitely unable to decide what would constitute a 'Delay' other than the inability to decide (see 'Delay')." The cards rebel against their fixed order with contradictory statements that intersect and reference one another within a self-reflexive web.

Artist Dan Graham wrote about *Card File* in a 1967 *Arts* magazine article, "The Book as Object." Graham described *Card File* as "both object and linguistic system," and referred to a work by Mallarmé that

FIG. 48. (top left)
Lucas Samaras.
Book 4 (Dante's Inferno).
Mixed media. 5³/₄ x 11⁵/₈ x 9³/₈

FIG. 49. (top right)
Lucas Samaras.
Book.
Thermography in 98 colors, collage-mounted on die-cut masonite panels.
10 x 10 x 2

250. Levin, *Lucas Samaras*, 40. Samaras's influence was unremitting in the latter half of the twentieth century. For example, his first one-person show occurred at the Dwan Gallery in 1964–65 in Los Angeles, the same year that his work appeared in the Whitney Museum Biennial. An *Artforum* review of the Dwan show noted his "relentlessly brutal" *Book No. 8*. Nancy Marmer, "Los Angeles," *Artforum* 13, no. 4 (January 1965): 11–12. In 1972 a Whitney Museum exhibition included *Book* along with altered boxes and books by Samaras—several of which were pictured in the accompanying catalogue.

251. Graham described the Mallarmé work as: "A projected 'Book,' whose multi-dimensional structure was to be realized in a planned series of meetings (performances) [and that] was sketched by Stéphane Mallarmé in notes recently discovered dating from as early as 1866. The physical apparatus was to consist of six boxes, diagonally placed, each to contain six movable sections." Dan Graham, "The Book As Object," *Arts Magazine* 41, no. 8 (Summer 1967): 23.

the poet had described in 1866.[251] In so doing, Graham suggested a European paternity for the still-emergent sculptural bookwork. The format of *The Card File*—booklike but not a book— coexists with related formats that touch upon ideas about container, information, and documentation. Like a cousin to *Card File, Blood of a Poet Box* (1965–68, fig. 51), by Eleanor Antin, also organizes information, but her findings are organic, gathered from one hundred poets and smeared on glass slides arrayed in a specimen box. As a compendium, the work's tiny glass sheets and even its informational content (names of the poets on the slides, handwritten key on the lid) approximate a poetic encyclopedia—but this one is written in blood, life's most precious substance, and not yet burdened with the tragic connotations of HIV. Antin did not present *Blood of a Poet Box* as a book-related work. Still, the bookish hybridity of the work is compelling. Antin's work suggests parallels to works such as Duchamp's *Boîte-en-valise* and Rauschenberg's *Shades* (1964), two other compendiums of specimens, the first autobiographical and the second visual.

FIG. 50. Robert Morris.
The Card File
47 x 10½ x 2

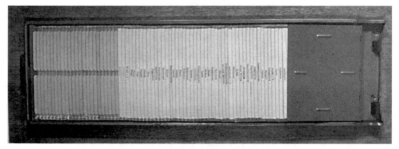

The Pompidou Museum, Paris. Courtesy Dwan Gallery, New York. © 2005 Robert Morris/Artists Rights Society (ARS), New York

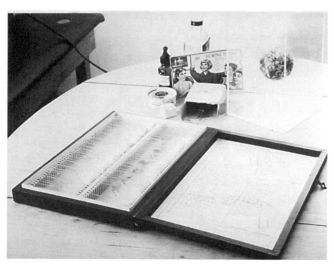

FIG. 51. Eleanor Antin.
Blood of a Poet Box
11½ x 7¾ x 1½

Collection the Artist. Courtesy Ronald Feldman Fine Arts, New York

THE APPROPRIATED BOOK

Joining the box, a second trend in 1960s' sculptural bookworks was the appropriation of the book object itself as content, freeing the book from specifics of title and author. American awareness of book metaphors deepened with some of the works on show in *The Art of Assemblage* exhibition at the Museum of Modern Art in 1961. In the catalogue, organizer William C. Seitz defined assemblage as collages, objects, and constructions that share two conditions: "1. They are predominantly *assembled* rather than painted, drawn, modeled, or carved. 2. Entirely or in part, their constituent elements are preformed natural or manufactured materials, objects, or fragments not intended as art materials."[252] At that time, books constituted non-art materials. Seitz's primary aim was to inject assemblage works in the canon of the art world, so he related the assemblages to avant-garde precursors, which included *Unhappy Readymade, Boîte-en-Valise,* and other readymade replicas by Duchamp, as well as boxes by Cornell.

Shem (1958, fig. 52), by John Latham of London, uses books to dramatic effect. The work holds splayed and twisted books, envelopes, and other materials that were mutilated and adhered onto a burlap-covered door, the whole pierced with copper wire and painted. Latham stated that his use of books arose from formal concerns with the objects themselves; he was attracted to books for the "dynamic" element of the black on white that printed books contained, as well as for the "energy" that books represented as concentrated "accretions of different orders of 'memory.'"[253]

Books, for Latham, symbolize cultural hegemony, and so by altering and defacing books he symbolically undermined that authority. His defacements suggest a malevolence foreign to the detached irony of Duchamp's *Unhappy Readymade* or Cornell's book incisions. Latham wants to trigger an explosive response more symptomatic of the anarchism of the 1960s. Latham twisted the Mallarméan book into a disfigured scold railing against the society of the late 1950s.

As shocking as Latham's assemblage appeared to an unprepared viewer, its impact could not have competed with Dieter Roth's *Poetrie* (1967) nine years later. The contortions that Latham forced upon

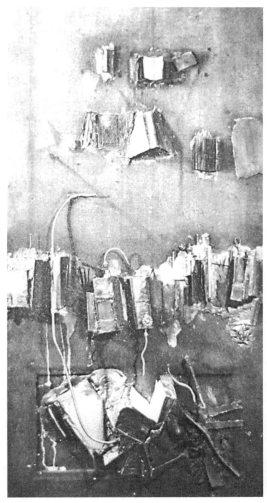

FIG. 52. John Latham. *Shem* 8'4" x 4"

Museum of Modern Art, New York

127

252. William C. Seitz, *The Art of Assemblage* (New York: The Museum of Modern Art, 1961), 6.

253. Interview with John A. Walker, "John Latham, Books for Burning," *Studio International* 200, no. 1018 (November 1987): 26.

books join here with Roth's Fluxus fascination for organic process. *Poetrie*'s "pages" consist of sealed plastic bags containing an orange substance, and a Plexiglass cover and spine. Roth drew a cheese wedge on one page to identify the contents, which are no longer recognizable from decay, and probably were a mystery even in 1967: who would have thought to put cheese into a book? *Poetrie* preceded even Ruscha's *Stains*.

The extensive text in Roth's book (mostly in German) consists of a series of random thoughts or aphorisms, numbered from one to 301. The last text reads: "301. It is two o'clock in/the morning/c'est parfait/ of course/d'accord/pardon/o/k!" In *246 little clouds* (1968), another book with numbered contents, Roth incorporates the act of making it into its design in a manner that undercuts trade publishing's conventions. The overexposed photography of the originals produced grayed pages that reproduce wrinkles, tears, and other imperfections. *Poetrie* extends that strategy into the very substance of the book, this process an organic cycle of the aging cheese. Evidence of bookmaking craft, that handmaiden to book art, was shunted aside so that *Poetrie* could incite in the viewer a mix of curiosity and revulsion, tokens of Roth's aesthetic.

ADDITIONS AND SUBTRACTIONS

I had never heard of W. H. Mallock and it was fortunate for me that his stock had depreciated at the rate of a halfpenny a year to reach the requisite level. I have since amassed an almost complete collection of his works and have found out much about him. He does not seem a very agreeable person....However, for what were to become my purposes, his book is a feast. I have never come across its equal in later and more conscious searchings. Its vocabulary is rich and lush and its range of reference and allusion large. I have so far extracted from it over one thousand texts, and have yet to find a situation, statement or thought which its words cannot be adapted to cover.[254]
—TOM PHILLIPS, ON *A HUMUMENT*

254. *Tom Phillips: Works and Texts* (London: Royal Academy of Arts, and Stuttgart and London: Edition Hansjörg Mayer, 1992), 255.

255. I am grateful to Betsy Davids for suggesting Charles Olson's poetry in light of *A Humument*.

In addition to booklike boxes and books as appropriated art material, a third trend in sculptural bookworks consists of altering the page. That strategy became associated with one artist because of his exhaustive and ongoing devotion to a single book. In 1966 British artist Tom Phillips ran across *A Human Document,* an 1892 Victorian potboiler by W. H. Mallock, in a London bookstall. He bought it for threepence, rechristened it *A Humument* (1966–73, fig. 53), and began a seven-year odyssey of alteration to its 364 pages. Phillips deleted texts through scoring, typing, and collage, and he painted on the page. His textual amalgam alludes to writers (Shakespeare, Ovid, E. M. Forster, Somerset Maugham) in collaged references that Phillips

said were inspired by William Burroughs's cut-up newspaper copy montages. Phillips even adds a central character to the story, Bill Toge, whose efforts to garner happiness are affected and commented upon in turn by Toge's alter ego. Finally, Phillips ignores the original timeline of the book, excising and reconfiguring page sequence to best serve his own anti-narrative.

The imagery in the book proliferates in a mélange of styles from Pop to Italian Futurism and German Expressionism to the medieval illuminated manuscript, with much drawing on the page not necessarily related to the story. The reconfigured texts emerge with a striking visual presence reminiscent of the *calligrammes* of Apollinaire and the activated space of Mallarmé. A contemporary parallel may be the "open field" poetic style of Charles Olson, in which the placement of each poetic line responds to the poet's oral, even physiological intent.[255] Like a postmodern Blake, Phillips "extended his editorial empire far beyond the confines of the novel."[256] As a final irony he visually links the pages via "rivers" of erasures (a typographical faux pas) that spill white space amongst text and imagery.

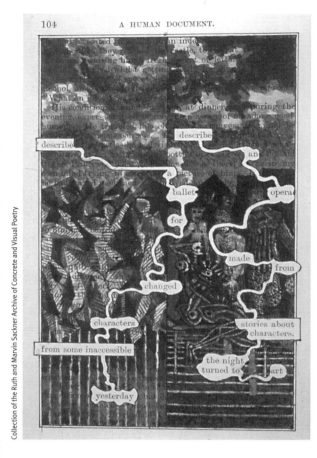

Collection of the Ruth and Marvin Sackner Archive of Concrete and Visual Poetry

FIG. 53. [CP7] Tom Phillips. *A Humument* 7³/4 × 6

The immediate influence exerted by *A Humument* is difficult to ascertain. No American works of the period display the same level of obsessive imbrications, although works that reflect a similar engagement with the page soon appeared in the works of Keith Smith and others. Still, *A Humument* attracted notice. It was first issued in installments: in a 1972 limited edition facsimile by Tetrad Press, and then in the first of several commercial facsimiles, beginning in 1980.[257] Daniel Traister relates that, "In a 1974 notebook entry, Phillips recalled the 'cult following' that *A Humument* achieved during the years when, 'in the form of graphics and excerpts' it appeared in various magazines. Most such periodicals, academic or avant-garde in nature, lacked either the circulation or the financial backing necessary to support adequate printing. Therefore they could only present their readers with a view of Phillips's which was at best a shadow of the work he was in process of evolving."[258] Artist's book collectors Ruth and Marvin Sackner of Miami Beach first saw *A Humument* in

256. Hubert and Hubert, *The Cutting Edge of Reading: Artists' Books* (New York City: Granary Books, 1999), 75.

257. Ian Tyson of Tetrad Press, in Cathy Courtney, *Speaking of Book Art: Interviews with British and American Book Artists* (Los Altos Hills, California: Anderson-Lovelace Publishers, 1999), 31.

258. Daniel Traister, *Human Documents: Tom Phillips's Art of the Page* (Philadelphia: University of Pennsylvania, 1993), 19.

the 1975 Basel (Switzerland) Kunsthalle, and immediately championed his work; in fact, Sackner later wrote that the two strongest influences over their extensive collection were the "visual-verbal works" of Phillips and the avant-garde bookworks of Russia.

PERFORMANCE AND INSTALLATION BOOKWORKS

It was not in any degree a gesture of contempt for books or literature. What it did intend was to put the proposition into mind that perhaps the cultural base had been burned out.[259]

—JOHN LATHAM, ON THE BURNING OF HIS SKOOB TOWERS

What alterations and desecrations have not yet befallen the artist's book? Fire, for one. The performance and installation bookworks of the 1960s were exercises in extending an idea out to its surreal extreme. Most infamous were the performances of John Latham, called "SKOOB Towers" ("books" reversed), that began in 1964. Unlike Duchamp's *Unhappy Readymade,* which was slowly obliterated by natural forces, Latham wanted to deliver a more immediate message. He built a SKOOB Tower near the British Museum, which also housed the British Library, and then set the books afire, also igniting a public outcry. To Latham, books represented not a gateway to intellectual expansion but the residue of a closed and contrived system of "knowledge" that upheld a network of political and economic interests. He emphasized in a later interview that he built his towers from encyclopedias because they represented the "fixed mode of knowledge" to which he objected.

A second work of Latham's ended up residing on U.S. soil. Like *Poetrie,* by Roth, Latham's *Art and Culture* (1965, fig. 54) coexisted as book and process, inert yet organic. It began as an attack on the Formalism of Clement Greenberg, who argued in *Art and Culture* (1961) that painting progressed toward greater "purity" when an artist focused on properties such as color, scale, composition, and stroke. The artist was meant to pursue that purity much as an existentialist searched for absolute truths. Abstract Expressionism represented Formalism's apex. With that argument, Greenberg enjoyed nearly hegemonic influence in the art world, conferring star artist status and otherwise defining (and so controlling) perceptions about contemporary art.

What better target, then, for dethroning formalism than *Art and Culture?* Latham borrowed a copy of the book from the library at St. Martin's School of Art in London, where he taught part-time. Then he organized a "STILL and CHEW" event at his home, where he and his guests chewed pages from the book ("consuming" its contents), then dropped the remains into a 30% sulfuric acid solution that eventually

259. Walker, "John Latham: Books for Burning," 28.

rendered a distilled liquid. Latham and his friends thus appropriated and resituated art's discourse, along with the idea of a gatekeeper's control of an art world edifice. When the library recalled the book several months later, he presented the library with a transformed "distillation" of Greenberg; the next day Latham was fired. He promptly responded by housing the bottle and his dismissal letter in a leather case, in the spirit of Duchamp's *Boîte-en-valise*. He then sold *Art and Culture* to the Museum of Modern Art in New York.

No 1960s bookwork artist in the United States approached the theatricality of Latham's fiery SKOOB Towers. *Words* (1962), by Allan Kaprow, merged the spontaneity of his happenings (from 1958 on) with the kinetic energy of Action Painting. Action Painting was a term applied to American Abstract Expressionists such as Jackson Pollock, to describe a painter's spontaneous application of paint to canvas. Pollock moved as in a dance around a canvas on the floor, pouring and dripping paint to create a calligraphic layering of brushstrokes that was believed to mirror the artist's conscious state. Kaprow's *Words* engulfed the viewer not in a painted surface but in a dynamic "written environment,"[260] where words and sentence fragments were meant to mirror the energy and dynamism of the street. In one room, the walls teemed with writings, and paper streamers hung from the ceiling. Red and white lights blinked on and off, and recorded voices murmured. In an adjacent room, streamers, chalk, and lipstick awaited the contributions of visitors.

Unlike the refusal of reading implied by "deviant" bookworks such as those by Samaras, Kaprow wished with *Words* to free text from the typographic constraints of the page and expand the act of reading outward into a layered and associative environment, to be entered, heard, and perhaps modified. Kaprow recreated *Words* at the Museum of Contemporary Art in Chicago in 1967. Critic Harold Rosenberg commented that "the public as a collective collaborator in works of art is notoriously lacking in talent, and it was unlikely that Kaprow's booth would be any more interesting at the end of its engagement than it was at the start."[261]

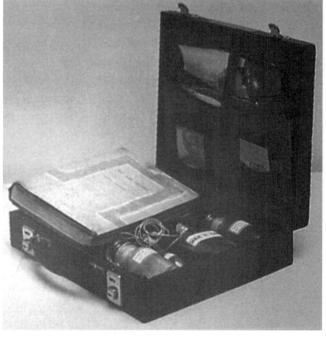

Museum of Modern Art, New York (Blanchette Rockefeller Fund)

FIG. 54. John Latham. *Art and Culture* 3 1/8 x 11 1/8 x 10

260. Lawrence Alloway, "Artists as Writers, Part Two: The Realm of Language," *Artforum* (1974), 33.

261. Harold Rosenberg's review of the exhibition was originally written for *The New Yorker*. Rosenberg, *Artworks and Packages*, 148.

The book-as-environment recurred in the 1960s, at the scale of Kaprow's room and at the smaller pedestal size of Rauschenberg's *Shades*. Perhaps this desire to be inside of a book was merely an intermedial extrapolation from the idea of the book-as-a-world. Alison Knowles took the next logical step with *The Big Book* (1967–69, fig. 55), on show in Chicago along with *Words*. Knowles adopted a human scale, like Kaprow, but Knowles's work was recognizably booklike: eight feet high, four feet wide, and eight "pages" deep, with castors supporting pages hinged to a spine of galvanized steel. Knowles filled *The Big Book* with homely conveniences, including a typewriter, hotplate, and even a toilet amid the silkscreened photographs, lights, and paintings. Tapes played back the sounds of the construction of *The Big Book*. This womblike environment could incubate a writer as the writer wrote about being in a book while caught in the mirror of a mirror of a book. Harold Rosenberg, when confronted with *The Big Book,* could only marvel in homage to the book's expanding artistic

FIG. 55. Alison Knowles.
The Big Book

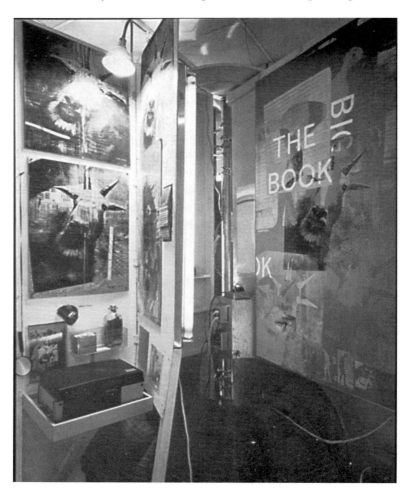

identity. Rosenberg praised the work as "a physical metaphor that literally contains everything. It is the story of the artist's life presented through copious samples of [Knowles's] domestic and cultural surroundings."[262]

If any pretense remained of the book's untouchable cultural eminence, it soon vanished behind cheesy pages, menacing knives, and flaming SKOOB towers. The eruptions and conflagrations of the 1960s devoured the book, engineered by artists hungry to appropriate, incise, or explode it into room size, their iconoclastic strategies commensurate with the book's own cultural prominence.

How can the art world's subjugation of the book be explained? Sociologist Howard Becker used combative terms to describe the usurpations, where artists "invade...an established crafts world" and, on the prowl for new media, forage and pillage, violating standards of production, to instead apply "aggressively nonutilitarian standards" to create "objects of aesthetic contemplation, as objects of collection and ostentatious display, and as items of investment and pecuniary gain."[263]

Book artists, however, remained largely invisible in the 1960s, even to each other. Few cooperative links existed at this time. Distribution, patronage, and critical reception remained a dream for bookwork artists, although fine printers and deluxe book artists enjoyed rudimentary support networks. In the public eye, the book was persistently viewed as a vehicle—an art vehicle, perhaps, but still a mere housing for text or for prints. This period of the artistic discovery of the book in America generated enthusiasm that expanded in the 1970s with the recognition of the identities of artist's book and book artist, and finally moved the book beyond the status of a mere vehicle for information to that of an artifact.

262. Ibid., 150.

263. Becker, *Art Worlds,* 278.

IV

THE 1970S: EXPLOSION

Every book of the new art is searching after that book of absolute whiteness, in the same way that every poem searches for silence.[264] —ULISES CARRIÓN, 1975

The principal difference between the book hack and the book artist is that the former succumbs to the conventions of the medium, while the latter envisions what else the book might become.[265] —RICHARD KOSTELANETZ, 1977

Art it may be; reading it ain't.[266] —ABE LERNER, 1978

THE FINE PRESS BOOK

Behind the archetype of printing stands the archetype of writing; and behind the archetype of writing stands the archetype of the Word, the root source of our evaluative instinct, the expressability of our deepest attestation of significance, what we make of our lives.[267] —WILLIAM EVERSON

Instead of collectibles we have produced our own lives, lives which are their own satisfaction, not defined by exchange for money, power, or the trappings of a glorious career.[268]

—FRANCES BUTLER

OUT OF THE CRADLE

To describe American book art in the 1970s as a decade of explosion risks dismissal as cliché or overstatement. Still, the range and multiplicity of creative invention and organizational expansion concentrated within book art of the period demands it. Perhaps "explosion" can be clarified as contained within the domain of an emerging art form, in a loose-knit community where booklover and book artist, writer and collector overlapped. In this world, the proliferation of work and the rudimentary efforts at organization, exhibition, and criticism started an art world in which the different needs of the fine press book, the deluxe book, and the bookwork could just as easily collide as converge. This story of the headlong growth in books and artists in the 1970s will be told in the next six chapters.

The three epigraphs that open this section capture the range of insight and opinion in a decade characterized by debate. Ulises Carrión described a search for the perfect communion between reader and book as achieving a state of "absolute whiteness," where the messenger disappears and the message takes root. His poetic analogy contrasts with the urge of Richard Kostelanetz and others to seek clarity amidst a chaotic diversity by defining what a book artist was and was not. The pithy dismissal by Abe Lerner also deserves attention, because it summed up the concerns of those protectors of fine printing, the admirers of historical typography. In the field as a whole there was no single guiding voice, but rather several competing conversations at once, with no agreement as to what an artist's book should be.

In the 1970s, a literary text remained the primary content of fine press books as a whole, and fine printing flourished across the U.S. Printers such as Harry Duncan continued to teach book design in which, as he said, "An appropriate book...should *become* the text, and therefore exist as it communicates."[269] Poet and printer Clifford Burke, of Cranium

264. Carrión, "The New Art of Making Books," in Lyons, ed., *Artists' Books,* 38.

265. Richard Kostelanetz, "Book Art," in *Wordsand* (Burnaby, British Columbia, Canada: The Simon Fraser Gallery, Simon Fraser University, in cooperation with New York: RK Editions, 1978), 51.

266. Abe Lerner, "Assault on the Book, A Critique of Fine Printing at Private Presses in the U.S. Today," *Private Library* I, no. 4, 3rd series (Winter 1978): 169. Review of *Out of the Cradle, Endlessly Rocking,* by Richard Bigus.

267. William Everson, Introductory essay, *The Printers' Chappel of Santa Cruz* (California: Printers' Chappel of Santa Cruz and Santa Cruz City Museum, 1986), n.p.

268. Frances Butler, Preface, in *Trance and Recalcitrance: Twenty Years of Poltroon Press, The Private Voice in the Public Realm* (San Francisco: Edizione Velocissime Faville: Pacific Center for the Book Arts in association with the Friends of the San Francisco Public Library, 1995), 6.

269. Duncan, "The Cummington Press," *Doors of Perception,* 14.

Press in California, published a quarterly poetry journal titled *Hollow Orange* and chapbooks of poetry, such as *Redwood Haiku and other poems,* by Lew Welch (1972), which includes a drawing by Magda. Printer Henry Morris, of Bird & Bull Press in Pennsylvania, often published his own writings, such as his essays on papermaking, publishing, and printing history, presented in *Bird and Bull Pepper Pot* (1977), which is bound in Morris's own decorative paste papers.

Other books of the 1970s heralded the decisive move of fine art into fine printing. The influence of fine art appeared in a visual prerogative that determined a book's character. *Out of the Cradle Endlessly Rocking* (Labyrinth Editions, 1978, fig. 56), for example, contains poetry by Walt Whitman that was gathered by printer Richard Bigus into shapes that direct the reader's eye. A repeated word plunges diagonally down a sheet of pristine Japanese Hosho paper:

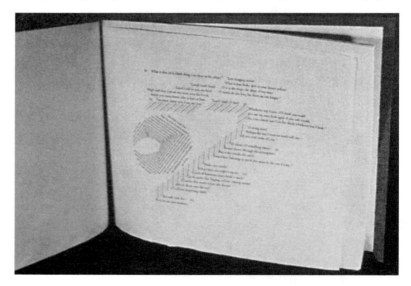

FIG. 56. Richard Bigus.
Out of the Cradle Endlessly Rocking
19 x 24

"endlessly endlessly endlessly." To its left, the title of the poem spins in upon itself like a gyroscope. To its right, the poem bursts across the ribbon of "endlessly"s as if propelled by centrifugal energy.

Walt Whitman's poem passionately exults: "O throat, O trembling throat!/Sound clearer through the atmosphere!/Pierce the woods, the earth,/Somewhere listening to catch you must be the one I want." On every sheet the whirling title repeats like a necessary generator of the stanzas. Richard Bigus printed Whitman's poem in five colors on ten sheets of paper, then slipped each sheet within a folded transparent paper sleeve bound into gray clothbound covers. The format allows the sequential viewing of a bound book, as well as the removal of sheets for wall display.

In 1978 *Out of the Cradle* signaled the growing presence of the fine press book-as-artifact, a product of the continued expansion of studio art into fine printing. As a symbol of that change, *Cradle* generated cries of both praise and reproach. Reviewer Abe Lerner pronounced the work as Abstract Typography, and judged its "appeal [as limited] only to the *viewer*....The *reader,* confounded, confronts lines of poetry irregularly arranged, festooned with patterns of words and phrases disjointed, disconnected from their sentences."[270] By associating Bigus's typography with modern art, Lerner meant to emphasize its distance from book culture; such a work "must be filed under A for art, not B for books."[271] Yet Lerner also praised the pages of the book as "fascinating to look at, with their skillful combination of rich individual elements—Centaur type, Japanese paper, lovely colours, and superb presswork—all handled with great artistic feeling."[272] Just handsetting the type for such a complex, allover design constituted an achievement. Lerner ultimately concluded that Bigus represents the "ambition [for] the typographer to be an artist," and so conspires in what Lerner fears to be "the impairment of respect for the book."[273]

Bigus did not deny an ambition to approach fine printing as a fine art. In response to a similar critique of a later book, he proposed a manifesto for a new fine press book, one designed

> to make the reader aware of the significance of the literature and the language. Throughout the process of design....I saw the entire paper surface not as space but as form....To an artist or poet, the book represents a vehicle with which s/he can communicate using a sequence of colours, forms, shapes, textures, proportions, words, etc. without ever necessarily signifying a thought or representing an object....The book is a tool with unlimited artistic possibilities that our modern aesthetic has misunderstood because of its utilitarian historical function. Electronic communication technology is relieving the book of its ancient burden; for this reason the fine press book is becoming a medium for artistic expression in multiple editions.[274]

As a poet, Bigus invested language with power. As an artist, he absorbed early avant-garde typography from travels in Europe and from poring over *Kontext* magazine, and *Pioneers of Modern Typography* (1969) by Herbert Spencer. Bigus did not seek to reify the power of poetry in conventional typography, but rather to visually embody a poem's emotional flux. He shared an appreciation of the striking effects of typographical infractions with the Futurists, the Constructivists,

270. His emphasis. Abe Lerner. "Assault on the Book," 169.

271. Ibid.

272. Ibid. Bigus recalled that, "Abe Lerner purchased all of my books that he criticized. He always said that he respected my work in large part because I published good literature. He represented an era and his options and views were often brushed off by my contemporaries as simply out-of-date and old-fashioned but I took to heart a lot of what he said and re-evaluated aspects of my work because he was sincere." Author email interview with Bigus, June 22, 1998.

273. Ibid., 168, 170.

274. Richard Bigus quoted by Lerner, "Assault on the Book," 167–68. Bigus writes in response to criticism of his 1977 book, Pablo Neruda's *Ode to Typography*, which incorporated a striking zigzag typographical design.

and visual poets such as Apollinaire. (In fact, the typographical inter-play of *Out of the Cradle* reflects the spirit of the calligrammes of Apollinaire pictured in Spencer's book.) When Bigus described the physical and cultural transformations of the book in a language simi-lar to that of Mallarmé and McLuhan, he was realigning fine printing into a vital artistic practice for his generation, with the artisan now identified as an art worker.

Bigus also helped to produce *Granite and Cypress* (1975, fig. 57), a key work that represents the maturing of the fine press–deluxe hybrid. It was designed and printed by William Everson, who had left the Dominican Order and his identity as Brother Antoninus in 1969 to marry, and then taught printing (from 1971) at the University of Cali-fornia–Santa Cruz. By the 1970s, Everson had achieved a larger-than-life stature from his poetry, his printing, and his personality.

In *Granite and Cypress*, Everson printed a selection of the poetry of Robinson Jeffers, with the help of students, including Bigus. Print-ing at the Lime Kiln Press on a hand press donated by the Allens, Everson again chose the New Style type by Frederic W. Goudy that he had used in *Novum Psalterium* twenty years earlier. He chose the type because he believed that Goudy based its design on a tenth-century hand-lettered English Psalter. To complement that typographical her-itage, Everson used Castellar initials whose elegant lines recalled hand-drawn versal capitals. Everson created an oblong book format, whose wide pages allowed the rich mystical language of Jeffers to ap-pear as the poet wished, "like the pulse and withdrawal of the tides."[275] Unimpeded, the long lines unroll across the page: "The clapping blackness of the wings of pointed cormorants, the great indolent

FIG. 57. William Everson. *Granite and Cypress;* artist, William Prochnow. 12⅝ x 17⅜

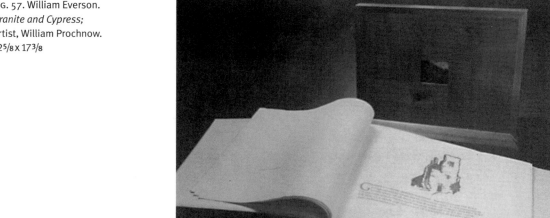

planes / Of autumn pelicans nine or a dozen strung shorelong, / But chiefly the gulls, the cloud-calligraphers of windy spirals before a storm, / Cruise north and south over the sea-rocks and over / That bluish enormous opal...."

The wide page also encourages a more leisurely paging. In extending its width into a dominant element, however, Everson then faced an expanse of blank versos. To resolve the dilemma, he turned a negative into a positive in a manner that thrilled or disturbed the reader: he skip-fed the dampened English Hayle paper.[276] The skip-feed resulted from a second pull through the press that left a ghostly reverse imprint of itself on the sheet, offset from the backup, so that in the finished book the reader read a stanza on the verso, then turned the page to see its reverse reflection on the verso, like a whispered echo. To house the book Everson again surprised the fine press world by covering the book's foldover boards in natural linen, leaving the spine as a strip of wood that is open-laced with deerskin rawhide. A wooden box of polished Monterey cypress serves as the slipcase, its center marked with a granite inset (Jeffers wrote the poems while building his Tor house and Hawk Tower with granite from his own quarry).

At $250 per copy (a steep but not exorbitant price), *Granite and Cypress* sold out in advance of publication. With only a few reservations, Abe Lerner accorded it "one of the finest books given us by the American private press movement,"[277] and in a review the eminent Joseph Blumenthal pronounced the skip-fed strategy of Everson a "revolutionary and wonderfully satisfying solution"[278] to the problem of the blank versos, a solution that set up a tension between the violation of fine printing rules and Everson's own masterful printing skill. The scale and sensuousness of the slipcase suggests the drama of a deluxe book, and yet the literary astuteness and printing ability of Everson left no doubt of his fine press allegiance. The fact that Everson's innovations received such accolades (and support from collectors) no doubt encouraged other printers to consider the use of unconventional techniques and materials.

Within the West Coast book community, Everson embraced an identity as a metaphysician of language and the book. In a like spirit, Richard Bigus later proclaimed a vision of the book as a gateway, its destination alterable, its parts artistic properties, its "paper surface not as space but as form." No matter how astonishing was Everson's use of skip-fed pages, Bigus's rejection of typographical norms posed the greater challenge to the book as a literary vehicle, prompting one letter writer to brand him a "bibliophilic Quasimodo."[279] And yet to today's eyes, schooled in the layerings and interruptions of the typography of the 1980s and 1990s, Bigus's pages appear readable and even

275. William Everson, book prospectus, quoted by Lee Bartlett, *William Everson: The Life of Brother Antoninus* (New York: New Directions, 1988), 230–31.

276. Everson first used the skip-feed method in *A Man Who Writes,* the last work printed before his departure from the Dominicans. Michael Peich, "William Everson: Fine Printer," 36–48.

277. Lerner, "Assault on the Book," 161.

278. Joseph Blumenthal, untitled review, *Fine Print* 2, no. 2 (April 1976): 27. Blumenthal also included the book in *The Printed Book in America*.

279. Letter from fine printer Henry Morris that takes issue with the positive review written by William Everson, of Bigus's *Ode to Typography. Fine Print* (vol. 4, no. 3, July 1978): 80.

somewhat restrained. Everson and Bigus revisualized the literary fine press book, even as Lerner lamented a perceived loss of the poetic voice along with the loss of typographical restraint.

The appearance of *Granite and Cypress* in 1975 also marked the inaugural year of the San Francisco journal *Fine Print,* which became the voice of the maturing fine press community. The first issue of *Fine Print* appeared as a modest newsletter of eight pages, with Sandra Kirshenbaum, a former librarian and rare-books dealer, as its editor and publisher, joined by associate editors D. Steven Corey (a rare book librarian) and printers George Ritchie and Linnea Gentry. Its Open Letter from the Editors stated that its mission was to "view the fine printing scene, East and West, North and South, reporting on what the private and specialized presses are doing, and presenting accurate up-to-date bibliographic descriptions of their major works." A fine printer designed each issue and printed it letterpress. Four years later, *Fine Print* had metamorphosed into a substantial journal in an elegant 12" x 9" format, as if to emulate its respected predecessors, the *Colophon* or the *Fleuron.*

The strengths of *Fine Print* lay in its reviews of fine press and deluxe books and in articles on related aspects of book art. The ultimate impact of *Fine Print* on the evolving fine press and book art worlds is indisputable, as the only substantive U.S. journal. Its purview extended to selected books that incorporated innovations such as those of Everson and Bigus, and it also reported on some bookwork activities, such as the 1979 conference at Visual Studies Workshop (discussed below). But inevitably the focus of *Fine Print* on fine printing opened it to critiques of parochialism. Writing from the luxury of hindsight, printer Gerald Lange captured the strengths and weaknesses of *Fine Print* and reflected that the journal

> contributed to the growth of the [book art] phenomenon but seemed unaware of where it had all come from and where it was going, and its postulating of traditional values only clouded the question. Never queried was the idea that the renaissance and the new "fine press book" (and *Fine Print* itself) had originated as a natural evolvement of the turbulent sixties' small press movements, and that their impulse had more to do with the upheavals of this period than with the various practices or activities associated with the commercial or trade industries of printing or book manufacturing or, for that matter, with the various artistic and craft movements associated with the book from the 1890s through the 1930s.

While the artist's book is more exclusively a postwar development, the present-day fine press book is thought without a question, as a natural extension of the private press movement, to have a long continuum of activity, with its origins in the Renaissance (and more significantly, its rebirth at the turn of the century). The present-day fine press book's lineage to this heritage, however, is tenuous.[280]

Fine Print witnessed the final throes of metal type as it gave way to electronic photographic composition. In "Metal Type: Whither Ten Years Hence?"[281] Paul Hayden Duensing, typographic editor for *Fine Print*, recalled that by 1974, the commercial printing industry in America had transitioned from the hot metal of the 1960s to photographic composition (only to further alter in the 1980s with digital electronic imaging). In the 1970s a wave of discarded cylinder presses arrived on the used or scrap-metal markets, and most type foundries diversified, merged, or closed altogether. Quality metal type grew increasingly scarce, and fine press printers responded in alarmed disarray.

In imagining the future of fine printing, Duensing judged prospects dim for the survival of the most basic pleasures of a printer, the "sense of personal satisfaction arising from hands-on involvement in assembling the letters, making decisions, and using the best of one's tastes and talents to create a superior piece of printing."[282] Although Duensing's essay ended on a determinately optimistic note, his list of compromises that had been made to electronic composition expressed the pained nostalgia that besieged fine printers. But rather than merely elegizing the demise of metal type, *Fine Print* promoted a new breed of digital font designers trained in calligraphy and familiar with fine printing.[283] By the mid 1980s, Charles Bigelow, Kris Holmes, Matthew Carter, Sumner Stone, and others were translating their historical, technical, and aesthetic knowledge into readable fonts suitable for computers and laser printers.

If discussion of the displacement of metal type dominated fine printing in the 1970s, the second issue as Abe Lerner articulated it was the emergence of the printer as a visual artist no longer committed to literary preeminence. Others would argue, however, that printers such as Bigus more precisely captured the tone of a poem through typographical transformation. The emergence of the artist-as-printer was an unanticipated consequence of the role of higher education in the renaissance of fine printing. Fine printing on campus was being conducted increasingly from a studio (rather than a library or literary) perspective. Although Lerner praised some printing teachers, he unleashed

280. Lange, "From Where to Where? Abbreviated Suspicions Concerning Postwar Book Arts Movements." *Bookways* (nos. 15 and 16, Summer 1995): 62–63. The geographic focus of *Fine Print* broadened considerably in the 1980s. Some issues highlighted early and contemporary book art in Europe, such as Germany (April 1986), Czechoslovakia (January 1987), and the Netherlands (October 1989).

281. Paul Hayden Duensing, "Metal Type: Whither Ten Years Hence?" (January 1985), in Charles Bigelow, Paul Hayden Duensing, and Linnea Gentry, eds., *Fine Print on Type: The Best of Fine Print Magazine on Type and Typography* (San Fransisco: Fine Print and Bedford Arts, 1989), 81–83.

282. Ibid., 82.

283. One of the future scenarios proposed by Paul Hayden Duensing presaged a development that by the 1990s offered new life for fine printing. Duensing suggested that "letterpress fine printers may well use state-of-the-art technology to generate film negatives from which letterpress plates may be made by any of several methods...." Within just five years, improved digital resolution and font software teamed with polymer plates to open up possibilities for computer designs that integrated imagery and text on a single plate. In the late 1980s, printer Jim Trissel explored those visual possibilities and proselytized about the potential of the photopolymer platemaker, convincing several campus fine presses to invest in the technology. See Trissel, "Polymer Printing on the Letterpress," *Off the Shelf and On-Line: Computers Move the Book Arts into Twenty-First Century Design* (Minneapolis: Minnesota Center for Book Arts, 1992); see also Gerald Lange, *Printing digital type on the hand-operated flatbed cylinder press* (Marina del Rey: Bieler Press Monographs, 2001).

scorn on the Yale School of Art (Bigus's alma mater), where "the essential modesty of a book designer and the respect he must have for his text are not characteristics which would win approval."[284] Beyond the perceived conflict between the printing craft and artistic license, Lerner revealed a persistent moralism associated with the historical typography as originally preached by Stanley Morison and others. The source of the outrage is directed more toward the artistic ego-as-interloper than toward the books themselves.

The transformation of book art education, however, did not mean a denial of the literary fine press book, but the broadening of education's mandate to include visual equivalence or even dominance. The Midwest and West generated the most activity at both ends of the educational spectrum. In 1973 Harry Duncan moved from Iowa to teach at the University of Nebraska–Omaha; about his new imprint, Abattoir Editions, he drolly remarked, "Wordsworth's immortal lines, 'We slaughter to instruct,' might be appropriate.'"[285] By 1980 Duncan himself was worrying over some printers who were "repudiating the traditional goal of book production and turning to what Clifford Burke calls 'typographic printmaking,' attempting self-expression in works of fine rather than applied art."[286]

In 1982 David Farrell reflected on the results of his survey of U.S. collegiate and university presses, that "The contemporary American collegiate presses are more likely to be found in residential colleges or art departments than in departments of English or literature where Gaskell found them....Many of these contemporary presses are to be found in the graphic design and printing (including printmaking) studios. They may employ a fulltime printer-teacher; they are often used for the training and practice of serious artists, writers, and craftsmen."[287]

With the presence of the artist in fine printing, the identity of the printer was bound to change. No one did more to refute the sense of the printer-as-servant than "Voltaire the Hamadeh" (Walter Hamady), who had by now emerged, with his Perishable Press, as the architect of the most whimsical devices in fine printing. Soon after he arrived at the University of Wisconsin in Madison, Hamady linked irascibility to inspiration in books created through compulsive craftsmanship and a commitment to contemporary writing. *The Interminable Gabberjabbs* (1973, fig. 58) was the first book in a series that immediately acquired legendary status in the book art community. With the Gabberjabbs he created his own personal playground.

Hamady printed the first of the *Interminable Gabberjabbs* in six colors on a variety of Shadwell paper scraps (his own handmade paper). The sheets were handsewn into blue Fabriano paper wrappers,

284. Lerner, "Assault on the Book," 162, 167.

285. Quoted by Mary Richmond, "Harry Duncan and The Cummington Press," *Books at Iowa* no. 7 (1967): 4.

286. Duncan, "The Art of the Printed Book," 61.

287. Farrell, *Collegiate Book Arts Presses*, 10.

along with U.S. Geologic Survey maps of the Blue Mounds region where he lived. Maps and other quirky nonart material often appeared in these self-professed indulgences (although Hamady also published poetry books of elegant restraint). In the *Gabberjabbs*, any of the humdrum objects and reminiscences of life could provide creative fodder, seen here in the plethora of footnotes for the poem. The "mapping" of the Blue Mounds' strata in *Gabberjabbs* also symbolizes the semiotic geography of bookmaking that Hamady delighted in disrupting. For example, in the "Foreward / Preface/Acknowledgments / Introduction" of the book, Hamady acknowledged a need for an appendix, then slyly collaged in an organ from a secondhand engraved anatomy book, breezily adding that, "we did not have an Appendix so we used an old uterus instead." Hamady freely admitted that the inspiration for his first Gabberjabb arose from irritation at the "totally boring" intrusion of footnotes into a recent edition of *Moby Dick*; in trickster fashion he responded, "What the hell, why not footnote a poem."[288]

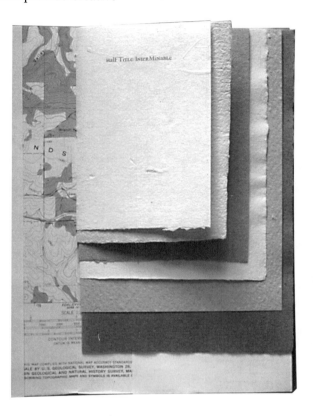

FIG. 58. [CP8] Walter Hamady. *The Interminable Gabberjabbs* 11 x 6 1/2

Not an author but an artist's personality determined the tone and content of Hamady's Gabberjabbs. His additions and subtractions suggested a Fluxus or Dadaist relishing of incongruous, even hilarious sleights-of-hand. Pages were ripped, folded, sewn together, die-cut, or rubber-stamped. He happily mimicked institutional book indignities, such as the gluing in of library card pockets.

Kathy Walkup responded to this bookish drollery in a *Fine Print* review in 1979 of five Perishable Press books. She compared his books to those of the crafty Roycrofters: "Are they more eccentric than innovative? Are [the books of Hamady] enduring, or merely endearing? Is Walter Hamady a contemporary genius, or the Elbert Hubbard of our day?" Amidst other praise, Walkup confessed that the intimate, chatty colophons and title pages left her feeling "like an outsider, the way a child feels when she is excluded from the gang's treehouse."[289] Walkup ended her review by withdrawing her provocative Roycrofter analogy, but added that she hoped to see the "innovation" and "joy and drive" of the Perishable Press directed toward "a larger or more extended work rather than their repetition in an almost vast output of small volumes, however vital they may be."

288. Walter Hamady, "The Perishable Press Limited," in James P. Danky, Jack A. Clarke, Sarah Z. Aslakson, eds., *Book Publishing in Wisconsin: Proceedings of the Conference on Book Publishing in Wisconsin, May 6, 1977* (Madison, Wis.: University of Wisconsin Library School, 1977), 11.

289. "Recent Press Books," *Fine Print* 5, no. 3 (July 1979): 77–79.

290. *Made in the Midwest: Walter Hamady's 6431 Students*. Racine, Wisconsin: Charles A. Wustum Museum of Fine Arts, n.p. Hamady later recalled that his comment on the pica ruler "was what Harry Duncan [said] early on, when I was marvelling at his 'perfected' pages, getting the lines to back up perfectly!" Hamady, in letter to the author, November 30, 2003.

Hamady's unparalleled skill as a printer and designer did much to mitigate his iconoclastic tweaking of convention; in his books, craft and art happily cohabit. As for the substance of his influence, Hamady exerted the greatest influence in teaching, through his personality. For example, in the print shop, more experienced students were expected to help beginners to solve technical problems. Printer Barbara Tetenbaum recalled: "Walter did not teach us much about book design or history. His typical answer to any technical question was, 'You own a pica ruler, don't you?' Instead he taught us how to See and how to Look, Technique followed vision."[290] Hamady validated the personal as inseparable from artistic expression (a stance still tainted with immorality in a book world that prized "invisible printing"), while he also insisted that every book meet the highest standards of craft and unified design.

FINE PRESS GATHERINGS: EXHIBITIONS AND CONFERENCES

When I started [in 1971] there was a fair amount of networking, a community gathered around fine printing and literary small presses, and there were events, gatherings, conferences, and newsletters. In the fine printing and fine binding end there were things like the Roxburghe Club, a dinner meeting club with a speaker, lots of collectors and librarians, men only at that time. "Artists' books" was not even a term and there was nothing in the art world to connect anyone who had been making books with anyone else. By the middle 70's there had started being some exhibitions of artists' books in the Bay Area and the term had emerged....The term was a little bit current among those people who had begun to identify themselves through those exhibitions.[291]

—BETSY DAVIDS

291. Betsy Davids interview with Courtney, *Speaking of Book Art*, 63–64.

292. Blumenthal, *The Printed Book in America*, 123.

As the field matured, exhibitions proliferated, and rudimentary networking led to the first conferences. A review of a few key exhibitions suggests that the canon had shifted to include greater visuality. Showings at established institutions generally celebrated the heritage of fine printing from England—and by now, from America. In 1973 the Morgan Library opened *Art of the Printed Book, 1455–1955* to mark the 500th anniversary of printing. Joseph Blumenthal selected 112 books, beginning with Johann Gutenberg's Bible of 1455. Blumenthal included books by Americans such as the Grabhorns, D. B. Updike, and Dard Hunter. In 1977, Blumenthal followed up with seventy books shown at Dartmouth College Library in *The Printed Book in America*. The same early printers reappeared, now joined by "men and women of our own time—the recent past and the still uncertain future."[292] Newcomers included Lewis and Dorothy Allen, Leonard Baskin, Carroll Coleman, Harry Duncan, William Everson, and Andrew Hoyem.

A nearly deistic devotion drove Blumenthal in his selection criteria: "What is fine printing? Fine printing involves an esthetic dedication. It is an expression of the human spirit which, through the arrangement and presentation of the printed word, reaches toward order and harmony and beauty. Fine printing implies scholarship, artistry, and craftsmanship at the command of the practitioner, whether in printing houses, at private presses, or in workshops of college art departments—whether on automatic machinery or on hand equipment."[293] One cannot fault Blumenthal's credentials as a printer and historian or dismiss his requirement for excellence in literary selection, book design, and execution. He chose established presses with the exception of Andrew Hoyem—Hoyem had, however, partnered with Robert Grabhorn until 1973. Blumenthal's illustrated history marked a coming-of-age for U.S. fine printing, now worthy of such prominent exposure.

Two New York City exhibitions at the end of the decade expanded the fellowship of fine printing: "Printer's Choice: A Selection of American Press Books, 1968–1978" (December 1978 to February 1979) at the Grolier Club, and "Seventy from the 1970s: A Decade of Fine Printing" (February through April 1980) at the New York Public Library. The lists of American presses represented in the two exhibitions were nearly identical. They ranged from typographically driven books by Duncan and Merker, to experimental designs by Everson and Bigus, to more visual delights by Hamady and Van Vliet.[294]

Along with the quiet proliferation of the campus fine press came rudimentary organizing and networking. Much of this had previously occurred under the informal auspices of collectors' clubs and printers' Chappels. Other sites served as informal meeting places for printers. For example, from 1975 the West Coast Print Center in the Bay Area provided low-cost printing to the literary and arts communities, and yet it did much more than that. Alastair Johnston, of Poltroon Press, recalls that, "When the NEA boom hit, I got a part-time job as a typesetter at the West Coast Print Center, and Frances [Butler, also of Poltroon] and I gave lectures there on the history of type and layout. Most of the employees were also publishers, and we all moonlighted, running our own projects after hours."[295]

With institutional access to services and support on campus, a few gatherings occurred. They began on November 10, 1979, with the "Conference on Contemporary Press Books in the USA" at West Chester State College in Pennsylvania, followed by "The Art of the Printed Book" from April 9 to 11, 1981, at the University of Nebraska–Omaha.[296] At each gathering the debate continued over the relative importance of innovative design or literary integrity. At Omaha, described as "the

293. Ibid., x.

294. Non-campus presses represented in both showings included Warwick Press of Carol J. Blinn, Cranium Press of Clifford Burke, Poltroon Press of Frances Butler and Alastair Johnston, Five Trees Press, and the Bird and Bull Press of Henry Morris.

295. Johnston, "Recollections of a Picaresque Past," in *Trance and Recalcitrance*, 12.

296. Both conferences were announced in *Fine Print*. Speakers at the Pennsylvania conference in 1979 included Bonnie O'Connell, of Penumbra Press (later to take over from Harry Duncan at Abattoir Editions in Omaha, Nebraska), and Daniel Traister, of the Rare Book Room at the New York Public Library. Fine printers also attended conferences hosted by binders and papermakers, as well as gatherings with a more countercultural affiliation, such as the Friends of Books and Comics Fair in San Francisco (1972), where Betsy Davids says she first met fellow fine printers. Author telephone interview with Davids, April 29, 1998. The underground comics movement of the 1970s exerted a vigorous influence; its relationship to book art deserves further research.

first international conference on the Art of the Printed Book," the organizers scheduled readings by seventeen poets, in addition to panels and presentations. That strategy was adopted by subsequent book art conferences to celebrate literary content along with design.

"Wayzgoose: A Symposium for Contemporary Bookmaking" in San Francisco from August 23 to 26, 1979, actually predated the campus conferences, and due to the participation of Britain's Sebastian Carter of Rampant Lions Press in England, the conference can claim credit as well for the first international gathering. Assembled without benefit of a campus infrastructure, the massive volunteer effort coordinated three exhibitions and panels whose participants included Adrian Wilson, Kim Merker, Kathryn Clark, and publisher David Godine.

WOMEN AT THE PRESS

About the silliest sight in the world is a group of printers discussing the Psychology of the Hyphen. Yet these mangy fellows will stand around for hours arguing how England should be divided. And these wretched specimens cant read or write their own names—they cant remember what you tell them from one minute to the next, yet the poor beggars lightly bandy about such highflown clap-trap as Oxford gives it Eng- or a casual reference to Miltons Paradise Lost.[297]

—JANE GRABHORN

...because I wanted to devote more time to Five Trees [Press], I cut my other work to part-time and sank into fairly abject poverty. [In 1976] we had moved to a warehouse with a women's off-set press, Jungle Press, and with Clifford [Burke] at Cranium. Cheryl Miller and I founded Peartree Printers, strictly for job printing, and worked from the same premises....Most of the available printing jobs went to members of the Roxburghe Club, which was strictly male, so we were fighting our way. There hadn't been a women's letterpress job shop in San Francisco since the Women's Co-operative Printing Union folded in 1901.[298] — KATHY WALKUP

Despite evidence of the maturing of fine printing in its exhibitions and conferences, one area remained unchanged: the general impression that men still dominated fine printing. After all, theorist Beatrice Warde first wrote under a male pseudonym in the early twentieth century. Although a younger generation of women had been printing since the 1960s, and a few (such as Claire Van Vliet) achieved and maintained prominence early on, their numbers only gradually increased. In the 1970s the growth of woman-run presses followed the revitalization of feminism, as seen in the founding of the respected Five Trees Press in 1973 by Kathy Walkup (whose statement appears above), along with partners Cheryl Miller and Jaime Robles.

Crucially, a few printers were being rediscovered as role models. Printer Susan King recalled her delight with the books of Jane Grab-

horn's Jumbo Press, first shown to King by Helen Alm on the steps of the Woman's Building:

> ...[They had been printed] in the 1930s...or 1950s. She was very impressive...her Jumbo Press stuff was just a riot. I...saw her and Ruscha's books at the same time, in the early days [of the] Woman's Building, and her work spoke to me as much as his work did. Kathy Walkup was taken with her too, [along with] a lot of people in California printing, [as]....an older woman doing....all this great stuff about learning to print. There is a wonderful [section] about the proofreader. Things are going along pretty well, [then] in comes little mary sunshine, hooray, hooray, two 'l's' in California—you know, [she has] the proofreader poke fun at the pretentiousness of fine printing.[299]

Jane Bissell Grabhorn (1911–1973) married Robert Grabhorn in 1932 and assisted at the Grabhorn Press with proofreading and binding. Under her Colt Press imprint, Jane Grabhorn published books about fine eating and Californiana[300] as well as writings by Oscar Lewis, Henry Miller, Jane Austen, and others. In her earlier Jumbo Press books, she sought freedom from fine printing's strictures. She printed them on the premises of the Grabhorn Press, and yet, as she declared in 1965, "I would not let anybody touch those [books]. I wanted no slickness there at all, and [they] didn't have it either."[301] The typography immediately alerts a reader to her lighthearted approach, with justified margins that march on irrespective of conventional word breaks or hyphens. The odd, even surreal fragments that result complicate reading into teasing wordplay, as in the comical commentaries from her *Typografic Discourse, for The Distaff Side of Printing, a book by ladies* (1937). Her "TENET NUMBER TWO, [which] concerns the matters of technique and the fallacy of its overemphasis" concludes,

> Jumbo herself suffers from the condescension of her mate— a lordly fel / low—who a long time ago mastered the works and biographies of all the / printers since the beginning of printing. He can also spot the name of / a type and spit on the dot of its eye ten yards away. Also this marvell / ous male periodically corners Jumbo and rattles off a terrifying group of / figures evidently designed to demonstrate with what ease a person, pro / viding he has inside information, can use certain sizes of spaces with diff / erent sizes of type and they will fit. Something like that. For Jumbo's pa / rt, she roots

297. From *The Compleat Jane Grabhorn. A Hodge-Podge of Typographic Ephemera, Three Complete Books, Broadsides, Invitations: Greetings, Place Cards, etc, etc.* (San Francisco: Grabhorn-Hoyem, 1968), n.p. The lack of apostrophes was intentional on Grabhorn's part.

298. Kathy Walkup interview with Courtney, *Speaking of Book Art,* 106. Five Trees published until 1979. Not long after, Walkup took over the Eucalyptus Press at Mills College. (Eucalyptus Press had been active from its founding by Rosalind Keep in 1930, to the 1960s. It was reactivated by Clifford Burke, and then Betsy Davids, in the 1970s.) In the fall of 1983 Mills College started an academic program leading to a Master of Arts degree in Book Arts (until 1989).

299. Author interview with King, Los Angeles, November 8, 1995. See also King interview in Courtney, *Speaking of Book Art,* 112–25.

300. Some of the Colt Press books sold well. For example, the Colt Press *Epicure* series included *The Epicure in Hawaii...* (1938), which went through three 1,000-copy editions.

around until she finds something she wants. And with what /
a glad and mighty trumpet call is it welcomed! The rafters
tremble with / the sound of the little elephant's joy.[302]

Grabhorn's wickedly silly "discourses" were all the more devastating
for their accuracy, as well as, it must be recognized, her "insider sta-
tus" at the Grabhorn Press, one of America's most respected fine
presses. Her celebration of the private voice of a memoirist also fore-
shadows feminist strategies to displace the "gendered" male voice of
society with one that sought intimacy, vulnerability, and delight in
the unexpected. No wonder that women printers who encountered
her books in the 1970s viewed her as a kindred spirit.

Women were just beginning to print letterpress in the early
1970s, however, and generally still met one another only by chance.
For example, although Betsy Davids founded Rebis Press in 1971, it
wasn't until 1973 that she met other women printers. She met Frances
Butler and Alastair Johnston in the mid 1970s when Rebis Press hap-
pened to move into the building that housed Butler's fabric company.
By the late 1970s, networking opportunities increased along with the
maturing field, as in 1978, when Davids met Susan King at the artist's
book exhibition, *Artwords and Bookworks*.[303]

Women printers met by chance because in general they were not
yet recognized as key players in the printing community. King recalls
that time: "I longed to be connected with [the fine printing] tradi-
tion, but they wouldn't let me in. Women who came after me were let
into all the printing clubs, but I was never asked. I think they had no
idea what I was doing. I wasn't in a social position where I was being
a nice girl and effecting a relationship with the older guys who would
invite me to the printing clubs."[304]

Eventually, women fine printers loosely associated within their
own informal art world for networking, research, and critical sup-
port. Sandra Kirshenbaum's editorship for *Fine Print* helped to vali-
date the participation of women in the fine press world, along with
the journal's evenhanded presentation of women's voices alongside
those of men. *Fine Print* also helped with networking. For example,
in the July 1976 issue it announced a Mills College exhibition, "Two
Centuries of Binding by Women," which showed over 100 American
and English fine bindings from the nineteenth and twentieth cen-
turies. Much research remains to be done on the contributions of
women to the development of the fine press book.

The interest in the memoir by feminists, along with an aesthetic
that valued craft and handwork, reinforced the entry of women into
printing. Here was yet another incarnation for the artisan as an inde-

301. Jane Grabhorn, *Jane Grabhorn, The Colt Press*. Oral history interview with Ruth Teiser (Berkeley, 1966), 1.

302. Grabhorn's eccentric line breaks are reproduced here. "A Typografic Discourse for the Distaff Side of Printing, a book by ladies," Grabhorn and Hoyem, *The Compleat Jane Grabhorn*, n.p.

303. Author interview with Davids, April 29, 1998.

304. Susan King interview in Courtney, *Speaking of Book Art*, 120.

pendent publisher directed toward personal "liberation," nurtured and given voice through the cooperative enterprises of feminism (shades of William Morris's artisan-as-change agent!). Equally important, most of those artists—such as Davids, Walkup, and King—had little interest in setting up boundaries, and so supported a more inclusive kind of bookmaking. Rather than defending the fine press book or deluxe book or bookwork, they desired to build a diverse community and audience, and to some degree, they achieved both.

CROSSOVER: THE CENTER FOR BOOK ARTS

In that pluralistic spirit, an exhibition organized by The Center for Book Arts (CBA) in New York placed fine printing on equal footing with all manner of book-related art. *Book Makers, Center for Book Arts First Five Years* showed at the Cooper Union Art School from October 24 to November 9, 1979. The participants were described as "members and friends" of CBA. On display were fine printing, sculptural bookworks, designer bindings, and innovative binding structures, alongside wood engravings and handmade papers. Without question, this was a different community of artists; none of the books by the presses here had been selected for show in the exhibitions at the Grolier Club or the New York Public Library.[305] This book art community appeared diverse and enthusiastic, as if CBA were less interested in establishing a canon than in building an eclectic community of working artists. That open-door spirit came to characterize CBA and later book art organizations, but it has also subjected them to dismissal as frivolous retreats for crafty hobbyists.

The diversity of CBA reflected the interests of its founder, Richard Minsky, who opened CBA in 1974 as a print shop, bindery, and gallery in a storefront on Bleecker Street near the Bowery.[306] In his own art he conflated the rigors associated with his training as a binder, with Dadaist provocations. For example, in 1973 he rebound an 1834 copy of *Pettigrew's History of Egyptian Mummies* (fig. 59) by wrapping it in linen strips. The reader is required to unwind it to read its story, as if directed by the wraiths described within. Critic Rose Slivka later claimed that, "With this book, at the time, [Minsky] significantly changed the relationship of the book to its cover."[307]

Minsky extended his book art extravagance in his *Birds of North America* (1975, fig. 60). The book received the brand—or accolade—of censure from a 1975 Guild of Book Workers exhibition at Yale University. After receiving the invitation to exhibit from the Guild, Minsky glimpsed a pheasant skin for sale by a street vendor, and J. J. Studer's

305. The artists drawn to CBA varied in experience and stature in the art world; all shared an interest, however, in experimenting with the book form. The established artists included Hermann Greissle, Douglass Morse Howell, Hedi Kyle, and Stella Waitzkin. Minsky himself had had a one-person show at The Zabriskie Gallery on 57th Street. In comparing the CBA show to those at the Morgan Library and the NYPL, Minsky recalled that "the others were more fine press and design. I thought that was covered. We had limited space, we had limited facilities...the idea is that...you have to be very specific about what you do....These people...came to us because they weren't getting support in the traditional establishment and they had heard...that this wacky guy in New York was being supportive of people who were doing something that was not traditional using these traditional methodologies." Author telephone interview with Minsky, April 29, 1998.

310. Minsky email to the author, August 13, 2000. CBA served as a model for later book art organizations, from Artists Book Works in Chicago, to BookWorks in London. Other organizations that served the fine press book and its related arts, and that opened in the 1970s, included, in the East, Bowne and Company's historical printing shop (with equipment available to artists) in 1977, and The Creative Arts Workshop in New Haven, Connecticut, set up by Polly Lada-Mocarski and others in 1979. In the Southwest, The Print Shop at the Palace of the Governors Museum in Santa Fe opened in 1979. In the West, volunteers organized The Pacific Center for Book Arts in 1979, although its plans for a site were deferred until its reincarnation in 1998 as the San Francisco Center for the Book.

311. Roylance, "Gérard Charrière Bindings at the Princeton Graphic Arts Collection," *Fine Print* 6, no. 2 (April 1980): 60.

312. Tom Taylor, "The Relationship Between Fine Binding and Fine Printing," *Guild of Book Workers Journal* 33, no. 2 (Fall 1995): 57.

313. Dubansky, now a Grolier Club member, currently runs the book conservation division for the Thomas J. Watson Library at the Metropolitan Museum of Art in New York.

FIG. 61. [CP9] Hedi Kyle. *April Diary* 10 1/2 x 5 1/2

of Congress recruited leading British conservator Peter Waters (who helped after the Florence flood) to set up a conservation program that also sponsored interns. American practitioners such as Frank Mowery, Doris Freitag, and Don Etherington joined international leaders to teach and speak at the proliferating classes, conferences, and seminars. The newsletter of the Guild of Book Workers (1976–) facilitated networking in addition to its *Journal* (1962–). With all this local activity, U.S. students no longer felt it necessary to commit to lengthy European apprenticeships.

Some conservation binders unleashed quirky and inventive artistic personae, alongside the maturing professions of designer binding and book conservation. The works that resulted constitute a fascinating and influential byway in book art. Two of these artist-conservators showed work in *First Five Years* from CBA. Mindell Dubansky, an early CBA binding apprentice who studied at Camberwell in England, contributed *Elvis Book* (1977), an embroidered book of photographs tucked into a blue suede shoebox.[313] Hedi Kyle exhibited *April Diary* (1979, fig. 61), which she later christened a flag book, based on an accordion structure called the concertina. This structure has been enormously influential in book art. Opened by the reader with a satisfying snap, the rows of pages flip over, revealing their reverse sides. Upper and lower rows of pages face center, each page capable of hiding or revealing imagery or text as the book is manipulated by the reader. The opened book can be both book and sculpture as it steps out into a modulating surface of light and cast shadow, in which complex image-text interactions can literally unfold.[314]

Gary Frost, another conservation binder and artist, exhibited *The Tracts of Moses David* and The Children of God (1978, fig. 62) in the 1978 San Francisco exhibition.[315] *The Tracts of Moses David* defies simple categorization. The book holds cult pamphlets issued by the

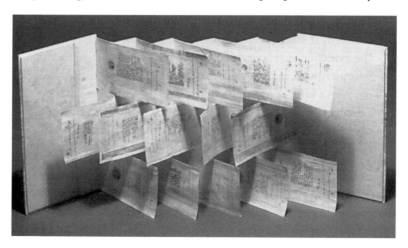

pendent publisher directed toward personal "liberation," nurtured and given voice through the cooperative enterprises of feminism (shades of William Morris's artisan-as-change agent!). Equally important, most of those artists—such as Davids, Walkup, and King—had little interest in setting up boundaries, and so supported a more inclusive kind of bookmaking. Rather than defending the fine press book or deluxe book or bookwork, they desired to build a diverse community and audience, and to some degree, they achieved both.

CROSSOVER: THE CENTER FOR BOOK ARTS

In that pluralistic spirit, an exhibition organized by The Center for Book Arts (CBA) in New York placed fine printing on equal footing with all manner of book-related art. *Book Makers, Center for Book Arts First Five Years* showed at the Cooper Union Art School from October 24 to November 9, 1979. The participants were described as "members and friends" of CBA. On display were fine printing, sculptural bookworks, designer bindings, and innovative binding structures, alongside wood engravings and handmade papers. Without question, this was a different community of artists; none of the books by the presses here had been selected for show in the exhibitions at the Grolier Club or the New York Public Library.[305] This book art community appeared diverse and enthusiastic, as if CBA were less interested in establishing a canon than in building an eclectic community of working artists. That open-door spirit came to characterize CBA and later book art organizations, but it has also subjected them to dismissal as frivolous retreats for crafty hobbyists.

The diversity of CBA reflected the interests of its founder, Richard Minsky, who opened CBA in 1974 as a print shop, bindery, and gallery in a storefront on Bleecker Street near the Bowery.[306] In his own art he conflated the rigors associated with his training as a binder, with Dadaist provocations. For example, in 1973 he rebound an 1834 copy of *Pettigrew's History of Egyptian Mummies* (fig. 59) by wrapping it in linen strips. The reader is required to unwind it to read its story, as if directed by the wraiths described within. Critic Rose Slivka later claimed that, "With this book, at the time, [Minsky] significantly changed the relationship of the book to its cover."[307]

Minsky extended his book art extravagance in his *Birds of North America* (1975, fig. 60). The book received the brand—or accolade—of censure from a 1975 Guild of Book Workers exhibition at Yale University. After receiving the invitation to exhibit from the Guild, Minsky glimpsed a pheasant skin for sale by a street vendor, and J. J. Studer's

305. The artists drawn to CBA varied in experience and stature in the art world; all shared an interest, however, in experimenting with the book form. The established artists included Hermann Greissle, Douglass Morse Howell, Hedi Kyle, and Stella Waitzkin. Minsky himself had had a one-person show at The Zabriskie Gallery on 57th Street. In comparing the CBA show to those at the Morgan Library and the NYPL, Minsky recalled that "the others were more fine press and design. I thought that was covered. We had limited space, we had limited facilities...the idea is that...you have to be very specific about what you do....These people...came to us because they weren't getting support in the traditional establishment and they had heard...that this wacky guy in New York was being supportive of people who were doing something that was not traditional using these traditional methodologies." Author telephone interview with Minsky, April 29, 1998.

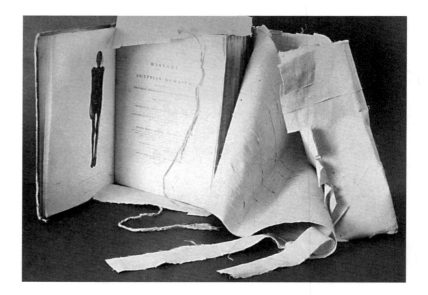

FIG. 59. Richard Minsky.
*Pettigrew's History of
Egyptian Mummies* (right)
12 x 27 x 10¼
Private collection.

FIG. 60. Richard Minsky.
Birds of North America (below)
Dimensions variable.
Private collection.

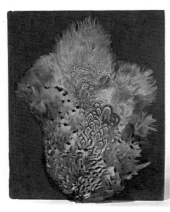

classic treatise on birds was thus transformed. Minsky recalled that, "Satisfied with my new work, I shipped it off to Yale for the exhibitThe first report I got was that the conservator screamed when she opened my package and saw what at first glance appeared to be a dead bird." An uproar ensued. When Minsky arrived to photograph the work *in situ,* he found the display case empty and the curator, Dale Roylance, ascribing its absence to a deteriorating condition. Minsky accompanied Roylance to the vault, to find the binding just as he'd sent it. "Some of the feathers had always been sticking out at odd angles. I pulled a few feathers off the bird and scattered them around the exhibit case, telling Dale, 'If anybody asks, tell them the bird's molting!' [Roylance] put it back in the exhibit."[308]

Minsky's provocative personality, his unorthodox blend of iconoclast with craftsperson, punctuated the community of artists that gathered around CBA. Given the active inclusivity of CBA, it is tempting to portray the early book art community as one united by a mutual bonhomie. CBA did succeed at establishing itself as a nexus for an emerging art world, described by Howard Becker as a "network of people whose cooperative activity, organized via their joint knowledge of conventional means of doing things, produces the kind of art works that [the] art world is noted for."[309] But if CBA tried to provide a safe haven in which craft and art could freely interact, it naturally had to endure the same aesthetic and financial conflicts inherent in any community. Not everyone wanted what it offered: studio access and support free of the constraints of the traditional fine press aesthetic. CBA's inclusiveness challenged traditionalists in fine printing, for whom the perfection of craft was an end in itself and a finished book

represented a binder or a printer's skill and heightened the esteem accorded to the literature held within the book. Some of the artists who frequented CBA would be likely to view the conventions of fine binding as useful skills, and yet they might respond by testing the boundaries of those conventions. Even so, Minsky maintained that, "...one of the reasons I started the CBA....[was that] instead of putting the artists down, [CBA would] raise their craftsmanship up."[310]

The bound extravaganzas of Richard Minsky demonstrate that hand bookbinding had evolved from a craft to an interpretive art form, even if binding did not enjoy the kind of campus sponsorship that fine printing did. Dale Roylance contrasted the support for campus presses, in a 1980 article in *Fine Print*, to the lack of academic support for "creative bookbinding....There are no binding schools connected with an academic institution (except the bindery at Mills College, Oakland...which has a tenuous existence)."[311] Roylance also noted positive developments, however, such as the expansion of private teaching and conservation, and the growth of the private and public collecting of fine bindings.

Local binding organizations produced programs, such as the First Annual Members' Exhibition sponsored by The Hand Bookbinders of California in 1973. In 1978 the Museum of Modern Art in San Francisco sponsored *Hand Bookbinding Today, an International Art,* which later traveled to Kansas City (discussed below, with the deluxe book). Most U.S. fine press binding, however, continued to display a restrained, even demure style. Bookseller and publisher Thomas Taylor recalled his surprise in 1981 when invited to discuss binding at a book art conference:

> Every book produced by the printers in attendance, certainly a thousand volumes or more, had been in some way bound up for sale and preservation. But the nature of the binding, technically or aesthetically, was seldom of great concern. It was something slapped on at the end to display the evidence of typographic genius contained within, and its best attribute, in the printer's eyes, would always be simplicity, even a kind of plainness that would not compete with the typography. Many of America's greatest printers in this century came out of the midwest, and it may be that this attitude betrays something of those origins, an outward modesty designed to conceal an inner richness.[312]

Within the binding world, the specialty of conservation binding (by which is meant the planning, care, and preservation of books and other library materials) grew into a respected discipline. The Library

306. Minsky credits Abram Lerner for the idea of starting an organization. Minsky was contracted as a binder for The Hirshhorn Museum and Sculpture Garden. At one point he asked Lerner, the Director of the Hirshhorn, why the museum's collection contained no books that were art. Lerner replied, "If you want books to be seen as art, you have to start an organization so you can get museum shows." Minsky email to the author, August 13, 2000. To name his organization, Minsky simply reversed the term, "art book." The term "book art" does appear at an earlier time, however. In Helmut Lehmann-Haupt, *The Book in America*, he refers to the influence of "Book arts courses in library schools" (293).

Wordsmiths have generated several variations on the term "book art." In 1973 Clive Phillpot hyphenated it into "book-art." Phillpot, "Feedback," *Studio International* 186, no. 957 (July–Aug. 1973): 38. Four years later Phillpot called it "book as artwork." Phillpot, "Artists' books and book art," *Art Library Manual: A Guide to Resources and Practice,* Philip Pacey, ed. (New York: Bowker Press, 1977), 355–63. In 1981 Deborah C. Phillips ran it together into "bookart." Phillips, "Definitely Not Suitable for Framing," *Art News* (December 1981): 62–67.

307. Rose Slivka, "From the Studio," *The East Hampton Star,* April 9, 1992; from Richard Minsky's web site on 15 April 1998. *Pettigrew's History of Egyptian Mummies* first appeared in *The Object as Poet* (Washington, D.C.: Smithsonian Institute, 1977). That exhibition, at the (Smithsonian's) Renwick Gallery, is discussed below with the sculptural bookwork.

308. Quotes related to the story of *The Birds of North America* from Minsky's web site, April 16, 1998.

309. Becker, *Art Worlds*, x.

310. Minsky email to the author, August 13, 2000. CBA served as a model for later book art organizations, from Artists Book Works in Chicago, to BookWorks in London. Other organizations that served the fine press book and its related arts, and that opened in the 1970s, included, in the East, Bowne and Company's historical printing shop (with equipment available to artists) in 1977, and The Creative Arts Workshop in New Haven, Connecticut, set up by Polly Lada-Mocarski and others in 1979. In the Southwest, The Print Shop at the Palace of the Governors Museum in Santa Fe opened in 1979. In the West, volunteers organized The Pacific Center for Book Arts in 1979, although its plans for a site were deferred until its reincarnation in 1998 as the San Francisco Center for the Book.

311. Roylance, "Gérard Charrière Bindings at the Princeton Graphic Arts Collection," *Fine Print* 6, no. 2 (April 1980): 60.

312. Tom Taylor, "The Relationship Between Fine Binding and Fine Printing," *Guild of Book Workers Journal* 33, no. 2 (Fall 1995): 57.

313. Dubansky, now a Grolier Club member, currently runs the book conservation division for the Thomas J. Watson Library at the Metropolitan Museum of Art in New York.

of Congress recruited leading British conservator Peter Waters (who helped after the Florence flood) to set up a conservation program that also sponsored interns. American practitioners such as Frank Mowery, Doris Freitag, and Don Etherington joined international leaders to teach and speak at the proliferating classes, conferences, and seminars. The newsletter of the Guild of Book Workers (1976–) facilitated networking in addition to its *Journal* (1962–). With all this local activity, U.S. students no longer felt it necessary to commit to lengthy European apprenticeships.

Some conservation binders unleashed quirky and inventive artistic personae, alongside the maturing professions of designer binding and book conservation. The works that resulted constitute a fascinating and influential byway in book art. Two of these artist-conservators showed work in *First Five Years* from CBA. Mindell Dubansky, an early CBA binding apprentice who studied at Camberwell in England, contributed *Elvis Book* (1977), an embroidered book of photographs tucked into a blue suede shoebox.[313] Hedi Kyle exhibited *April Diary* (1979, fig. 61), which she later christened a flag book, based on an accordion structure called the concertina. This structure has been enormously influential in book art. Opened by the reader with a satisfying snap, the rows of pages flip over, revealing their reverse sides. Upper and lower rows of pages face center, each page capable of hiding or revealing imagery or text as the book is manipulated by the reader. The opened book can be both book and sculpture as it steps out into a modulating surface of light and cast shadow, in which complex image-text interactions can literally unfold.[314]

Gary Frost, another conservation binder and artist, exhibited *The Tracts of Moses David* and The Children of God (1978, fig. 62) in the 1978 San Francisco exhibition.[315] *The Tracts of Moses David* defies simple categorization. The book holds cult pamphlets issued by the

FIG. 61. [CP9] Hedi Kyle.
April Diary
10¹/₂ x 5¹/₂

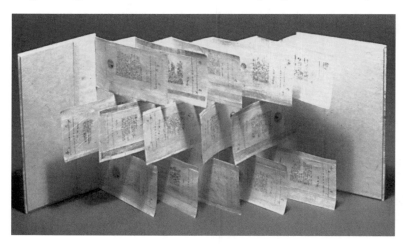

Children of God, collected by Frost from bus and train stations. Frost's lavishing of attention on pamphlets constituted a departure from the usual content of a "designer binding." Binders usually acquired a book of classic literature, or a fine press book issued unbound, "in sheets," for which they created an original binding. Frost's ephemeral pamphlets instead suggest a Fluxus interest in "found" detritus repositioned within an art context. For *The Tracts of Moses David* Frost flawlessly executed a red leather binding that incorporated a medieval raised-cord structure on wooden boards. He embellished that traditional, historical model with a bristling miscellanea that included tiny toy guns and bowling pins—even a toy train engine dangled from a tiny chain, perhaps to evoke medieval chained libraries. Unlike Samaras, however, Frost wants to captivate, not threaten, the reader. His leather binding suggests the authority of the cult even as its playful accouterments undercut its writings in a Dadaist's subversion. Book conservators such as Kyle and Frost researched and developed alternative structures and materials for conservation purposes, joining invention to scholarship.

Papermakers, like binders, slowly coalesced into a book art community. Handmade paper attracted artists who valued its fibers that carried pattern and texture; its pigment and dyes that added color; and the casting techniques that shaped and scaled paper pulp into sculpture. A flurry of experimentation and production generated critical attention, and writers repeatedly christened the 1970s a paper renaissance. Jonathan Clark announced in 1976, for example, that "there is already a paper 'renaissance' occurring, with individuals across the country producing paper for personal use."[316] By 1982, Trisha Garlock looked back on the 1970s to report that "papermaking programs have been introduced into nearly every college and university art department. Fine arts presses and publishers have also added facilities or provided access to them. Many small mills for producing paper by hand have been established, and a new breed of master craftsman has been born."[317] Handmade papers appeared in book art exhibitions (such as *The First Five Years* at CBA). Papermaking ateliers as well as papermaking by individual artists proliferated.[318]

As in binding, the history of hand papermaking demands its own study, but one mill, Twinrocker Inc., of Brookston, Indiana, propelled the nascent U.S. hand papermaking onto an international stage. Kathryn Clark studied printmaking at Wayne State University, and

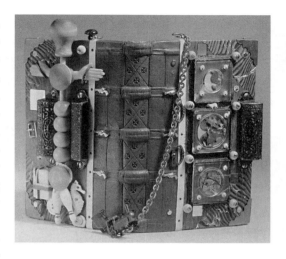

FIG. 62. [CP13] Gary Frost.
Tracts of Moses David
7 7/8 x 5 1/2

314. Kyle studied at the Werk Kunst Schule in Wiesbaden. In 1970 she began work as a binding conservator at New York's Botanical Gardens, and continued her studies with Laura Young. Author interview with Kyle, Minneapolis, April 12, 1997. In 1986 Kyle moved to the Philosophical Society of America (Philadelphia) to serve as its book conservator until her retirement. Kyle also taught in the M.F.A. Book Arts program at The University of the Arts in Philadelphia.

315. After receiving an M.F.A. degree from the School of the Art Institute of Chicago in 1969, Frost trained in library conservation under Paul Banks at the Newberry Library from 1969 to 1981, and taught at the School of the Art Institute of Chicago from 1972 to 1980 (with time off for a Library of Congress internship in 1974). He taught at Columbia University in the School of Library Service from 1981 to 1986, followed by the University of Texas–Austin. In 1999 he became the Conservator for the University of Iowa Libraries–Iowa City.

316. Clark, "Acquiring Handmade Paper: A Printer's View," *Fine Print* 2, no. 2 (April 1976): 21.

317. Garlock, Foreword, in Jane Farmer, *New American Paperworks*, San Francisco, California: The World Print Council (1982), 3.

318. See Marlene Schiller, "The American Community of Hand Papermakers," *American Artist* 41, issue 421 (August 1977): 39–44; Cynthia Clark, "An Industry Survey: Papermaking Revisted," *The Print Collector's Newsletter* 10, no. 3 (July–August 1979): 80–86; and Silvie Turner and Birgit Skiöld, *Handmade Paper Today: A Worldwide Survey of Mills, Papers, Techniques and Uses* (New York: Frederic C. Bell, 1983).

319. Howard Clark's refinement of a Hollander-type beater in the late 1970s noted in Jane Farmer, *Paper as Medium* (Washington, D.C.: Smithsonian Institution Traveling Exhibition Service, 1978), 10, was part of a succession of inventions that benefited the field. Other inventors have included Harold Paris and Chuck Hilger, Ron McPherson, and Lee Scott McDonald.

then moved to San Francisco in 1971 with her husband Howard, a mechanical engineer. Soon after, Clifford Burke and other book artists persuaded them to open a paper mill in the basement of their apartment building. In 1972 Howard's father died, spurring their relocation to the family farm near Brookston. Howard's engineering training complemented Kathryn's knowledge of paper and printmaking, and they expanded Twinrocker into several farm buildings, with Howard designing and building equipment as needed.[319] From the beginning, the Clarks looked beyond the production of prints, books, and custom-made papers, to develop Twinrocker into a collaborative atelier that included research and teaching. Like so many in the field, they understood that they were making history by helping to build a discipline, and they accepted the responsibilities that accompanied such pioneering efforts. In addition to production and research, the Clarks sponsored apprenticeships, lectured, and taught throughout the country.[320]

A visit to Twinrocker by Claire Van Vliet in 1976 (fig. 63) marked an early high point for collaboration. With the Clarks, Van Vliet translated her considerable gifts as painter and printmaker into what became known as paper pulp painting, where image and substrate melded colored paper pulps. The resulting work, *Aura* (1977, fig. 64), was claimed by Kathryn Clark as the first book "to use paper pulp to form the complete illustration."[321] Van Vliet's process involved delicately placing the twelve colored pulps next to one another on the mold, then repeating her actions to make an edition of fifty. The overall palette captured the alchemy of autumn as expressed by Hayden Carruth in the poem within, where, "all day the mountain flared in blue September air." *Aura* was tucked into a folded paper wrapper onto which the poem was printed. The work could also stand up and open into a vibrant screen of overlapping landforms shouldering across the panels, in colors that deepened from glowing orange to violet.

FIG. 63. Kathryn Clark of Twinrocker Inc. (*on left*) with Claire Van Vliet, during Van Vliet's visit in 1972.

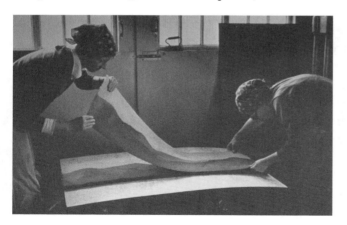

Papermakers eventually gathered, beginning in 1975 with the "First North American Hand Papermakers Conference" in Appleton, Wisconsin, where both the Dard Hunter Museum and the Institute of Paper Chemistry resided.[322] In 1976 the Santa Barbara Museum hosted a conference along with the exhibition, "The Handmade Paper Object," and another gathering followed at the Center for Book Arts in October, 1977. The most substantive paper event of the

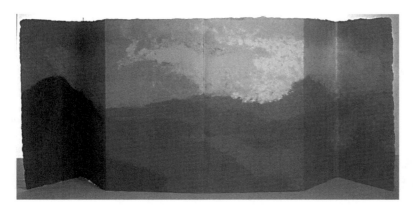

FIG. 64. [CP21] Claire Van Vliet.
Aura
15 x 47 (open)

1970s occurred at the San Francisco Museum of Modern Art in March, 1978. The World Print Council (founded in 1972) sponsored an international conference and publication, *Paper—Art and Technology, The History and Methods of Fine Papermaking with a Gallery of Contemporary Paper Art.*

The research and dissemination of hand papermaking's historical, technical, and scientific knowledge by artist-teachers such as Timothy Barrett and Winifred Lutz deepened and expanded a knowledge of the properties of the medium. The entry of hand papermaking into educational and atelier settings through printmaking or through fine presses created a base of institutional support, but the papermaker as scholar-artist-teacher also flourished outside of academia. Dard Hunter embodied that role (as did, later, Douglass Morse Howell) in his independent paper mill and his stubborn pursuit of research, writing, and production despite little recognition or support. In 1984 Kathryn Clark reflected this spirit of artistic entrepreneurship by declaring: "We wanted to prove to the Europeans that we could make paper as good as any of theirs, and now we are getting orders from Europeans."[323]

Hand papermaking did succeed in breaking into gallery exhibitions, in contrast to binding. Work by Caroline Greenwald and Michelle Stuart represents handmade paper's range in art world profiles. In *Tender Papers in a Notebook* (1977), by Greenwald, lengths of kite line were embedded in handmade Japanese paper pages. The kite lines overlap with the paper's fibers in seemingly random distributions to link page to page in a structure that is only barely suggestive of a traditional book's sewn signature. Greenwald's works also attracted the attention of galleries because of her interest in working large: for example, *Open* is a room-sized installation (1976), where Greenwald multiplied and opened pages out into a book that stretched to forty-seven feet in length. Suspended above, the pages transmute into wings, their apparent fragility belied by the strength of the

320. Kathryn Clark, quoted by D. J. R. Bruckner, "With Art and Craftsmanship, Books Regain Former Glory," *New York Times Magazine* (October 28, 1984): 49. Another early Twinrocker apprentice was Timothy Barrett, who worked with the Clarks until 1975, solidifying a lifelong involvement with paper that he has since directed into teaching, production, and scholarship. In 1975 a Fulbright Scholarship sent Barrett to Japan for two years, which led to his *Japanese Papermaking: Traditions, Tools, and Techniques* (New York, Tokyo: Weatherhill, 1983). After operating his Kalamazoo Handmade Papers in Michigan, Barrett joined the faculty of the University of Iowa Center for the Book in 1985.

321. W. Thomas Taylor, "A Survey of American Hand Papermakers," *Bookways*, no. 9 (October 1993): 35. After three visits to Twinrocker, Van Vliet installed a small papermaking facility in her Vermont studio in 1978. She also has collaborated with Katie MacGregor and Bernie Vinzani at their mill in Whiting, Maine. The paperworks that Van Vliet makes include two-dimensional prints, some of which are diptychs and triptychs in a monumental scale that portray the landscapes and skyscapes of Vermont.

322. A *Fine Print* review of the conference stated that "Specialists at the Institute were also able to participate with their technical knowledge of paper engineering and chemistry," evidence of the early partnership with art and science in hand papermaking. "Shoulder Notes," *Fine Print* 2, no. 2 (April 1976): 24–25.

323. Kathryn Clark in D. J. R. Bruckner, "With Art and Craftsmanship," 49.

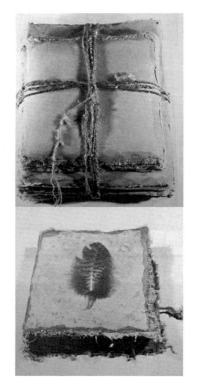

Japanese paper's fibers. The effect is reminiscent of a bird caught in arrested flight, or of similar transformations suggested by the sculptures of Eva Hesse.

Trained as an artist, Michelle Stuart worked briefly as a cartographer. A mapmaker's point of view is revealed in Stuart's identification with landscape, in works that often resemble a bound book or scroll. For example, to make her Rock Books (two examples appear in fig. 65), which Stuart has created periodically since 1973, she began by adding earth from a particular site to her paper pulp. In later works she used muslin-backed rag papers, onto whose surface she pounded and rubbed rocks and other natural substances, embedding the evidence of their making into a reinvented history. Although textless, the heavily worked paper evokes a story of the enduring landscape even as it also represents its erosion.

Stuart also made scrolls that unrolled from the gallery wall, to approach the viewer with an interplay between print, book, and installation. The scroll format invited a larger scale, as in *Niagara II, Niagara Gorge* (1976, fig. 66), which stretches to sixty-two feet in length. Stuart even exploded the scroll's scale beyond the gallery in a monumental work of Land Art: *Niagara Gorge Path Relocated* (1975, fig. 67). The scroll marked the site of Niagara Falls' location 12,000 years ago. Stuart worked the paper surface with earth and stones from the historic site, then rubbed the surface to polish it, until, "As the paper becomes worked, to me it feels like skin, the most delicate, soft, and warmest of surfaces."[324] Her scrolls unfurl like flags that celebrate their arduous fabrication. To complete *Niagara Gorge Path Relocated,* Stuart unrolled the enormous 62' x 460'-long scroll on site, and left it to erode back into the earth.

Paper—Art and Technology argued in 1978 that paper had broken through the barrier between craft and the art world, especially when viewed as sculpture or as an adjunct to printmaking. How did paper cross over, to be recognized both as a force in book art and printmaking, as well as gaining some measure of art world respect? Consider the properties of paper. To make paper sheet by sheet requires a concentrated, rhythmical process, a directness and meditative repetition that appealed to artists disillusioned with the more industrial aesthetic of Minimalism. The very different works by Greenwald and Stuart reflected interests and concerns shared by artists involved in concurrent movements such as crafts, feminism, *arte povera,* and Process Art, with its emphasis on the transformations of organic substances.

Did the art world respond to the book metaphor in these paper works? Curators more likely appreciated that the works of Greenwald

and Stuart adapted to a variety of scales, thus avoiding the book's enervating trap within a display case. For the paper-astute, Greenwald's use of Japanese paper added cultural associations of humble functionality and spirituality.[325] Finally, it must be recognized that these signature works, repeatedly exhibited and reproduced, were free of text, thus allowing viewers to enjoy their booklike connotations without grappling with a text's explicit meanings. They were also unique works, and so avoided any lingering bias against multiples, editioning, and the market.

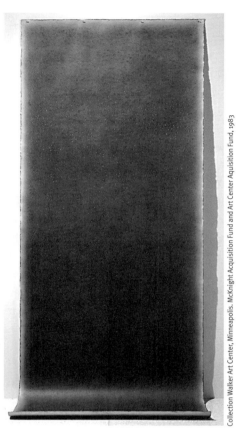

FIG. 66. Michelle Stuart. *Niagara II, Niagara Gorge,* 1976. Red shale, gray shale on muslin mounted on rag paper. 156 x 62

Collection Walker Art Center, Minneapolis. McKnight Acquisition Fund and Art Center Aquisition Fund, 1983

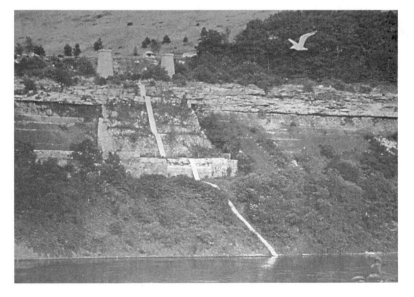

FIG. 67. Michelle Stuart. *Niagara Gorge Path Relocated*

325. See Timothy Barrett, *Japanese Papermaking,* 11.

159

THE PLURALISTIC BOOK

For lovers of fine printing, greater visuality foretold a diminishment or neutralizing of the lucid symmetry favored by the typographical revivalists. For many artists, increased visuality revitalized bookmaking as an artistic choice no longer freighted with typographical imperatives. In the 1970s, three presses—Druckwerk, Rebis Press, and Poltroon Press—challenged fine printing standards concerning the book's typographic, graphic, and material integrity. Johanna Drucker, of Druckwerk (at that time, Chased Press), created a manic masterpiece of handset type in *From A to Z* (1977, fig. 68). The story relates an infatuation played out in a parody of the literary scene of San Francisco. Narrative threads overlap and overrun the page. Poems appear on the recto pages, across from bibliographic and critical reception data pertinent to each poem on the verso pages. Drucker spoofed book conventions in the spirit of Walter Hamady by incorporating commentary and information about her characters into the title page, table of contents, introductory notes, and endnotes. But unlike the whimsy of Hamady's book, Drucker provokes discomfort as her book unravels the social and artistic entanglements of an insular literary community.

Drucker commingled dozens of typefaces in a visual profusion that suggests avant-garde typography (an interest of Drucker's). The narrative sets a pace described by Betsy Davids and Jim Petrillo as "a reader's steeple chase, ranging from straightforward prose narratives in easily legible type that can be read at a gallop to high-hurdle passages that are considerably sportier reading, with abbreviations, run-on

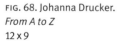

FIG. 68. Johanna Drucker.
From A to Z
12 x 9

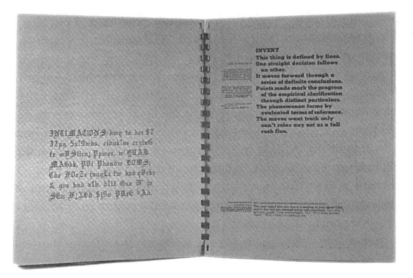

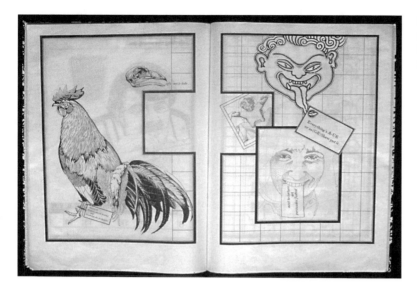

FIG. 69. Frances Butler,
Alastair Johnston.
Confracti Mundi Rudera
18 x 13

words, secret meanings, alphabet soup."[326] The book also showcases typographical gymnastics, in that Drucker limited herself to write and handset it using the type from the forty-eight typecases at hand, each piece of type used only once, forcing Drucker to edit her writing as she handset the text from page to page. She recalled later that, "by the time the endnotes were set, for instance, many substitutions of punctuation, dollar signs, uppercase letters, and other inventions were necessary to produce meaningful (but highly cryptic) statements."[327] The persevering reader welcomes the substitutions in that they inject a playfulness into the self-referentiality of the narrator.

Moving from a cryptic to a graphic iconoclasm, the Poltroon Press, of Frances Butler and Alastair Johnston, produced books that challenged fine press norms of typographical balance and literary primacy. In *Confracti Mundi Rudera,* translated as "fragments of a shattered world" (1976, fig. 69), Butler commandeered the page as a field and reorganized it with dotted lines, repetitions, and layerings. The book was printed letterpress on transparent paper in an edition of 60 copies. Butler and Johnston avoided allegiance to any confining aesthetic, and viewed design and content as highly negotiable entities. Pages emerged odd and off-kilter, as if succumbing to a graphic vertigo. Johnston and Butler refused an ordered, regimented page for a design that broke ranks to call attention to itself through the insertion of unexpected, often bizarre, "found" images (a rooster, a bird's skull) and equally eccentric texts. Pages whose incongruous elements edge or overlap one another achieved Poltroon's goal to create "not illustrations of the words but parallel sources of information and emotional allusion."[328]

326. Betsy Davids and Jim Petrillo, "The Artist as Book Printer," in Lyons, ed., *Artists' Books,* 161.

327. Drucker, *The Century of Artists' Books,* 167–68.

328. Frances Butler, "Exploring the Image," in *Trance and Recalcitrance,* 28–29.

FIG. 70. [CP14] Frances Butler,
Alastair Johnston.
Logbook
12 x 8⁵/8

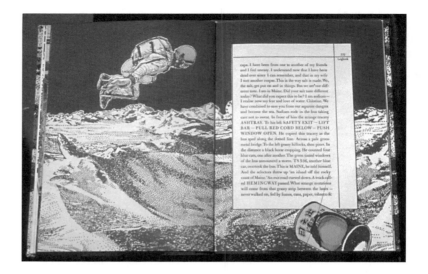

Poltroon Press released *Logbook* in 1977, written by Thomas
Raworth. The letterpress-printed book included color from pochoir,
or hand-stencilling. The book's purported narrative is composed of
fragments from a ship's log kept by the narrator. Any sense of a log as a
diary of observation and reflection is, however, soon derailed by jumps
and digressions in the narrative. Some observations are inflicted on
the reader in disturbingly private admissions, such as, "I understand
now that I have been dead ever since I can remember, and that in my
wife I met another corpse. This is the way salt is made." Raworth allows
no separation between private and public in his narrator's desperate
world. Johnston and Butler spill that ambivalence of the narrator
onto the page in tipping perspectives and floating objects (fig. 70),
with Butler's pointillist style (barely) relating it all within a shifting
field of dots. A sense of threat or violation persists, occasionally
overt; for example, beneath a lush blue sky in a desolate landscape,
the reader's point of view peers over the shoulder of a rifleman as he
sights down its barrel. Two openings later, the reader has become the
target, and confronts the grill of a Mack truck head-on, the words on
its grill firing: "Boom! Boom!" The makers of *Logbook* avoid a straight-
forward narrative, and revel instead in accumulating the sly turn of
phrase, the visual hocus-pocus, and the melding of the sinister with
kitsch, where "Each page turning became a risk." [329]

Rebis Press fashioned books from unconventional materials that
dramatically altered the reading experience. Betsy Davids founded
Rebis Press in 1971, and, joined by Jim Petrillo in 1972, Rebis pub-
lished writings by Davids and others. Davids viewed their books as
anomalies in both fine printing and the arts:

329. Ibid., 29.

330. Author's telephone interview
with Davids, April 29, 1998.

331. Ibid.

332. Ibid.

The way I felt about our books at that time was that...within a culture of gallery art, our books actually looked a little tame, [without] a strong object character. But within the context of traditional fine print books, they looked really wild...as if they had a lot of object character. So...I was bridging both worlds [of art and fine printing,]...I wasn't the only person in that position.[330]

Davids believes that the traditions espoused by Stanley Morison and Beatrice Warde were a given, "built into everybody's thinking, learning [and] backgrounds in terms of making letterpress books [and] fine print books—everybody was carrying that around with them already," and she could participate in the emerging discourse most cogently by making books that challenged those expectations. Naturally, though, "there were people who would question whether these were books, whether this was an appropriate way to make a book, and it had a lot to do with the materials, the look of them."[331]

In 1976 Rebis issued *The Softness on the Other Side of the Hole* (fig. 71), a short novel by Kenneth Davids, her former husband. The plot involved an affair conducted through a hole between two bathrooms in a coffee house. The plywood cover of the book reveals a hole with hair visible behind it. Opening it, the hair configures into pubic hair curling from a photoengraving of a female torso. Davids recalled that, "when you first looked at the book [the torso] was part of the [book's] visual character...and raised those kinds of issues probably as dramatically as anything we did in the 1970s. It was the reluctance [in the fine printing world] to allow for non-traditional materials in bookmaking that I was really conscious of."[332] The impact of *Softness* was stunning within a book context. The fact that its typography reveals a keen design sense and quality printing only heightens its unsettling effect.

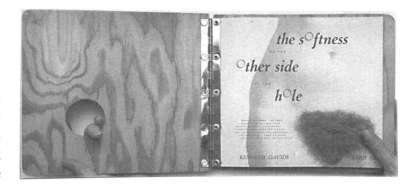

FIG. 71. Betsy Davids, Jim Petrillo. *The Softness on the Other Side of the Hole* 9 x 10

Davids appreciated the impact that such materials deliver to a traditional fine press audience, inciting an erotic titillation that complicates the act of reading amidst a reader's questions and reactions. To touch the (socially) untouchable and join in the liaison triggers a rush of emotion (distaste? desire?), as if Duchamp's shocking nude beyond

the peephole in *Étants donnés* (1946–66) had suddenly been brought within reach. *Softness* illustrates how a book could engage, shock, and unnerve a reader on an intimate level seldom granted to art.

In 1978, Davids and Petrillo toured the United States, giving performances, conducting bookmaking workshops, and presenting lectures that highlighted artists' books from the West Coast. The books by Druckwerk, Poltroon, and Rebis Press transport the fine press book and its artisans into a conspiratorial deployment of typographical, visual, and material stratagems more familiar to bookwork artists. In this quarter, the influence from hybridization was already recognizable. As evidence, these books by the transgressors of fine printing embody the larger cultural upheavals that assailed the ordinary book of the day.

THE UPS AND DOWNS OF THE ORDINARY BOOK

So the numbers are conjectural but extremely high — twice as many [little] magazines in print at any moment in the mid 1970s as existed altogether in the first thirty-five years of little-magazine history.[333] —MICHAEL ANANIA, 1978

The fact that we can and do ask [the question] may be part of the process of debilitation which, presumably, we fear; and it could, conceivably, hasten [the end of the book].[334]
 — GEORGE STEINER, "AFTER THE BOOK?" 1972

If the artist's book is inextricably linked with the cultural status of the common book, then the growth of book art in the 1970s coincided with a time of unprecedented confusion over the trade book's present and future roles. By then, changing economics and readership patterns had sent trade publishing into turmoil, leaving little agreement on its future. *The State of the Book World* (1980) captured the confusion, with essays that ran the gamut from doomsayer Alfred Kazin foretelling the devouring of publishing by conglomerates, to the temporizing of Ernest Boyer that "television is the most immediate, the book the more versatile," and, thus "both will be the teachers of the future."[335] Dan Lacy emphasized the economic frailty of trade publishing, despite its immense size:

333. Michael Anania, "Of Living Belfry and Rampart: On American Literary Magazines Since 1950," *TriQuarterly* 43 (1978): 10.

334. George Steiner, "After the Book?" *Visible Language* 6: 3 (Summer 1972): 198.

Over the last thirty years this dying industry has grown in sales from $400 million to more than $4 billion and in titles published from about ten thousand to more than forty thousand. Though it is hard to define what is and isn't a book publisher and hence to count their number, that number has certainly more than doubled. The cost of books has risen

sharply, but it is an increase much less than that of, say, theater or movie tickets, and the birth of the mass market paperback industry has made books far more widely available than ever before and relatively more cheaply. Enormous sums were raised and invested in publishing to make possible the production of the vast quantities of educational material required in the postwar decades.[336]

Lacy went on to downplay the perceived threat that huge chain bookstores posed to independents (in this he was mistaken). The publishing world had dispersed into a matrix of discrete yet overlapping entities, whose growth seemed increasingly at odds with visions of the book's irrelevance posed earlier by Marshall McLuhan and others. But like a neurosis, such worries resurfaced in 1972 from literary critic George Steiner, who asked, simply and devastatingly, "After the Book?"[337] That question echoed throughout the book world in fear not only of the diminishment but of the growing insignificance of the book. Steiner's nervous preamble (quoted at the start of this section) suggested a superstition that just to raise the question could initiate the decline. Such was the uneasy status of the trade book by the 1970s.

Steiner invoked Mallarmé's cultural maxim, where, "the true aim of the universe, of all vital impulse, is the creation of a supreme book—*le Livre*." Steiner mourned the loss of the book's prestige as valorized in the private library, a place and a way of life predicated on a "*bourgeois* order founded on certain hierarchies of literacy, of purchasing power, of leisure, and of caste" (his italics).[338] In its place, conditions of contemplative reading had given way to the "anti-language" movement and to "attacks on traditional literacy, on the transcendental view of the artist's and thinker's enterprise, and on the validity of language....It is not so much a 'counter-culture' which is being developed, but a 'post-culture.'"[339] Students in this post-culture resented the "egotistical claims on space and silence" that facilitated a traditional approach to "classical" reading, and instead sought out more "audio-visual" forms of "information, persuasion, [and] entertainment."[340] Such entertainment testified to the impact of television, which eventually crowded out even the picture magazines such as *Life* and *Look*.

The cultural enfeeblement of the book seemed imminent: from the victory of television in its image, movement, and sound; from book collecting's loss of esteem; and from students' refusal to give their full attention to reading. Contrast this dire forecast to the dramatic growth in trade publishing noted by Don Lacy, above. The future of

335. Ernest Boyer, "The Book and Education," in *The State of the Book World, 1980* (Washington, D.C.: Library of Congress, The Center for the Book, 1981), 28. The Center for the Book, which published *The State of the Book World,* was established by Congress in 1977 under the direction of the Library of Congress, to "stimulate appreciation of books, reading, and the printed word." John Y. Cole, "Preface," in *The State of the Book World, 1980,* 1. In the 1980s, the Center founded state affiliates, mostly in libraries, to disseminate programs and to generate interest in books and reading.

336. *The State of the Book World,* 11–12.

337. Steiner, "After the Book?" 197–210.

338. Ibid.

339. Ibid.

340. Ibid.

the trade book was evidently more complicated than simple survival or disappearance. The book's future would instead incorporate competing forces that included a shift away from the idea of the book's cultural preeminence and the embrace of new media, balanced by the public's persistent choice of books to read in their more limited free time.

This cultural confusion about what the book would become could not help but affect bookmakers. The situation was exacerbated by the commercial adoption of offset printing, which inched letterpress printing ever closer toward anachronism. Fine printing not only depended on the diminishing supply of hot type, but it also was associated with a traditional (read: obsolete) book culture. Most fine printers responded by either emphasizing fine printing as a means of relief printmaking (as if to seek an art world alignment), or, perhaps cringing at such a strategy, printers embraced anachronism as a part of bookmaking, a choice that they felt separated (and so protected) the printer from the machinations of the contemporary art milieu. After all, had not William Morris undertaken the Kelmscott Press in a conscious repudiation of the printing standards of his day?

Nevertheless, visuality had settled into trade publishing, and with that the public's conception of the book was also changing. Text faced increasing challenges in capturing and sustaining reader interest. Designer Adrian Wilson described this new kind of book in 1967:

> [this kind of book] is predominantly pictorial or graphic, [a] book whose visually oriented author thinks in terms of the photograph or diagram and how it can be clarified in the text or caption. Today, this method has special currency and vitality because of the competition and power of television, the cinema, and the picture magazine. Contrary to the book in which the author prepares a complete manuscript this kind of book can be designed and illustrated before the text has been written. As in copy for advertising or magazine design the text can be written to fit the layout, often an exciting discipline in itself.[341]

Arguments animated the decade. From the cultural elegizing of Steiner to the range of opinion in *The State of the Book World,* extreme positions were staked out and defended. The small press publisher or little magazine likewise underwent expansions and contractions in audience size that were even more pronounced than those of trade publishing. In 1978 Michael Anania (also quoted at the start of this section) tried to explain the flurry of activity in little magazines:

341. Adrian Wilson, *The Design of Books* (Salt Lake City and Santa Barbara: Peregrine, Inc., 2nd edition, 1974, 1st edition, 1967), 67.

342. Anania, "Of Living Belfry and Rampart," 10. See also Susan R. Gurney, "A Bibliography of Little Magazines in the Arts in the U.S.A.," 13.

An explosion in little-magazine publication....is supported in part by the availability of grants...but depends, as well, on a growing population of writers and on access to various kinds of printing technology....The world of little magazines is characterized not only by growth but by incessant change. Magazines die, not only because they lack funds but because their editors, often quite deliberately, allow them to die— sometimes out of frustration or exhaustion and sometimes because they feel that the task of the magazine has been accomplished.[342]

Although separate from the fine press world, the world of little magazines shared with it a commitment to independent publishing and contemporary literature. In addition, little magazines were often published from campuses, the same location where the growing number of campus fine presses resided.

"YOUR MONEY OR YOUR LIFE"

The growth in trade book publishing as cited by Don Lacy, above, was due in part to a stronger economy. That economy produced new sources of income for fine printers, but not without controversy. In higher education a small stream of institutional support underwrote some of the operating costs of campus fine presses. That support was the envy of unaffiliated artists, but the nature and degree of funding varied widely. Walter Hamady described his situation at a conference on book publishing in 1977:

> I'll be perfectly candid with you, the reason we put a high price on [a book] like this...is to encourage libraries and private collectors to buy direct from us or put a standing order in. Because dealers are very devilish people, and obviously they're in it for the money, and they have to have a discount. So I figure, really, what do we have to make on this book, paying ourselves not even plumbers' wages....I try to figure on the basis of what we really have to have...and then add 30%....Sometimes I give books away. In fact, that's what happens to a goodly part of the edition. Usually between 50 and 75 copies is all that we ever sell. The rest we give to friends, trade, just give away. But again, I think the objective is certainly not one of money. [343]

343. Hamady, in James P. Danky, Jack A. Clarke, Sarah Z. Aslakson, eds., *Book Publishing in Wisconsin*, 12.

As noted earlier, the first grant for Harry Duncan (of several) arrived in 1967 from the National Endowment for the Arts and Humanities for $10,000. Duncan directed such support toward underwriting publishing costs in hopes that lower book prices would broaden a buying audience usually dominated by libraries and private collectors. Those lower book prices, however, also promulgated a skewed sense of value that was only fractionally representative of the hundreds of hours of a printer's time and the investment in press and type. (This point should not minimize the challenges faced by campus presses. Most are notoriously under-funded, and their financial circumstances can dramatically worsen simply from a shift in campus politics.)

What of the independent fine printer without institutional support? Rising equipment and materials costs did not permit independent fine printers to set prices competitive with the subsidized book prices from some campus fine presses. A few non-campus independent printers did receive grants. Betsy Davids and Susan King received funding for fine print editions in the late 1970s, during a period when they qualified as small presses for the Literature Program of the National Endowment for the Arts (NEA). The NEA awarded Claire Van Vliet funding through its Master Craftsman Apprenticeship program in 1976–1977. Fine printing and government arts funding matured at about the same time, but in the 1970s Davids, King, and Van Vliet remained more the exception to the rule for independent book artists.

Some believed that the solution to increased funding support for fine printers lay with the printers themselves. Publisher David Godine argued in "The Small Fine Press as Business" that fine printers had to develop as a business, and return printing to its populist roots, to make a living. Godine noted that a number of influential fine presses were subsidized by income from family wealth (including the Kelmscott Press), or by job printing. He added: "I mention these precedents to make it clear that fine printing has always catered to and been supported by a finite and wealthy market, and fine publishing—in which production quality is at least equal to editorial content—has always met with difficulties and resistance in the public marketplace."[344] Having dispensed with the fantasy of financial autonomy, Godine listed the present-day challenges of fine printing as: the rising costs of staff and materials, the dropping availability of quality Monotype composition, and distribution. Godine supported the ideals of literary and artistic excellence by attending to the crucial practicalities of building an audience: "I realize it may sound mercenary and venal, but I believe that the entire purpose of publishing a book is to do just what the word connotes: make the book *public*. Most fine presses do not publish, they *privish*."[345]

344. David Godine, "The Small Fine Press as Business," *Fine Print* 7, no. 4 (October 1981): 118.

345. Ibid., 119. His emphasis.

There remained detractors to Godine's call for the fine printer–as-entrepreneur, however, despite its hearkening back to the original focus for publishing, which is today described as audience development. Frances Butler, for example, adopted the voice of an art worker instead of a printer-publisher in an effort to locate Poltroon Press outside of the influences that the art world exerted over audience and reception:

> Poltroon Press was founded on the theory that a private press, financed by other work and not by selling its products, should not accept the formula that time is money, should not rework marketing formuli like reprinting famous authors in textual reliquaries. The phrase *Your money or your life* is the ultimate threat to intelligent creativity. Our productions, in all of their variety, have resulted from the intensely private use of time, or the practices of both trance and recalcitrance.[346]

Butler insisted that a printer work from an inner prerogative free from outside economic influence, concerned only with artistic practice. Of course, Butler's fabric company (Goodstuffs Handprinted Fabrics, 1969–1979) and then her faculty position, as well as the various jobs that Johnston held, contributed their own subsidy to Poltroon Press. Butler and Johnston viewed their work as serving to protect them from the need to engage in market exchange as printers, and so helped them to avoid distractions to their bookmaking. On this point alone one expected Butler to agree with the convictions of Richard Bigus, who later recalled that, for William Everson, "Ideally, every aspect of a book was thought through and deliberately reflective of the spirit and nature of the text and not left to established conventions or forces of economics. This sensibility was [Everson's] greatest gift to his apprentices...along [with] his sense of perfection."[347] The aesthetic of Everson and Bigus, however, could also point the fine press book toward the materials and scale (and price) of a deluxe book. Such a direction was equally anathema to Poltroon. In 1981 Alastair Johnston assailed Everson's *Granite and Cypress* as "a work entombed in a wooden box with a headstone of slate from Jeffers's private quarry, a most mortifying job of packaging designed to please the rapacious Jeffers collectors."[348]

The 1970s brought exciting developments for the increasingly varied fine printing community. The growth and variety of institutional and government subsidies contributed mightily to the expansion of the fine press book and book art. Literary fine printing still produced compelling books and devoted practitioners, and collectors continued to pay homage. In the view of the traditionalists, art

346. Butler, her emphasis, in *Trance and Recalcitrance*, 6.

347. Author email interview with Bigus, June 22, 1998.

348. Alastair Johnston, "Literary Small Presses," 14.

had emerged as the perceived siphoner or corrupter of book values (and even of the book's cultural mandate), causing a loss of the focus on literary publishing. And yet, in the midst of such change, fine printing had built an art world by the end of the decade. It had quietly claimed a place on campuses; it had given rise to criticism, exhibitions, and organizations; and it had helped to generate related worlds in hand bookbinding and papermaking. Still, the disappearance of letterpress loomed. Not blessed with second sight, fine printers could not foresee a future where computer technology delivered new hope to fine printing with the polymer plate. There seemed no liberating the fine press book from conflicts over content and design, edition size and price, and changing printing technologies. By the end of the 1970s, traces of moralism and nostalgia still clung to the fine press book, even as some printers stretched to incorporate in it new realms in literature and art, typography and material.

The Deluxe Book

It almost seems inappropriate to refer to this remarkable collaboration as a 'book.' The physical presence and overall effect of this magnum opus are stunning. Foirades/Fizzles overwhelmingly becomes more of an exquisite object, a package, a unique container, and holder of verbal and visual ideas than it does a book in any usual sense of the term.[349]

—HOWARD J. SMAGULA

...I conceived of the book both to be seen in sequence, that is, by turning the pages one by one in the proper sequence for it to be experienced in time like music, not at random, and as hung as an exhibition....I also should mention that several people have cut up some of the pages and framed just the aquatint image. A sacrilege. Not only is it a violation of the book as a book, but the images are related to the typeface, visually as well as in meaning, so that the whole page is the work of art, not just the plate on it.[350] —ROBERT MOTHERWELL, 1972

Unjustifiable is the touch of exclusivity and the tendency to despise any book whose illustrations are photomechanically produced or drawn on the stone or engraved by artisans.[351]

—GABRIEL AUSTIN, 1974

Many deluxe book artists continued in their pursuit of artistic innovation, but in formal terms only, in the imagery on the page, rather than in the altering of a book's materials and structure to reflect its content. A few surprising fusions emerged: in fine press–deluxe hybrids, in activist content and in non-art materials, and in the delights of designer binding. The key deluxe developments concerned the response from artists to issues of display and reception—based on the limitations of the bound book, incapable of wall display— rather than in the production of groundbreaking individual books.

Foirades/Fizzles (1976), by Jasper Johns, with text by Samuel Beckett, was the most high-profile deluxe production of the decade, and as such represents an exemplar of the deluxe book in the European tradition. It shows us what was and was not considered a successful deluxe book, from an art world perspective. The book begins with Beckett's haunting prose: "I gave up before birth, it is not possible otherwise, but birth there had to be." The sentence continues, unrolling like a loosened internal tape to fill the first page before generating a period. References to the body, to loss, and to disappearance enmesh the reader in the emotional and intellectual entanglements of the narrator. This is the land of No Exit, stifled by pervasive ennui. One expects revelation from such a wordy deluge, but it does not arrive.

To the laconic existentialism of Beckett, Johns responded with marks and emblematic body parts in thirty-three etchings of grays,

349. Smagula, discussing the book by Jasper Johns and Samuel Beckett from 1976, *Currents, Contemporary Directions in the Visual Arts* (Englewood Cliffs, New Jersey, 1989), 127.

350. Robert Motherwell, discussing his deluxe book, *A la Pintura*, interview with Heidi Colsman-Freyberger, "Robert Motherwell: Words and Images," *The Print Collector's Newsletter* 4, no. 6 (January–February 1974): 126.

351. Gabriel Austin, "The Modern Illustrated Book: A Neglected Field for Collectors," *The Print Collector's Newsletter* 4, no. 6 (1974): 130.

blacks, and whites, and two color lithographs. Here, the pictures are as elusive as the text, and everything appears to be in pieces: the reader immediately encounters a dismantled body in a blurry face printed with sugar-lift, ear and lips misshapen but discernible. The book alternates French and English texts, and Johns adds imagery to that contrapuntal cadence. The book ends—literally disjointed— with a foot and a hand. Handling the book adds a further impediment, as, once out of the box, the thick paper in an accordion format slows one's paging—a bit clumsy, whether or not intended.

Why did *Foirades/Fizzles* generate more comment than any other deluxe book in the 1970s? Certainly, it is a stunning production in the deluxe tradition. No doubt as well, the public attention was in part due to the maturation of the U.S. deluxe book. Inevitably, however, the acclaim primarily resulted from the pairing of cultural superstars from America and France, since, "Johns is to painting as Beckett is to drama." [352] In fact, for some critics the work's identity as a book seemed only to get in the way of its art. In the statement that begins this section, Howard Smagula sounds unsettled by the powerful effect that *Foirades/Fizzles* had on him, as if he disapproved of all that effort directed into the ubiquitous format of a book. When considered from a book art perspective, *Foirades/Fizzles* deserves a more modest critical reckoning. Beyond an invigorating pairing of voice and image, it is a sensitive but not revolutionary book design. Perhaps its greatest contribution lies in the doubled voice and imagery, both of which tease but do not deliver on the intimacies they broach.

The critical hyperbole surrounding *Foirades/Fizzles* epitomized an odd sort of neophytism, a conundrum common to the deluxe book or to any artist's book that rose into the rarefied realm of art. Critics might dissect an artist's style, yet shrink from describing the experience of paging through a book. [353] Then again, few deluxe books challenged their viewers to reconsider the conventional properties of reading. The resulting critical lethargy remained the most glaring weakness of the deluxe book. Contrast this to fine press critics, who had formulated their program by mid-century, and were by now responding to challenges to that program from the perceived encroachment of imagery on the literary page. Or consider the multiple bookwork, as we will below, whose critics actively promulgated an (admittedly exclusionist) ideology in the 1970s. Compared to that, the "book" in deluxe book was stifled by the critical silence that surrounded it.

Absent from the hoopla surrounding *Foirades/Fizzles* was an homage to Europe as the preeminent source for deluxe books. Instead, the French-American pairing of the book seemed to symbolize the equal billing sought by Americans. But did America deserve it?

352. Smagula, *Currents*, 126. The Petersburg Press, the British atelier that published *Foirades/ Fizzles*, operated a New York branch from 1972 through 1990.

353. An example of successful critical consideration is the unpublished essay by Karen Wirth, "Word and Image in *Foirades/Fizzles*" (Minneapolis, 1989). Wirth, herself a book artist, educator, and critic, related *Foirades/Fizzles* to the history of the illustrated book as well as to principles of book design.

Had there been a true upswing in U.S. deluxe book publishing? Few supporters would probably have claimed American dominance of the deluxe book at that time. In fact, Breon Mitchell premised the exhibition, *Beyond Illustration: The Livre D'Artiste in the Twentieth Century,* on the continued prominence of Europe. The French nomenclature used by Mitchell reflected his observation that Europeans produced most of the 100 books on exhibit, which "have rarely been seen [before] in the United States."[354] While providing a history of the modern French deluxe book, Mitchell also addressed its "serious methodological problems."[355] He stated that the preference for visual over literary content in the deluxe book had produced a critical myopia where the "literary component is rarely touched, let alone discussed meaningfully in relation to the artist's work."[356] In addition, Mitchell noted the public's limited access to deluxe books, which only compounded the lack of informed criticism.

Despite the fact that the deluxe book existed within an increasingly international art world, the sense of leadership in Europe had grown less certain. Antoine Coron later pointed to a stagnant European economy as a contributing factor, and then listed the losses that France had sustained: the last publication by the artist-publisher Iliazd in 1974 (and his death in 1975); Tériade's last book in 1975 (he died in 1980); and the death of artists associated with the deluxe book, including Picasso (1973), Max Ernst (1976), and Calder (1976).[357] The United States could fill that vacuum if it could generate books of comparable stature.

For the most part, the next generation of American deluxe book artists were still in school. Only a few printmaking teachers made books consistently, notably Antonio Frasconi, who began teaching at State University of New York–Purchase in 1973. In the spirit of Frasconi's *Viet Nam!*, a handful of young printmakers created books of prints charged with social content. Chief among them was John Risseeuw, who studied with Walter Hamady and has taught since 1980 at the University of Arizona–Tempe. Risseeuw's books and portfolios disclose their political and social concerns in understated or surprising ways.

Risseeuw's Pyracantha Press published *The Politics of Underwear* in 1973 (fig. 72). It begins: "The bra-strap of America / is broken / please fix it." A strap falls across a page, as if discarded. At first it whispers in an embossment that invites a caress of the handmade paper, and then the lingerie reemerges on subsequent pages in lithographed tropical hues of pumpkin and purple, as if blushingly "uncovered" by the reader. The Optima type is large, perhaps too much so, but its size also enforces a sense of exposé, even though the intimate details

354. Mitchell, *Beyond Illustration,* 5. A few Americans appeared in the exhibition, such as Leonard Baskin and Mary Ellen Solt.

355. Ibid.

356. Ibid., 6.

357. Antoine Coron, "The Plight of the French Illustrated Book Today," *The Print Collector's Newsletter* 17, no. 4 (September–October 1986): 131.

FIG. 72. [CP23] John Risseeuw.
The Politics of Underwear
14³/₄ x 11¹/₄ x ¹/₂

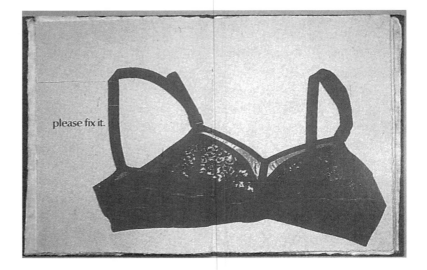

of elastic and lace have shifted on the page into pattern and color. Beneath its whimsicality a sense of revelation through violation persists, evocative of a time of social chaos and political betrayal; in 1973, the year that *Underwear* appeared, the bombing of Cambodia ended and the Watergate hearings began. The sense of exposure, and the overlap of the personal and political, are all the more disquieting when revealed from within the sanctuary of the deluxe book.

IN AND OUTSIDE OF THE ATELIER

In spite of challenging books like *The Politics of Underwear*, the deluxe milieu remained relatively stable. The U.S. print ateliers were healthy and maturing, with ULAE, that key contributor to the deluxe book, meriting a retrospective in 1978: *Words and Images: Universal Limited Art Editions,* at the University of California–Los Angeles.

The deluxe book world provided refuge for some hand bookbinders who wanted their work viewed less as craft and more as "designer binding." *Hand Bookbinding Today, an International Art,* opened in 1978 at the San Francisco Museum of Modern Art, and traveled to Kansas City and Philadelphia. In July of that year, *Fine Print* included an illustrated supplement from the catalogue, and international binders, including Great Britain's Bernard Middleton and Philip Smith, traveled to the United States. The exhibition marked a watershed for U.S. binding, even though Americans produced only 21 bindings out of the 123. Its museum venue was made much of, and long overdue; one reviewer stated that the only comparable U.S. showing had been at the 1939 San Francisco International Exposition."[358] The

358. Jerome Tarshis, "Bookbinding International," *Craft Horizons* 38, no. 3 (June 1978): 46–49.

catalogue essay by curator Eugenie Candau (a binder as well as the museum's librarian) determined that the beginnings of designer binding coincided with the modern *"livre d'artiste,"* whose graphic content tended more toward the evocative than the illustrative, and whose leaders (such as Pierre LeGrain and Paul Bonet, whose books showed in *Beyond Illustration*) innovated in image, materials, and form. After asserting this fine art heritage, Candau brought into her discussion note of the British Arts and Crafts' pursuit of integrity in structure and material, as if to reestablish a book art balance.

These artistic bindings can be traced to a deluxe heritage. Most of them glowed from leather inlay and onlay, and binding innovations were generally confined to those of technique. Only a few departed from expectations, such as Gary Frost's *The Tracts of Moses David,* discussed above. For overall impact, nothing approached Philip Smith's book walls, which conquered the book's inherent limitations of scale with a new, vibrant theatricality. Smith showed *The Lord of the Rings* (1970–71, fig. 73), which consists of a six-volume surface where the sweep of pattern periodically coalesces into recognizable forms. Smith invented techniques to create the painterly surfaces of his bindings. In 1958 he developed feathered onlays, which consist of parings off the grain surface of the leather that result in "tattered" edges that blend into adjacent onlays or the background skin. In 1969 Smith invented "maril" of waste parings and off-cuts mixed with adhesive, that he formed into blocks, then planed into areas whose effect he described as marbled inlaid leather. Smith also devised what he called emulsified maril, that he worked with wet, like clay modeling on a surface, or like an impasto of paint. Maril was also created by overlaying layer after layer of scraps of leather, and then compressing and planing slices off the blocks at different angles to the edges. Smith applied his innovations to sculpt a dense, layered visual field reminiscent of a collage or an impastoed painting.[359]

Smith's book walls offer a single book's access, yet the volumes also visually relate to one another on the wall (as "real" art would), creating an expansive, sensual topography that begs for a reader's touch. American collectors responded, buying his work at art world prices. Smith argued fiercely for binding's artistic independence in writings that exerted influence simply from instigating that dialogue. In 1982 he stated that:

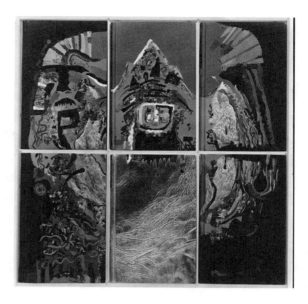

FIG. 73. Philip Smith. *The Lord of the Rings,* by J.R.R. Tolkien, 1970–71. Six-unit book wall of six copies of the 1969 deluxe edition in a walnut and perspex case with aluminum dividers. 575 x 539 mm. © Philip Smith Private collection, USA.

359. Descriptions of processes from Philip Smith emails to the author, December 29, 2003.

What I am searching for is a way of delineating that particular book with a new expression of its individuality, for an expression without words of the *personality* of that particular book. So in the declining years of the need to bind books by hand for reading, a quite new approach is being developed. It should be made clear that the handful of true pioneers are not competing with the 'craft-binders' because the traditionalists cannot or will not see that our aims are in a totally different world.[360]

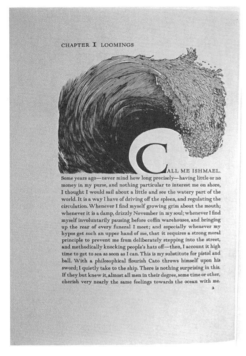

FIG. 74. Andrew Hoyem.
Moby-Dick, or The Whale
15 x 10

The style and scale of the book walls symbolizes a new generation of binders. They identify themselves as artists first and mastered binding techniques as one would learn the discipline of painting—as a means to serve an artistic muse. They later rewrote the rules as the need arose. To a great extent, however, the fine art context of designer binding remained constrained by its patronage (as Eugenie Candau noted), which continued to be centered in the conservative bibliophilic community. Candau hoped that other museum showings would broaden that base of support, but few followed the lead of San Francisco.

In contrast to designer binding's foray into an art world venue, the fine press-deluxe hybrid was by now well established within book art, even though it could not escape from persistent criticisms of the deluxe traits that distinguished it. More than any other hybrid of the period, the surfacing in 1979 of *Moby-Dick* (fig. 74), Andrew Hoyem's deluxe colossus, by Herman Melville, created a wake that shook both the deluxe and the fine press communities. The book embodies Hoyem's ambitions for the Arion Press. Unwieldy by fine press standards at 576 pages, with a page size of 15" x 10", the book's exhaustive triumph of handset type and 100 wood engravings also pays homage to fine press principles. Engraver Barry Moser pictures the whaling world as if in anthropological reportage, delineating species of whales, whaling gear, and views of whaling ships and ports. The sustained impression of the book is of the color blue. The blue morocco leather binding of the book inhabites a blue slipcase. Blue handmade paper carries a whale watermark, and blue display capitals punctuate the commissioned type named Leviathan.

In his books Hoyem hoped to attain an American synthesis of image and text on what was then perceived of as a European scale:

Despite the hazards of artistic licensing, I wanted to propel the French tradition of incorporating original prints into books toward a further expression that would be unmistak-

360. His emphasis. Philip Smith, *The Book: Art and Object,* quoted by Roy Harley Lewis, *Fine Bookbinding in the Twentieth Century* (New York: Arco Publishing, Inc., 1985), 60.

ably American. These were not to presume to the grand lineage of illustrated books that would include the *Hypnerotomachia Poliphili* of Aldus from 1499, nor were they to be volumes that merely served as typographically unrelated containers for a suite of etchings or lithographs. The goal was to fully integrate text and graphics with the hope that the whole might be more than the sum of [its] parts.[361]

Moby-Dick was no less a triumph than *Granite and Cypress,* by William Everson, and *Endlessly Rocking,* by Richard Bigus, but it sought to achieve a perfection of means, materials, and scale in service to a literary classic.[362] In that, it recalls the ideals set forth by printer Lewis Allen in 1961, in which he stated that a superior book ultimately coalesced from "a seventh sense [on the printer's part, as] the sum of [the other ingredients,] combined with delicacy, restraint, and apparent casualness without evidence of sterile formula—all in harmony to subtly interpret the text, like a handsome well-constructed bridge between author and reader."[363]

Such ambitions exact a price: the fine press–deluxe hybrid *Moby-Dick* cost $1,000, a figure well above that of any fine press book at the time. The fine press community buzzed, and shocked librarians worried at intimations of an inflationary trend.[364] But collectors lined up, and the 250 copies of the book sold out within a year, joined by a trade edition in a photographically reduced format two years later from the University of California. *Moby-Dick* was unapologetically grand, a spectacular book that "creates its own space around it as it stands, and laughs at criticism, even as it sings its own song."[365] Amidst the celebrating, Hoyem succeeded in toppling barriers that shielded fine printing from art world prices.

COLLECTING: THE BOOK AS ART

How have changes in printmaking over the past twenty-five years affected book illustration and artists' books? In every way. The tendency toward mixed media works, the renewed interest in papermaking, typesetting, bookbinding, and other crafts related to the book, and artists' continued interest in personal verbal/visual communication have all infused the subject of the book with new vitality and unlimited possibilities. [366]

—JANE FARMER, 1981

The success of hybrids such as *Moby-Dick* and the maturing world of book art created a collecting community for the deluxe book that was active but parochial, peopled by bibliophiles who wanted traditional illustrated books, or art collectors who sought work by renowned

361. Andrew Hoyem, "Working Together: Collaboration in the Book Arts," *Visible Language* 25, no. 2/3 (Spring 1991): 204.

362. Other, later books from Arion Press often incorporated innovative formats, however, beginning with *Flatland* (1980), by Edwin Abbott, a quirky satire about a two-dimensional world pictured in the author's line drawings and in the hand-colored, die-cut illustrations. The accordion-fold book resides within an aluminum frame, which allows for conventional reading, yet it also opens out into a thirty-three- foot-long screen.

363. Allen and Allen, Introduction, *The Allen Press Bibliography,* 9.

364. Betsy Davids recalled that news of *Moby-Dick* had just broken during her U.S. tour with partner Jim Petrillo. As they met with librarians about their own work, they listened to librarians repeatedly express concern over its price. Author's telephone interview with Davids, April 29, 1998.

365. Stuart C. Sherman, "Recent Press Books: The Arion Press." *Fine Print* 6, no. 2 (April 1980): 53.

366. Farmer, "Prints and the Art of the Book in America," in *American Prints and Printmaking: 1956–1981* (New York: Pratt Graphics Center, 1981), n.p.

artists. The modernists of Europe continued to dominate collecting. On October 6, 1976, Sotheby's auctioned 114 deluxe books, including work by Bonnard, Picasso, Maillol, and Matisse, as well as more recent books by Braque and Vasarely. For collectors attuned to contemporary art, it seemed to be the right time for the deluxe book to emerge as a contemporary collectible, and to some extent stunning books produced in limited editions by Jasper Johns and others met that need.

A few artists made books whose content responded to issues inherent to the deluxe book's dual roles as a work of art and a bound book. Richard Tuttle challenged the deluxe book's associations with rarity, with *Interlude* (1974). Published in twenty-four copies from Brooke Alexander (his gallery), the book's hand-drawn forms suggest arcs and partial spirals, evoking a mysterious asceticism that permeated his books, first seen in *Story with Seven Characters* (1965, fig. 5). In *Interlude,* Tuttle provides perforated pages, in a gesture that embodies the collector's urge to rip out a sheet and so transform page into print on the wall. In so doing, Tuttle highlights art world presumptions in which format (bound book or portfolio?) affects valuation: books of prints are valued less than individual prints. Considering the propensity of deluxe book collectors to engage in just such a desecration (note the impassioned rebuke by Robert Motherwell that begins the deluxe section), Tuttle-as-trickster literally embeds those conflicts over rarity and connoisseurship into the page, demanding that the collector choose between the desire to separate print (page) from book, or to preserve the integrity of art that has entered a collectible milieu.

Only a few dealers risked representing books within the art world. One of them, Kathryn Markel, opened her New York gallery in 1976 after working at Landfall Press in Chicago. She sold artwork until 1986 that included a variety of artists' books. In 1984 Markel contributed an article to a special issue of *Craft International,* "The State of the Book Arts." Her article, "Hey! Wanna Buy an Artists' Book?" identified three kinds of artists' books in terms of their marketability: the "artists' self-made Xerox" book (multiple bookwork), the *livre de luxe* (deluxe book), and the "hybrid *livre de luxe*" (sculptural bookwork). The lack of profitability of the multiple bookwork was no surprise to Markel, considering that such books usually sold for between two and five dollars. Also no surprise, she found that the deluxe book offered the best return to the artist (and the gallery), priced at $150 to $3,500 in editions of perhaps 300, especially from "an artist [who is] a known quantity." But to her dismay, Markel found the sculptural bookwork nearly impossible to sell:

These are the hardest books to market, because they are so difficult to categorize. While the hybrid *livre de luxe* appeals to both art and book collectors, the unique artists' book appeals to neither. Libraries rarely collect them because they are not in edition, and they rarely have the $500 or more required. Print departments in museums cannot buy them because they are not multiples, and the sculpture and painting departments tend to think they are only an idiosyncratic adjunct to more important painting and sculpture (and often they're right). Regular book collectors cannot justify paying up to $3,500 for a unique piece by an emerging artist when they can buy *livres de luxe* by famous artists for less, and the average art collector finds it difficult to spend a lot of money on something he/she can't hang on his/her wall.[367]

Markel's struggle to sell the type of book "that interests me the most" refuted the rhetoric premised on its easy salability (discussed below with the bookwork). Her comments suggested quite the opposite, that the sculptural bookwork delivered a suggestive and winning impact, but generally exacted financial sacrifice from a gallery owner; as Markel put it, "My gallery, which is the only one in New York that regularly shows artists' books, can sell at the most six [sculptural bookworks] in a year."[368]

In 1976, the same year that Markel established her gallery, The Fendrick Gallery of Washington, D.C., opened *The Book as Art,* organized by Barbara and Daniel Fendrick and accompanied by a modest catalogue. The tone of its essays was decidedly upbeat, with Daniel Fendrick proclaiming that, "Today increasing numbers of American artists are turning to books, either as unique objects or in limited editions, as a challenge to their creativity."[369] The Fendricks selected seventy-three "artists' books" (note their inclusive term) created between 1965 and 1975. Deliberately eclectic, their taste ranged from deluxe books to multiple and sculptural bookworks.

Rather than fit the works into an aesthetic focus, the Fendricks adopted a scattershot approach for a confusing but inclusive representation of the field. In his essay, Daniel Fendrick did not present himself as a mediator or interpreter but as a compiler—and an astute dealer. At one point he invoked Vollard as paterfamilias to the deluxe book ideal of the "ultimate in luxury, technical virtuosity and beauty," then slyly added, "A partial maquette for [Bonnard's] *Parallèlement* sold 18 months ago for $129,400."[370] But the impeccable taste of the Fendricks was not merely dictated by an atelier's imprimatur. For example, they included the independently published *Blanco* (1974), by Adja Yunkers,

367. Kathryn Markel, "Hey, Wanna Buy an Artists' Book?" "The State of the Book Arts," *Craft International* (October-November–December 1984): 27.

368. Ibid. Perhaps the most respected dealer in bookworks was Tony Zwicker (–2000). Zwicker sold antiquarian and rare books for ten years beginning in the mid 1970s (for dealer Barry Scott); it was during that period that she began to investigate artists' books. Her interest soon grew into a passionate advocacy of works by an international array of artists. As a dealer, Zwicker exerted considerable influence over the development of private and public book art collections in the 1980s and 1990s. See Michael Von Uchtrup, "Tony Zwicker, 1925–2000," *Umbrella* 23, no. 1 (April 2000): 3–4.

369. *The Book as Art* (Washington, D.C.: Fendrick Gallery, 1976), n.p.

370. Ibid.

371. A year later the Fendricks curated *The Book as Art II*. The catalogue essay for the second show reads like a time capsule of exhibitions and events from across the country, ending with a note about the upcoming designer binding exhibition in San Francisco, as well as the American books selected for Germany's *Documenta*.

its text by Octavio Paz, printed letterpress amid lithography, silk-screen, collage, hand painting, and embossments. The boosterism of the Fendricks contrasts markedly to Markel's subdued commentary of eight years later, but then, the Fendricks had comparatively less to lose. The book shows at the Fendrick Gallery comprised a smaller proportion (and risk) of their expenses, and the Fendricks also clearly enjoyed representing the top deluxe books of the time.[371]

CRITICISM: THE BOOK STRIPPED BARE

Despite the sporadic support from dealers and exhibitions, the deluxe book suffered from a lack of informed criticism. Only a few critics referenced persistent issues that concerned authorship, artistic integrity, and elitism (in the restricted access of the public to expensive, limited editions). Fewer still incorporated a book's imagery, literature, and structure in their writings.

In the Fall of 1973, *The Book Stripped Bare: A Survey of Books by 20th Century Artists and Writers* attempted to relate one kind of artist's book to another. The exhibition showed books from the Arthur Cohen and Elaine Lustig Cohen collection, along with books from its host, Hofstra University's Fine Arts Library. Susie R. Bloch did not limit the exhibition to deluxe books; in her catalogue essay she noted that, "Although the exhibition necessarily and centrally includes major examples of the *livre de peintre,* its design is not to mount a survey of it, but rather to celebrate *the book,* conceptually and as an object, as one of the most consequential and interesting art forms of the period."[372]

Bloch pointed to Stéphane Mallarmé as, crucially, recognizing "the *meaning of format*: a recognition which moved against the 'artificial unity that used to be based on the square measurements of the book.'"[373] Within her focus on the early avant-garde, Bloch related two very different kinds of books to one another: Mallarmé's *Un coup de dés* and Matisse's *Jazz* (both books were discussed in chapter 1). Bloch stated that the two books shared a rejection of the "artificial unity" that is imposed by the conventions of book design.

Decisively, Bloch did not deny the deluxe book a place in Mallarmé's "meaning of format." It too could orchestrate image and text into "a book in which typography and even the foldings of the pages achieve an ideational, analytic and expressive significance."[374] Even so, Bloch devoted most of her essay to multiple bookworks. She noted that subversive content could hide behind a conventional design, allowing an artist to take advantage of an unsuspecting reader's "intellectual habit of the book; the [book's] eminent quality of inti-

372. Her emphasis. Bloch, *The Book Stripped Bare*, n.p.

macy and introspectiveness."[375] Bloch suggested different directions (or their combination) from which a successful artist's book could arrive: one drenched in experiential delights, the other disguised within an ordinary book's appearance ("habit of thought") whose contents subvert conventions of the book and reading.

Bloch's brief but cogent essay was the most important U.S. writing in the 1970s related to the deluxe book. She freed the deluxe book from artificial standards concerned only with its prints, its preciousness, or its painters. More than any writer at the time, Bloch identified bookwork progenitors for book artists hungry for a heritage, as well as for academics and collectors still largely unaware and unappreciative of books (particularly bookworks). She did not deny artistic membership to deluxe books, but she did distinguish their visual nature from those of the early avant-garde, whose "ordinary" book appearance supposedly distanced them from the associations and pretentions of the art world. The only missing ingredient in her criticism remained an engagement with the literary component of the books—but then, few deluxe book writers grappled with literary interpretation before Renée Riese Hubert's *Surrealism and the Book* in 1988.[376]

Bloch's landmark essay was reprinted twelve years later in the influential *Artists' Books: A Critical Anthology and Sourcebook.* Was the challenge that Bloch set to the deluxe book recognized back in 1973? Did the deluxe book community respond to her raising of the aesthetic bar to meet the expectations of Mallarmé? Did anyone notice that Bloch considered deluxe books in equal terms with bookworks (although neither term was current then)?

The exhibition at Hofstra University generated much discussion, but most of it centered on the early avant-garde bookworks that had languished until then in the public eye. In fact, a growing body of critical writing that promoted the multiple bookwork based its art world membership on a rejection of the precious materials and high prices associated with the deluxe book. The last thing those writers wanted was proximity to a deluxe persona.

One does not have to look far for examples of writings that advocated for the multiple bookwork above all other artists' books. In January of 1974, Diane Kelder published a review that concerned three book exhibitions: *The Art of the Printed Book, 1455–1955* at the Pierpont Morgan Library (discussed above with the fine press book), *The Book Stripped Bare,* and *Artists Books* at Moore College of Art in Philadelphia, which showed a wide range of work (that exhibition is discussed below with the multiple bookwork). From today's perspective Kelder's critique sounds nearly rote, although at the time it ex-

373. Ibid.

374. Ibid.

375. Ibid.

376. In *Surrealism and the Book,* Hubert examined the illustrated book in its common, bookwork, and deluxe manifestations.

pressed a fresh art world preference. Kelder did not accept Mallarmé as a dual parent to the deluxe book and bookwork, as did Bloch. Instead, Kelder selectively applied Bloch's thinking only to the multiple bookwork, arguing that the *Artists Books* exhibition "revealed that most contemporary American artists and an impressive number of Europeans have rejected the eye appeal of the *livre de luxe* in favor of what Susi Bloch termed the 'intellectual habit' of the book."[377] The belief of Bloch that the deluxe book and the bookwork shared a paternity with Mallarmé was overlooked or lost in the surge of advocacy for the multiple bookwork.

Nancy Tousley's "Artists' Books" appeared in *The Print Collector's Newsletter* at about the same time as Kelder's review. Like Kelder, Tousley praised the hands-on accessibility of the multiple bookworks in *Artists Books,* but Tousley also discussed the show's sculptural and installation bookworks, such as *Book,* by Lucas Samaras, and *The Big Book,* an installation bookwork by Alison Knowles. In Tousley's overview, the diverse meaning of "artist's book" regained its realistic, if motley, demeanor. The books on display were to be paged through, circled around, perhaps gaped at, but neither Kelder nor Tousley took into account the inclusive aesthetic of Mallarmé that Bloch had emphasized.

One debate stimulated by *The Book Stripped Bare* concerned the use of commercial media to print deluxe books, a practice disparaged by traditional book collectors. Bloch supported new media; she praised the artistry of *Jazz,* for example, which was printed by silkscreen. Gabriel Austin's "The Modern Illustrated Book: A Neglected Field for Collectors" appeared after Tousley's review in *The Print Collector's Newsletter.* Austin (head of the Book Department at Sotheby Parke-Bernet) praised some of the Hofstra books (many of them Surrealist), singling out "some of the finest modern illustrated books—which would be *livres de peintres* if their illustrations were not 'reproductions'—[and which] include works by most of the best artists. Dufy and Matisse quite deliberately worked with photo-reproductions, using photography as an aesthetic technique. The results are not disappointing."[378] Austin (whose statement begins this deluxe section) proclaimed *Jazz* "one of the finest of modern books," and finished with a thrust at lingering sanctions over media: "Most of these works are not, as they say, in the artist's 'autograph.' From the results, one wonders if this autograph theory has not been used merely to exclude and make scarce what many artists thought they were trying to spread and make common."[379]

In a later issue Philip Hofer responded with the cautionary "Book Illustration: An Essay." Hofer founded the Department of

377. Diane Kelder, "Prints: Artists' Books," *Art in America* (January 1974): 112–13.

378. Austin, "The Modern Illustrated Book," 130–31.

379. Ibid.

Printing and Graphic Arts at the Houghton Library, Harvard University, where he served as its curator until 1968. (Hofer also curated exhibitions crucial to the fine press canon, such as *The Artist and the Book: 1860–1960 in Western Europe and the United States,* discussed in chapter 7.) He responded by agreeing with Austin that, "I for one, do believe photography is an art, not simply a technical process. I also believe that technical developments that simplify labor in rendering pictorial matter—*and still retain its qualities or bring added artistic effects*—are valid in the making of books today."[380] Then Hofer qualified his acceptance of new media with the objection that, "many technical innovations usually remove the printed result farther from the initial vigor or subtlety of the artists' creative act."[381] Hofer acknowledged that Austin "has probably correctly detected a certain snobbism and ardent advocacy of the *livres de peintres*"[382] that marginalized books with photomechanical imagery. To some extent Hofer accepted membership in that group, since he believed that "a 'reproduction' has not yet been made—so far as I know—that an expert cannot distinguish from the original, let alone improve."[383] It is tempting to oppose the auction-house scholar (Austin) to the university scholar (Hofer) and draw the obvious conclusion as to why one promoted the expansion of the canon and why the other, to some degree, wished to defend its limits. Their exchange enacted debates over authorship that had raged in the arts since the proliferation of Andy Warhol's silkscreened Brillo boxes.

In the 1970s, debates over authorship and authenticity concerning the deluxe book were conducted in genial tones, and although these debates hinted at an interest in diversifying means and media, the public demeanor of the deluxe book remained basically unaffected. How different was the fine press book world, which struggled with the various incongruities dogging its growth, from increasing visuality on the page to the doomsday cries over the disappearance of letterpress. The world of the bookwork was immersed in a different struggle, as we will see below, as it attempted to assimilate and respond to a flood of books. In contrast, the deluxe book world evolved quietly and comparatively smoothly. It remained burdened with its book and print-world issues, but nonetheless secure in its accompaniment to print-making. It gained vitality from an increasingly international artistic milieu, along with occasional injections of fine press and bookwork content and strategies. Still, it remains tempting to mourn the lost opportunity of critics who could have followed the lead of Susi Bloch and transplanted the deluxe book into a more robust critical environment.

380. His emphasis. Philip Hofer, "Book Illustration: An Essay," *The Print Collector's Newsletter* 5, no. 1 (March–April 1974): 16.

381. Ibid.

382. Ibid.

383. Ibid.

THE MULTIPLE BOOKWORK

The 1970s were incredible, the 1970s were the greatest time to be alive. The 1970s was the best of all possible decades, because you could do things, you had the technology—you didn't have the technology in the 1960s. In the 1970s you had a reason for change, [whereas] in the 1960s you had a reason to revolt for change. But in the 1970s you could change, and a lot of people did, and you had all the tools for change.[384]
— JUDITH HOFFBERG

In an art context, innocence was valid only in the beginning, when the existence of artists' bookworks had not yet been acknowledged. This is the case with Ruscha's and Dieter Rot's books. Not that they were naive. They weren't. But, in those days, perhaps, anything could have been an artist's bookwork, since making a book implied a choice of such radical nature that nothing else counted. Since a book hadn't any aesthetic pretensions or connotations, choosing such a way of communication was meaningful enough. That is also why those first books intentionally looked like ordinary books, to stress the fact that in spite of their artistic purposes they were, basically, books.[385]
— ULISES CARRIÓN, 1979

INTERVIEWER: Did you meet private collectors of this kind of material in Europe?
FRANK: Where collectors end and artists begin, where artists end and information amasses and distributors begin, and where those end and collectors begin, etc, etc., it's really hard to tell, but I met plenty of something.[386]
— PETER FRANK, 1978

During the rapid expansion of the fine press book, its printers faced crucial questions: about the encroachment of imagery on the page, about the uncertain future of printing with a diminishing supply of hot type, and about the survival of the ordinary book itself. The 1970s were an invigorating and unnerving time in which growth and loss seemed equally possible. The deluxe book, on the other hand, grew slowly but steadily, although it produced relatively few innovative books after the flurry of experimentation in the 1960s. (The deluxe book will flourish again in the 1980s, beyond the range of this study.)

The multiple bookwork, however, is at the epicenter of the explosive growth of artists' books in the 1970s, a decade which portrays a heady time of activism, access, and production for book artists. The scope of work led Germano Celant to write in 1971 that "from 1969 on it becomes impossible to keep tabs on all bookworks produced."[387]

The diversity and depth of multiple bookwork production and innovation is breathtaking. Within that diversity, the increasing presence of the multiple bookwork took on three key aspects: internationalism, activist publishing, and photography, which included

384. Author interview with Hoffberg, Santa Monica, California, November 6, 1995.

385. Ulises Carrión, "Bookworks Revisited," in *Second Thoughts* (1975, 1980), 65.

386. Peter Frank interview with Jacqueline Brody, "Peter Frank: A Case for Marginal Collectors," *The Print Collector's Newsletter* 9, no. 2 (May–June 1978): 45.

387. Tim Guest, ed., *Books by Artists* (Toronto: Art Metropole, 1981), 104 (footnote).

documentary and memoir. Despite such a richness in production, issues of reception continued to limit the recognition of the multiple bookwork. Few private collections focussed on the multiple book-work, leaving librarians to document the period. In book art, the 1970s were "the best of all possible" decades, but only to those who made books or knew about them.

NO LONGER INNOCENT: INTERNATIONAL INFLUENCE

Paradoxically, two international writers influenced the early book art discourse in America more than other writers. The first was Dutch poet and artist Ulises Carrión, who made unprepossessing yet adroit books such as *Mirror Box* (1979, fig. 75). *Mirror Box* is not a box but a book, a book about boxing; thus begins the wordplay in the mind of the reader. In *Mirror Box*, its "punch" is acted out, then denied by the thick, muffled felt pages that seem to absorb the blows of the boxers. Their skirmish is indicated by the facing R's on the cover that mirror one another; inside, the figures—one blue and one pink—feint and jab in equal measure. The use of pink and blue by Carrión suggests a battle between the sexes, or perhaps his experience as a gay person struggling against heterosexual presumptions. In this match, neither boxer wins. The work's simple, amusing imagery and its syncopated repetitions also recall Carrión's participation in rubber stamp and mail art. *Mirror Box* is emblematic of his writing and influence: ruminative and restrained, but rich with wordplay.

The writings of Carrión comprise the first European voice to gain currency in the looseknit book art community of the United States. Carrión was born in Mexico, and moved to Amsterdam in 1970. He founded the In-Out Center (an exhibition space) in 1972, and the gallery-bookstore Other Books and So in 1975 (financial constraints forced the closing of Other Books and So in 1978 and its eventual conversion into a private archive). His art spanned artists' books, film, mail art, and performance, and the scope of his art-making and organizing was typical of the informal international networking of the 1970s. Carrión's works appeared in group exhibitions in the United States from 1977 on, and, more important, he visited the United States as a lecturer. For example, he delivered "Bookworks Revisited" at a conference at Visual Studies Workshop in Rochester, New York in November 1979. That conference, "Options in Independent Art Publishing" (discussed below) was described as the first international gathering of artists and critics in the United States.[388]

388. Carrión was invited to repeat the lecture at the Art Institute of Boston a short time later. Before that, Carrión published the essay in his *Second Thoughts* in 1975 (Amsterdam: Void Distributors), and *The Print Collector's Newsletter* also published the essay, around the time of the second printing of the book in 1980. Carrión's first one-person exhibition in England took place in 1975; his first one-person show in the U.S. occurred in 1980 at the Art Institute of Boston. Carrión died in 1989.

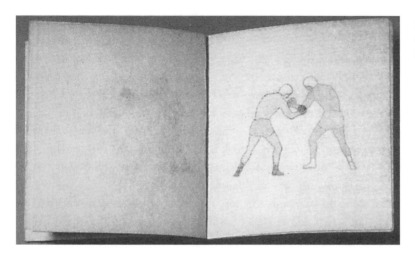

FIG. 75. Ulises Carrión.
Mirror Box
71/4 x 71/4

In his writings, Carrión gave the multiple bookwork artist a voice, and sometimes behind that voice Mallarmé's presence could be detected: "Written language is a sequence of signs expanding within the space; the reading of which occurs in...time."[389] Carrión's statement from "Bookworks Revisited" that begins this section locates artists' books in history, and so presumes their artistic maturity for a field still largely amnesic in 1979. Following that observation, he counseled, "Time has passed and our situation is totally different. We are no longer innocent. Now it isn't enough to be an artist in order to produce bookworks. Now it isn't enough to produce books in order to affirm that they are bookworks."[390] A mature art form carried responsibilities for the artist to recognize a book's artistic lineage and to reflect that maturity in an awareness of the expressive properties of the book form.

Working through his numbered sections, Carrión laid out what he did and did not consider a bookwork, a term he said he first encountered with *Artists' Bookworks* in 1974, an exhibition curated by the British Council. Carrión noted Cubist precursors, and nodded to Mallarmé as he considered the related paged format of the newspaper. He also cited the contributions of books made by Fluxus and Conceptual artists because their books looked "as normal as possible"[391] to a public wary of other art vehicles. Carrión ascribed influence over the artist's book to the visual and concrete poets who early on "destroyed forever the delusion and made evident, to whoever had eyes and wanted to see, that printed language is space."[392]

The essence of the artist's book, for Carrión, was structural. It resided in the inherent sequentiality of the codex binding: "Earlier I said that a book is a sequence of pages. This apparently simplistic definition implies a radical shift in our centuries-old understanding

389. "The New Art of Making Books," in Joan Lyons, ed., *Artists' Books: A Critical Anthology and Sourcebook*, 3rd ed. (Rochester, N.Y.: Visual Studies Workshop Press, 1991, (third printing; first printing in 1985), 31.

390. Carrión, "Bookworks Revisited," in *Second Thoughts*, 65.

391. Carrión, "Bookworks Revisited," in *Second Thoughts*, 66. Carrión's phrase echoes Susi Bloch's recognition of the book form's "habit of thought" from 1973.

392. Ibid., 65.

of books."[393] Step by step, Carrión defined and refined until he ended with a two-part definition: "What our definition has failed to take into account is the reading, the actual experience of the bookwork by a viewer. Bookworks must create specific conditions for reading. There must be a coherence between the possible, potential messages of the work (what our fathers called 'content'), its visible appearance (our fathers' 'form'), and the manner of reading that these two elements impose, or suggest, or tolerate. This element I call 'rhythm.'"[394]

Before "Bookworks Revisited," Carrión wrote "The New Art of Making Books" in 1975, publishing it in a Mexican journal and later in his own *Second Thoughts*.[395] The essay was first read by an American audience when Carrión handed it in typescript to Richard Minsky during a visit to New York, and Minsky circulated it to the membership of CBA sometime around 1975 or 1976.[396] In the essay, Carrión grappled with the practical realities of book and page design, which he delivered with a poetic turn-of-phrase. Under "What a Book Is," he cautioned, "a book is not a case of words, nor a bag of words, nor a bearer of words,"[397] emerging at the end of the section with: "To make a book is to actualize its ideal space-time sequence by means of the creation of a parallel sequence of signs, be it verbal or other."[398]

Like Mallarmé before him, Carrión understood that the power of an artist's book lay in its ability to "create specific conditions for reading."[399] He focused on the experience of touching a book and turning its pages, and observed that these conditions altered with every reader, every book, every reading. Once exposed to such a heightened sensitivity of sight, touch, and even sound and smell, bookmakers and readers were "no longer innocent," and the book as a cultural icon could be engaged as an art form and removed from the cloistered confines that supposedly had protected it from assault. Of course, the book had never been truly separate from artistic manipulation, as avant-garde artists in the early twentieth century had already demonstrated. What Carrión did was to restate that understanding for a contemporary audience: "The new art knows that books exist as objects in an exterior reality, subject to concrete conditions of perception, existence, exchange, consumption, use, etc."[400]

Carrión recognized that the act of arranging type on a white page constituted a nearly physical exchange in which, "the introduction of space into poetry (or rather of poetry into space) is an enormous event of literally incalculable consequences."[401] Finally, Carrión reached beyond language to bring the reader back to the book itself:

393. Ibid.

394. Ibid., 67.

395. Later still, "The New Art" was reprinted in Lyons, ed., *Artists' Books*. In addition, *Umbrella* magazine carried writings about Carrión as well as an interview (1979). A special issue on artists' books in *Art-Rite* (no. 14, Winter 1976 / 1977), included a statement by Carrión.

396. Author telephone interview with Minsky, April 23, 1998.

397. Carrión, "The New Art of Making Books," in *Artists' Books*, 31.

398. Ibid., 32.

399. Ibid., 36.

400. Ibid.

401. Ibid., 35.

A writer of the new art writes very little or does not write at all.

The most beautiful and perfect book in the world is a book with only blank pages, in the same way that the most complete language is that which lies beyond all that the words of a man can say.

Every book of the new art is searching after that book of absolute whiteness, in the same way that every poem searches for silence.[402]

Carrión's writings fed a field hungry for ideas, new directions, and poetic clarity. As a poet, he privileged language. He seldom if ever discussed imagery, but rather called for the judicious placement or withholding of words in order to engage in a "new art [that] creates specific reading conditions."[403] A book represented a gathering of ineluctable planes of significance set into motion by the reader. Reading, Carrión implied, recognized absence as well as presence. It relied upon a physical, even visceral interplay between fingers, eyes, and mind.

In 1977 the arrival of Clive Phillpot as the Librarian at MoMA marked the pivotal move of the multiple bookwork into the establishment art world, even if it was through the side door of the library. In Phillpot's previous position as Librarian of the Chelsea School of Art in London, he encountered artists' books by Europeans and Americans that shaped his conviction of the multiple bookwork as an artifact deserving of art world recognition. After only a few months at MoMA, Phillpot resolved to form a collection of multiple bookworks.[404]

With Phillpot, the multiple bookwork gained a passionate advocate whose international perspective was equal to that of Carrión. Phillpot wrote about artists' books beginning in the 1970s, but since his legacy has gained its greatest force from his writings in the 1980s and 1990s, this discussion will concern those essays. When Phillpot confronted the diversity in book art, he created clarity through exclusion. For example, in a 1982 article for *Artforum,* he dispensed with the "moribund 'art-of-the-book' tradition" (i.e., fine press and deluxe) and art-book trade publishing, but also cautioned that the term "artists' books" carried elitist associations at odds with the multiple bookwork.[405] He accepted Carrión's definition of bookworks as "books in which the book form, a coherent sequence of pages, determines conditions of reading that are intrinsic to the work," even though he worried that Carrión recognized bookworks produced by writers as well as those produced by artists. Phillpot distinguished

402. Ibid., 38.

403. Carrión, "Bookworks Revisited," in *Second Thoughts,* 67.

404. Phillpot recalled that when he arrived in New York, there were "multiple artist books" scattered throughout MoMA's collection. The books were filed as pamphlets, as exhibition catalogues, or as "problems needing attention." He decided to catalogue the books "normally," but added the prefix "AB" to the classification to place them within the artists' books collection in Special Collections. The earliest collecting of multiple bookworks at MoMA dates to 1970, when Kynaston McShine acquired them in preparation for the *Information* exhibition. Phillpot letter to the author, November 22, 1993; and Riva Castleman interview with Jacqueline Brody, "'A Century of Artists Books': Between the Pages with Riva Castleman," *The Print Collector's Newsletter* 25, no. 5 (November–December 1994): 176.

405. Phillpot, "Books Bookworks Book Objects Artists' Books," *Artforum* 20, no. 9 (May 1982): 77. Elsewhere in the essay Phillpot states that the term "artist's book" was associated with unique books or book objects, as well as with books of paintings or collages, as the word is used by the French for the *livre d'artiste.* Writings by Phillpot that concern the artist's book date back at least to a "Feedback" column for *Studio International* in 1971, vol. 184, no. 947 (September): 64.

multiple books by their "look" (they often resembled innocuous pamphlets), and also by a populist "philosophy that separates their makers." In contrast, he associated sculptural bookworks with craft and preciosity as unique works that "reject the Gutenberg revolution," whereas multiple bookworks, by their very nature, "desire to make art more accessible through multiplication."[406]

Interestingly, Carrión also exempted sculptural bookworks from consideration, but not because of their edition size. For Carrión, the page was the key, and since most sculptural works could not be paged through, they were not bookworks. In addition, Carrión took pains to debunk a myth embraced by some multiple bookwork artists, of the omnipotent power of offset printing. Artists in the 1960s and 1970s believed that since the offset medium facilitated printing large numbers of books, it followed that those books would find readers, and so "enlarge infinitely the number of possible consumers."[407] Direct access to readers would also provide artists with greater autonomy from critics. To these notions, Carrión scoffed, "This view was obviously based on total ignorance on the part of the artists of the traditional book world that, in its 500-year history..., has developed with market mechanisms and a celebrity syndrome similar to those that typically oppress the art world."[408] So, artists wished to "liberate themselves from galleries and art critics. I would like to ask, what for? To fall into the hands of publishers and book critics!"[409] Carrión's no-nonsense rebuttal countered the populist zealotry that dominated early debates over the multiple bookwork.

Ever the librarian, Phillpot hoped to clarify one kind of artist's book from another, by providing definitions of the disparate works in his 1982 essay. One term followed another, as unique books nestled close to book objects, and bookworks segued into artists' books, to multiple books, to multiple artists' books, and, finally, to multiple bookworks, a term also adopted for this discussion. Phillpot's writings demanded that a book demonstrate artistic integration of content and form in a holism that is "not as common as one might suppose," since, "few bookmakers produce works that are really dependent upon the book form."[410] However, for Phillpot, multiple bookworks were generated primarily by visual art; for Carrión, language served as the initiating force. U.S. book artists benefited from both perspectives. In fact the two men acted as theoretical bookends, neither completely dismissing the potential contributions of literary or visual art, and each committed to the creative wellspring they championed.

Finally, one encounters nostalgia in Phillpot's writings, almost from the beginning. Unlike the nostalgia of Judith Hoffberg in the statement beginning this section, Phillpot's nostalgia is tinged with

406. Ibid.

407. Carrión, "Bookworks Revisited," in *Second Thoughts*, 63–64.

408. Ibid., 64.

409. Ibid.

410. Phillpot, "Books Bookworks Book Objects Artists' Books," 77.

frustration, based in a realization that the artist's book as an artifact had been overtaken by competing artistic interests. The whirl of production around the multiple bookwork in the 1970s shifted in the 1980s into a rise in painterly and sculptural interests that benefited the sculptural bookwork and the deluxe book. Phillpot's censure only increased with time; in 1993 he worried that the populist ideal to produce books that carried "an implicit belief in literacy [was being] sideswiped by the cult of the anti-literate, unopenable, fetishistic book object."[411] Amid his despair at witnessing "the work of hundreds of artists without talent [becoming] hideously visible," Phillpot remained grateful to artists who have "come through the 1970's and 1980's still adhering to the aesthetic of the multiple bookwork."[412] In Phillpot's mind, multiple bookwork artists gained heroic stature for refusing to participate in the greed of the 1980s, which is what he believed often motivated artists who made sculptural bookworks. Perhaps if the hosannas for the multiple bookwork had been met by voices of equal persuasion for the sculptural bookwork, both forms would have benefited.

The ascription by Phillpot of greed as a motivator to some makers of sculptural bookworks is suspect, since so few of the works sold (as noted above with the deluxe book). Phillpot's sustaining contributions to the artist's book's critical climate remain his trenchant interpretations of content and form within an international context. His efforts toward definition are equally valid (whether or not one accepts every judgment), and he also rightly related the multiple bookwork to the larger realms of art and literary publishing. From today's perspective Phillpot's inexhaustible proselytizing achieves its own heroic stature. It would be incorrect, however, to characterize the period as viewed through his aesthetic, which so resolutely separated different kinds of artists' books. As has been noted, exhibitions at Center for Book Arts and other organizations displayed multiple bookworks alongside sculptural bookworks, fine press, and deluxe books.

In addition to Carrión and Phillpot, a few other in-depth writings that concerned multiple bookworks appeared in English, and a selection of those writings conveys a broader sense of the discourse in the field. As early as 1972, the Nigel Greenwood Gallery in London published a 1971 essay by Italian critic Germano Celant, *The Book as Artwork 1960/1972*. For Celant, artists' books arose from within a myriad of international art movements, and were further influenced by trends in communications media and intermedia art. Phillpot critiqued the essay by Celant as "disappointing; although it is one of the first pieces about book art as an adjunct of conceptual art, it really amounts to a cobbling together of a series of annotations to the

411. Phillpot, "Twentysix Gasoline Stations," 10.

412. Ibid., 11.

works, without any real analysis of the use of the book as a medium."[413]

In the United States, "Book Art" by Richard Kostelanetz appeared in his self-published *Wordsand* in 1978 (RK Editions). In it, Kostelanetz departed from Carrión and Phillpot to embrace all aspects of bookmaking, welcoming the mix: "An innovative book is likely to strike the common reviewer as a 'non-book' or 'anti-book.' The appearance of such terms in a review is, in practice, a sure measure of a book's originality....One purpose for the present is to see what alternative forms and materials 'the book' can take: can it be a pack of shufflable cards? Can it be a long folded accordion strip?...Is it 'a book' if its maker says it is?"[414] Whether or not artists were cognizant of a heritage, such concerns were in the air and were talked about by artists and others (some to be discussed below) who were just discovering the book's potential, although Kostelanetz deserves notice for his unapologetic pluralism.[415]

For writers such as Kostelanetz, the artist's book resided far from the threats of cultural displacement that pursued fine printing. Here was the book-as-activist-vehicle, its critical climate lively, its past influences suggestive but not overly constraining to future innovation. Given that, did the larger art world take notice? Yes and no. Beginning in the mid 1970s, intermittent articles and essays introduced the artist's book to a generalist audience. The articles were evidence of art world interest, and yet their content from one to another remained superficial and, thus, depressingly similar. They demonstrated that book art had failed to establish a strong enough presence in the art world that could lead to widespread and sustained recognition; the artist's book needed to be introduced to art lovers, over and over again. For the most part, such overviews accepted the definitions of the "artist's book" as the same as the multiple bookwork, as described by Carrión and Phillpot.

Artists viewed themselves as participants in an international art world, and invoked Marshall McLuhan as a reference point to justify the globalization of art through technology. By the 1970s, Walter Benjamin's essay had gained greater circulation with its publication in English in 1968.[416] "The Work of Art in the Age of Mechanical Reproduction" was increasingly relevant in a blindingly visual media environment. By the 1980s and 1990s, debates that opposed the original to the copy and authenticity to artificiality examined the collisions between entertainment, art, culture, and commerce in what came to be known as the "postmodern"—intersections long familiar to makers and collectors of every kind of artist's book. Books were no longer viewed as repositories of finite meaning, but rather as permeable mem-

413. Phillpot, "Feedback," *Studio International* 186, no. 957 (July–August 1973): 38.

414. From "Book Art," reprinted in Lyons, ed., *Artists' Books*, 29–30. Kostelanetz is a poet, artist, and critic who works in a variety of media, including visual literature.

415. Two late 1970s alternative art journals devoted special issues to the artist's book. The Idea Poll in *Art-Rite* (Winter 1976/1977) gathered statements by book artists and book reviews. *The Dumb Ox* (no. 4, 1977) began with the obligatory interview with Ed Ruscha, followed by essays such as the erudite, "Artists' Books, Primers of Visual Literacy," by Joan Hugo.

416. Still, early in that decade, knowledge of the writings of Walter Benjamin remained uneven. For example, in curator John L. Tancock's extensive essay for *Multiples of The First Decade* (Philadelphia: Philadelphia Museum of Art, 1971), he reviewed European precedents and contemporary work at length, and discussed issues such as, "What is 'Original?'" He referenced Marcel Duchamp's readymades and Victor Vasarely's writings, but he did not mention Benjamin.

branes whose information could yield multiple interpretations, even as they effortlessly crossed geographical (and political) boundaries.

COLLECTING THE ANTI-COLLECTIBLE BOOK

The collisions the artist's book incited between culture and commerce contributed to its problematic relationship to patronage and collecting. To some degree, the multiple bookwork delivered what it promised: affordable and portable art-as-books. Yet few individuals chose to collect in earnest, and as a result the largest collections were amassed in institutional settings, on the shelves of libraries. Clive Phillpot tirelessly promoted the collectibility of the multiple bookwork to librarians. Implicit in his writings was an invitation to librarians to acquire the books themselves, and so to participate along with him in developing the field. The reality, however, behind Phillpot's boosterism, was humbling: for him, as for other art librarians, relatively little work time could be devoted to acquiring artists' books: only five percent of his time, he estimated.[417]

Another challenge to collecting artists' books lay in the uncertain status of the art librarian in museums and art schools, and even at America's preeminent modernist art museum. In 1993 Phillpot commented, "it is only in the last few years, with a new generation of curators, that the artist book collection has actually been welcomed [at MoMA]. Indeed most of them expected such a collection to exist. Formerly I had to weather criticism about the (meager) funds and resources spent on the collection. We are increasingly lending artist books to MoMA (and other) exhibitions."[418] Despite operating under frustrating constraints such as these, the position of Phillpot in America's top art library (as well as his involvement on the board of Printed Matter bookstore) helped to legitimatize the multiple bookwork as collectible, and the act of collecting as an opportunity for librarians to reach beyond secondary sources to acquire original art. It was an exciting premise, and one that Phillpot used to advantage. In fact, the populist underpinnings of the multiple bookwork suited librarians perfectly, committed as they were to public access: these artists' books were books in multiple, and at a low cost.

Phillpot practiced what he preached. In 1985 the artists' books collection at MoMA was listed with others in the back of Lyons, ed., *Artists' Books*, as totaling 2,000 items, dating back to Phillpot's arrival in 1977. To put its size into perspective, the collection of MoMA at that time was only exceeded by the Visual Studies Workshop Independent Press Archive (3,000 to 4,000). The School of the Art Institute of

417. Letter to *JAB* 4 (Fall 1995), in which Phillpot explains his reasons for retiring from the Museum of Modern Art.

418. Phillpot letter to the author, November 22, 1993.

Chicago listed 500 to 1,000 books, and Rochester Institute of Technology Library listed 1,000; collections then drop down into the hundreds (several collections were not included in that listing, such as the Atlanta College of Art, and Otis Art Institute). MoMA's 1993 acquisition of the Franklin Furnace Archive enacted the book art equivalent of a friendly takeover, akin to the purchase by the Getty Center of the Jean Brown Archive in 1985, which numbered 1,000 to 2,000 books. By the time MoMA acquired Franklin Furnace's archive in 1993, the combined total of both collections (with duplicates) numbered over 17,000 items.

By 1982, librarian Janet Dalberto reported that three major distributors of artists' books offered "starter" collections (Printed Matter listed 200 books for $1,300) or worked with a library to select a core group of works—the field had matured to the point where such guidance was necessary.[419] Artist Conrad Gleber, of Chicago Books, described the audience for artists' books in 1984 as "any librarian in any museum and other artists."[420] Although the hope was largely unspoken at the time, an underlying expectation was that library collecting would not be the sole end-result but could also serve as a means to attract larger audiences, and perhaps (although some eschewed this aim) generate art-world respect as well.

The surge in collecting artists' books may also reflect a reaction of librarians to the technological changes that increasingly distanced them from the hands-on pleasures of books. Elizabeth Esteve-Coll wrote in 1992 that, in the 1970s, librarians faced the first generation of computerized cataloguing. They also encountered early ruminations over the electronic book, concerns that (along with a growing awareness of conservation needs) dominated the library profession at the time: "From the mid-1970's to the mid-1980's, there was a preoccupation nationally, and internationally, with library automation and its implications—the scholar librarian was a disparaged figure, the librarian as bookman or woman seemed an old-fashioned concept and by the late-1980's was becoming extinct, a kind of bibliographic dinosaur."[421] All the more reason for a librarian to gravitate toward collecting works that could not be subsumed electronically, in addition to (perhaps) subliminally reviving one's professional persona by acquiring contemporary art.

When Phillpot arrived in the United States, collecting was in fact already underway by a few astute librarians and curators. Most notably, Joan Hugo began collecting for Otis Art Institute in Los Angeles in 1957; in 1972 an exhibition at Otis called "Possibilities" documented Hugo's prescient collecting sensibility. In a special artist's book edition of *Art-Rite* journal in 1977, Hugo declared that for art school librarians,

419. Janet Dalberto, "Acquisition of Artists' Books," *ART Documentation* I, no. 6 (December 1982): 170.

420. In Braun, "Artists' Books," 72.

421. Elizabeth Esteve-Coll, "The Art Book: The Idea and the Reality," *Art Libraries Journal* 17, no. 3 (1992): 5.

"the development of such collections should become a prime goal... for artists' books are the common readers of contemporary art."[422]

PRIVATE COLLECTING: PETER FRANK AND THE SACKNERS

Institutions led in collecting, and for the most part, private collecting remained unrecognized. The statement that begins this section by poet and critic Peter Frank, one of a "new breed of collectors,"[423] reveals that multiple bookwork collectors were most often other artists or the peers of artists. Such collectors are difficult to track or to quantify; in fact, *The Print Collector's Newsletter* (which published the interview with Frank in 1978) was the only major journal of the time that focused on such "marginal collectors." By 1978 Frank's various involvements had garnered him considerable influence. He coordinated the selection of American artists' books for Kassel's 1977 Documenta, and also served on the board of directors at Franklin Furnace.

In that 1978 interview Frank dismissed the concerns of traditional collectors in the areas of archiving and public access:

> I should also mention that on my bookshelves are a lot of books treated with less than the exquisite care and respect of a traditional bibliophile. I admit I'm not able to take adequate care of some things that may need greater care. But it's my opinion that the whole book art/marginal-art thing is also a way of escaping preciosity without escaping objecthood and that many artists—not nearly all of them, but many of them—regard the book as something to be thumbed through. Not put into a plastic bag in some anaerobic chamber, but to lead a normal book life.[424]

Collecting, for Frank, was a participatory, even a social activity. When asked where he met book artists he reported: "Bookstores, archives, conventions, the College Art Association, that sort of thing. And they contact me. I participated in the first convention of the Associated Art Publishers last October in San Jose, and I met *everybody*. A real book-out."[425]

The status of the multiple bookwork collector confounds an easy fit within the disciplines of art or book collecting because private collectors such as Peter Frank represented change. Frank collected art that had been created in opposition to the established practices of the art world. For contrast, consider again Walter Benjamin's "Unpacking my Library," which extolled a traditional collector's pleasures:

422. Joan Hugo, "Artists' Books, Primers of Visual Literacy," *The Dumb Ox*, no. 4 (1977): 23. Art school librarians assembled collections of artists' books at the Otis Art Institute (Joan Hugo, 1957–); the Flaxman Library at the School of the Art Institute of Chicago (1971–); the Atlanta College of Art Library (1975–); and the Virginia Commonwealth University Library (1979–).

423. Brody, "Peter Frank," 40–46. Frank dated his collecting of artists' books and ephemeral artwork to the mid 1960s, with the discovery of books from the Something Else Press.

424. Ibid., 44.

425. Ibid., his emphasis.

"The most profound enchantment for the collector is the locking of individual items within a magic circle in which they are fixed as the final thrill, the thrill of acquisition, passes over them....The period, the region, the craftsmanship, the former ownership—for a true collector the whole background of an item adds up to a magic encyclopedia whose quintessence is the fate of his object."[426] Benjamin's beloved "magic circle" of collecting is reminiscent of his "aura" (discussed in chapter 8), in which the perceived value of a work accrues from factors such as its provenance and its limited numbers.

Collectors of multiple bookworks may have been equally interested in a book's provenance, but they esteemed the populist spirit represented in a large edition size. The multiple bookwork offered the younger generation the opportunity to acquire works that represented a rejection of the establishment. Indeed, many multiple bookworks were not signed, and some were even distributed free. For these collectors, the vicarious identification with an object's maker— with artists situated outside of the mainstream—provided its own satisfaction, as it did for Peter Frank, in validating membership within that community.[427] To participate was to collect something not meant to be collected in the traditional sense, itself an appealingly contrary act.

Another essential piece in the distribution puzzle was the dealer, but dealers for the multiple bookwork did not exist as they did for other kinds of artists' books. The problem, as ever, was one of money. As Kathryn Markel noted above, such works simply could not offer a dealer sufficient remuneration.[428] By the 1970s, bookstores such as Printed Matter in New York and Art Metropole in Toronto, as well as a few supportive generalist bookstores, helped to serve that tiny market.

The extensive private collection of Ruth and Marvin Sackner incorporated all manner of artists' books, including multiple bookworks, under the "visual-verbal" theme. Their collecting began with their viewing work by Tom Phillips at the Basel Kunsthalle in 1975, as noted in chapter 9. Equally influential was a visit made by the Sackners to Kassel's Documenta 6 in 1977, where "bookworks and book objects" intrigued them, although, "at that time, we paid no thought to ever acquiring any of the unique Artists' Books on display."[429] Just two years later, the notion of a "visual-verbal" collecting focus was rekindled by their encounter of *An Anthology of Concrete Poetry*;[430] it deepened with the Auction of Russian and European Avant Garde Art and Literature at Sotheby's; and it finally clarified in a visit to the artist's book archive of Jean Brown.[431]

Ultimately, the Sackners chose to establish an archive and selected *Un Coup de dés* by Mallarmé as the initiating work. Marvin Sackner

426. Walter Benjamin, "Unpacking My Library: A Talk About Book Collecting," in *Illuminations*, 60.

427. Anthony Storr concurs: "Great artists, although we cannot emulate them directly, are demonstrating that even our deepest and most powerful emotions can be expressed and ordered; and when a particular work gives us so intense a thrill that we feel we must possess it, we can be sure that in some way or other it reflects our own inner world." "The Psychology of Collecting," *Connoisseur* 213, no. 856 (June 1983): 38.

428. As an exception, Barbara Moore and Jon Hendricks founded Backworks in 1977, as a Fluxus archive and mail-order business, which emerged from their own involvement in Fluxus.

429. Ruth and Marvin Sackner, *The Altered Page, Selections from the Ruth and Marvin Sackner Archive of Concrete and Visual Poetry* (New York: Center for Book Arts, 1988), n.p.

430. Emmett Williams, ed., (New York: Something Else Press, 1967).

431. The holdings of the Jean Brown Archive included not only artists' books, but concrete and visual poetry, and Fluxus and Lettrist works. The Getty Research Center later acquired the Archive in 1985.

described their endeavor as "a unique, all encompassing Archive …leaving others to judge the merit of the individual works for the future,"[432] whose scope would encompass "historical roots and contemporary trends in Concrete and Visual Poetry together with artworks and bookworks utilizing imaged words and worded images."[433] By assembling an archive, the Sackners could build their collection in a spirit of witness and celebration, rather than be constrained by the selective discrimination of a connoisseur. Although they maintain a private collection, the Sackners have long welcomed visits by artists and scholars to their archive, which is housed in their Miami Beach home. In light of the present discussion, the aesthetic openness of the Sackners demonstrates an even-handed populism true to books.

The questions posed by the multiple bookwork to institutional collectors actually helped it enact its anti-establishment program. Was it book or art? Could it be both? Phillpot was right. Choosing to collect contemporary art involved librarians in debates about artistic intent, and moved their institutions from reflective repositories to active art-world participants. In fact, book art has repeatedly inspired the transformations of librarians into critics or curators.[434] What soon became clear was that public access to the works, and thus their future influence, required institutional patronage; alternative nonprofit organizations could offer only limited support.

As noted above, multiple bookworks also held the potential to transform private collecting. Peter Frank represents a recasting of the collector's identity to reflect the spirit of the artists themselves. When asked if he thought he would collect other work if he had more money, Frank mused that, "My guess is that I'd prefer this material. All in all it takes up less room and it's more interesting than collecting 'normal' art. I'm a writer and I feel comfortable with it the way I wouldn't with even a large painting that I like. [I like] its intimacy— the way you share it with someone, the way it's been shared with you."[435]

The collecting of the multiple bookwork proceeded, but not in the terms of the wide public impact that had been envisioned for it. Rather, its intimacy in (as Peter Frank put it), "the way you share it with someone, the way it's been shared with you," seemed destined to find readers in the same way, one at a time. To some degree the artists didn't help, with unconventional book designs and quirky or nonexistent marketing.[436] The lessons of Something Else Press (whose books often adopted trade book designs for their format and covers) were unconvincing for many artists interested in making books that didn't follow the rules, and who shuddered at the thought of having to market their own work. These artists depended on a few nonprofit organizations to fill the gap between production and distribution,

432. Ruth and Marvin Sackner, "Forming a Collection," *Ruth and Marvin Sackner Archive of Concrete and Visual Poetry* (Miami Beach: Ruth and Marvin Sackner, 1986), 47.

433. Sackner and Sackner, *The Altered Page,* n.p.

434. Particular to the multiple book-work, in addition to the various involvements of Phillpot, such a list would include librarians Jean Brown, Judith Hoffberg, Joan Hugo, Barbara Pascal (who founded Artworks bookstore with Hoffberg and Lael Mann in 1979), Gary Sipe (director of the Atlanta College of Art Library), and Sipe's successor, Jo Anne Paschall. Paschall (who trained as a printmaker) ran the library from 1979 to 1988, then moved to Nexus Press as assistant director, then director as of 1992. Janet Dalberto, "Collecting Artists' Books," in *Drexel Library Quarterly* (1983): 78–90.

435. Brody, "Peter Frank, 46.

436. The following section will discuss artist-run bookstores that addressed those distribution and marketing challenges.

facing challenges that were immense and unending. Chief among the few early organizations devoted to the artist's book were the bookstore Printed Matter as its patron saint of distribution, and the archive Franklin Furnace as its guardian angel.[437]

TO HAVE AND TO HOLD:
PRINTED MATTER AND FRANKLIN FURNACE

...a museum called and inquired about The Xerox Book, saying that they felt it to be so important that they were getting up a special fund to purchase it and planned to offer up to $2,000 for it. They then asked me if I would put a copy away for them. I wasn't even sure whether we had a copy left in stock. My answer, though, was that we did not "put books away"—that it was first come, first serve—and that, in any event, the book cost $25.[438]

—INGRID SISCHY

The Book Bus was doing well. They were selling $60,000 worth of books. People really loved having the combination of books—having poetry, having visual books, and artists' books. There was a great cross over audience in those days.[439] —JOAN LYONS

What function does an artwork that is cheap, portable and potentially unlimited serve? It functions, as so many artists are aware, as alternative space—a channel that circumvents the exclusivity of galleries and the critical community.[440] —MARTHA WILSON

The organizations of Printed Matter and Franklin Furnace were so crucial to the development of the multiple bookwork that it is difficult to imagine the 1970s without them. By the time Clive Phillpot arrived in New York City in November 1977, the two nonprofits had only just formalized a network amidst an emerging community of artists committed to the multiple bookwork.

Book organizations such as Printed Matter (on whose board Phillpot later served) comprised a tiny sliver out of America's vibrant alternative arts scene, which was populated by artists who felt they had emerged from the activism of the 1960s armed with new forms of art that freed them from the conventions governing the art establishment. In particular, artists were fired up by a sense of entitlement for controlling the exhibition and reception of their art. For the multiple bookwork, those skills of organizing bore fruit with the opening in a Hudson Street storefront of the bookstore and gallery Printed Matter. Organized in 1976 by Sol LeWitt, Lucy Lippard, Pat Steir, and others, Printed Matter began with the big hopes and small scale common to alternative nonprofits: "Distribution is primarily by mail order, and Printed Matter is currently sending promotional circulars to galleries, universities, and individuals. They hope in this way to reach about

437. The institutional imprimatur bestowed on multiple bookworks and ephemera (and thus on the value of collecting such materials) has now come full circle. Major museums have organized exhibits on Fluxus (Walker Art Center), the Beats (The Whitney Museum), and Conceptualism (Museum of Contemporary Art, Los Angeles), in which artists' books and other ephemera played an important role.

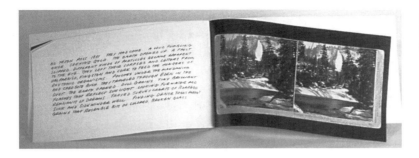

FIG. 76. Michelle Stuart.
The Fall
8 x 13

75,000 people initially. They are also advertising in several periodicals. A catalogue of the books they distribute is available for $1.00. Most of these books distributed by PM cost between $3.00 and $6.00 although they have one book for 35 cents and another for $20.00."[441]

Time and money were in chronically short supply. Printed Matter began as a nonprofit distributor and a for-profit publisher, but time demands from the bookstore convinced it to cease publishing in 1979 and to focus on selling books through the store and through mail order. Still, from the initial twelve titles published by Printed Matter came some of the strongest multiple bookworks of the decade, such as *The Fall* (1976, fig. 76), by Michelle Stuart. The book dramatically differs from Stuart's unique handmade paper Rock Books discussed earlier, and yet *The Fall* evokes a similar lyrical, timeless quality in its recognition of remnants of the past residing in the present. Its oblong shape accommodates stereographs on its right-hand pages. These mid-nineteenth-century artifacts picture Yosemite Valley vistas in eerie near-doublings, images produced by a twin-lens camera. Every page shows a waterfall, the different sites united in their record of Nature's turbulence. In a fictitious memoir handwritten on the left-hand pages, Stuart combined the voices of early settlers with stories of the animal, vegetable, and mineral inhabitants of the region. Her impassioned text is visually mirrored on the facing pages, in the enormous energy that drives the water of the twin waterfalls as it is thrown out and down into space. *The Fall* suggests a time now lost, when the mystery of nature was an accepted, inextricable part of life and not held separate, ignored, or neutralized.

Given the early success of Printed Matter in publishing, and its dominant distribution presence within book art, one might be tempted to inflate the actual numbers of books produced. Just as the total counts of artists' books in early library collections were vague, the estimates of early book production seem premised on visions of prolificity rather than specifics. The reality reflected growth, but on a small scale. The premiere catalogue of Printed Matter in 1977 listed 350 works by about 150 artists "at prices ranging from 50¢ to $20,

438. Group interview conducted by Anne Edgar, "A Conversation with Printed Matter," *Afterimage* 12, no. 6 (January 1985): 10.

439. Joan Lyons interview with Brad Freeman, edited into informal commentary, *JAB* 4 (Fall 1995): 13.

440. Martha Wilson, "Artists' Books As Alternative Space," in *The New Art Space* (Los Angeles: Los Angeles Institute of Contemporary Art, 1978): 35.

441. Eugenia Harris, "Artists' Books: Distribution is the Problem," *Afterimage* 4, no. 4 (October 1976): 3. Printed Matter issued its first catalogue in May–June 1977.

with most under $5." [442] By 1980 a writer estimated the production throughout the 1970s at over 2,000 artists' books. [443]

The economics governing printing and mail-order distribution meant that holding down the price of the multiple bookwork exacted financial sacrifice from the artist. As early as 1977, Edit DeAk, one of the founders of Printed Matter, noted that, while the markup of most retail books was five to eight times its production cost, "artists' books are seldom given this kind of markup, the artist usually receives a larger royalty (when s/he receives one at all), and furthermore the books are published in small quantities so the price per copy is higher." [444] A print run of 1,000 copies lasted for years, and thus, "the lack of any distribution and advertising, and the disinterest of most publishers in treating the artists' book as anything other than a promotional giveaway, is...not surprising." [445] So, what kept Printed Matter in business, in the face of such fiscal adversity? DeAk freely admits to a more complex incentive, a "declared devotion against the odds. We consider the odds a truth and what we do a necessity, thereby placing our activities dead center into the limbo of this paradox." [446]

Printed Matter provided the missing link of distribution for the multiple bookwork. Despite its best efforts, it has endured an unending struggle for financial stability. Tight budgets hamper marketing, such as in the mail-order catalogues that can only be intermittently released, and which alert readers to only a fraction of the total holdings in the store. Printed Matter provided a crucial outlet for international books. It did such a good job that in 1978 Ingrid Sischy told an interviewer that twenty-five to thirty percent of the clients of Printed Matter were European or Australian. Those artists sent their books to Printed Matter in order to distribute them to buyers back in their home countries. [447]

Sischy's statement that begins this section captures Printed Matter's distribution ethics, if we may call them that. Printed Matter put into practice the democratic ideology of the multiple bookwork by holding to the original price of a book despite its rarity. In spite of its ongoing financial struggles and the concessions made along the way, Printed Matter has continued to distribute books in that originating spirit; it currently operates out of a rented space in Chelsea. In the final reckoning, Printed Matter has made a difference, putting books into the hands of buyers—never enough books, never enough buyers— but a difference, just the same. [448]

The proliferation of the multiple bookwork without Printed Matter is inconceivable, but a number of other artist's book bookstores also contributed to what Carl Loeffler termed the "new heroics." [449] For the makers of artists' books, their greatest challenge

442. Unsigned notice, *The Print Collector's Newsletter* 8, no. 2 (May–June 1977): 46.

443. Janet Dalberto, "Acquisition of Artists' Books," 169. The estimate of 2,000 books was echoed by Ingrid Sischy, "If Marshall McLuhan were a gypsy...," in Sischy, *National Arts Guide* 1 (January–February 1979), 2–3.

444. Edit DeAk, "Printed Matter and Artists Books," *LAICA Journal,* no. 13 (January–February 1977): 29.

445. Ibid.

446. Ibid., 30.

447. Kate Linker, "The Artist's Book as an Alternative Space," *Studio International* 195, no. 9901 (1980): 79.

448. Printed Matter has had to undergo a number of transformations in its struggle to survive and flourish. Overhead costs continually necessitate fundraising initiatives and creative partnerships. The Spring 1990 Printed Matter catalogue announced an expansive new space in SoHo, made possible through the sponsorship of the Dia Art Foundation. In its 1997–98 catalogue a planned website was announced, hosted by Dia Center for the Arts. At the same time, Director David Platzker acknowledged the bookstore's "substantial debt," adding, "I must thank all of the artists and suppliers who have been exceedingly patient." In *Printed Matter, Books by Artists 1997/1998,* 5. In 1999 Printed Matter was again sent scrambling for survival, when Dia asked it to vacate its space. In December 2000 it signed a sublease agreement for another Manhattan space in Chelsea.

lay in solving that riddle of production and distribution. Even as multiple bookwork artists championed the book's populist potential, daunting realities stood in the way of their creation. The economic truism of offset printing's diminishing returns (costs decrease as the size of print runs increase) loomed large as an absurd tease to artists struggling to raise upfront costs of between $1,000 to $10,000 in production funds, knowing full well the odds stacked against selling even a few hundred copies of a book.[450]

Artists represented by a gallery sometimes leveraged the publication of a book to coincide with an exhibition, although often those productions included catalogue contents and so diluted the artistic impact of a work. The public relations aspect of such works was obvious to gallery and artist alike, and, in spite of the good intentions of some galleries, the art world's ease of appropriating the book as "fad-ridden merchandise"[451] was not lost on a struggling book artist.

To the idealists of the 1970s, every stubborn problem needed only ideas and energy for its solution. Distribution remained dependent on reception, however, and review mechanisms did not begin to meet the influx of books—the efforts of Phillpot, Lucy Lippard, and others notwithstanding. Regular review publications included *Afterimage* (published by Visual Studies Workshop from 1972), *Umbrella* (Judith Hoffberg, ed., 1978–), and *Flue* (Franklin Furnace, 1980); as well as occasional reviews that appeared in other journals, such as *Artforum, Avalanche, Flash Art, Artweek, Small Press Review,* and *Studio International*. In addition, *The Print Collector's Newsletter* (*PCN*), later rechristened *On Print* and then *Art On Paper,* has proved a staunch supporter of both the deluxe book and the multiple bookwork. Inconsistent coverage added to the woes of sporadic exhibitions, and limited options for hands-on encounters kept the audience small, as collector Peter Frank indicated, despairing that "artists who publish 500 books wind up with 490 in their closet."[452] One positive development for individual artists in the 1970s was government funding. In 1974 the National Endowment for the Arts opened the Individual Artist grant category of Works on Paper to book artists; before that, artists had been limited to the categories of Artists, Photographers, and Crafts.[453]

Economic pressures, however, were unrelenting. In 1976 Lucy Lippard vowed in *Art in America* that, "one day I'd like to see artists' books ensconced in supermarkets, drugstores, and airports and, not incidentally, to see artists able to profit economically from broad communication rather than from lack of it."[454] Just seven years later, beyond the thrill of start-up and into the daily travails of service and survival, Lippard lamented that "practitioner Mike Glier wrote a

449. Carl Loeffler, "Distribution: The New Heroics," *The New Art Examiner* (March 1978): 8. Bookstores in or near the U.S. that carried multiple bookworks in the 1970s included (followed by founding date): Art in Form, Seattle (ca. 1979); Art Metropole, Toronto (1974); Artworks, started by Judith Hoffberg, Barbara Pascal, and Lael Mann in California (Venice, later Los Angeles, 1979); Bookspace, founded by Miles De Coster in Chicago (1978); Bookworks, at Washington Project for the Arts in Washington, D.C. (1976); and Woodland Pattern in Milwaukee (1979). Alexandra Anderson, "Scrapbooks, Notebooks, Letters, Diaries—Artists' Books Come of Age," *ARTnews* 77, no. 3 (March 1978): 68–74.

450. Estimate by Drucker, "The Myth of the Democratic Multiple," in *Figuring the Word: Essays on Books, Writing, and Visual Poetics* (New York City: Granary Books, 1998), 177. If raising printing dollars set a challenge, for artists who lived outside of cities the lack of access to a sympathetic print shop could prove insurmountable. In this light, the influence exerted by the artist-run presses (discussed below) was crucial to the success of the multiple bookwork. The scarcity of those facilities, however, meant that only a tiny fraction of artists wanting to publish could be served.

451. DeAk, "Printed Matter and Artists Books," 29.

452. Quoted by Braun, "Artists' Books," 71.

453. Actual numbers of book artists receiving grants before 1974 are unknown, since the National Endowment for the Arts (NEA) did not track them as an art category. Telephone conversation with Josh Dare of the NEA, 1993.

454. Lucy Lippard, "The Artist's Book Goes Public," *Art in America* 65, no. 1 (January–February 1977): 48.

VISUAL STUDIES WORKSHOP 4 ELTON STREET ROCHESTER, NEW YORK 14607 (716) 442-8676

THE BOOK BUS CATALOG NO.1 1977

FIG. 77.
The Book Bus

few years ago that the next step for artists' books was 'to become politically effective and to communicate to a diverse audience.' A few years and no giant step later, Glier is saying, 'We're past the careful nurturing stage and into do or die competition with mass culture. If artists' books remain a novelty in the art world, they are a failure.'"[455] By Glier's standards the multiple bookwork had failed because it had not achieved widespread recognition by 1983. Such unrealistic standards for success thwarted the multiple bookwork, especially when seen from the point of view of the larger art world—galleries and museums, with all of the money and access that they controlled, were equally limited in the degree of influence that they could exert over the general public. Given the demands of marketing books, and especially books whose content was not easily definable, it is hard to imagine what else could have been done to bring books to the multitude. Actually, the 1970s produced one inspired solution—at least for a time—for truly localized distribution.

The Book Bus cooperative began as a consortium of seven presses in 1973 to distribute books to Northeastern U.S. college campuses. Joe Flaherty was its director. The Book Bus (fig. 77) solved the problem of the book's dependence on touch to disclose its many-leveled pleasures to potential buyers. As noted in the quote that begins this section, Book Bus visitors encountered artists' books within the wider milieu of small press, photographic, and literary books. Its audience potential convinced Joan Lyons of Visual Studies Workshop to issue one of her books, *Abby Rogers to her Grand-Daughter,* specifically with Book Bus distribution in mind; that book eventually went through two printings of 500 copies each.

The Bus not only sold books but changed lives. Clifton Meador, for example, first encountered artists' books when he was a senior at Rhode Island School of Design, with the arrival of the Book Bus (Meador, a noted book artist, eventually directed Nexus Press for a time).[456] Eventually the consortium felt it could no longer carry the project, and the Visual Studies Workshop invited it to move to VSW. At VSW, Flaherty, now with Don Russell, joined the distribution efforts of the Bus with those of VSW. They began a mail order catalogue and an on-site bookstore, while maintaining the Bus. Ultimately, the aging engine of the bus, along with the 1978 gas crisis and the accompanying economic slowdown, proved the undoing of the Bus.[457]

Equally important as distribution to the future of the artist's book was the challenge of documentation and exhibition. Concurrent with

455. Lucy Lippard, "Conspicuous Consumption: New Artists' Books," in Lyons, ed., *Artists' Books*, 50.

456. Meador interview with Brad Freeman, *JAB* 7 (Spring 1997): 1–12.

457. Flaherty and Russell continued mail order distribution, and eventually moved from VSW to found the independent Writers and Books in Rochester, which continues to operate today as a thriving literary center. Joan Lyons letter to the author, August 7, 2003.

Printed Matter's inception, Martha Wilson, a book and performance artist, founded Franklin Furnace in her New York City apartment and storefront as a bookstore and archive. By the end of the first year, Wilson and the staff of Printed Matter had decided to "divide up the pie," to each pursue part of their broad missions. Wilson concentrated on the museum and archive functions, and Printed Matter focused on bookselling. From that point forward, Franklin Furnace mounted exhibitions, many of international scope with accompanying catalogues; it rented collections of artists' books for use by colleges and galleries; and it hosted artists' readings and performances. Documentation remained an emphasis for Wilson: already in October 1976, NEA funding was helping Franklin Furnace to compile a descriptive bibliography.

In October 1976, writer Eugenia Harris estimated that in its first ten months Franklin Furnace had catalogued 300 books.[458] By 1978, the Archive had increased to 2,000 items, and "The organization continues to receive at least one publication a day: 'They come by mail, or people just appear at the door, book in hand,' says [curator Jacki] Apple. 'There is no observable centralization of these efforts. Artists all over the country and in Europe take it on themselves to produce their own individual efforts.'"[459] Bigger was better, and broader, too: Franklin Furnace accepted every donation, including bookworks in formats other than the codex: "even when a block of concrete was labeled 'concrete poetry' by the artist, that was a book as far as we were concerned. It was an artist's book because the artist said so and because it was done in an edition."[460]

At *The New Art Space*, a 1978 conference (with publication), representatives gathered from alternative arts organizations such as Franklin Furnace and Printed Matter. Martha Wilson spoke at the conference on "Artists' Books As Alternative Space," and coined the phrase "the book as an alternative space," providing the multiple bookwork with its most enduring mantra. Wilson had turned a concept implicitly understood by artists into a metaphorical catch phrase that equated the book's spatial properties and portability to the independence and activism prized in the 1970s. After all, for nonprofit organizations, independence was symbolized in a separate space. If space, then, was recognized as a locus of control, the artist's book offered a means to create one's own environment—transportable and affordable. With that phrase, Wilson also associated the multiple bookwork with a sense of avant-garde prescience and even preeminence.[461] Catch phrases, however, tend to oversimplify complex situations. What was left out of the alignment of the multiple bookwork with an avant-garde, "outsider" sensibility, was the iden-

458. Harris, "Artists' Books: Distribution is the Problem," 3.

459. Anderson, "Scrapbooks, Notebooks," 72.

460. Martha Wilson interview with Thomas Padon, in Cornelia Lauf and Clive Phillpot, *Artist/Author: Contemporary Artists' Books.* (New York: Distributed Art Publishers, Inc., and the American Federation of Arts, 1998), 113.

461. Others followed suit. For example, in 1980, *Studio International* carried two articles. The first, "Is the Alternative Space a True Alternative?" provided answers to a survey of artists and alternative arts professionals by Rudolf Baranik. It included the question, "What is the role of artists' books?" *Studio International* 195, no. 9901 (1980): 69–74. Following Baranik was an article by Kate Linker, "The Artist's Book as an Alternative Space," in which she noted that the book's "specific contribution lies in providing an artspace beyond space as a counter both to the commercially-limited object and to the paradox of the public precinct." Her emphasis: 77. By 1982 Martha Gever could set up an opposition simply by titling her article: "Artists' Books: Alternative Space or Precious Object?" *Afterimage* 9, no. 10 (May 1982): 6–8.

tity of the book as an insider object, that most familiar of forms.[462]

From the way a book inhabits space to the book's shaping of space through movement, Franklin Furnace recognized parallels between aspects of performance art and the performative properties of artists' books. The archive and gallery inhabited the first floor and mezzanine level of the storefront, and Wilson soon roughed in a performance space in the basement. In 1978 Alexandra Anderson reported that, "Both [Martha] Wilson and [curator Jacki] Apple feel that the phenomenon of artists' books and the rise of performance art are strongly related. This interaction may be attributed to the continuing trend among experimental artists toward the dematerialization of the object and the increasing breakdown of demarcations between separate areas of creativity. Performances, like books, exist in time and depend on the sequential unfolding of ideas and visual effects."[463] Writers and artists often alluded to the performative aspect of handling books, to setting them into motion through touch, or, as Richard Kostelanetz wrote in 1978, "to accept[ing] the edges of the page, as you accept the proscenium which contains the play. Both are places of action."[464]

From today's perspective it is important to distinguish between the three kinds of performance that relate to books: between the performative aspect of looking at an artist's book; performance art itself; and books about performance art. Reading involves a set of procedures that are tactile and that book artists can alter in atypical ways. In that sense, artists' books highlight the inherently performative nature of the book form. This attribute is separate from the artistic endeavor of performance art as a separate historical fact which created its own arc in the 1970s. Finally, performance artists increasingly published books whose contents consisted of frozen photographic records of movement, accompanied by an artist's notes or other material. Although some of these books can be argued to be artists' books, they often do not creatively engage the book form, and so remain more documentation than innovation.

Michael Snow of Canada succeeded in fusing performance, photography, and the book form in *Cover to Cover* (1975), one of the decade's most important books to offer a seamless cinematic journey. Snow's book was embedded in the U.S. art scene from its inception. Snow lived in New York from 1962 until 1972, during which time (in 1970) he represented Canada at the Venice Biennale. The publication of *Cover to Cover* coincided with the opening, at (New York's) Museum of Modern Art in 1976, of two Snow exhibitions in film and photography. In *Cover to Cover*, Snow as pied piper leads two photographers and the reader through a day that is far from routine. It

462. The influence that Franklin Furnace exerted within the book art community did not spare it from the travails of survival that assailed all nonprofits. By 1982, Anne Edgar wrote that after six years the archive had amassed 3,500 titles and 10,000 other items (artists' periodicals, mail art, ephemera, posters, etc.). Anne Edgar, "Franklin Furnace," *ART Documentation* I, no. 6 (December 1982): 176. Unrelenting financial pressures finally led Wilson to sell the archive to the Museum of Modern Art in 1993. In a 1998 interview, Wilson cited increasing problems with fundraising that contributed to her decision to sell, especially in light of the irony that "it is very expensive to maintain artworks that were originally designed to be inexpensive. The charge to conserve [Lawrence] Weiner's *Statements* [which originally sold for $1.95]...was $350." As for the building, "we recognized that the largest collection of artists' books in America was being housed in a wood-and-brick loft in Tribeca with a water sprinkler system." Thomas Padon, interview with Wilson, in Cornelia Lauf and Clive Phillpot, *Artist/Author,* 120. On February 2, 1997, Franklin Furnace closed its public space at 112 Franklin Street for a website and plans for live and cybercast performance art. For a cautionary update about the fate of Franklin Furnace and other alternative organizations, see Robert Atkins, "On Edge: Alternative Spaces Today," *Art in America* 86, no. 11 (November 1998): 57, 59, 61.

463. Anderson, "Scrapbooks, Notebooks," 72.

begins innocently enough. The front cover of the book pictures the inside of a door, framed within the page itself and showing doorknob, deadbolt, and latch catch. The reader opens the book and on the verso endsheet see Snow standing with his back to us, facing the outside door. All of the photographs in the book appear as full-page halftones, free of margin or frame; to turn the page we must "touch" the door. Opposite to Snow, we see the closed door on the recto, but it appears from the inside, pictured as on the cover. We witness the entrance of Snow from behind him on the verso pages even as we see the door opening in toward us on the recto pages. The resulting synchrony is irresistible as the book becomes "a machine that powers its own imagery within a reproducible system,"[465] where paging sets that world into motion.

That machine is revealed as two photographers who accompany Snow, snapping pictures of his every move from opposing points of view. Snow later described the system: "There are 360 pages—360 photos—and the whole thing is basically built on this recto-verso principle, that the other side of the page is the other side of what is being photographed. Also it is built of sequences of varying lengths so that while individual photos are, I hope, very interesting alone, they are always part of a sequence which is itself part of a large 'narrative' which is itself about the book."[466]

Photographic play and montage interrupt the book's cinematic forward march. Most dramatically, about halfway through the book Snow appears to drive his car up and around a loop, as if caught on a Wheel of Life (fig. 78), and we must turn the book with Snow, to follow the piper. Now holding the book upside down, we watch Snow arrive at a gallery and enter, walk over and pick up a book, a book with a door on its cover, this cover, this book. The conceit circles

464. Richard Kostelanetz, Introduction, *Visual Literature Criticism: A New Collection.* Kostelanetz, ed. Carbondale, IL: Southern Illinois University Press, 1979. Co-publication of *Precisely: Three Four Five;* and *West Coast Poetry Review* 5, no. 3, issue 19, Richard Kostelanetz and Stephen Scobie, eds., 13.

465. Lew Thomas review of 1976, reprinted in *The Dumb Ox* (1977), then in Thomas, *Structural(ism) and Photography* (New York: Museum of Modern Art, 1978), which was itself shown in several book art exhibitions in the 1970s.

466. Quoted by Ann Goldstein, "Artists in the Exhibition," in *Reconsidering the Object,* 215

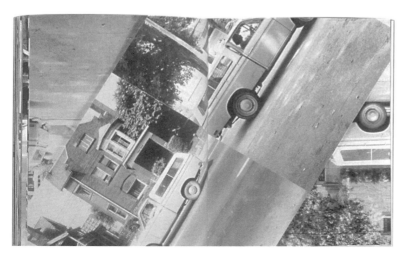

FIG. 78. Michael Snow. *Cover to Cover* 9 x 7

neatly in, as succeeding close-ups show Snow's hand holding the book, the book now nested within the book. Finally, the two doors face one another, mimicking in recto-verso the book's (and the door's) front and back, until the pages end and we turn over the book to view its back cover and find pictured—yes, the outside/other side of the door. We have exited the book in near-perfect reversal, and assume that we could reenter it from the back cover and proceed back to front if we wished, however awkward that Eastern access might feel to a Western reader. The book art community immediately recognized the importance of *Cover to Cover* in its merging of the properties of a book with the photographic medium to create a cinematic effect. *Cover to Cover* showed in nearly every exhibition of the period.

CONVERSATION AS CONTENT: HOMPSON AND APPLEBROOG

May I have a glass of water with no ice, please?
Just tell him that you have changed your mind again.
Try to guess the names I have circled.
Some of the bruises are covered by my collar.
The paper will be a shiny yellow. Bright yellow.
I think she's told everyone about her tits.
In case you didn't notice, we're reading the same list.
You shouldn't have taken it apart in the first place.[467]

—DAVI DET HOMPSON

Look at me.
We are drowning,
Walter.[468]

—IDA APPLEBROOG

The books of Ida Applebroog and Davi Det Hompson best represent artists' books of the 1970s that were directed by language—not as narrative, but as voices that call out in a language that has been reshaped into haunting, offhand utterances. Applebroog claimed performance as integral to her books in their titles, iconography, and texts. Hompson demonstrated the unsteadiness of meaning in language, beginning with his own reconfigured name (Davi Det Hompson from David E. Thompson). In the 1960s and 1970s, a multitude of voices emanated from his concrete poetry, performance, and poster art, along with the simple white pamphlets that he issued in editions of hundreds.

467. Davi Det Hompson, *May I Have a Glass of Water with No Ice, Please?* (1976), n.p.

468. Ida Applebroog, *Look at Me,* (1979), n.p.

In *May I Have a Glass of Water with No Ice, Please?* (1976, fig. 79), whose entire text is quoted above, Hompson reveals himself as a master of the inconsequential made portentous, whose odd collection of statements accumulate into amusing if uneasy juxtapositions. The voices in this innocuous, staple-bound pamphlet elude relationship or narrative flow. Instead, absurdity accompanies grief in the same way that they can infiltrate daily life to surprise, amuse, or shock us. For example, the speaker's revelation of bruises immediately charges the following mention of bright yellow paper with an effect like a slant rhyme—not exactly a bruise but close enough to damaged skin to elicit a wince. The next line, about tits, can launch buffoonery or suggest an abuser's taunt that precedes a punch. But Hompson seeks conundrum rather than clarity, and so he ends, obscurely, with, "you shouldn't have taken it apart in the first place," which can be read as a casual remark or as a reference to a relationship gone bad.

The voice of Ida Applebroog is equally unnerving, and yet unique in its tortured brevity, as though, struggling to speak, she can only manage to choke off a word or phrase. *Look at Me* (1979) begins in small caps, like a voice whispered from off-stage, in hiding. Turning the page, the reader sees a man standing over a woman on a bed (fig. 80). He looks up and away, and she clutches his arm. Perhaps we turn the page quickly to escape the pathetic image of desire and refusal—but relentlessly Applebroog repeats the image on the next two pages, forcing us to witness this dissolution, or perhaps she wishes to mimic the replaying of a rebuff in the victim's mind. On the next page the woman cries out, in type that cuts across on a diagonal: "We are drowning, / Walter." Again we turn the page to find that same image, and then, finally, the last page is a blank, offering silence as in relief—or abandonment.

Applebroog's books are not illustrated in the conventional sense. Her images provide clues necessary to the decoding of a text; each needs the other to work. Applebroog's modest cartoony pictures evade the sense of play or happenstance found in the books by Hompson. She does not tell a story so much as implicate the reader in a private crisis or loss, in a language of brooding inevitability that weighs down the figures, like a heaviness of spirit.

Applebroog began showing work in 1978 at the Ellen Sragow gallery in New York. She worked on rhoplex-treated vellum (rhoplex is a resin substance). She photographed drawings on the vellum, from

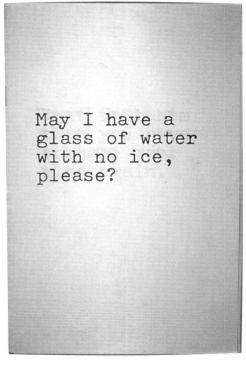

FIG. 79. Davi Det Hompson. *May I Have a Glass of Water with No Ice, Please?* 8 1/2 x 5 1/2

FIG. 80. Ida Applebroog.
Look at Me
7¹/4 x 6¹/4

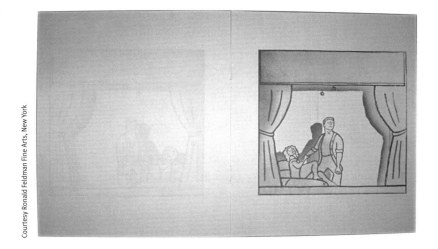

Courtesy Ronald Feldman Fine Arts, New York

which figures and backgrounds had been cut out and outlined in acrylic, the image often framed by schematic curtains or shades suggesting a window or a stage. When illuminated, the cast shadows evoked a frozen puppetry, dioramalike, like the Indonesian puppetry admired by Applebroog. Then she photographed the sequences and made books from them, first showing the books in 1979 at Franklin Furnace. She based their twenty-four-page format on "dirty books, with all the taboo subjects, that we passed around as kids."[469] Applebroog printed and distributed her books as the Black Books series in 1977, followed by the Dyspepsia Works in 1979 (now often called the White books), and the Blue Books in 1981, for twenty-eight books total. At first the books (about 500 copies per edition) were sent free to friends, acquaintances, and art world professionals whom she did and did not know; later, she priced them at a few dollars.

In subtitling the books as performances, Applebroog literally stage-manages the context of the reader, denying the role of a passive receiver to instead thrust her or him into the role of an active observer—or even a voyeur of the combustions hinted at within. These puppet shows are far from child's play. Their automatons are dull workaday humans engaged in unkindnesses or even cruelties, delivered through the machinations of power and powerlessness. If there is humor in Applebroog's books, it is the humor that transforms despair into a means of coping that recognizes absurdity in the midst of entrapment. Her relentless dissections carry a sense of moral outrage directed against the complacent untruths murmured in the books. The unrelenting intimacies that she portrays in coolly detached renderings appealed to many, including those in the women's movement, as missives from "a social realist who looks at humanity from the inside out, rather than from the outside in."[470]

469. Ruth Bass, "Ordinary People," *ARTnews* (May 1988): 153.

470. Susan Krane. *Art at the Edge: Ida Applebroog* (Atlanta, Georgia: High Museum of Art, 1989), 2.

The story behind Applebroog's books turns on what is meant as opposed to what (little) is said. The story in Hompson's books reveal the ironies and absurdities contained within what (a lot) is said much of the time. Both artists mine language devalued by society, in statements not remembered or recorded, but simply spoken, soothingly, mindlessly, or desperately. The kinds of off-kilter yet on-target narratives tucked into the books of Hompson and Applebroog represent a heightened art world interest in narrative and the memoir, often in league with photography, and far removed from earlier Minimalist detachments. Most dramatically, the interests coalesced in video, performance, and body art. But, in true postmodern fashion, books offered an especially responsive format for narratives whose story was often ambiguous, even contradictory. The evocative disjunctions of Hompson and Applebroog are further heightened within the bound format of a book, as a format that presumes a (literal) closure to the unwary reader.

PHOTOGRAPHY'S FACE FOR THE MULTIPLE BOOKWORK

Loophole, *our first collaboration, was an investigation of the three levels of mind, body and spirit; through, in, on, and over. The animation of objects explored in conjunction with the movement of the camera, word, and the table of contents...were the means by which we developed the narrative thread.*[471]
—HELEN DOUGLAS

Art seems pure for a moment and disconnected from money. And since a lot of people can own the book, nobody owns it. Every artist should have a cheap line. It keeps art ordinary and away from being overblown.[472]
—JOHN BALDESSARI

In 1979 Ingrid Sischy ended an essay on artists' books for the (U.S.) *National Arts Guide* by dedicating the essay to a selection of book artists. Among the over 100 names, Sischy included Michael Snow of Canada, Marcel Broodthaers of Belgium, and Telfer Stokes and Helen Douglas of Great Britain. The photographic books of these artists won over American artists because of their linking of Conceptual content with cinematic pacing.

More often than with language, multiple bookwork artists told stories with pictures. The photobookwork, in particular, offered artists enormous flexibility in strategy and content. It knew no bounds: like a common language, its imagery crossed nationalities. European multiple bookworks found ready U.S. exposure through exhibition, through distribution at Printed Matter, and through the writings of Clive Phillpot, Lucy Lippard, and a few others. In addition to Michael Snow's *Cover to Cover*, which was discussed above,

471. Helen Douglas, "The Two I's Within the We: Why and How I Make Books," *JAB* 3 (Spring 1995): 8.

472. John Baldessari, *Art-Rite* (No. 14, Winter 1976–77): 6.

FIG. 81. Marcel Broodthaers. *Voyage on the North Sea.* London: Petersburg Press. 5³/₄ x 7

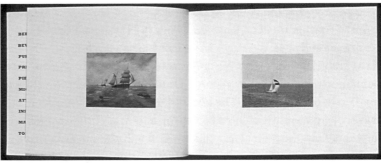

two influential European books demonstrated the communicative range possible with the photobookwork.

The first book, *Voyage on the North* Sea (fig. 81), by Marcel Broodthaers, teases its readers with questions about representation and rarity. Broodthaers published the book in 1973 with Petersburg Press of London, where he was living at the time. Three years later he died, and around that time the book was discussed in *Artforum* and in *The Print Collector's Newsletter,* concurrent with Broodthaers's first one-person show in America.[473] The modest size and appearance of the book belied its complexity. Its imagery came from two sources: a nineteenth-century amateur romantic painting of sailing ships in rough seas, and duotone snapshots of a pleasure sailboat slowly crossing the North Sea, a sliver of land barely visible in a later image.

Broodthaers constructs movement in the book with assiduously edited details from the painting: a buoy, scudding clouds, the bow of the ship, even details of the brushstrokes themselves. These snippets, enlarged and isolated singly or reduced and grouped on the page in pairs or as a group of four, deliver a surprising punch, as color and brushstroke capture the push of the wind behind sails and the arch and dip of a boat's ungainly passage through choppy waters. In contrast to the painting, the grainy black-and-white photos appear oddly static, the billowing sails seemingly unconnected to the flat water (at least when viewed from this distance). At the same time that Broodthaers published the book, he released a four-minute silent film by the same title. Taken together, the book and film relate awkwardly, as if Broodthaers meant to highlight the cinematic strategies of close-up and montage that he had successfully used in the design of the book, by withholding them from the film. In the film, the artist slowly pages through the book, the sluggish pace refusing the fast and fluid flow that moviegoers expect, while also denying viewers the tactility and independent access associated with looking at a book.

The presentation of the book also undermines convention. Its pages are uncut, thus their doubled thickness slows a reader's

473. Nicholas Calas, "Marcel Broodthaers' Throw of the Dice," *Artforum* 14, no. 9 (May 1976): 34–37. In the 1970s, in addition to exhibiting in Europe, Broodthaers appeared in four one-person New York shows, beginning in 1976. His first appearance in an artist's book exhibition (so described) was in 1976 in *Artists' Books,* in Great Britain. His *Voyage on the North Sea* was pictured and described in the artists' books special issue of the U.S. journal *Art-Rite,* in Winter 1976/1977. Articles that discussed his books provided another route for influence to enter the U.S.; for example, in Pat Gilmour, "The Prints of Marcel Broodthaers." *The Print Collector's Newsletter* 7, no. 2 (May–June 1976): 45.

progress, and acts at odds to the usual ease of paging. An odd remonstrance by Broodthaers appears inside the cover: "Before cutting the pages the reader had better beware of the knife he will be wielding for the purpose. Sooner than make such a gesture, I would prefer him to hold back that weapon, dagger, piece of office equipment which, swift as lightning, might turn into an indefinite sky." The restraint demanded by the artist mocks the urge of a traditional book collector to forego cutting open the pages of a rare book, trading its immediate and practical use against future sales value. A peek reveals that there is nothing to see on these interior pages, but by invoking the convention (and also echoing Mallarmé [474]) Broodthaers interrupts and redirects our experience of this book into thoughts of preciousness, valuation, and even violation. Still, art world issues are secondary to the stories that the book prompts, no matter that it is (otherwise) free of text. A reader cannot help but notice that the brushstrokes of the painting more successfully evoke a sense of sailing than do the photograph's workaday dullness. Has painted illusion triumphed over the photographic eye? The reader responds by projecting his or her own fantasies or fears onto the book, viewing the passage over big water as a romantic adventure or an exhausting egress toward shore, depending on one's identification with painting or picture.

The second key work, *Loophole* (1975), may at first suggest a bracing contrast to A *Voyage on the North* Sea. Telfer Stokes and Helen Douglas produced the book as the first of many collaborations under their imprint Weproductions, from Scotland. The artists describe the title as representing the movement by a reader through the book, "forming a loop & then looping the loop." [475] Just so, the narrative tease in the book does not tell a story in a linear fashion, but rather it accumulates, stuttering, from a number of suggestive relationships between objects and spaces. One of the first sequences depicts the forward movement of a wheelbarrow, page by page (fig. 82), which Stokes later equated to a "mind on a wheel." [476] A series of revelatory sequences unfold throughout the book, but revelatory in a prosaic manner, like a Duchampian readymade under construction, as the photographed objects and surfaces shift in a surreal montage that confuses what object is pictured and where it sits in space. Both the site of *Loophole* and its found texts endure such constant change, forcing the reader's perception to follow along. Some transformations inspire reflection, as when the surface of a white wall, now recognizable as an expanse of paper, is torn away to uncover dark brick, and then, as bricks in the wall are removed, the bright light of an adjoining room leaps into view, effecting a material metamorphosis from paper, to stone, and into light.

474. Mallarmé wrote: "The virginal foldings of the book are unfortunately exposed to the kind of sacrifice which caused the crimson-edged tomes of ancient times to bleed. I mean that they invite the paper-knife, which stakes out claims to possession of the book." Mallarmé, "Spiritual Instrument," in *Stéphane Mallarmé*, 83.

475. Telfer Stokes and Helen Douglas, Weproductions' "List of Publications 1972–90."

476. Telfer Stokes, "The Why and How I Make Books," *JAB* 3 (Spring 1995): 12.

FIG. 82. Telfer Stokes, Helen Douglas.
Loophole
7 x 4¼

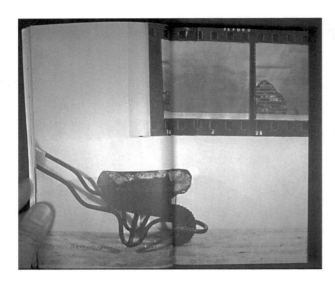

From here, the textual element of the book expands into sound as its systems of meaning multiply. For example, diagonal lines reveal themselves to be greatly magnified threads exiting a sewing machine, and the name of the machine, SINGER, invokes the music that Stokes and Douglas augment with a dance diagram. The book ends with a table of contents (the only conventional text) that names the preceding series (Knot, Wheelbarrow, etc.). The reader responds by looping back to match pictures to labels, only to meander again into musings cued by the book's artful juxtapositions.

The complex associations that Stokes and Douglas bring to bookmaking are initially hidden beneath the messy but invigorating pages (far from the reserved appearance of Broodthaers's page design). But *Loophole* is no Toyland. Its commonplace objects are engaged in serious business with camera and book, where the book serves as a member of the work crew in a construction contrived for our benefit. The fact that these spaces were themselves assembled "like small film sets" only deepens the metaphor of representation, in making or pretending to make a wall, or a story, or a book. Douglas recalled that "The wheelbarrow pages that begin the book were the biggest set [that Stokes] had ever made. We had poles marking the edges of the page and we knew where the center line was; we positioned our cameras side-by-side for left and right page (we had identical Pentaxes), so that there was a little overlap over the spine."[477] The books of Weproductions entered the U.S. book art scene through the writings of Clive Phillpot, through Printed Matter, and through exhibitions such as the 1978 Los Angeles extravaganza, *Artwords and Bookworks* (described below), in which *Loophole* and four other Weproductions books appeared.[478]

At the beginning of the 1970s, the photobookwork in the United States was dominated by a restrained Conceptual agenda that used photography in two ways: to document an ephemeral event, or, in the books of Ed Ruscha, to refuse any fine art appeal. Following in the wake of Ruscha and others, Conceptual photobookworks quietly multiplied into an undeniable presence, confirmed by the exhibition *Artists and Photographs,* at the Multiples Gallery in 1969. Instead of a catalogue, the gallery released a boxed publication of five books, which included *LA Air,* by Bruce Nauman, and *Babycakes,* by Ed Ruscha.

477. Helen Douglas interview by Cathy Courtney, in *Speaking of Book Art,* 132–33.

478. In addition to Phillpot discussing the books of Weproductions in 1976 in *Artists Books* (Arts Council of Great Britain), that same year he reviewed an exhibition of their work in London for *Studio International* and, later, discussed *Loophole* in "Visual Language, Visual Literature, Visual Literacy" for the U.S. journal *Visual Literature Criticism: A New Collection* (Carbondale, IL: Southern Illinois University Press, 1979), a co-publication of *Precisely: Three Four Five* and *West Coast Poetry Review* 5, no. 3, issue 19.

Although united in their Conceptual interests, multiple book-works comprised vastly different personalities. For example, *Brick Wall* (1977, fig. 83) displays a masterful understatement by Sol LeWitt, Conceptualism's founding father, who began in the mid 1970s to extend his systems into photography. To make *Brick Wall,* LeWitt photographed the brick expanse opposite his studio window at different times of the day. Unlike the artificial solar day imposed upon *246 little clouds* by Dieter Roth, LeWitt discovered a surprising range in the natural play of light across the supposedly immutable brick. LeWitt's duotones imply a diurnal progression from sunrise to sunset, reenacted within the circumscribed arc of a turned page, like the studies by Monet of Rouen Cathedral (to which this book was compared). The uneven surface of the wall, its grid softened further by shadow, reveals a subtlety of line and tone seen also in LeWitt's wall drawings. His books succeed in part because they connect Conceptual content to an insistent materiality through looking and touching. The brick wall may appear forgettable, but LeWitt's dedication to looking arouses in the reader a similar urge to reach out and explore the wall's palpable surface, distilled into the page as its surrogate.

In contrast, the changing relations enacted by the books of another key artist, John Baldessari, are semiotic puzzles of the familiar coupled with the unnerving. His *Fable—A Sentence of Thirteen Parts (with Twelve Alternate Verbs) Ending in FABLE* (1977, fig. 84) unfolds into four arms to reveal media images of cowboys, gangsters, and comedians along with bland, throwaway views, such as a car window. Attempts to comprehend the book force the reader to shift in and out of sense, as some of the handwritten words cooperate in simple semantic equations (SEE accompanies a view out a car window), while others are more suggestive: SCHEME appears beneath two men talking. Still other combinations simply don't add up, denying

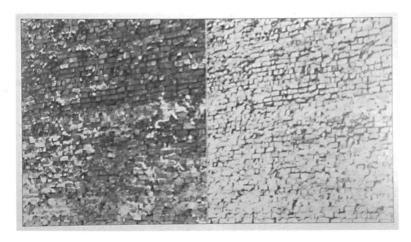

FIG. 83. Sol LeWitt.
Brick Wall
10 1/4 x 8 3/4

FIG. 84. John Baldessari.
Fable—A Sentence of Thirteen Parts (with Twelve Alternate Verbs) Ending in FABLE
3¹/₂ x 5 (closed)

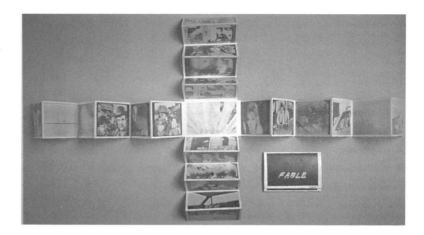

any meaning to images now reduced to empty media icons. The cross shape of the opened book adds its own connotations that diverge from the banal entertainers pictured within. Perhaps Baldessari means to suggest that television delivers present-day fables, its viewers waiting to be told what to believe.

PICTURING THE VISUAL STUDIES WORKSHOP PRESS

By 74 all the components of VSW Press were in place. We had artists titles, a research series, and poetry. It was fun. We had a press—it just sort of happened. At that time there was an interest in artists' books developing. It had to do with the development of artists' alternatives. And artists publishing was seen as part of all that.[479]

—JOAN LYONS

The rise of photobookworks by Conceptualists and others was propelled by a zeal for self-publishing that overtook artists like a religious conversion. By the 1970s, even trade publishers mimicked a grassroots spirit, seen in *Printing It: A Guide to Graphic Techniques for the Impecunious,* by Clifford Burke, published by Ballintine Books. In it, Burke (best known as a fine press printer) described how to print with offset, mimeograph, letterpress, and even paste-up with an IBM typewriter, to show "how it is possible to make pennilessness and some simple skills work as powerfully as lots of dough and snazzy studios."[480] Anyone could publish, and nearly everyone did.

A contagious organizing spirit resulted in offset presses run by artist-facilitators, who often worked with other artists to experiment with new applications of offset printing, some in color.[481] These artist-facilitators linked the excitement of independent publishing to experimental work in a tradition of research and development com-

479. Lyons interview with Brad Freeman, in *JAB* 4, 12.

480. Burke, *Printing It: A Guide to Graphic Techniques for the Impecunious* (New York: Ballantine Books, 1972), 7.

mon to any emerging art medium. In the spirit of Eugene Feldman, Joe Ruther,[482] and others, printers such as Kevin Osborn at the Writer's Center, Philip Zimmermann at Space Heater Multiples, and Michael Goodman at Nexus Press spent hours coaxing lush, striking books from machines previously directed toward commercial ends. Some artist-printers operated within a collaborative community of support that linked production to exhibition to distribution. Although few in number, such organizations exerted great influence, and none more in this early period than that of the Press at Visual Studies Workshop (VSW).

VSW began in 1969 in Rochester, New York, as an artists' space and graduate program (administered through SUNY-Buffalo) with thirty students. Artist Keith Smith recalled that, between 1974 and 1980, each year over 200 students applied to VSW, from whom Nathan Lyons, Joan Lyons, and Smith selected eleven.[483] Joan Lyons credited Nathan for the idea of starting a press to expand the programs and presence of VSW, applying his experience with publishing from his tenure at the George Eastman House between 1957 and 1969. In 1971, VSW printed a few books on an old letterpress proofing press, but only in 1972, with an old offset press, scavenged "from somebody's garage," was the Visual Studies Workshop Press established, even though, back then, "the term 'book artist' did not yet have currency."[484]

In 1974 Nathan Lyons created *Notations in Passing*, admired in photographic circles for its "flow," which consisted of the subtle interplay between photographs throughout a book, a characteristic previously explored in books such as Walker Evans's emblematic *American Photographs* (1938). With the founding in 1969 of Aperture Books, photographic books gained an established imprint. Most photographic books still followed a monographic approach of "books that looked like portfolios between covers."[485] A few self-published photographic books integrated mark-making and found materials to resemble "repositories not only of dumb facts but of personal visions."[486]

For example, in 1970 Ralph Gibson's Lustrum Press published *The Somnambulist*, a visionary's record of dream-like fragments. Gibson and other photographers produced books described as "photobiography,"[487] such as *A Loud Song*, by Danny Seymour, another Lustrum Press publication from 1971. These books carried appropriated mass-media images or reinterpreted historical photography techniques. Also produced were books whose photographs had been altered from handwork—such as *Vagabond* (1975), by Gaylord Herron, which combined photographs with painting, writing, and Bible quotations. (Photobookwork alter-aesthetics will be explored further below, in the work of Keith Smith, Syl Labrot, and Todd Walker.[488])

481. Betsy Davids and Jim Petrillo coined the term "artist-facilitators" in "The Artist as Book Printer," in *Artists' Books,* 159.

482. Brad Freeman recalled meeting printer Joe Ruther (d. 1987) in Tallahassee, Florida, in 1976, whose printing approach he described as a "willful and aggressive intervention into each phase of the production process...." Brad Freeman, *Offset: Artists' Books and Prints* (New York: Interplanetary Productions, 1993), 1. Also in *Offset,* Johanna Drucker's essay provides an excellent overview of the practical and metaphorical properties and paradoxes of offset printing from an artist's perspective.

483. Author email interview with Smith, part 3, December 20, 1998.

484. Lyons interview with Brad Freeman, *JAB* 4, 11–12. VSW's facilities expanded in 1972 with the help of a $7,000 grant that funded a new graphic arts camera, darkroom sinks, and an offset duplicator. A few years later a Heidelberg KORD came to the press, followed by typesetting equipment and, by the late 1980s, a pre-press computer lab. Since 1968, VSW has provided a higher-education entrée to artists interested in Visual Studies, including the photobookwork, but it has also had to repeatedly battle for its existence. In 1982 VSW lost its affiliation with SUNY Buffalo due to cutbacks, and then in 1986 it regained its M.F.A. degree program, which is now operated through SUNY Brockport. Throughout that period without a graduate program, VSW's programs continued operating; these included the Gallery, the Press, the Media Center, the Research Center, *Afterimage* journal, and artists' residences and summer workshops. As of 2003, over 350 artists' books and titles in the visual arts have been produced at the Press. Author email from Lyons, July 23, 2003.

485. Lyons interview with Courtney, in Courtney, *Speaking of Book Art,* 47.

486. John Szarkowski, "A Different Kind of Art," *New York Times Magazine* (April 13, 1975): 17. Quoted by Candida Finkel, "Photography as Modern Art: The Influence of Nathan Lyons and John Szarkowski on the Public's Acceptance of Photography as Fine Art," *Exposure* 18, no. 2 (1981): 22–37.

Some photographers benefited from increased opportunities for grant support. In the 1970s the National Endowment for the Arts increased support for photography to about six million total dollars, directed to individual artists (1971–), museum programs (1973–), and photography books (1975–). Around 1981, most of the funding was reallocated or eliminated. See Charles Desmarais, in James Enyeart, ed., *Decade by Decade: Twentieth-Century American Photography from the Collection of the Center for Creative Photography* (Boston: Little, Brown; Tucson: Center for Creative Photography, University of Arizona, 1989), 98.

487. A term used by Desmarais, in Enyeart, *Decade by Decade*, 92.

488. The story of the artistic development of photography is beyond the scope of this discussion, and it should be emphasized that Lyons and Szarkowski were only two players in a busy history. For general background, see Finkel, "Photography as Modern Art"; Phillips, "The Judgment Seat of Photography," in Richard Bolton, ed., *The Contest of Meaning: Critical Histories of Photography* (Cambridge, Massachusetts, and London, England: The MIT Press, 1989); and Desmarais, *Decade by Decade*. For a resource specifically on photobookworks, see Alex Sweetman, "Photobookworks: the Critical Realist Tradition," in Lyons, ed., *Artists' Books*.

489. Joan Lyons interview in Dugan, *Photography Between Covers*, 95–96

490. Lyons interview with Courtney, in Courtney, *Speaking of Book Art*, 47.

At VSW, the involvement by Nathan Lyons in the photographic book conferred on it artistic validation, albeit indirectly. Students applied to VSW for the chance to study photography with Nathan and then sometimes discovered a fascination with bookmaking from Joan Lyons or Keith Smith. The sensibility of Joan Lyons and her direction of the VSW Press offered a distinct but complementary aesthetic to that of Nathan, as she observed:

> There are two attitudes you can have about printing. Most printing that goes on in this country is a reproduction of some copy. Most photographic books are trying to be as close as they can to being a facsimile of the original photograph. That's one kind of marvelous and very valid attitude about printing and the other is a kind of printmaking approach and that's the area of printing I'm interested in. In other words, there's no original copy that's reproduced, the image evolves out of the process itself and the first time it's evident is on the printed page, so the books are, in every sense, original prints. They're primary material, and that to me is incredibly exciting, and what is infinite and endless about printing.[489]

Joan Lyons printed her first VSW Press book in 1972, *Self Impressions*, offset in fifty copies. Its content utilized waste materials she culled from a Sonia Sheridan workshop with the new Color-in-Color copier by 3M, when "Sonia persuaded me to get up on the machine and she made copies of me."[490] Lyons swept up the unused prints and reapplied them as offset plates for the book, her text printed letterpress on the facing pages. Like many artists of the time, Lyons was excited by the visual-tactile interplay between unconventional content, bindings, and materials. Among other experiments, she sprouted seeds in her *Seed Word Book* of 1975 and executed visual progressions in books secured by a single bolt or with staggered elongated pages threaded through in "Venetian blind" style. The progressive revelation of imagery and its resulting alterations or distortions invested her books with a sense of organic transformation associated with children's books.

THE COPIER AS PRINTMAKER

The capacity of the new graphic machines for instant production has the most profound implications for the visual world. The artist, who once spent hours rendering an orange, can photograph the orange whole, cut up into any variety of forms, or squeezed into juice, and can rephotograph it within minutes. In an hour's time he can produce 120 variations; in eight hours he can have almost 1000 different versions of the orange.[491]

—SONIA SHERIDAN, 1970

The 1970s marked the beginning of the copier's use by artists for image production and self-publishing. VSW's sponsorship of a copier residency by Sonia Landy Sheridan and Keith Smith (see their collaborative *Smithsonian,* 1973, fig. 85) helped to legitimize copier printing as a new printmaking medium and one adaptable to bookmaking. Margot Lovejoy later summarized the technical and artistic parameters of the copier: "As an imaging tool, the machine is a unique, electronic photographic device with a fixed field (the glass image platen—normally 8½ x 11" to 11 x 17") and a shallow depth of field designed primarily for copying flat materials. Three-dimensional objects placed in contact with the glass platen are rendered sharply in defined detail with the focus diminishing in areas further from the glass, creating unusual illusory effects."[492] Copier artists struggled with an art world bias against the commercial connotations of the machine and the unconventional production values of its prints. Art world recognition of the copier-printed *Electronic Variations,* by Melissa Gurdus (1966), discussed in chapter 6, was an anomaly for an artist's book.

Copier history dates to Chester Carlson's 1939 patent for electrophotography, developed by the Haloid Company (later Xerox), which named it xerography. In the 1950s, copiers entered offices, where they served the escalating needs of business for the immediate duplication and dispersal of information. Encouraged by the appropriation and multiplication of mass media imagery by Pop artists, other artists investigated the formal properties of the copier—that is, if they could get access to one. Few artists could afford to own a copier, along with its high maintenance costs; instead, in the 1960s, artists gained access to copiers through educational institutions or at early copy centers.

Judith Hoffberg recalled that "the Xerox machine only became popular in 1963, so popular at fifty cents a throw, if you were lucky to find a library in your university that allowed it to happen, or else you went down to the PIP or something like that. So what happened is that you stood in line and looked at this machine."[493] Wallace Berman

491. *Software: Information Technology: Its Meaning for Art* (New York: The Jewish Museum, 1971), 24.

492. Margot Lovejoy, *Postmodern Currents: Art and Artists in the Age of Electronic Media* (Ann Arbor: U.M.I. Research Press, 1989), 115.

493. Author interview with Hoffberg, Santa Monica, California, November 6, 1995.

FIG. 85. Keith Smith and
Sonia Sheridan.
Smithsonian
9 x 12

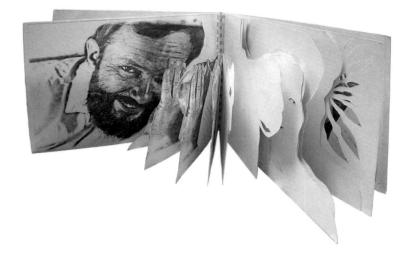

experimented with Verifax (an early copier) in the mid 1960s, making collages for his *Semina* journal by laying items directly on the platen. Fluxus and Conceptual artists developed strategies specific to the copier, including the exploitation of its characteristic high-contrast graininess; the development of so-called "light painting" from an artist's movement of objects (or body parts) across the platen; and the direct imaging of items on the platen to compose foreshortened still lifes. By the 1970s, artists could choose from a number of printing options, including the copier, kwikprinting, verifaxing, mimeograph, the Gestetner, and the electric stencil.[494]

In 1968, 3M Corporation developed "Color-in-Color," the first full color copier. The Color-in-Color was advertised as capable of producing an 8-1/2 x 11" color copy in sixty seconds. It was designed as a truly interactive, automated machine, allowing for altered color relationships, values, and densities on command, and able to create twenty-seven different color combinations from a single original.[495] At the invitation of 3M, Sheridan, professor at the School of the Art Institute of Chicago, teamed up with Keith Smith to research the creative potential and color-rendering capacities of the new machine. Other artists had experimented with copiers before them, but Sheridan's advocacy for copier-generated art extended into her founding of the Generative Systems Department at the School of the Art Institute of Chicago.

In November 1971, VSW sponsored a generative systems workshop by Keith Smith and Sheridan, with 3M support. That kind of programming support was key to the acceptance of the copier as an artist's book medium. The workshop, along with a talk by the inventor of the machine, Dr. Douglas Dybvig, took place in Spring 1972.[496] In July 1973, Sheridan returned to VSW for another book workshop

494. The Gestetner was a variation on the mimeograph. The electric stencil eliminated the need to type manually or draw on a stencil, by scanning artwork and punching tiny holes in the stencil where lines and pictures appeared. Burke, *Printing It,* 18.

495. Lovejoy, *Postmodern Currents,* 117.

496. Author email interview with Smith, part 2, December 16, 1998.

with photographer John Wood, critic A. D. Coleman, and Smith. At that workshop, Smith and Sheridan collaborated on *Smithsonian*, one of about ten books made during a two-week "book marathon." Joan Lyons noted that, "I remember clearly one book they did that had to do with their two portraits on one plate that took an hour to print and then took Keith several days to very elaborately cut up."[497] Turning the pages of *Smithsonian* sets into play a bewitching transformation as Keith becomes Sonia. Even as the two faces remain distinct, they also overlap and combine before Sonia emerges. The book enacts the collaboration's intellectual and emotional interplay, punningly reflected in the title of the book, an amalgam of their names.

Despite its array of expressive possibilities, the copier never distanced itself from its origins as an office workhorse. Any artistic use of it, then, constituted the subversion of traditional fine art categories and challenged preconceptions about art's rarity and the gulf between the copy and the original. Artists soon recognized that the copier could serve as the perfect emblem of a postmodern age.

ALTER-AESTHETICS

I had done one book previous to that, which was a lot of etchings, but when I got done with it, it was nothing more than a bunch of etchings held together by the binding. It wasn't a book. A book is more than the sum of its parts....A book has to be conceived and designed for the totality of it.[498]

—KEITH SMITH, 1976

Surfaces, a rusted edge, whatever, became detached from their surroundings and floated free. Appearances became separated from meaning. The skin, the surface of reality, was transposed into film.[499]

—SYL LABROT, 1976

These words are not captions. The photographs are not illustrations. However, feel free to try to connect these in any way you can possibly imagine.[500]

—TODD WALKER, 1976

Keith Smith's early experiments with copier-printed books only hint at his contributions to book art. In fact, any discussion of Smith's books must begin with the tribute that here is an artist deserving of a book all to himself. Smith has done more than any American book artist to analyze, extend, relocate, and communicate the book's expressive range. His output is extraordinary, in numbers and formats and lyricism. From 1967 to 1980 alone, Smith completed seventy-six books in a variety of formats and edition sizes; as of 2003, he has made over 200 books, including eight popular textbooks that explore various aspects of bookmaking."[501] Due to limitations of space, only a few of his early books can be noted. He is the first of three

497. Lyons interview, *JAB* 4, 12. Keith Smith later noted that both he and Sheridan spent days involved in meticulous cutting to create *Smithsonian*.

498. Keith Smith interview in Dugan, *Photography Between Covers*, 79.

499. Syl Labrot, *Pleasure Beach* (1976), n.p.

500. Todd Walker, Afterword, *for nothing changes* (1976), n.p.

501. Smith discusses all of his books (to date) in *200 Books, An Annotated Bibliography* (Rochester, New York: keith smith BOOKS, 2000).

artists in the 1970s who reconfigured the look of photography in books.

Smith received a B.A.E. degree from The School of the Art Institute of Chicago in 1967, studying printmaking and photography. From the beginning, he resisted identifying with any single medium: "When I was a student, one day I went to two critiques. I went to my etching critique, and my etching teacher said, 'These aren't etchings, these are photographs that you made on the etching plate.' Then I went to my photography teacher and he said, 'These aren't photographs. You're a printmaker who uses photography.'"[502] Smith's breakthrough arrived with the impact of any conversion. Working in his darkroom to make film-positives to contact print onto etching plates, Smith turned on the light to check on an exposure, then moved his hand away because his fingers covered the image. Suddenly he stopped, and refocused from the surface, into depth:

> I saw that the picture was not the opaque black shapes on the clear sheet of acetate, but rather, a combination of that plus anything else viewed in front of or through the transparency. This excited me; I had seen freshly. I yelled and immediately held the dripping sheet of film in front of the enlarger, the wall, my arm, my penis. I ran out of the darkroom laughing, looking at everything in the apartment through this sheet of film. I placed it on the mirror and looked at myself. I slapped it on the window where it clung. Someone walked by; I watched through the printed image.[503]

Smith had undergone a Mallarméan revelation, a re-viewing of the photograph as marks flowing across a spatial plane more than as a static picture printed on opaque paper. That spatial plane could be a book page, and if transparent it opened up tremendous interactive potential. Smith thought in pictures—not simply in pictures that related to one another across a page opening, but pictures that responded to one another down through a book's strata of rectos and versos.

For example, in *A Change in Dimension* (Book 2, 1967, fig. 86), Smith distributed film positives into a "compound picture made up of the transparency and whatever else might be seen through it."[504] Enlarged fingers and fish float in a field of rectos until, page by page, they shift onto the verso half of the book, peeling away the visual density from the right side to reveal a striking picture of an eye, Smith's trademark image. Because the last image is printed on opaque paper, its steady gaze takes on a weightiness that challenges the reader to reconsider the vicissitudes of sight and touch in the now-permeable book.

After revisualizing the page as a transparent slice out of a compound picture, Smith launched on a procreative journey. From his

502. Keith Smith interview in Dugan, *Photography Between Covers*, 81.

503. Smith, *Structure of the Visual Book* (2d. ed., rev. Fairport, New York: The Sigma Foundation, 1992), 12.

504. Ibid., 13.

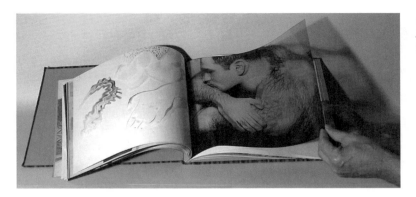

FIG. 86. [CP18] Keith Smith. *A Change in Dimension* 11 x 14

hands emerged books transformed by nearly every photographic and printmaking process, including film positives, transparencies, Verifax transfers, and cyanotypes. Smith cut and tore pages, collaged or drew upon them, watercolored and sewed upon them, and later generated type and imagery from the computer. Hugely prolific, Smith reused photographs in a protean epic of picture-making, his pictures of friends and home commingling into a family of images that reconfigured from one book to another. After further study and teaching, Smith relocated to Rochester to teach non-silver, silkscreen, and bookmaking at Visual Studies Workshop from 1974 to 1983. Smith's explorations of the photobookwork derive from his enthrallment with the elastic form of the book, with its intimate exposures, and ultimately with its partnership to Smith's own evolving autobiography of revelation and transformation as an artist and an openly gay man.

The exhaustive investigation of the book's properties by Smith calls to mind early avant-garde bookworks, as well as the playful invasions of Dieter Roth, although Smith emphasizes that his early bookmaking investigations were conducted in a vacuum.[505] Compared to the Fluxus beguilements wrought by Roth, the early works that Smith created appear restrained. In truth, Smith's aesthetic is more aligned with a book's ritualistic consecration than with the bacchanalian romp that Roth performed with image, format, and material. Smith's books are always about pictures, not pictures put into books, but each embodying the other, where "books are pictures—moving pictures through time and space, [and] making books creates images between the pages, so you not only have the printed pictures, but those implied...[by the pictures that] the viewer creates in their mind as they experience your book."[506]

In time, Smith turned a book inside out, with Book 24 (1971, fig. 87). The book has film positives for pages and a lightbulb in its binding. Viewed in a darkened room, a reader instigates the environment by turning the pages. A changeable shadow play of pattern and distortion

505. As Smith put it: "There was no one I am aware of who was making books in Chicago. I had no knowledge of art history, so I did not know Ed Ruscha was making books in California in the middle 1960s or ever heard of Dieter Roth until almost 1980!" Smith credits Gary Frost with suggesting that he turn his film positives into a book: "It was the best and nearly only help I had towards the idea of conceiving books." Author email interview with Smith, part 1, December 12, 1998.

506. Author email interview with Smith,, part 1, December 12, 1998.

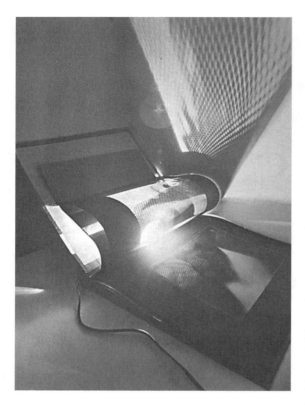

FIG. 87. Keith Smith.
Book 24
15 x 15

through the film positives moves in and out of focus across the walls, and across the viewer as well, if he or she leans over the book for a closer look. In Book 24's dependence upon translucency, *Shades,* by Robert Rauschenberg, comes to mind— but Smith did not so much bring the environment into a book, as Rauschenberg had—as make a book that delineates its own shifting environment.

Smith also made books in the 1970s that enacted the physical transgressions of the sculptural bookwork, such as in his *Exploding Book* and *Burned Book.* Other book artists, largely unknown to one another, covered the same terrain around that time (the Center for Book Arts in New York had opened only the year before). Unlike other sculptural bookworks, however, most of Smith's books move beyond symbol or metaphor to necessitate touch. Smith makes books of the body that act as physical and emotional intercessors to animate images of friends and self in his private iconography. Much of his work is about the longing for revelation within the private and controlled realm of the book, yet a realm readily opened to others. Smith's vision and prolificity, already apparent in the 1970s, did not lead to national influence in book art until after his publication in 1984 of *Structure of the Visual Book,* the first of several textbooks on nontraditional bookmaking, and whose illustrations include his own works. Few people had seen them before that. In fact, typically, it was Smith's photography (not his books) that was represented by Light Gallery in New York City, and that won him two Guggenheim fellowships.

Smith and other artists often cite the influence of *Pleasure Beach* (1976), by photographer Syl Labrot, for its demarcation of new expressive boundaries for the offset printing of photographs. In the foreword to *Pleasure Beach*, Labrot writes that "photography is much more than just silver prints. There is the pleasure of all sorts of homemade color processes, separations, halftones made by fine line, the indulgence in special effects, and ultimately the controlling of all the processes which go into book making; for this is not a book of reproductions of already existing pictures, but rather a matter of *making* pictures with the printing press."[507] The book portrays wintertime prowls around Pleasure Beach, an abandoned amusement park, and a

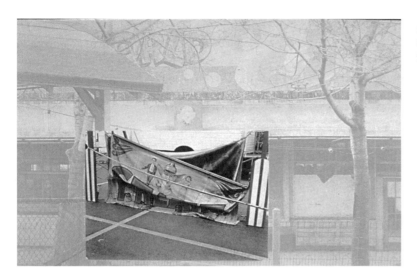

FIG. 88. [CP16] Syl Labrot.
Pleasure Beach
11 x 16

fitting stage on which Labrot sets fantasy and reality at odds with one another. Fantasy is the aggressor here; it overruns the pictured reality in the press. Labrot emphasizes that "color separations, graphics, type, page layout, halftones, and stripping are all part of the authorship—they are the authorship, and there is not a matter here of the reproductions being good, for there is no reproducing involved."[508] From the peeling surfaces and faded colors in one image, Labrot washes out a background and then juxtaposes it to another, seemingly hung on a wire (fig. 88), the natural lighting in the foreground oddly clean and sharp across the flaccid banner.

For Labrot, as, earlier, for Eugene Feldman, offset printing was not reproduction but invention. Photography and printing offered access to both recording and altering, where "the documentary appearance of a photograph was really a bland mask for its own, separate reality."[509] Labrot's book generated much interest at the time; several of the photo-bookmakers interviewed in 1979 for *Between Covers* made reference to its importance. Keith Smith recalled it as the first book he encountered that was created on the offset press, where "the book IS the originals," the product of an arduous printing process in which even the book's black type was composed of four colors.[510] The process materials for *Pleasure Beach* were exhibited at VSW during its 1979 "Options in Independent Art Publishing" conference, discussed below.[511]

Photographer Todd Walker also made photobookworks that crossed into printmaking; in fact, in addition to his self-published books, he worked in silkscreen, lithography, black and white and color photographic prints, and eventually experimented with offset printing on

507. His emphasis. Labrot, *Pleasure Beach,* n.p.

508. Ibid.

509. Ibid.

510. Author email interview with Smith, part 5, December 21, 1998.

511. Kathleen Weldon, Center for Book Arts newsletter, nos. 3 and 4 (Fall 1979/Winter 1980), n.p. Labrot's early death in 1977 cut short his promising work in experimental offset printing in color.

his own press. Walker left a career as a Los Angeles commercial photographer in 1970 to teach at the University of Florida–Gainsville and then taught at the University of Arizona–Tucson until his retirement in 1979. His art-making resolutely voids his earlier commercial aesthetic: "In all the areas that I work with—posterization, solarization, the nude—I often feel that I'm skating on the edge of disaster...and I think that some of that risk may be why I do it. This is part of the decision making of everything I print because I'm doing landscapes and nudes (both of which were used up years ago) so I'm finding something within that."[512]

Walker juxtaposes contemporary content and technique to methods associated with the past, creating invigorating blends. In 1976 he published *for nothing changes...* (fig. 89), in which he excerpted the 1652 retelling by Robert Burton of a story by Democritus (370 B.C.), where a rational man rejects and is denounced by an irrational society. Walker combined this narrative with contemporary newspaper excerpts. Facing each page of paired texts are color photo lithographs of

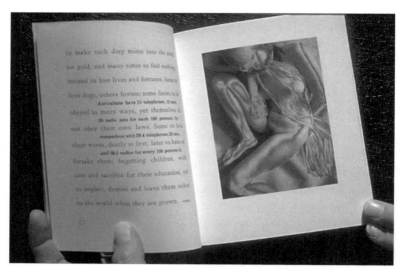

nudes. Some of his printing techniques intervene in pictured reality to "isolate a line or a value" and emerge as a modulating plane of shape, color, and form to offer what he calls "alternatives to the world."[513]

Walker's apologia that begins this section refuses traditional roles for image and text so that they may encounter one another on equal terms. In *for nothing changes...* he achieved a difficult but compelling relationship between divergent parts. His use of contemporary media, initially discordant, removes the distance of history from the quoting of Democritus, who argues for a moral life but does not

512. Todd Walker, *...one thing just sort of led to another...The photographs of Todd Walker* (Tucson, Ariz.: Thumbprint Press, 1979), 14.

513. Ibid., 16.

discount the social isolation that is its cost. What a contrast to the movie promotion quoted elsewhere in the book, which thrills at providing "a ticket to war's back room" full of bodies and blood. To this, Walker juxtaposes a third element, the nudes that could have been dismissed as derivative. But in this context, their evidence of life's fecundity suggests the incorruptibility of hope.

Books by Walker, Labrot, and Smith transform the photobookwork through the sensibility of printmakers, in which (in their words) "photographs are not illustrations" and "words are not captions"— instead, pictures and texts reveal what lies below the "skin, the surface of reality." Their books inspire a fresh way of seeing. Only a handful of arts communities noted the books of Smith, Labrot, Walker, and a few other artists during the 1970s. Innovative books alone could not create an art world. Connections were needed, to link makers to books to readers to critics.

BUILDING COMMUNITY
BUILDING A NETWORK

McLuhan's Mistake—The Book is Back.[514]

—CANDIDA FINKEL AND BUZZ SPECTOR, 1978

Visual Studies Workshop fosters a photographic community that reaches beyond the borders of the school and actively seeks to answer the needs of book artists concerning distribution and networking. In 1975, VSW's Book Service expanded from photographic books to handle artists' books, opening a crucial distribution conduit in the United States that predated Printed Matter. As Book Service and gallery coordinator Alan Winer claimed: "One thing we're trying to do is to return a higher percentage of the price of the book to the artists. These are all basically 'limited edition' books and are, therefore, very expensive for people to produce....The whole trend is an attempt to humanize publishing.'"[515]

Visual Studies Workshop Press invited the international community to "Options in Independent Art Publishing" in November 1979. Organizers Don Russell and Helen Brunner hoped to assemble what was later described as "the first major forum for consideration of contemporary artists' books, from duplicator-printed manifestoes through one-of-a-kind bookworks."[516] Their efforts at a pluralistic overview of the field resulted in a cornucopia of books, presented histories, and networking. The organizers sought out presenters who could relate the artist's book to a global art world and expansive aesthetic. Two hundred fifty attendees heard speakers and panels whose participants included Richard Minsky, Clive Phillpot, Sheila DeBretteville, Dick Higgins, Martha Wilson, Joan Lyons, Judith Hoffberg, Betsy Davids, and Jim Petrillo. Fifty exhibitors showed at a book fair. The books themselves varied, from Ingrid Sischy's sampling of fifty new books from Printed Matter, to Jacki Apple of Franklin Furnace showing "one-of-a-kind book sculptures."[517] International work was covered in talks by Ulises Carrión (Europe), David Buchan (Canada), and Felipe Ehrenberg (South and Central America). Nathan Lyons announced that in 1981 the National Endowment for the Arts would open a funding category specific to Artists' Books under the Visual Arts category of Prints and Drawings. Books seemed to have caught the attention of the art world's gatekeepers at last.

In truth, the VSW conference was not the first forum for discussing contemporary artists' books, but it was the most successful in

514. Title of review by Candida Finkel and Buzz Spector, of the Chicago exhibition in 1978, *The Art of Offset Printing,* in *The New Art Examiner* 5 (March 1978): 6–7.

515. Quoted by Harris, "Artists' Books: Distribution is the Problem," 3.

516. Weldon, Center for Book Arts newsletter, nos. 3 and 4, n.p.

517. "For and against in Rochester," unsigned brief review, *The Print Collector's Newsletter* 10, no. 5 (November–December 1979): 194–95.

518. Carl Loeffler, "La Mamelle," *The Dumb Ox* (no. 4, 1977), 40–41.

519. Author interview with King, November 8, 1995, Los Angeles.

520. Other resources on offset printing include *Offset: A Survey of Artists' Books* (Cambridge, Mass.: New England Foundation for the Arts, 1984), by Gary Richman; and two essays by Drucker: "The Myth of the Democratic Multiple" (1997), and "Offset: The Work of Mechanical Art in the Age of Electronic (Re)production" (1993), both reprinted in Drucker, *Figuring the Word.*

521. Buzz Spector outlines early Chicago activity in *Artists Book Works, A Decade in Illinois* (Chicago: Artists Book Works, 1993). He notes the founding of Artists Book Works in 1982 by SAIC graduate Barbara Metz (with Bob Sennhauser and Robert Loescher), after Metz visited the Center for Book Arts in New York in 1978. In 1994, Artists Book Works and another nonprofit, Paper Press (run by Marilyn Sward), combined and reconfigured into the Columbia College Chicago Center for Book and Paper Arts. It began by offering an M.A. degree with a concentration in Book and Paper Arts; in 1997 it added an M.F.A. degree in Interdisciplinary Book and Paper Arts.

522. From Joan Lyons, "Book Conference 1990 Observations," notes on previous conferences, distributed to organization representatives attending "Book Arts in the USA: 1st National Conference," at Center for Book Arts, New York, March 30 to April 1, 1990.

523. Finkel and Spector, "McLuhan's Mistake," 6.

524. Braun, "Artists' Books," 69.

525. In 1982 Gleber and Rubini relocated Chicago Books to New York City, then later moved to Tallahassee, Florida, where they collaborate on *The Future of the Book of the Future,* an ongoing traveling exhibition.

its organization and attendance. Carl Loeffler, who formed the Associated Arts Publishers (AAP) in 1977, organized the "Convention Art Publishers/Exhibition Art Periodicals," a book fair and workshops, at San Jose State University in 1977.[518] Betsy Davids described the gathering as a series of events rather than as a conference, and Susan King agreed: "There was just a handful of people [and] there was a bookfair....[Perhaps it was during] a time set aside to have a presentation. I remember people sitting around in a circle on folding chairs and talking....about distribution and [other subjects]....What I remember seeing at one of the early [gatherings] were Betsy [Davids] and Jim [Petrillo]'s books....I thought their stuff was just amazing."[519]

The artistic acceptance of the multiple bookwork for which these conferences were lobbying would not take place until the medium of offset printing, whose material presence remained undeniably commercial, its slick planographic surface persistently viewed as merely reproductive and so not creative in and of itself, benefitting from an art world acceptance of photography. One pioneering effort occurred at Wesleyan University, with the exhibition and catalogue *Offset Lithography* (1973), by Louise Sperling and Richard S. Field. It traced the history of offset technology and its emergence as an artistic medium.[520] Despite such efforts, widespread artistic recognition continued to elude offset printing.

Interest in book art was contagious, however, and a loose network of offset printing and artist's book relationships took hold in Chicago, overlapping at the School of the Art Institute of Chicago (SAIC).[521] In 1978, the SAIC exhibited *The Art of Offset Printing,* accompanied by a modest brochure. Like the show at Wesleyan, the Chicago exhibition presented offset first as a commercial printing process (showing posters, comic books, etc.), and then as an art medium. A concurrent conference hosted Lucy Lippard, Clive Phillpot, Judith Hoffberg, Don Russell, and others.[522] A review by Candida Finkel and Buzz Spector argued that the exhibition "brings Chicago into the arena of small press books and offset art now dominated by New York and California."[523]

After working as a journeyman printer in Florida, Conrad Gleber taught at SAIC in the early 1970s, and also made offset art. In 1976, inspired by the recent founding of Franklin Furnace in New York,[524] Gleber started Chicago Books with fellow photographers Jim Snitzer and Gail Rubini (Gleber and Snitzer had both taken a bookmaking class with Keith Smith).[525] Gleber's own art paid homage to the megalomanical printing capacities of offset, in sculptural pieces where tons of stacked paper were built up into six-foot-high, three-dimensional images of the same picture. That same accumulative

strategy reappears in his *Chicago Skyline* (1977, fig. 90), whose pages fan out from a single sprocket into a repeat-image of clouds and blue sky and a distant view of Chicago along the bottom edge, which is actually comprised of four successive views that step across the horizon. The city appears in sepia tones as a miniaturized presence, for once marginalized by the regnant sky overhead.

The ties of Keith Smith with Jim Snitzer and Conrad Gleber, and the ties of Gleber with SAIC, illustrate the crosscurrents that activated a period where photographer-printers grappled with mastering bookmaking and the technical idiosyncrasies of the offset press, even as they sought to extend or ignore commercial printing standards in order to enlarge its visual repertoire. The arrival of Michael Goodman in Chicago in 1974 established another link in the network. In 1973, Goodman helped to found the Nexus Photographic Cooperative gallery in Atlanta. Goodman left for graduate study at SAIC, where he met Gleber and (Goodman later recalled) learned about the kind of visual flow that Nathan Lyons was talking about in Rochester. Goodman attended printing trade school at night, and returned home to help transform the nascent photographic Nexus Press into a collaborative offset press, where artists assisted by printers luxuriated in multiple print-runs and improvisatory presswork and book structures.[526] An early key work from the press was *Parallel* (1978), by Kevin Osborn.

Osborn pursued a similar approach to bookmaking at the Writer's Center in Bethesda, Maryland, an organization founded by a group of writers in the mid 1970s to offer readings, along with typesetting services and a bookshop. After receiving his M.F.A. from Visual Studies Workshop in 1977, Osborn helped establish the printing facility at the Center, and inaugurated a workshop on artists' books, and that same year the National Endowment for the Arts responded with funding. In its first three years, the Writer's Center published twenty books, with the artists often assisting Osborn at the press.[527] Osborn's own aesthetic was a painterly one. His *Repro Memento* (1980,

526. Sources for the early history of Nexus Press include an essay by Jo Anne Paschall, "Nexus Press: A View From the Loading Dock," *Talking the Boundless Book: Art, Language and the Book Arts* (Minneapolis: Minnesota Center for Book Arts, 1995); and Paschall's interview with Brad Freeman, *JAB* 3 (Spring 1995), 2, 4–7. Paschall and Freeman are both former directors of the Press. Nexus Press closed unexpectedly in April 2003; its future is uncertain.

527. In 1986, Osborn moved a small offset press onto the premises of Pyramid Atlantic in Maryland, in an exchange of space for his consultancy in teaching and programming. In 1987, Helen Frederick, director of Pyramid Atlantic, hired Brad Freeman to be the master offset printer (Freeman had just graduated from Visual Studies Workshop). When Freeman moved on to graduate school at the University of the Arts in Philadelphia, Osborn sold the press at Pyramid. As of 1993, Pyramid Atlantic has sponsored an offset residency program and other programs at the Borofsky Center. Helen Frederick telephone conversation with the author, April 22, 1999.

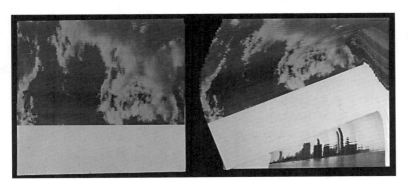

FIG. 90. [CP5] Conrad Gleber. *Chicago Skyline.* 7 1/2 x 11

FIG. 91. Kevin Osborn.
Repro Memento.
11 x 7 1/2

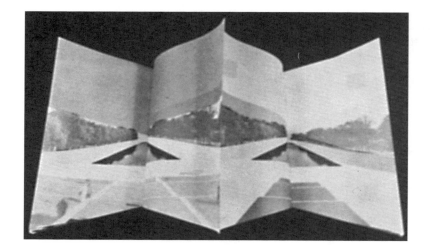

fig. 91) resembles a pamphlet but opens into an accordion trapezoidal shape, whose translucent pages glow from colored inks. A single perspective on the inside is slowly assembled on its pages, but if the book is opened out, the perspectives multiply to picture the repeating views of an empty monumental space. Pages decrease in height toward the middle, and send the pictured space careening in toward the gutter of the book, the resulting effect stimulating yet unsettling.

A complete delineation of a U.S. family tree of offset presses awaits further research to trace the relationships of friendship, collaboration, and influence. Each artist-run press solved the financial puzzle of publishing by combining in-kind exchanges with fundraising and collaboration. For example, Chicago Books asked each artist to pay for the materials and binding of a book, and the press contributed the cost of labor, technical assistance, and equipment. It sold books through a yearly subscription (forty dollars for six books), and supplemented its income with commercial printing work, particularly for arts organizations. Nexus Press funded a few artists' books each year and supplemented that publishing with Artist Initiated Projects, where the Press wrote letters supporting an artist's efforts to raise production funds.

Each press also evolved an identifiable aesthetic that reflected its particular circumstances, its printer's philosophy, and its available technology—although books from all of the presses shared strategies common to photographic content. As should be clear from this selective review, many photobookwork aesthetics coexisted in the 1970s. For example, books from Visual Studies Workshop Press, Chicago Books, and Women's Graphic Center (to be discussed below) were printed both in black-and-white and color. But books from Nexus Press and the Writer's Center raised color printing to a virtuosic level

528. Syl Labrot, "The Invention of Color Photography," *Pleasure Beach,* n.p. Other publishing collectives and cooperatives active in the late 1970s included Richard Kostelanetz's Assembling Press, The Open Studio Workshop, the Collation Center, and Women's Studio Workshop.

not previously associated with the multiple bookwork, and helped to pioneer an artistic appreciation for color printing uncommon to the time. Syl Labrot described the bias against color offset printing in 1975: "I know of many people who say they do not like color pictures and much prefer black and white. In the museums, the displays of artistic photography are almost wholly monochrome. In the history [books], the great artists in the media all worked in black and white. It is as though the existence of color photography is still in some doubt at the upper aesthetic levels."[528]

ARTISTS' BOOKS PERSONALIZE THE POLITICAL

RAPE IS

when you attempt to prosecute the rapist and find yourself on trial instead. RAPE IS
when your boyfriend hears your best friend was raped and he asks, "What was she wearing?"[529]

—SUZANNE LACY, 1972

...what came out of that Woman's Building was pretty dynamic. It wasn't so gender oriented in the sense of fanatics—you got women who were trying to voice some of the problems of being a woman, and finally unleashing it because they got permission. The book was a real facile way of doing it, and they learned how to print. There resulted...an amazing array of diversity, books about incest, books about race, all of the above, and pretty remarkable. The book was really a catalyst for understanding the feminist movement.[530]

—JUDITH HOFFBERG

Usually inexpensive in price, modest in format, and ambitious in scope, the artist's book is also a fragile vehicle for a weighty load of hopes and ideals: it is considered by many the easiest way out of the art world and into the heart of a broader audience.[531]

—LUCY LIPPARD, 1973

Rape Is, by Suzanne Lacy, conveys the searing anger and edgy wit of truths long denied. Women poured their stories into books printed with mimeograph, copier, letterpress, and offset, fired by feminism and inspired by the book's twin strengths of intimacy and outreach. The message dominated the medium, and passion and rage coexisted with humor and irony. *Rape Is* (1972, 1976, fig. 92) bluntly declares truths about rape as attack, coercion, or harassment at a time when the subject was taboo. Access to the book itself demands violation. The reader must rip open a red sticker that seals the book, an enactment reflective of Lacy's involvement in performance art. Inside, the "menstruation red"[532] endsheets, and the book's gatefolded pages fold back "like those of the vagina," as Debra Dunn put it in 1977.[533] Its pages carry two-step statements that tick off like a timebomb,

529. Suzanne Lacy, *Rape Is.*

530. Hoffberg interview, Santa Monica, November 6, 1995.

531. Lucy Lippard, "Postface," in *Six Years,* 45.

532. Review of *Rape Is, The Dumb Ox* (1977): 54.

533. Ibid.

FIG. 92. Suzanne Lacy.
Rape Is.
5³/4 x 5³/4

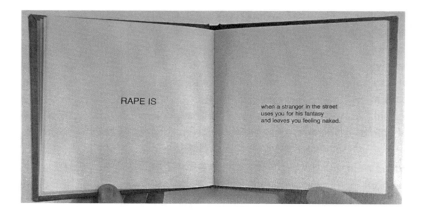

interrupted by the gutter of the book: "Rape is / when you are sitting on your grandpa's knee and he slips his hand into your panties."

Rape Is caught the tenor of a time when artists sought activist avenues. From the 1960s on, every facet of American life, every institution and norm was questioned or attacked. The Vietnam War crested in public consciousness with the 1970 invasion of Cambodia, and riots erupted across the United States. The art community responded with a sit-in at the Metropolitan Museum of Art staged by 500 artists. Artists organized protests through groups such as the Art Workers' Coalition, Artists and Writers Protest Against the War, and WAR (Women Artists in Revolution, an offshoot of the Art Workers' Coalition).

When the personal became political, access to printing facilities allowed the production of art, free from the interference of museums and commercial galleries. (At the same time, a gallery owner, critic, or curator might respond favorably to such books if they arrived by mail, a ploy used by Ida Applebroog and others.) The idea was that by publishing books, artists could both make art and retain their independence from the establishment. Such an agenda was welcomed by the women's movement, where books offered a personal way to tell truths.

In 1970, Judy Chicago organized the first feminist art class at California State University at Fresno, and in 1971 Miriam Schapiro and Chicago inaugurated The Feminist Art Program at California Institute of the Arts in Valencia, where Suzanne Lacy produced *Rape Is* in 1972. The imposing scale and machined materials of Minimalism were giving way to a confluence of artistic endeavors, some of which appealed to women artists. Women were drawn to Fluxus art, which offered real objects re-presented; the crafts drew converts; and the figure reappeared, drawn or as a participant in Performance and Body Art. Conceptualist formats and strategies also attracted women

artists who preferred (or needed) to create with inexpensive materials in intimate, ephemeral formats. Artists need not have read Mallarmé to appreciate the feminine attributes of a book; the critic discussing *Rape Is*, above, immediately recognized the significance of the gate-fold openings and red endsheets. Books were the perfect partners for a women's movement premised on cooperation and connection.

The Women's Graphic Center was an essential resource for women bookmakers in Southern California. It was located in the Woman's Building, a center for art and culture that opened in 1973 in Los Angeles.[534] Susan King first heard of plans for the Woman's Building from Judy Chicago, whom King and other graduate students had invited to speak at their New Mexico campus. King moved from Kentucky to New Mexico to study ceramics in the graduate program; today she can't help but wryly note how printed matter provided the spark for her move to Los Angeles and her eventual involvement with bookmaking:

> ...when I think about it, we came because of propaganda. Sheila [de Bretteville] had made this extraordinary poster that said all the right things and was so touching [laughs], you just wanted to lay on your little orange and yellow bedspread and weep. [It's appeal to me was that] it was all through printing. [In] the politics of the 1960s, people were organizing, [such as] Clifford Burke—so there was that whole stew of people moving on to [experiment with portable art formats] like artists' books....[535]

At the Woman's Building in 1973, King helped to set up a kiln, but soon was drawn in other directions.

In 1975 King made her first book at the Graphic Center, which she viewed later as a step in a natural evolution from the workshops she took in language and writing: "That was the great thing...about the climate [at that time. You believed] you could do everything. You would write something, and then you would design a book, and then you would print it, and then you would distribute it, and there was no separation."[536] King was moved by the convictions of Woman's Building co-founder Sheila De Bretteville, who articulated a humanist design model directed toward social and political change as a paradigm for a cooperative learning environment. Such a model put into practice the feminist ideal of equal voice. This design model organized the surface of a printed piece along a grid, and so it "had to do with making everything equal, giving everyone equal space, giving everyone equal voice on the page."[537]

534. Co-founder Sheila de Bretteville brought in Helen Alm from Cal Arts to run the Graphic Center in the second year of the Woman's Building, and the extension program offered a book class open to the public but also separate from the regular curriculum. In Spring of 1974 de Bretteville and Alm received funding from the California Arts Commission and the NEA to expand the facility, and acquired equipment including an offset press, more letterpress type, a process camera, and a vacuum table. Helen (Alm) Roth, "Women's Graphic Center," *The Dumb Ox* (1977): 38. After a number of transformations, the Woman's Building closed in 1991.

535. Author interview with King, Los Angeles, November 8, 1995.

536. Ibid.

537. Ibid.

King immersed herself in bookmaking, establishing her own Paradise Press imprint in 1976, and running the Graphic Center itself from 1975 to 1984.[538] King's *Passport* (1976) mimics the official document as if to permit the reader passage into the episodes of King's own life glimpsed in the photographs within. *Trunk Pieces* (1978), by Jacki Apple, appropriates another recognizable format. It adopts the look of a sepia-toned family album full of photos, passport, and postcards to tell a story about unrequited love and betrayal, familiar themes made real by objects that recall actions, dreams, and disappointments.

A year after *Passport,* King produced *Pacific Legend* (1977, fig. 93). The title suggests several meanings. "Pacific" recalls King's night swims in the ocean near her studio in Venice, California (described within), the nighttime ocean evoked by the purplish-blue ink of the diazo prints that make up the pages. "Legend" carries an antique flavor of wild west connotations for this transplanted Kentuckian. The book begins with a cautionary note: "Blue printed in an edition of 300 copies. Blue print has a limited life and should be kept from light to prevent rapid fading." The effect of the warning—intended or not—transforms a reader's expectation of a pleasurable intimacy into a furtive, secretive hoarding. Each touch and turning of the velvety pages brings a savoring of the saturated color in the knowledge of its inevitable diminishment. King's story of her search for a self-acceptance independent from art world celebrity is reflective and subdued, as if muted by the literal aging of the book, its evanescence inevitable in the Southern California sunlight. In a reversal like that which the blueprint represents, King tells of her return to her Southern literary roots to craft a writer's voice that, "breeds strange characters out of traditional codes of honor." The stories in *Pacific Legend* are sharpened by an exile's objectivity, one that questions paradise in the midst of yearning for it.

As a printer, King cites early influences from the unlikely duo of Ed Ruscha and Jane Grabhorn. The books of Grabhorn and Ruscha could not be more dissimilar on the surface, although at that early time every artist's book "was...presented as artists making books, and it didn't matter that one might have been made in 1937 and another in 1963.[539] In addition, King cares little for separating books by fine press or offset media. The point is the message, and from a closer look, Grabhorn and Ruscha both seek to puncture inflated beliefs: printerly, artistic, or cultural. Ruscha deadpans his reportage of the celluloid mythos of California, with the book as a neutral reflector. Some of the books that Grabhorn made under the Jumbo Press imprint are about printing at a time when most women didn't print, and these books reveal her delight in using the press for whimsy when

538. In 1974, on the opposite coast, four women founded the Women's Studio Workshop (WSW) in Rosendale, New York, and in 1979 artists' books became one of their publishing focuses.

539. King interview in Courtney, *Speaking of Book Art,* 120.

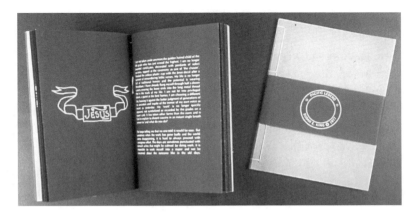

FIG. 93. [CP22] Susan King.
Pacific Legend.
8 x 6

genuflection was the expected response. Both artists share a fascination with legends, but not to pay homage to—rather to cross-examine, perhaps waggishly.

Most books coming out of the women's movement faced even greater challenges in reception than other artists' books. Conceptual books had thus far attracted the most sustained art world attention, and many (but not all) of those books were made by men. Women's books had to battle the familiar art world prejudice against books, as well as overcome disinterest in an aesthetic often at odds with the more familiar Pop or idea-based art.

It took Lucy Lippard to consider the contributions of those artists' books as revelatory of women's experience. Writings by Lippard equaled, and perhaps exceeded, those by Clive Phillpot in situating the artist's book within a larger art milieu. Her writings began with Conceptualism and expanded to include (among other concerns) books that addressed women's issues. Perhaps her influence, although appreciated in the artist's book world, is not as widely recognized as Phillpot's because Phillpot focused his writings almost exclusively upon the multiple bookwork. In contrast, Lippard has written on nearly every facet of art-making since the 1960s. Given her breadth of art world interests, her contributions to the artist's book are remarkable.[540]

In 1977, Lippard wrote "Surprises: An Anthological Introduction to Some Women Artists' Books" for the feminist journal *Chrysalis.* In it, she argued for an aesthetic conducive to women bookmakers: "The book as a field onto which the viewer projects her own meanings is a potentially effective medium for a new kind of communication. It offers a sensibility particularly suited to a visual approach and a collage esthetic, a fragmentation focusing on relationships between parts rather than on their stylistic peculiarities. Much more than male bookmakers, women artists understand this and avoid pontification

540. Considering Lippard and Phillpot together, their writings complement one another in reaching most of the major English-language art journals of the period. In the 1970s, Phillpot published the "Feedback" review column in *Studio International,* as well as various writings directed to art librarians. His influence greatly expanded in the 1980s. Lippard wrote extensively from the early 1970s. Her writings that dealt with book art can be found in the Bibliography.

541. Lippard, "Surprises: An Anthological Introduction," 73–74.

542. See the exhibition catalogue, *Women's Autobiographical Artists' Books* (Milwaukee: University of Wisconsin, Art Museum Fine Arts Galleries and the Conference Center of the Golda Meir Library, 1987.). See also *Women and the Artist's Book: The Hidden Dowry* (New York University, 1995), a dissertation thesis by Barbara Haum.

and aggressive pointlessness."[541] Throughout her essay, Lippard quoted from the books themselves and interspersed her own observations along with reproductions from the books. Here as early as 1977 we encounter books by Susan King as well as Frances Butler, Suzanne Lacy, Joan Lyons, Martha Rosler, and Michelle Stuart, among many others. Lippard grounded her commentary in a sense of shared investment in the work rather than a distanced, formalist critique, and so provided a critical model that matched the artist's book's special appeal as an intimate yet populist format.

The number and impact of multiple bookworks by women in the 1970s is unmistakably a creative force of considerable momentum. Many early feminist books appeared to have been produced quickly, their makers seemingly more concerned with giving voice than with printing niceties, their content previously dismissed as irrelevant or "not really about art," their lifespan perhaps expected to be ephemeral. These books validated women as artmakers, and in return the women's movement welcomed books as safe territory in which the personal and political could be fused and focused.[542]

SHOW AND TELL: EXHIBITION AND RECEPTION

The real or fancied uselessness of books is one reason artists are now attracted to them. There is a nostalgia for books. For the generations brought up on and brought up by television, books are strange artifacts.[543]
 —JOHN PERREAULT, 1973

More important is that the grossly inflated status of the book as the important new art form of the 60's has been deflated to its proper place as but one of many notational forms available to visual art—alongside film, video and photography. The hysteria surrounding the promotion of "book as artwork" has thankfully subsided.[544]
 —JAMES COLLINS, 1973

Suppose art was as accessible to everyone as comic books? as cheap and as available? What social and economic conditions would this state of things presuppose?....The social responsibility of artists would increase proportionally with that percentage of the population her or his work affected. Some artists would meet this challenge by becoming more conscious of, and exerting more control over, the social implications of their work. Others would get scared and retreat to the old "Don't-ask-me-I-just-made-the-stuff-God-works-through-me" routine. Still others would run for President.[545]
 —ADRIAN PIPER, 1976

The accomplishments of the Women's Graphic Center should not suggest, however, that women bookmakers inhabited some separate, protected realm of production, exhibition, and reception. Far from it. Women showed their multiple bookworks alongside those of male

artists. Three major exhibitions in 1973, 1978, and 1980 chart the trajectory of the artist's book as well as the struggle by book artists with the persistent issues of definition, display, and critical reception. These key exhibitions occurred amidst many other showings of varying sizes and sophistication. In fact, for all of the grumbling among artists about a lack of sustained critical interest, in the 1970s the artist's book excited the passions of writers, both pro and con.

Artists Books was the first exhibition in America to name the book as an ally of art.[546] Over 200 books showed in Spring 1973 at Moore College of Art in Philadelphia, and then traveled to the Pratt Graphics Center in New York, finishing at the University of California–Berkeley Art Museum in early 1974. The catalogue was modest: small and saddle-stitched, with typewritten text and a few duotones. Gallery director Dianne Perry Vanderlip crucially applied the term of artist's book to reference a wide range of work: "If the artist conceived his work as a book, I have generally accepted his position."[547] *Artists Books* is seldom discussed as a selection of work from across the book art spectrum, but assumed to showcase multiple bookworks, despite Vanderlip's assertion. *Artists Books* also included deluxe books (by Kathan Brown and Antonio Tapies); collaborative artist publications (*Artists and Photographs; Aspen Magazine*); sculptural bookworks (*Book* by Lucas Samaras, and a carved wooden book by Lester Van Winkle); and even an installation by Maureen and Kerrigan Sullivan (*Ahboobanadam's Dreambook*), noted by reviewer Diane Kelder at the Pratt Graphics showing (but not listed in the catalogue).

At *Artists Books*, Fluxus and Conceptual books showed alongside key works such as *New York—West Side Skyline*, by Eugene Feldman, and *Electronic Variations*, by Melissa Gurdus. Vanderlip was strikingly astute in her selections, although arguments could be made today regarding missing emphases. Some artists merited several books, such as Ed Ruscha (fourteen) and Dieter Roth (sixteen). Few books carried overt political content; the artists' books in this show seemed happily resident within an art world whose challenges remained on formal grounds. Vanderlip installed the work in a user-friendly design that drew praise from reviewer Diane Kelder: "Whether standing, hanging or resting traditionally on flat surfaces, the books invited a direct personal contact which makes the viewer feel that as works of art they are uniquely accessible."[548]

The two catalogue essays complemented one another. In "Slices of Silence, Parcels of Time: The Book as a Portable Sculpture," Lynn Lester Hershman (then teaching at California College of Arts and Crafts) briefly sketched in a bookwork lineage. Hershman acknowledged that the ascent of the artist's book appeared ironic given

543. John Perreault, "Some Thoughts on Books as Art," in *Artists Books* (1973), 17.

544. James Collins, "...'Artists' Books,' Pratt Graphics Center," review of *Artists Books*, *Artforum* 12, no. 4. (December 1973): 86.

545. Adrian Piper, statement, *Art-Rite*, no. 14 (Winter 1976/1977): 8.

546. Mysteriously, the organizers of the exhibition deleted the possessive apostrophe in "artists'," and so set a confusing precedent. As recently as 1998, Stefan Klima notes in his *Artists Books: A Critical Survey of the Literature* (New York City: Granary Books, 1998) that, since "The *Artists Books* exhibition [of 1973], and two accompanying reviews, mark a beginning. It is for this reason I adopt the spelling *artists books*, without an apostrophe, unless quoting other sources." 8

547. Dianne Perry Vanderlip, "Foreword," in *Artists Books* (1973), 5.

548. Kelder, "Prints: Artists' Books," 113.

McLuhan's dismissal of books as outmoded, but argued that these books were far from tombs. These "book-like objects" acted like sculpture released from the pedestal, and so required an equally open-ended definition: "Broadly defined, a book is an instrument of communication that uses symbols to convey meaning and circulates to an audience. By extending the limits of definitions, one can include material not usually thought of as books."[549]

"Some Thoughts on Books as Art," by New Yorker John Perreault, suggested that the increasing interest of artists in books stemmed from the book's cultural diminishment. Clive Phillpot praised Perreault's essay in his review of the exhibition in 1973, calling it the "best attempt yet" to define the form, and quoting Perreault's wordplay: "Books as art are not books about art or books of reproductions of art or books of visual material illustrating literary texts, but are books that make art statements in their own right, within the context of art rather than of literature."[550] Perreault stressed the importance of the seriality of the book form and the page as a unit of the whole, along with a reading experience where "art information [accrues that] is additive [and] progressive, rather than discrete."[551] Taken together, the essays of Hershman and Perrault achieved a mature assessment of the artist book's experiential and artistic strengths at the onset of its U.S. rise.

Artists Books generated distinct critical responses that either heralded the art world entry of artists' books or undermined the populist claims of book artists. Most reviews focused on the multiple bookworks on show, largely ignoring the deluxe and sculptural works that joined them. A brief review by James Collins illuminated the challenges that the book format posed to critics. It appeared in *Artforum* in December 1973 and included the patronizing dismissal that begins this section. Collins's hostility was all the more curious because it came at the art world debut of the multiple bookwork, which hadn't yet had the chance to develop a "grossly inflated status."

Collins wanted to refute the populist rhetoric surrounding the artist's book, since "Artists' books as artwork have never been viable —except on a very small scale—outside the art system."[552] He indicted the "insider status" of the artist's book as an emerging art form, because it was collected by other artists:

I notice that a lot of these...books...have been lent by the same few people—incidentally not from their libraries but from their *collections*. Books often made as alternative to precious objects are quickly turned into them—to be collected rather than used. Paradoxically, as challenges to the

549. Lynn Lester Hershman, "Slices of Silence, Parcels of Time: The Book as a Portable Sculpture," in *Artists Books* (1973), 12.

550. Clive Phillpot, "Feedback," *Studio International* 186, no. 957 (July–August 1973): 38.

551. Perreault, "Some Thoughts on Book as Art," in *Artists Books* (1973), 17.

552. Collins, "...'Artists' Books,' Pratt Graphics Center," 86.

normal distribution system of art these books only get heard about by being taken back into it, i.e., by shows like 'Artists' Books.' Many of these books here only exist through the passionate collecting of a few on the mailing list of a few.[553]

Collins struggled with the idea of the overlap of art with book. He reacted to the semantics of listing works lent to the show as from "collections" rather than "libraries." He did not recognize that art collecting could be an affordable pursuit and that an artwork could be a utilitarian object. In fact, as demonstrated by the comments of Peter Frank, quoted above, the multiple bookwork succeeded in embodying an affordable, manipulable, collectible art.

Collins did locate an Achilles heel of many artist's book exhibitions. He deplored the "bewildering diversity" of the books on display, from which "contradictory and often hostile positions about the nature of art and books result."[554] Given the range of work, Collins may have been justified; we do not know if the show's didactic labels helped to contextualize the works on show. Collins also pointed out a paradox familiar to every marginal art movement: that artists must exhibit within the art world in order to gain the notice of the public.

Five years later, an entirely different exhibition opened in Spring 1978 at the Los Angeles Institute of Contemporary Art (LAICA), then traveled to Artists' Space in New York City in the summer, to Herron School of Art in Indianapolis in September, to New Orleans Contemporary Art Center in late Fall 1978, and then to Australia and New Zealand. *Artwords and Bookworks* filled the galleries at LAICA with over 1,500 works by 600 artists. The exhibition included artists' books along with artists' periodicals, and ephemera such as mail art, posters, and decals. Here was realized the book art explosion of the 1970s—one reviewer called it "a librarian's nightmare and a booklover's dream."[555] The unillustrated catalogue brimmed with typewritten essays, a bibliography, and lists of catalogues from suppliers and exhibitors.

The exhibition welcomed international participation and showcased Fluxus and Conceptual works, although few overlaps existed with *Artists Books*. The exhibition's size differentiated it from *Artists Books* five years earlier, but more telling was its criteria that declared it as an open show for "inexpensive multiples." With these words, co-curators Joan Hugo and Judith Hoffberg inaugurated the largest showing of artists' books to date in America. The catalogue essay by Hugo placed the works in a historical context of early book history, from movable type's invention to avant-garde experiments, all gener-

553. His emphasis. Ibid.

554. Ibid.

555. Susan C. Larson, "A Booklover's Dream," *ARTnews* 77, no. 5 (May 1978): 144.

ated from "the belief that ideas have a life of their own, independent of their value as commodities."[556] Hoffberg's essay responded to distribution issues by rechristening the postal service as "the art information network...which allows a direct access into verbal and visual thinking of artists today."[557] Hoffberg also noted the many books by women that were on show, and in comparison to *Artists Books* that number was truly impressive. *Rape Is,* by Suzanne Lacy, and *Passport,* by Susan King, joined books by others, including Ida Applebroog, Mary Beth Edelson, Mary Fish, Cheri Gaulke, Martha Rosler, Carolee Schneeman, and Athena Tacha.

The mailbox may have been the museum and the book a time traveler, but nothing could match the kind of synergy unleashed by visiting the exhibition. U.S. artists could see first-hand important work by European artists such as Simon Cutts, Ronald King, Warja Lavater, and Telfer Stokes; and they could compare printing effects that ranged from letterpress to copier to offset, although offset predominated. Networking occurred around the exhibition, and later that year Judith Hoffberg formalized that network into her international review publication *Umbrella,* still published today.

Artwords and Bookworks innovated with an installation design that went well beyond the reader access invited by *Artists Books.* More living room than white cube, viewers were encouraged to "stand, sit, stretch, lie down on pillows and interact with an indoor landscape of artists' books, mail-art, postcards, book-objects, cinematographic flip-books and other paged and printed items which strain the limits of believable 'bookness.'"[558] This reviewer also noted a trade-off, in that the hands-on installation discouraged the display of fine press and deluxe books. And Hoffberg recalls another review that criticized the huge number and variety of works as confusing.[559] From today's perspective that critique may have merit, because certainly it would have been impossible to discern a recognizable theme amidst the tidal wave of work. Perhaps it can be argued that a more discerning selection could have strengthened the artist's book's lobbying for art world acceptance. But such a non-curated, open-call exhibition was part of a stance that was true to the time and to the populist book itself. Its format demanded an equally open and unconventional approach to critical reception, one that was unfortunately largely unavailable then (and today, for the most part).

If *Artists Books* represents the recognition and naming of the U.S. artist's book, and the exuberant *Artwords and Bookworks* its adolescent flowering, then perhaps *VIGILANCE: Artists' Books Exploring Strategies for Social Concern* can be viewed as the artist's book's activist

556. Hugo, "Museum Without Walls," in *Artwords and Bookworks* (1978): n.p.

557. Hoffberg, "The Museum is the Mailbox," in *Artwords and Bookworks,* n.p.

558. Susan C. Larson, "A Booklover's Dream," *ARTnews* 77, no. 5 (May 1978): 144.

559. Interview with the author, Santa Monica, November 6, 1995. Additional background from Hoffberg, "Distribution and its Discontents," *Reflex* (May/June 1990): 10–12.

young adulthood. Lucy Lippard and Mike Glier curated the exhibition in 1980, placing the art in several sites that led from a display at Printed Matter, to posters and installations in the blocks between it and Franklin Furnace, to an installation within Franklin Furnace itself. Inside Franklin Furnace, four tables each held four stacks of books, the books tethered to the tables by cords. Nearby, four glass cases displayed military paraphernalia, and overhead a tiny camera hung, watching, a machined equivalent of society's overseers.

The catalogue resembled a political flyer, with a brief essay by Glier that declared: "The artist's book [is] a successful democratic form looking for compatible subject matter."[560] Perhaps Glier and Lippard hoped to argue for the political relevance of the book form in opposition to the recent art world shift toward star artists and the big money paid for art. Or perhaps they meant to emphasize the book's strengths with the intimacies of direct address as an antidote to the atmosphere of Big Brother, symbolized by the camera suspended overhead. Now more than ever was the time to proclaim the past successes of the artist's book, along with its potential for social and political engagement. *VIGILANCE* also cast a broader net, beyond aesthetic turf, to consider "artist's books as vehicles for aesthetic / social investigation. These investigations have two directions, inward to the self and outward to the other. Awareness deepens on the development of both."[561]

Both *Artforum* and *Art in America* reviewed the show, perhaps prompted by the art world profiles of Lippard and Glier and the ambitious premise of the exhibition. The longer review in *Artforum* by Tony Whitfield included a comment on the installation. He noted that the exhibition demanded a high degree of commitment on the part of the viewer; that is, one had to sit down and read through the books to fully experience the show. Those books were often all or mostly text, and herein lay the challenge, since, "either fragmentary or long-winded, narrative or expository, technical or prosaic, or any combination thereof—the degree of clarity with which language is used becomes vital to [each book's] success."[562]

To its credit, the Lippard-Glier installation gave all the books equal status. Unconfined by a display case or by a curator's mediation through descriptive labels and selected page openings, the books interrelated as they were meant to in a non-art world, as if piled on a desk or arrayed along a bookstore shelf. Equitable, yes, but the presentation also highlighted the communicative weaknesses of many of the books. Experiencing the exhibition was not so much determined by the interaction of image, text, and form as by the "require[ment of] the development of a researcher's methodology,"[563] an imperative

560. Mike Glier, *VIGILANCE: Artists' Books Exploring Strategies for Social Concern* (New York: Franklin Furnace, 1978): 1.

561. Ibid. A few book titles from *VIGILANCE* reflect the curators' interest in assembling a show whose books dealt with social custom and politics: from *Post-Partum Document,* by Mary Kelly, to *Essential Documents: The F.B.I. File on Jean Seberg Part I,* by Margia Kramer. Some books represented collective presses, such as *Attica Book,* Benny Andrews and Rudolf Baranik, eds., issued by the Black Emergency Cultural Coalition, Artists and Writers Protest Against the War in Vietnam.

562. Tony Whitfield, "'Vigilance: An Exhibition of Artists' Books Exploring Strategies for Social Change,' Franklin Furnace," *Artforum* 19 (September 1980): 69. Note that Whitfield mistitles the exhibition; rather than "Social Change" it should have read "Social Concern."

further underlined by the spare setting of tables and books: in this gallery there was work to be done by the visitor. Didacticism doesn't tend to win converts, and Whitfield chafed against the constraints implicit in such a curatorial program: "Never, not even in the works that clearly record the presence of an artist's hand, are we allowed to feel justified in judging the works in 'Vigilance' on purely formalist terms."[564] Such challenges are familiar to activist artists who hope to engage as well as educate the public. Although the friendly persona of a book can excel at delivering difficult content, *VIGILANCE* also demonstrated the opposite: that polemics do not exempt the book from formal concerns, and that stultifying content will cripple the appeal of any artwork.

Artists Books, Artwords and Bookworks, and *VIGILANCE* produced modest catalogues but still exerted considerable influence within the book art world. Their catalogue essays argued for the book as a form uniquely suited to an intimate art experience, to populist proselytizing, and to international networking. What more could an artist want? Attention, for one thing. Given the proliferation of books and the dedication of curators, why didn't artists' books more readily achieve artistic recognition? These three shows offer a clue.

Artists' books resist the limits of gallery installation (except for sculptural bookworks, discussed below), yet books shown *en masse* with hands-on access drained the energy and focus of even the most devoted viewer. So how to show them? These exhibitions varied in approach, from interpretive installation to informal hands-on access. No one has yet devised a means for engaging the artist's book in a manner that satisfies both a viewer's limitations of time and an understanding of the book as an art form (and thus a need for didactic guidance), as set against the measured, hands-on perusal that provides the best possible book experience. Unlike other art forms, the artist's book does not easily inhabit any public setting: gallery, bookstore, or library. If its distribution is a challenge, its reception—the final arbiter of the art world—remains confounded by the book's inherent complexities.

Despite its vexations, the "weaknesses" of the artist's book in exhibition may perhaps be reconsidered as challenges posed to the art world. There is no single solution to this dilemma, but the best alternatives that have appeared since the 1970s have integrated a variety of options that are based on a book's paginated structure (we will return to this point in the conclusion). These display strategies incrementally reveal a book's story, and so respond to the essential traits of an artifact whose expressive rewards are commensurate with a reader's commitment.

563. Ibid.

564. Ibid.

THE SCULPTURAL BOOKWORK

Here is the book as sculpture, the book as bed, the book for burning, the book transformed, burnt, chained.[565]

—DAVID SHAPIRO, 1977

I'll tell you how I started all this. I was on a train going to Philadelphia reading the biography of Nixon, and I started scratching it out as I read it, and by the time I got to Philadelphia I had scratched the whole book out. Then I started nailing books shut and tying them up, and all these objects came from scratching out Nixon because before I started doing these things I used to print very fine editions of books—and then I started taping. Everything is done so they cannot open. They're tarred and feathered; they're bolted; they're wrapped in bundles.[566]

—BARTON BENES, 1977

The number of multiple bookworks produced in the 1970s seemed so great as to crowd out other kinds of artists' books, but one had only to view an exhibition at Center for Book Arts in New York, or at the Fendrick Gallery in Washington, D.C., to gain a more accurate picture of book art that included sculptural bookworks. In the 1970s U.S. artists began to work with the book as sculpture, as a vehicle for metaphor or symbol, a work meant to be looked at but not paged through. These artists worked exclusively with sculptural interpretations of the book form to produce playful and provocative works.

The decade began with an exhibition of related work that offered a European heritage to the U.S. sculptural bookwork. *Multiples of the first Decade,* curated by John L. Tancock at the Philadelphia Museum of Art in 1971, included precursors to the multiple, such as works by Victor Vasarely, Bruno Munari, Daniel Spoerri, and Diter Rot (aka Dieter Roth). The relevance of *Multiples* for the development of the sculptural bookwork lay with works such as *Book,* by Lucas Samaras, and *Shades,* by Robert Rauschenberg, as well as related works such as *Boîte-en-valise,* by Marcel Duchamp.

At the Documenta 6 exhibition, in Kassel (1977), books enjoyed an unprecedented emphasis in a "Books" section further divided into "The Metamorphosis of Books" (fifty-three artists) and "Concept-Books" (twelve artists).[567] Even so, one reviewer complained of a dearth of books of "sequential content" in favor of "the Surrealist-derived line of book-as-evocative-artifact [which included those books that had been] skewered, burned, plastered, torn, [or] made in floppy fabric."[568] As if in response, an *Artforum* review by David Shapiro, quoted at the start of this chapter, argued that the artist's book section was the single "rigorously selected exhibition" at Documenta,

565. David Shapiro, review of Documenta 6, "A View of Kassel," *Artforum* 16, no. 1 (September 1977): 62.

566. Barton Benes, artist statement, in *The Object as Poet* (Washington, D.C., The Smithsonian Institute, 1977), 26.

567. Depending on your definition of an artist's book, this was not the first time that Documenta showed sculptural bookworks, contrary to Stefan Klima's claim in *Artists Books: A Critical Survey.* For example, Kassel's Documenta 4 (1968) included early works by Diter Rot (aka Dieter Roth), as well as *Shades,* by Robert Rauschenberg (1964). The 1968 Documenta also included works related to the sculptural bookwork, in the boxes by Joseph Cornell and Lucas Samaras.

568. Elizabeth C. Baker, "Report from Kassel: Documenta VI," *Art in America* 65, no. 5 (September–October 1977): 45.

whose "choice [was] honed to a savagely charming narrow line," and where "the ghost of Mallarmé indeed broods." [569]

In an amusing reversal, despite the mix of book types on show, the Documenta exhibition became associated with only sculptural bookworks, perhaps because of the unprecedented (at least for U.S. artists) international exposure that those works received. For example, the following year in the United States, Carl Loeffler argued for greater involvement by book artists in marketing in order to distribute their books "through the system." He added that the book artists who did not share those marketing concerns were, as he described them, artists of "the book-as-object orientation classically held by Documenta 6." [570]

Sympathetic American artists welcomed Documenta's show as a timely recognition of an expanding area in book art. But some knowledgeable Americans may have been surprised that the curators dated early sculptural bookworks only to 1972. Critic Werner Spies took the curators to task for such ahistoricism, stating that the lineage of "the book as object....is really too interesting and subtle to have been ignored in an exhibition as pretentious as this one is." [571] His review, written for a Frankfurt newspaper and later translated and published in 1982 in his *Focus on Art,* noted a number of early European sculptural works and exhibitions that would have provided Documenta with a more complete historical context. [572]

The decision by an artist to create a unique sculptural bookwork in the 1970s carried with it profound implications within the book art world. The choice to make a sculptural bookwork removed a work to exhibition only, even though, paradoxically, that removal did not affect its potential for widespread recognition from photographic reproduction. In addition, viewers tended to take umbrage at the sculptural bookwork's change in status from manipulable object to display only. Critical response ranged from surprised delight to infuriated revulsion (recall Clive Phillpot). Artists who made sculptural bookworks sought to stimulate both the emotions and the intellect, and realized that a viewer's initial response was tinged with the poignancy that accompanies any refusal. The sculptural bookwork represented a demise of a sort, whatever its visual enticements, in the movement of a book now stilled, its performative potential neutralized. For some viewers that negation only heightened an appreciation of the book as a tactile object. Sculptural bookworks reminded viewers of what we need and what we lose with and without books, as embodied in their playful or sinister manifestations.

569. Shapiro, "A View of Kassel," 62. As noted earlier, Peter Frank helped to select those U.S. artists in the show. But European artists naturally predominated, although such divisions proved negligible with works from international movements such as Fluxus and Conceptualism. The curators included a few influential "object-catalogues," such as Duchamp's infamous breasted *Surrealism* (1947), as well as sculptural bookworks by Dieter Roth and John Latham.

570. Loeffler, "Distribution: The New Heroics," 8–9.

571. Werner Spies, "Take and Devour: the Book as Object," *Focus on Art* (New York: Rizzoli, 1982), 238–39.

572. Spies cited exhibitions in Paris in 1969, Berlin in 1974, a collection in Alsace, and an International Book Fair in Nice. He also noted *Unhappy Readymade* by Duchamp (he called it "unlucky Readymade"), Surrealist works by Michel Butor, and even some unusual seventeenth-century books.

Barton Benes stands out more than any other artist for his early inveigling of the book-as-trickster, in assuming one-liner identities that amused or surprised in the spirit of Duchamp, whom Benes admired. Found books caught Benes's attention, like the punning *Travel Book* on wheels (1974). His works often appear disheveled, as if Benes cast frenetically about to execute his latest brainstorm. Their surfaces shift and glimmer from paint strokes or dribbles of wax and gesso, shoe polish, or watercolor. With such simple means, Benes created bookwork icons that were mimicked (consciously or not) by artists in the following years. His most memorable creations seem to wreak the greatest havoc on the book, in works such as the beleagured *Censored Book* (1977, fig. 94), and *Bound Book and Glasses* (1975, fig. 95), malevolent objects in the spirit of Lucas Samaras.

When Benes's bookworks appeared in catalogues or journals, they instigated a phenomenon peculiar to the sculptural bookwork. For all their refusal of paginated access, sculptural bookworks such as those created by Benes reveled in photographic representation, their auras only growing brighter with each reproduction. As such, the subsequent influence of Benes has broadened incrementally as his books have been exhibited or pictured in the few catalogues and articles that have attempted to survey the field. (For example, in "The State of the Book Arts," a special issue of *Craft International* from October–November–December 1984, a bound and nailed book by Benes is pictured above an article by dealer Kathryn Markel titled "Hey! Wanna Buy an Artist's Book?") Such was the secret of the longevity of the sculptural bookwork, when compared to the editioned book, whose photographic impact was undermined by the demands of conveying its sequential, cumulative impact.

And yet, ironically, Benes himself remains largely unrecognized, even as his bookworks are mimicked. His works are quirky yet memorable—most people can "get it" simply by looking at the work or at a picture of it. Part of the reason for his relative obscurity within the field was due to the fact that by the late 1970s he had turned from altering books to working in other art formats; as he explained to an interviewer: "I know a lot of people only think of me as doing the

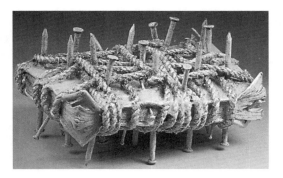

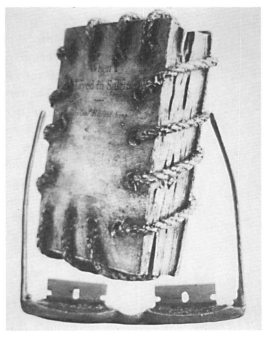

FIG. 94. (Top) [CP10] Barton Benes. *Censored Book.* 6 x 9¹/2 x 7

FIG. 95. Barton Benes. *Bound Book and Glasses.* Dimensions vary.

books...but I did 600 of them and I got tired. I found they were selling and it's such a temptation, you know, like bread and butter. You get into that cliché and then you hate it, and I find when something of mine really starts selling it's time to move on to something else...."[573]

Benes's work sparked some art world interest, but his influence might have been greater had his work appeared in the 1980s, at the time of the art world's rediscovery of painting and sculpture.[574] Work by Benes and others appeared during a transitional period in American sculpture, when Minimalist objecthood gave way to a Conceptual interest in sculpture as recorded action, to photographs of Land Art, and to the filing cabinets of Art and Language. Benes's artworks fit into a lineage that zigzagged from the witty readymades of Duchamp to the mining of the everyday and found materials by the Beats and Fluxus.

The recognition by Benes and others of the tactile and metaphorical riches of the book erupted en masse across the book art world. Such interests in material produced works such as those discussed above: the erotic *Softness on the Other Side of the Hole,* by Betsy Davids and Jim Petrillo; the paperwork sculptures and installations of Michelle Stuart and Carolyn Greenwald; and the interpretive bindings of Hedi Kyle and Gary Frost—even the feathered phantom of Richard Minsky. By the end of the 1970s, the understanding of the book's inherent sensuality had so permeated book art that the sculptural bookwork was only its latest manifestation.

Sculptural bookwork artists could still provoke astonishment with works that bristled from materials and excessive structural alterations. For example, *Book Seven* (1973–1974, fig. 96), by Marty Greenbaum, looks as if the book exploded into a roiling mass of pierced and painted pages, embedded with wax and rhoplex and sprouting feathers. From profusion to infusion: Stella Waitzkin drenched her found books in polyester resin. Waitzkin's resin encases her books in a haunting silence, in which waxy surfaces compel touch but withhold the book's contents. In *Metamorphoses I* (1974), a face mask gazes out from the pages' slurpy surface, the assemblage mounted on sandstone. The face looks with the viewer toward the back page on which a Wordsworth poem intones, "These hoards of truth you can unlock at will." For Waitzkin, truth resides in a reader's imaginings about a book, rather than in its text.

To critics, such works that deny a reader's touch appear to waste the sequential character of the codex book; to supporters, such visual glories hearken back to the book's medieval illuminated sanctity. Benes and Greenbaum may have begun their experiments in isolation, each responding to an ineffable but shared artistic impetus that

573. Jacqueline Brody interview with Barton Benes, "On and Off the Wall: Barton Lidice Benes," *The Print Collector's Newsletter* 9, no. 6 (January–February 1979): 186.

574. In a 1979 interview Benes notes one-person shows at the Center for Book Arts, Franklin Furnace, and Allan Stone, as well as group showings in and outside of New York City. His work had been bought by private collectors ("They're art collectors," he specified), as well as institutional collectors such as the Newberry Library in Chicago, and Princeton's Firestone Library. Ibid., 188.

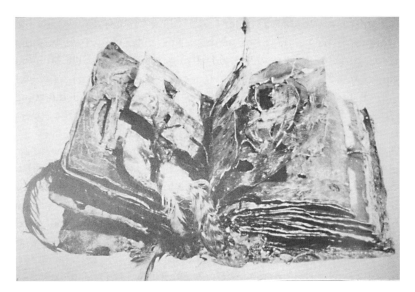

FIG. 96. Marty Greenbaum.
Book Seven.
9¹/2 x 12 x 6

arises every so often. But once brought together at the Fendrick and Markel galleries or at the Center for Book Arts, their work became part of the book art community. This was a busy and diverse community, one that already reflected the overlap and hybridism that would overtake book art in the 1980s. It would be in the 1980s, beyond the reach of this study, when sculptural bookworks would regularly appear in galleries, spotlit on pedestals or sprawling across gallery floors as installation bookworks.

The 1970s "was the greatest time to be alive," without a doubt, for Judith Hoffberg and others involved in book art who were building an international network linked by books. Organization, production, and reception connected that world in a spirit of activism and creative innovation. No wonder that Phillpot and others looked back on that time with nostalgia. If the artist's book didn't change the art world, for those readers who fell into its embrace it offered a form that forever altered their experience of reading and seeing.

But for all the work created and hours expended on its behalf, the artist's book did not attract the widespread recognition that its makers so desired. In the face of such earnest proselytizing and compelling books, why didn't the artist's book claim a permanent place in the art world by 1980? To the contrary, the artist's book did achieve art world recognition, but only of a capricious sort. Its reception was complicated by the complexity of the book form itself, as a performative medium that needed a reader's touch to engage in the "space-time sequence" (as Ulises Carrión wrote) that comprised each reading experience. The unfolding of this sequence could be endlessly

variable. For example, a reader could follow Michael Snow into and around a world built from pictures and contained, literally, from *Cover to Cover.* Or a reader could witness, page by page, the humiliations hinted at in the fierce utterances of Ida Applebroog's *Look at Me.* Or a reader could even confront a book that confounded reading altogether, such as Barton Benes's *Censored Book,* where the space-time sequence had been cruelly bound up and nailed shut.

In the 1970s, book art leapt into life in America. Terms were argued over. Organizations were started. Book structures were rediscovered or devised. And printing technologies were stretched to produce unrecognizable effects. Possibilities expanded in that period regarding who could make a book, how a book's contents could disport across a page, and how a book's materials and form could welcome or repulse a reader. The potential for expression seemed unlimited. Keith Smith started his lifelong investigation of the book form's every aspect, and Walter Hamady and Claire Van Vliet transformed fine printing into a studio practice that could produce a quirky monologue for a colophon or integrate a colorful expanse of paper-pulp painting to accompany a poem. A few deluxe book artists innovated with material to breathtaking effect, such as in the crystalline pages of Robert Rauschenberg's *Shades,* or applied subversive strategies, such as in the dare embodied in the perforated pages of *Interlude,* the edgy hybrid by Richard Tuttle.

Between 1960 and 1980 the artist's book gained stature, and showed its maturity in the variety of its materials and constructions, and in the content that it contained or released. This history has focused on the struggles and the satisfactions of beginnings, and on the work of creating and exerting influence. A few recognized this moment as a turning point in the artist's book's potential to embody a culture's hopes and fears. Consider again how Carrión described it in 1975, when he identified that awkward yet stimulating intersection between promise and growth that book artists occupied: "Time has passed and our situation is totally different. We are no longer innocent. Now it isn't enough to be an artist in order to produce bookworks. Now it isn't enough to produce books in order to affirm that they are bookworks."[575]

575. Carrión, "Bookworks Revisited," in *Second Thoughts,* 65.

THE NEXT CHAPTER

Since 1980, many of the earlier investigations into the content, form, and material of artists' books have matured into distinctive traits. That is not to say that artists' books today fall neatly into categories—nothing could be further from the truth. Rather, the field as a whole reflects the pluralism that overtook the 1980s art scene in America (indeed, I demonstrated that the development toward interdisciplinarity was well underway before 1980). The four types of artists' books are still identifiable today, and books will always appear that remain staunchly in one camp or another. On the whole, however, the characteristics of one kind of book or another are much less stratified. The trend toward interdisciplinarity has resulted in the creation of a toolbox of strategies, materials, and content shared by artists across the field. Every kind of book, from the fine press book and deluxe book to the multiple and sculptural bookwork, has been revitalized.

The makers of later artists' books have responded in a number of ways as these new tools became apparent. Some of the "next generation" of fine printers publish books of literature that incorporate the fine materials and generous size associated with the deluxe book. (Even though a small number of fine printers continue to create solely literary fine press books in a classic manner, the books of most fine printers have become more visually directed.) For example, at a 1999 book fair in Washington, D.C., printer Robin Price described herself as a maker of books that were "generally text-based." Her listeners chuckled, in acknowledgment that the fine press book has grown so diverse that such a distinction is necessary. Price, for example, published *Ravaged with Joy* in 1998 (fig. 97), which concerns a poetry reading by William Everson at the University of California–Davis in

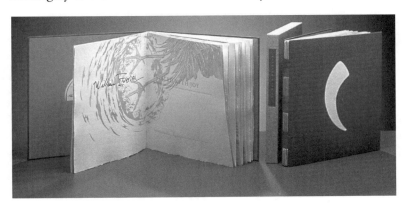

FIG. 97. [CP20] Robin Price.
Ravaged with Joy.
13 x 13

1975. Price includes with the book a CD of Everson's voice, and a pamphlet that contains the reminiscences of writers who witnessed the reading. The book is printed letterpress, its poetry accompanied by Keiji Shinohara's expansive woodcuts. With *Ravaged,* Price created a world in which every facet of the book's presentation responded to Everson as a writer, a reader, and an adventurer in the drama of his own life. In that sense her book participates in the lineage of William Everson's *Granite and Cypress.* Indeed, Price dedicated *Ravaged* to Everson, followed by a quote from Everson himself: "Writing, speaking, printing—a holistic effort to wrestle all the aspects of expression into an enduring coherence." Price brought an inspired coherence to *Ravaged,* one that encloses the reader in the realm of spoken poetry as well as in the pleasures of the sight and touch of a fine press book.

This history anchors a tradition for such fine press–deluxe hybrids, but that does not help Price as she describes her work for would-be collectors. When asked later why she emphasized the literary basis of her work, Price responded: "I rarely describe the work of the press in that way. It was in the context of the...fair [which showed work from across the book art spectrum] that I felt the need to distinguish the work in that way." Then she continued, partly in jest, "The shorthand version, depending on what hat I feel like wearing that day and who I'm talking to, is usually that I make fine press and artist's books. Oftentimes I say I'm a letterpress printer and leave it at that. Sometimes I say I make books by hand, then if I add the word 'publisher' people really perk up. It's funny to watch the power of that word ...[fine printer] Gerry [Lange] claimed that he used to say at parties that he was a brain surgeon. After that, 'no one asks you any questions.'"[576]

Other fine printers invest their books with a sculptural liveliness foreshadowed by books such as Claire Van Vliet's *Aura* and Walter Hamady's *Interminable Gabberjabbs.* Julie Chen's books, for example, fashion a journey through the use of pop-ups, movable parts, and other structural inventions. Her fine press book *Octopus* (1992) integrates letterpress printing and literary content with the sculptural character of a bookwork. *Octopus* holds a poem by Elizabeth McDevitt, which compares the complexity of emotional behavior to that of the octopus. Its shaped pages carry the lines of the poem as it steps back toward a dark center in a tunnel book format, and its colors reflect the shadowy hues of the ocean depths. Chen's books succeed because their materials and bindings work in concert with their literary content.

Deluxe books in the 1980s and 1990s explored three distinct directions. A later book by Leonard Baskin, *Capriccio* (1990, fig. 98), represents the first trend, which produced books of increasing size

576. Robin Price email to the author, January 25, 2000.

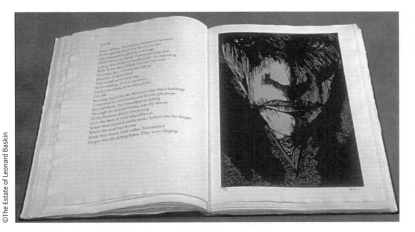

FIG. 98. [CP1] Leonard Baskin. *Capriccio.* 20¹/5 x 14¹/4

and splendor. Such books were sought out in growing numbers by the collectors that emerged from the booming economy of the 1980s. *Capriccio* is too large for lap reading (it measures 20¹/5" tall by 14¹/4" wide), and so demands a table surface. It holds twenty poems by Ted Hughes, printed in a commanding 30-point Spectrum type. Hughes's poems of suffering and reflection are visually balanced by Baskin's etchings, woodcuts, and wood engravings, printed in several colors on handmade papers from England, France, and Italy.

The second trend of the deluxe book continued an earlier interest in undermining the conventions of deluxe bookmaking. Henrik Drescher's *Too Much Bliss*, published in 1992 by Granary Books of New York, exemplifies this trend (fig. 99). *Too Much Bliss* is letterpress printed and bound in black linen cloth over boards, its cover perforated with holes that expose an odd array of drawn imagery on the pages underneath. Lifting the cover, the reader encounters not a sheet of paper but a page of latex, which is also riddled with holes. The latex sheets reappear throughout the book. Their heavy, slippery texture effectively halts a reader's smooth forward progress, while the images glimpsed through their perforations entreat the reader to delve deeper into the book to discover the ingredients of Drescher's "bliss." The pages brim with an odd distillation of found and drawn images and handwritten texts, in close proximity to (protected by?) the latex pages, whose associations incite in a reader more shudders than sighs of pleasure. *Too Much Bliss* challenges its readers in a trickster's spirit of invitation and refusal, as did its predecessors, Ed Ruscha's *Stains,* and Richard Tuttle's perforated *Interlude.*

The deluxe book of the 1980s and 1990s produced a third trend, that of the one-of-a-kind illuminated book. Timothy C. Ely has worked in multiple, but most of his work is done by hand, as seen in *The Open Hand Discovers* (1984, fig. 100). The leather binding incorporates black

FIG. 99. (Right) [CP19] Henrik Drescher.
Too Much Bliss.
12 x 9

FIG. 100. (Below) [CP17] Timothy C. Ely.
The Open Hand Discovers.
12³/₈ x 18⁵/₈ x ¹/₈

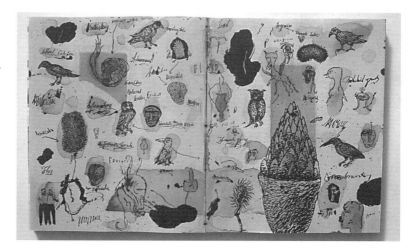

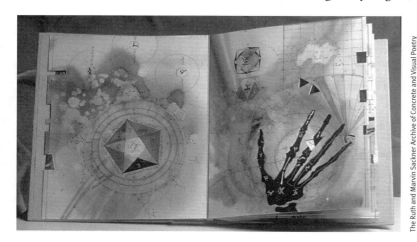

The Ruth and Marvin Sackner Archive of Concrete and Visual Poetry

hands that extend long, bony fingers; others of Ely's bindings glitter with gold and foil tooling, their surfaces encrusted with bones, sand, or other talismans. Inside *The Open Hand Discovers* reside Ely's meticulous drawings of ink, graphite, watercolor, gouache, and applied gold tea-chest paper. Hands reappear on several of the book's pages, fully fleshed or skeletal, floating before a shifting panoply of galaxies and landforms, along with Ely's personal hieroglyphic script. Ely concentrates his labors on the illumination of books with the same devotion that Tom Phillips applied to *A Humument* (1966–73), although Ely's story resides in fantastical sites which we then populate with our own imaginings.

Multiple bookworks emerged from corner copy shops or artist-run offset presses (and, eventually, from home laser printers) in the 1980s and 1990s. Two directions were discernible, and occasionally they converged. The first direction prizes activist content, as seen in Suzanne Lacy's *Rape Is* of 1972. Clarissa Sligh's *Reading Dick and Jane with Me* (fig. 101), published at Visual Studies Workshop in 1989, exemplifies this spirit. Sligh appropriated one of the standard American public school "Dick and Jane" readers, published from 1935 to 1965. She juxtaposes silhouettes of the figures of Dick and Jane to photographs of full-bodied African American children. Her texts

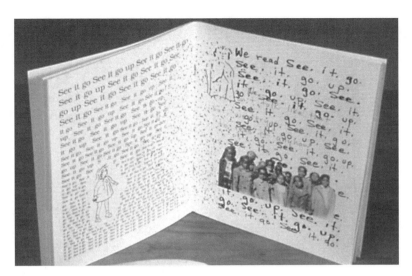

FIG. 101. Clarissa Sligh.
Reading Dick and Jane with Me.
8³/8 x 7

combine cut-and-pasted excerpts from the original primer with her own handwritten additions, to indict the primer's nostalgic portrayal of childhood in the 1950s.

A second direction taken by the later makers of multiple book-works reflects an interest in color and structural invention also seen in fine press books such as Julie Chen's *Octopus*. These multiple bookworks are usually printed at artist-run presses, where printers such as Brad Freeman, Clifton Meador, and Philip Zimmermann, es-tablished book artists in their own right, act as willing collaborators. Susan King's *Lessonsfrom the South* (fig. 102), printed at Nexus Press in 1986 (with Clifton Meador at the press), immediately found an audience. King's interest in memoir (as demonstrated in her *Pacific Legend,* 1977) is present here, not in a linear narrative progression, but rather through the accumulation of voices. These voices include King's reminiscences of growing up in the South, along with amusing notations of societal mores. Here she translates the "Language of the Fan" dating to ante-bellum society (one excerpt reads: "With handle to lips: Kiss me. / Open and shut: You are cruel."). King's texts rest within a book whose structure and materials convey an ethereal im-pression of light. Light filters through the translucent papers and the pierced concertina structure (designed by Hedi Kyle), the ink colors reflecting the softened palette of the light-drenched South.

The sculptural bookwork profited from the gallery culture of the 1980s, since it was the kind of artist's book most at home on a gallery pedestal. Buzz Spector and other artists such as Doug Beube, Basia Irland (fig. 103), and Sandra Jackman filled vitrines and galleries with sculptural and installation bookworks. Whether or not the sculptural bookwork sold in large numbers, the point for many involved with

FIG. 102. [CP24] Susan King. *Lessons from the South.* 10 3/4 x 7

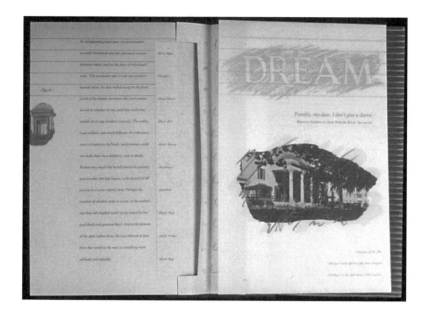

book art was that these works showed in galleries and so were perhaps the most visible kind of artist's book to gallery visitors. In the 1980s, the notice taken of sculptural bookworks by the larger art world was also due in part to the excitement generated by the provocative work of the German artist Anselm Kiefer. His Neo-Expressionist work gained prominence in the United States, in room-sized paintings and colossal books burdened with found objects, organic materials, slashing paint strokes, and historical allusions. In Kiefer's *High Priestess* for example, begun in 1985, 200 books with lead covers fill two steel bookcases, piled into stacks or leaning to one side, as if quickly shelved. The scale and visual impact of *High Priestess* are operatic, more a stage set than a library. Copper wire snakes around and between the books, as if to warn of a potential shock from their lethal contents. The books are too heavy to be easily lifted and paged, and so their contents can only be imagined second-hand; in fact, they hold a curious selection of photographs of clouds, remote landscapes, and industrial sites, interleaved with human hair and other debris.

Other sculptural bookworks in the 1980s and 1990s convey the mixed emotions that attend the book in a culture rapidly going digital. Books seemed to be in demand and bookstores were busy, but other technologies garnered increasing shelf space. The few remaining independent bookstores today, for example, are outnumbered by the chain bookstores that now carry books, books on tape, CDs, and espresso. To the book-buying public, bookstores have expanded into storehouses for music and spoken text rather than being restricted to a bibliophile's retreat. At the same time, the computer has become

577. Joshua Quittner, "An Eye on the Future," *Time* (December 27, 1999).

the book's fastest means of distribution: Jeff Bezos, founder of Amazon.com, was selected as 1999 Man of the Year by *Time* magazine, and that December, Amazon's web site attracted an average of 1,262,000 visitors daily.[577]

Two installation bookworks sought to generate in viewers the mixed emotions of anxiety and possibility that video and the computer generate, when placed in proximity to a book. The first work, *How to Make an Antique* (1989, fig. 104), by Karen Wirth and Robert Lawrence, forces a reader to compare the differences in information delivery between video and the book. A reader sits at a table that displays a disjunctive stylistic mix, and examines a book that carries a timeline and reflections on time from historians, philosophers, and scientists. The timeline and statements of the book are real, but its candor is undermined by text and imagery that soberly instruct consumers on how to "antique" furniture and how to make "instant-aged" blue jeans. Looking up, the reader sees the same book, opened on the video screen, while a hand turns its pages. The textblocks in the video book have been replaced with floating images of books, computers, "antiqued" furniture, and historical landmarks such as Stonehenge and the Parthenon, accompanied by slogans like "nearly ageless" and "probably unending." The information and wisdom of the bound book have been reconfigured by video into truisms in the glib voice of advertising.

Wirth and Lawrence's installation invites readers to consider how information varies with its vehicle. When forced to choose between book and video, a reader must act as judge in the unspoken cultural competition between the two—a contest in which the majority of the population has already awarded video (or the computer) the winner. The book allows a reader to read or reread, to scan the text or skip forward or back in the book. Video takes that control from the

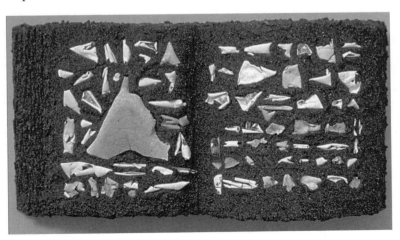

FIG. 103. [CP12] Basia Irland. *Endangered Wilderness Series: Costa Rica; Black Sand and Tortoise Egg Shells, Vol. I.* 7 x 12

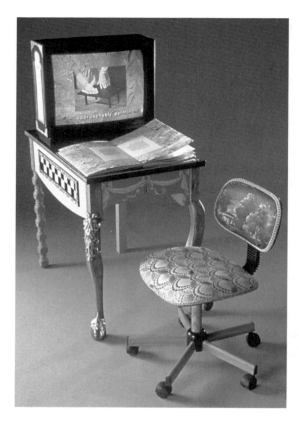

FIG. 104. [CP25] Karen Wirth,
Robert Lawrence.
How to Make an Antique
Dimensions vary.

reader, forcing a reader to proceed at its predetermined pace. And yet, even the most dedicated readers find their eyes straying to the color and movement on the screen, away from the linear presentation of text in the book. Wirth and Lawrence acknowledge the superiority of a book for conveying a linear, sequential text, but they also demonstrate the success of video as a purveyor of image and movement.

Since 1980, the computer has emerged as both rival and savior for the artist's book. In fine printing, the computer has proven to be a revitalizing force, with its high-resolution software in fonts and imagery available for relief printing through the polymer plate. Inside the computer, hypertext books link screens in a multidirectional web of reference and allusion somewhat akin to book browsing, if only in the mind. In spite of the best efforts of designers, however, the computer remains a box and a keyboard. Few if any artists have attempted to use the computer itself in a way that elicits a physical and emotional response from a reader the way a book can.

A second work, *Agrippa (a book of the dead)*, does use computer technology to provoke profound emotional responses in readers, but not through physical means. *Agrippa* emerged in 1993 from a collaboration between artist Dennis Ashbaugh and science-fiction writer William Gibson, guided by publisher Kevin Begos. Housed within a metal box, it includes etchings by Ashbaugh executed in a range of sepia tones. Upon closer examination, the abstractions resolve into drawings of DNA, overprinted with prewar advertising imagery. As the etchings are exposed to light, the advertising images fade away, leaving page after page of DNA fragments. *Agrippa* is about each person's ultimate disappearance due to death; its text comprises reminiscences by Gibson about his father, who died when Gibson was a boy. The text is on a floppy disc in a niche within the book, but the disc also holds a virus that destroys the text as it scrolls across the reader's computer screen. A reader has one chance only to absorb the story, and then, like Gibson's efforts to remember his father, the reader must rely upon memories and impressions. *Agrippa* captured Gibson's sense of irretrievable loss through its ephemerality of text and imagery. The book also fed the viewer's ambivalence toward the

computer in its form and technology, although *Agrippa* relied on that same technology to dramatize its story.

How to Make an Antique and *Agrippa* represent the continuing evolution of the sculptural bookwork as it joins with installation, video, and performance art. Do such works suggest the eventual demise of book art? New technologies pose an irresistible lure to artists—however, works like *Agrippa* are few. There is no evidence (yet) of artists foretelling the computer's takeover of the artist's book. There is no line of demarcation pointing toward some moment in time, distinguished by "BC" (before computer) and "AC" (after computer). It is possible that the book's demise may be hastened by palm-held computers of enormous memory that holographically page before the reader's eye. Still, the question remains: Is it a book if its pagination occurs in the eye and mind, but not through touch? We know what Ulises Carrión would say, since for him the essential character of a book resided in its pagination. All a computer can do is mimic that trait.

Book artists are equally sanguine about predictions of the "death of the ordinary book." In actuality, organizations welcome the computer—as a visual tool. Book art organizations readily exhibit works like *How to Make an Antique*—in fact, that work was funded with a book art production grant. In addition, a number of colleges that teach fine printing have purchased polymer platemakers to use in league with digital type and imagery. The greatest deterrent to increased computer presence in book art organizations and in higher education seems less a matter of attitude and more one of finances.

Some fine printers ignore the computer, but many have grown dependent on it. In the late 1970s, Gerald Lange studied with Walter Hamady and then started publishing elegant fine press books under the Bieler Press imprint. Along with relocating to Los Angeles, Lange experimented with the computer and became a convert, designing books and writing about the capabilities of computer software for type and page design, specific to fine printing. In truth, many book artists now refuse to consider a future for the artist's book where one information vehicle must supersede another. Artist Karen Wirth argues that such predictable oppositions are outdated; instead, "The printed book can be seen as a nexus between the book object that relies on the frisson of reading to make meaning, and the computer that depends on the frisson of the tactile book for familiarity."[578] Book and computer are at once independent and interdependent, and that trend is likely to continue to evolve and surprise us in ways we can't yet fathom.

578. Karen Wirth, "In the Space of Blurred Boundaries," *JAB* 13 (Spring 2000), 12.

CONCLUSION

Let us end by revisiting the question that began this discussion: what is and isn't an artist's book? Is the answer evident? What is clear is that the artist's book can assume different guises. In the twenty-year period between 1960 and 1980, when the artist's book emerged in America, book art developed along tracks that sometimes overlapped and often diverged, each reflecting different aspects and influences of the literary and art worlds. Avant-garde strategies transformed the book with materials and content that were radically at odds with its trade-book profile. Now the book could appear as removable Plexiglas sheets in an aluminum frame; or in an accordion-fold format that opened out to picture storefronts on a city street; or it could even be trussed up and pierced with nails. This range of work can be grouped into four key categories: the letterpress-printed fine press book, where text is ascendant; the deluxe book, often dominated by imagery, printed through a printmaking medium, and bound with costly materials; and the bookwork, which can be further divided into two distinct types (multiple and sculptural), whose content interacts with or comments upon the book as an object or as a symbol of culture. In a multiple bookwork, alterations usually occur on the page in a new interplay between image and text. It is printed in large edition, often cheaply, and directed by a populist intent, in order to reach a large audience. A sculptural bookwork, in contrast, is a work perceived as sculpture that responds to, comments on, or undermines the cultural associations with "book."

A number of factors contributed to the appearance and proliferation of artists' books. These factors pertain to art and social history and to the object itself, and they change depending on the kind of artist's book under discussion. Books published by artists were part of a larger movement in independent publishing, with its proliferation of small presses and little magazines. For many artists, that independence was part of a general activist political climate of the 1960s, characterized by a distrust of existing art world mechanisms for display and reception—including the galleries and museums that acted as gatekeepers for the art world. The independent art organizations that appeared in the 1970s indicated a flexing of artistic muscle that demonstrated a commitment to the direct address of the artist to the viewer (and the reader), free of the gatekeepers' control.

The artist's book met a number of needs of the 1960s and 1970s. Photographic imagery and language drew the attention of many

artists, and that kind of content suited the sequential book. Some books were purely visual (Keith Smith), others textual (Davi Det Hompson). Some artists were involved with Conceptualism (Sol LeWitt), others with Feminism (Suzanne Lacy); some pursued memoir (Susan King), and others transformed "found" language into haunting voices (Ida Applebroog).

The production of the fine press book coincided with a development of an interest in craft. Many fine printers continued an allegiance to solely literary content in the 1960s and 1970s. Books by Claire Van Vliet and Walter Hamady, however, heralded a heightened visual character in fine printing, in their experimentations with appropriated book formats and inventive structures, along with the appearance in their books of studio-bred interests in the use of pattern and color, and, in Hamady's *Gabberjabbs,* in the use of found detritus. The production of deluxe books increased along with the rise of printmaking. These deluxe books moved in two distinct directions, as seen in the elegant demeanor of Leonard Baskin's books or in the purposefully plain features of Richard Tuttle's books.

The multiple bookwork benefited from the growing access of artists to printing processes in the 1960s and 1970s: from mimeograph to offset to copier. The sculptural bookwork shared an interest in craft with fine printers, but in these pedestal works, the interest in craft transmuted into an interest in process that often resulted in works assembled from the oddments of everyday life. Artists such as master conjurer Barton Benes created book-scale works that amused or unsettled viewers, while Fluxus artist Alison Knowles built a book big enough to live in.

Nonprofit organizations played a crucial role for all book artists: artists printed books at the the Center for Book Arts (CBA), Nexus Press, Visual Studies Workshop, and Women's Graphic Center; they exhibited at CBA and Franklin Furnace; and they distributed their books through Printed Matter or through the informal network for fine press and deluxe books. An artist could make a book, exhibit it, and carry it from hand to hand or across continents, an intimate object yet one whose potential audience was limitless.

Any historical overview raises a number of implications. The telling of the story of a marginalized art form like book art amends previous art world assumptions about the 1960s and 1970s. First, the picture of the artist broadens to encompass the role of an independent publisher—or even of an artist standing at a copier or offset press—still an uncommon artist profile today. Additionally, the book artist emerges as a sophisticated manipulator of an artifact that requires

touch and an investment of time in order for a reader to fully experience it.

Second, the full spectrum of book art, from fine press to deluxe to bookwork, should be viewed and evaluated as art. Some might argue that only the bookwork merits discussion in an art context, but such a focus would limit the scope of achievements. For example, the fine press book could not be excluded as a mere vehicle for text, because it participated in the artistic and activist legacy of the Arts and Crafts movement and also produced innovative intermedia experiments like those of Claire Van Vliet. Others might dismiss the deluxe book from consideration, because many are produced as marketing vehicles for art dealers. The deluxe book, however, can also display the literary integrity of a fine printer, as in *Granite and Cypress* (1975), by William Everson, or it can challenge the values that underlie art collecting, as in the aesthetic provocation posed by Ed Ruscha with his unsavory *Stains* (1969). Both books enlarge the deluxe aesthetic by colliding with the conventions of the deluxe book's content or format. The strength of this history lies in emphasizing such divergences from the traditions of the deluxe book, because those divergences actually indicate key points where the deluxe book contributed to the historical trajectory of book art as a whole.

Third, this history creates a larger context for book art that touches on a number of related worlds. That larger context is necessary because the artist's book embodies the "bond between art and the public which makes use of it," just as a history should examine "how and with what intentions this bond determined artistic form."[579] Particular to the multiple bookwork, developments in typographical history point up how the multiple bookwork served as a conduit for modernist design as it entered the United States from Europe. The larger context of the fine press book is respect for craft, which challenges an art world bias that disparages works that can operate as a usable object and as a work of art. And the limitations of a closed art world system are revealed in the problems that all book artists grapple with in terms of production, distribution, and reception.

Fourth, this history emphasizes the crucial influence that printing technologies exerted over art-making. The achievements represented by some of the recent books from Nexus Press, in which artist-printers layer up to twenty-five colored inks onto a page from the offset press, are unthinkable without the early painterly experiments of Eugene Feldman, working at his press after business hours. The bookworks of Keith Smith, in addition, challenge the mainstream of the photographic community, with unique books of handworked pages of photographs that incorporate drawn or perforated alterations.

579. Hans Belting, *The End of the History of Art?* Christopher S. Wood, trans. (Chicago and London: The University of Chicago Press, 1987), 34.

Underlying this history of artists' books is a persistent question: Why the book? What was the significance of the book as an artistic choice? It is not simply a matter of art world influence. Not all books reference specific movements such as Fluxus and Conceptualism. There are many books in this history that do not respond to an art movement, but rather emerged from a curiosity about the book form, a fascination that has drawn artists to the book for over a century. Touch sets an implicit exchange between artist and reader into motion. In paging through an artist's book, the intellect of the reader seeks to anticipate or interpret each revelation amidst unleashed emotions, as body and book join in a private, sensuous encounter. The touch and paging through an artist's book hearkens back to childhood in a delight of movement, in the pleasurable accumulation of sequence, and in the esoteric relationship of text with image. What a reader recognizes in an artist's book is the reinvention of the art of storytelling within the incremental, organic unfolding of a book.

This history of the artist's book has unfolded in the art world, where it belongs. The history of book art complicates an art world context, however, because it highlights art world issues set into play with the transformation of the book from information vehicle into artifact. Those issues arise from the presumed opposition of the unique to the multiple object, of "high art" to popular culture, and of the overlap of art with craft on one side and with commercial technologies and industrial materials on the other. The artist's book also forces a rethinking of art world conventions of display, in the difficulties of showing books and of writing about looking through them, not just in looking at them. These questions have yet to be resolved. Such concerns are shared to some extent by other art forms, such as performance, video, and installation works—although the hand-held, one-on-one reading experience of an artist's book is particularly difficult for a reader to understand, when "reading" involves much more than scanning a text. A few key book art exhibitions from the 1970s tried to address these problems, with varying degrees of success. Each solution exacted a trade-off from the gallery visitor in either restricting access to books on display, or in disregarding the integrity of an installation's design for hands-on access—while the most effective displays were those that incorporated static with active means for display.

Some exhibitions in the 1980s and 1990s with larger budgets at their disposal attempted to solve the conundrum of access as balanced with a need for a work's preservation. Curator Katherine Martinez, for example, integrated videotaped pagings of exhibited books into her show at the Cooper-Hewitt Museum in 1988, "Surprise! Surprise!:

Pop-Up and Moveable Books." The videotapes brought to life the static books spotlit in vitrines, while avoiding the pagings by hundreds of viewers that could have damaged or destroyed them. At the same time, the viewer was reduced to imagining the element of touch that is crucial to experiencing any book, especially a pop-up book. Perhaps an ideal solution (budgetary concerns aside) would be to integrate all the options, with installed works and accompanying didactics, a "reading room" with copies of the multiples, as well as a videotaped viewing of limited-edition works. Some book art showings have successfully combined elements of access and interpretation. In the art world, the integration of books (some with hands-on access) along with work in other media, has become common in theme exhibitions at larger institutions such as the Museum of Contemporary Art, Los Angeles (on Conceptualism), and the Walker Art Center (on Fluxus art).

What trends can be predicted? Where will book art be twenty years from now? It is easy to predict a future for the artist's book as an artifact, because from today's perspective there seems no doubt of the continued fascination that books generate for artists. This does not presume, however, that the book's associations will remain static. The trade book is already perceived less as an information tool, and more as a purveyor of entertainment (fiction) or intellectual stimulation (nonfiction). Since the idea of the book's sacred status as a repository of meaning and wisdom is itself in question, the book will continue to mirror that uncertainty. Such confusion won't undermine the book's usefulness to artists but rather offer them greater metaphorical riches to cultivate. What works in the artist book's favor, as well, is that artists' books have garnered a more widespread recognition value. Even though artists' books continue to flourish just below the radar in the larger arts community, they are recognized as members of that community; few art world insiders are confounded today when confronted with an artist's book. Their response would more likely be determined by their interest in how a book was made (a print collector would savor a book from Andrew Hoyem's Arion Press, for example) and in what a book has to say (a librarian at an art college might seek out books whose contents reflect the social and political concerns of the day); and, admittedly, interest will always accrue to books made by an artist whose reputation is ascendant.

In spite of this modestly optimistic forecast, each kind of artist's book faces challenges to maintain and enrich its future. Fine press books have a secure future with polymer printing and the computer, although the travails involved in that kind of precise printing will continue to limit the number of devotees. Deluxe books have proven

their potential for carrying a rich strata of tactile and visual content, when the content is more than an excuse for producing yet another suite of prints. The makers of multiple bookworks face the continued diminution of offset printing options and of the presses that remain in operation for artists; they are notoriously difficult to maintain. Copiers remain a viable option for artists, and with the improvement of scanners, computer software, and laser printers, the future for the multiple bookwork may lie more in these home-based technologies. Finally, the sculptural bookwork and installation bookwork remain the most malleable kind of artist's book (literally); however, they are the artists' books that face the greatest challenge to avoid easy solutions and to seek, instead, content that generates sustained reflection. Only a few artists today can produce one-liners as successful as those of Barton Benes, whose punch lines often held a subtext of social critique. When that potential of the sculptural bookwork is met, it can metaphorically reflect the shifting landscape of art, books, and language, and so reveal ourselves to ourselves.

In the larger book community, evidence mounts of a fascination with the history of the book, and a number of studies have recently satisfied that hunger. Their subjects vary widely. Some are written for a popular audience, including *A History of Reading* (1996). Others are scholarly studies, such as *Scenes in a Library: Reading the Photograph in the Book, 1843–1875* (1998). Still others adopt the approach of a social historian, as in *Beauty and the Book: Fine Editions and Cultural Distinction in America* (2000). This interest in the book is not based on mere nostalgia but on recognition of the symbolic role of the book as a cultural artifact. Today we are surrounded by books devoted to examining the book's history and cultural significance.

Has this collective fascination with the book as a cultural artifact translated into widespread art world or book world recognition for the artist's book? Hardly. The artist book's achievement is a complicated one that does not fit into either art world category of "success" or "failure." Having said that, the artist's book is "the quintessential twentieth-century art form"[580] to those who have encountered and been changed by it. But recognition may continue to be retrospective, left to historians to devise, rather than a success that its creators can enjoy in the present.

The dedication to bookmaking by artists has recently yielded surprises. Today, many institutions that serve book art are strong and resilient, despite the demise of visual arts funding from the National Endowment for the Arts. In the last decade, several major book art organizations have begun or completed fundraising to move into a permanent space, either with a friendly landlord or owned outright.[581]

580. Drucker, *Century of Artists' Books*, 362.

581. They include the Center for Book Arts (New York City), Columbia College Chicago Center for the Book and Paper Arts (previously Artists Book Works, and Paper Press), Minnesota Center for Book Arts, San Francisco Center for the Book, and Pyramid Atlantic (near Washington, D.C.).

Such stability was unheard of in the early 1980s. In education, the existing M.F.A. book art degree programs continue to attract students, and a growing number of art colleges and universities now integrate bookmaking classes into their curriculum. At the same time, some established organizations have closed or radically altered the scope of their programming, including bookstores such as Bookworks in Washington, D.C., and organizations such as Franklin Furnace.

In an odd contrast to the institutional stability of book art, definitions of the books and of the artists who make them continue to fluctuate. It is symptomatic and revelatory of the persistent confusion about artists' books. The novelist and essayist William H. Gass provided a perfect illustration of the artist's book's marginalization. Gass extolled the abiding pleasures of perusing library shelves and paging through books in the 1999 article "In Defense of the Book," subtitled "on the enduring pleasures of paper, type, page, and ink."[582] He remarked, "We shall not understand what a book is, and why a book has the value many persons have, and is even less replaceable than a person, if we forget how important to it is its body, the building that has been built to hold its lines of language safely together through many adventures and a long time." He contrasts this object to the words scrolling across a computer monitor, that "have no materiality, they are only shadows, and when the light shifts they'll be gone."[583] Gass provides a cogent paean to the book and to its public servant, the library. Mysteriously, however, his essay is accompanied by pictures—not of traditional books, but of artists' books—in fact, sculptural bookworks. Here appears *A Book of Common Prayer* (1996), by Miriam Schaer, its shape that of the artist's hands embedded with tiny icons. Also featured is *Fixer 3/26/97,* by Berwyn Hung, a book literally immersed in photographic fixative, on that date, within a glass tank. And here, as if in benevolent, paternalistic tutelage, is *Shades* (1964), by Robert Rauschenberg, with its dangling electrical plug.

These distinctive bookworks and others appear beneath excerpts from the essay, but Gass makes no mention of the works while praising the pleasures of the traditional book. Because of that radical disjunction, the bookworks exert an unnerving presence, and raise questions at odds to Gass's praise. What are the bookworks meant to suggest? Did Gass request their presence? One must assume that they represent a ploy by an editor to catch a reader's attention. Are they meant to be visions of a book-diminished future? The statement of Gass placed beneath *Shades* suggests homage rather than eulogy: "Unlike the love we've made or meals we've eaten, books congregate to form a record around us of what they've fed our brains."[584] *Shades* does resemble what might be imagined as a mind's mix of informa-

582. William H. Gass, "In Defense of the Book," *Harper's* 299, no. 1794 (November 1999): 45–51.

583. Ibid., 46.

584. Ibid., 47.

tion, images and memories, although such a simplistic matching of text to picture does not provide a stage for these bookworks to truly inhabit. The bookworks appear as curiosities, which, it can be admitted, they are: one does not immerse a book in photographic fixative in order to be conventional. Thankfully, *Harper's* includes the descriptions of the bookworks at the back, so that at least a curious reader can imagine the qualities that each work is meant to suggest. Presented mute on the page amid Gass's bibliophilic musings that ignore them, the bookworks flout the very traditions that Gass celebrates.

The use of sculptural bookworks-as-illustration by a general interest magazine is symbolic of the marginalization of book art. Even so, the artist's book has indeed affected perceptions of the book and art, although its impact has accrued quietly over the years, without fanfare, one reader at a time. The artist's book, at the same time, has done more than merely reflect the major styles of the twentieth century in its presentation of imagery and text. Its booklike properties have transformed those styles, as in *Shades*'s reordering of a Rauschenberg "combine" into pages hung in space; or a Lucas Samaras bookwork that refuses a reader's presumption of touch with its encrusted knives and razor blades.

This history has identified a trend, from the mid 1950s forward, of artists working with books simply by recognizing that the book is an artifact capable of inhabiting both private and public realms. Such a performative object could enact the ideal of direct address, described by Ed Ruscha as "The way they're supposed to be seen...is when someone hands someone-else just one book at a time and place where they don't expect it." Artists could also alter or even refute expectations about direct address, such as with the untouchable sculptural bookworks by Samaras and Barton Benes. However diverse the strategies employed by their makers, artists' books have succeeded in reconfiguring and entwining the cultural entities of book and art.

Book art has invested the art of reading with a moment-by-moment significance, in experiences that are at once intimate and engaging. Imagine the absorbed reader at the point when a turning page reaches the height of its arc. At this pause, the reader inhabits a space of emotional and intellectual readiness, one full of question, possibility, and anticipation. The page lays back, another opening is revealed, and another layer delicately settles atop a life's layerings of pages, books, and stories. This is a kind of communion utterly unique to the book. How can we express the delight of such a submerging and uplifting exchange? Again we return to an invocation by Ulises Carrión: "Every book of the new art is searching after that book of absolute whiteness, in the same way that every poem searches for silence."

TIMELINE

1800

1804–1827 William Blake, *Jerusalem the Emanation of the Giant Albion*

1880s By now, U.S. publishing has adopted mass production techniques, including some machine-driven finishing for binding.

1884 Grolier Club founded, America's premier book collecting club.

1890 J. M. Whistler, *The Gentle Art of Making Enemies*

1894 Henri de Toulouse-Lautrec, *Yvette Guilbert* • Aubrey Beardsley, *Le Morte D'Arthur*

1895 William Morris, *Hand and Soul* • Stéphane Mallarmé essay, "The Book: A Spiritual Instrument." In 1897, Mallarmé designs *Un coup de dés jamais n'abolira le hasard.*

1896 William Morris, *Chaucer*

1900

1900 Pierre Bonnard, *Parallèlement,* with publisher Ambroise Vollard.

1905 T. J. Cobden-Sanderson, Doves Press Bible

1907 By now, Currier and Ives have sold over 7,000 lithographs of America's vernacular scenes.

1910

1913 Blaise Cendrars and Sonia Delaunay-Terk, *La prose du transsibérien et de la petite Jehanne de France* • Dard Hunter builds paper mill at Marlborough-on-Hudson in New York State.

In 1914 he casts type.

1914 American Institute of Graphic Arts (AIGA) founded.

1919 Marcel Duchamp instructs his sister Suzanne on the creation of the *Unhappy Readymade.*

1920

1923 Alexander Rodchenko designs Vladimir Mayakovsky's *Pro Eta* (*About This*).

1930

1930s Federal Art Project supports creation of prints in all media, including silkscreen and lithography.

1930 Grabhorn Press, *Leaves of Grass,* with Valenti Angelo's woodcuts.

1932 F. T. Marinetti and Tullio d'Albisola, *Parole in libertà futuriste tattili termiche olfattive* • Beatrice Warde lecture, "Printing should be invisible."

1934, 1936–1941 Duchamp constructs readymades, *Boîte verte* and *Boîte-en-valise.*

1936 Stanley Morison, *First Principles of Typography.* • *Modern Painters and Sculptors as Illustrators,* at Museum of Modern Art, curated by Monroe Wheeler.

1937 André Breton, *Nadja* • Marcel Duchamp, *Boîte-en-valise* • Jane Grabhorn, *Typografic Discourse, for The Distaff Side of Printing, a Book by Ladies* • Late 1930s Joseph Cornell alters boxes and books into sculptural bookworks.

1940

1940s High-speed offset machinery and photo-composition improves during World War II.

1945 Harry Duncan, *Esthétique du Mal* • Lewis and Dorothy Allen begin The Allen Press. • Weegee, *Naked City*

1946 Douglass Howell establishes (perhaps the first) New York studio containing a hand press and a beater for paper pulp.

1947 Henri Matisse, *Jazz,* with pochoir, through publisher Tériade. • Louise Bourgeois, *He Disappeared into Complete Silence,* published by William Hayter's Atelier 17, in New York since 1940.

1949 *The French Art of the Book,* at California Palace of the Legion of Honor.

1950

1950 Letterpress still viable printing option—but offset, improved during World War II, makes inroads into commercial printing.

1951 *Books for Our Time* opens in 1951 under AIGA's auspices. • Marshall McLuhan writes his first book, *The Mechanical Bride.*

1954 William Everson, *Novum Psalterium PII XII*

1955 Wallace Berman begins publishing *Semina.*

1956 Harry Duncan relocates from Massachusetts to direct the Typographic Laboratory at the University

of Iowa–Iowa City; in 1972 he relocates to teach at the University of Nebraska–Omaha. • William Klein, *New York*

1957 Eugene Feldman prints *Doorway to Portuguese,* in collaboration with Brazilian Aloísio Magãlhaes. • Jasper Johns, *Book*

1958 John Latham, *Shem*

1959 Leonard Baskin, *Auguries of Innocence,* with wood engravings. • Andy Warhol, *Wild Raspberries* • Robert Frank, *The Americans*

1960

1960s By now, offset printing and phototypesetting have permeated the printing industry.

1960 *Stones,* by Larry Rivers and Frank O'Hara, first publication from Universal Limited Art Editions (ULAE). • Claes Oldenburg, *More Ray Gun Poems,* with mimeographs.

1961 Harry Duncan, *Four Early Stories by James Agee* • *The Artist and the Book, 1860–1960,* in Western Europe and the United States, at the Museum of Fine Arts, Boston. • Books appear as found objects in *The Art of Assemblage* at the Museum of Modern Art

1962 Claire Van Vliet, *A Country Doctor* • Marshall McLuhan, *The Gutenberg Galaxy,* then *Understanding Media: The Extensions of Man* (1964). • Lucas Samaras alters his first book. • Robert Morris, *The Card File,* box as book. • Allan Kaprow, *Words,* a "written environment."

1963 Ed Ruscha publishes his first book, *Twentysix Gasoline Stations.*

1964 Claire Van Vliet, *Sun, Sky and Earth,* and *Four Letter Word Book.* • Robert Rauschenberg, *Shades,* lithography on Plexiglass, in brushed aluminum frame, with lightbulb, from ULAE. • John Latham, installation-performances: "SKOOB Towers"

1965 Richard Tuttle publishes his first book, *Story with Seven Characters,* with woodcuts. • Eugene Feldman, *West Side Skyline* • John Latham, *Art and Culture*

1965–1968 Eleanor Antin, *Blood of a Poet Box*

1966 Flood in Florence, Italy, heightens public consciousness of bookbinding and book conservation. • Melissa Gurdus, *Electronic Variations* • Richard (Dick) Higgins founds Something Else Press (operating until 1973). • Ed Ruscha, *Every Building on the Sunset Strip* • Tom Phillips begins *A Humument,* first issued in 1972 in a limited edition facsimile by Tetrad Press.

1966–1969 John Latham, *Art and Culture*

1967 Walter Hamady, *Plumfoot Poems, Reardon Poems* • Allen Press, *Dialogues of Creatures, Moralized* • Antonio Frasconi, *Viet Nam!* with woodcuts. • Keith Smith, *A Change in Dimension* • Andy Warhol's *Index (Book)* • Dieter Roth, *Poetrie,* with pages of sealed plastic bags holding decomposing cheese.

1967–1969 Alison Knowles, *The Big Book* installation

1968 English translation of Walter Benjamin's "The Work of Art in the Age of Mechanical Reproduction" (1936). • Dieter Roth, *246 Little Clouds,* from Something Else Press • *The Xerox Book,* published by Seth Siegelaub

1969 Visual Studies Workshop begins in Rochester, New York (VSW Press begins in 1972). • Sol LeWitt, *Four Basic Kinds of Straight Lines and Their Combinations* • Lucas Samaras, *Book,* in edition, with screen-prints, offset lithographs, die-cutting.

1970

1971 Miriam Schapiro and Judy Chicago begin The Feminist Art Program at California Institute of the Arts, where Suzanne Lacy produces *Rape Is* in 1972. • Betsy Davids founds Rebis Press, joined by Jim Petrillo in 1972. • Keith Smith, Book 24 • Philip Smith completes *The Lord of the Rings.*

1972 Kathryn and Howard Clark begin Twinrocker Inc. papermill.

1973 Walter Hamady prints the first *Interminable Gabber-jabbs.* • Richard Minsky, *Pettigrew's History of Egyptian Mummies* • John Risseeuw, *The Politics of Underwear* • The Woman's Building opens, which in 1974 adds printing facilities with the Women's Graphic Center. • Sonia Landy Sheridan and Keith Smith collaborate on the copier-printed

Smithsonian. • Marcel Broodthaers, *Voyage on the North Sea* • *Offset Lithography* exhibition at Wesleyan University.
• The Book Bus distribution cooperative goes on the road. • *The Book Stripped Bare: A Survey of Books by 20th Century Artists and Writers,* Hofstra University, with essay by Susi R. Bloch.
• *The Art of the Printed Book, 1455–1955,* at the Morgan Library. • *Artists Books* at Moore College of Art, Philadelphia.

1974 Richard Tuttle, *Interlude* (1974), with perforated pages. • Richard Minsky opens Center for Book Arts in New York City. • Marty Greenbaum, *Book Seven*

1975 Claire Van Vliet, *The Tower of Babel* • William Everson, *Granite and Cypress*
• Richard Minsky, *Birds of North America* • *Fine Print* journal begins. • First North American Hand Papermakers Conference in Appleton, Wisconsin.
• Michelle Stuart, *Niagara Gorge Path Relocated,* environmental scroll installation. • Telfer Stokes and Helen Douglas, *Loophole* • Michael Snow, *Cover to Cover* • Barton Benes, *Bound Book and Glasses*

1976 Rebis Press issues *The Softness on the Other Side of the Hole,* by Kenneth Davids.
• Michelle Stuart, *Niagara II, Niagara Gorge* scroll.
• Santa Barbara Museum hosts conference and exhibition, "The Handmade Paper Object." • Jasper Johns and Samuel Beckett, *Foirades/Fizzles* • *Beyond Illustration: The Livre D'Artiste in the Twentieth Century,* at Indiana Univer-

sity, Lilly Library. • Kathryn Markel opens her New York gallery, operating until 1986.
• *The Book as Art,* at The Fendrick Gallery, Washington, D.C. • *Printed Matter* organized by Sol LeWitt, Lucy Lippard, and others. Michelle Stuart's *The Fall* is published by Printed Matter. • Martha Wilson founds Franklin Furnace.
• Conrad Gleber begins Chicago Books with Jim Snitzer and Gail Rubini
• Davi Det Hompson, *May I Have a Glass of Water with No Ice, Please?*
• Syl Labrot, *Pleasure Beach* • Todd Walker, *for nothing changes...*

1977 Claire Van Vliet, *Aura,* with paper pulp painting, at Twinrocker. • Paper conference at the Center for Book Arts. • *The Printed Book in America,* at Dartmouth College Library.
• Caroline Greenwald, *Tender Papers in a Notebook. Open,* in 1976, a room-sized installation.
• Frances Butler and Alastair Johnston, *Logbook,* preceded by *Confracti Mundi Rudera* in 1976.
• Johanna Drucker, *From A to Z* • Susan King, *Pacific Legend* • Documenta 6, in Kassel, where books enjoy unprecedented emphasis.
• Clive Phillpot arrives to direct the Museum of Modern Art's Library.
• "Convention Art Publishers/Exhibition Art Periodicals," at San Jose State University, including a book fair and workshops.
• Sol LeWitt, *Brick Wall*
• John Baldessari, *Fable— A Sentence of Thirteen Parts (with Twelve Alternate Verbs) Ending in FABLE*

• Conrad Gleber, *Chicago Skyline* • Barton Benes, *Censored Book*

1978 Richard Bigus, *Out of the Cradle Endlessly Rocking*
• *Hand Bookbinding Today, an International Art,* Museum of Modern Art, San Francisco. • "Printer's Choice: A Selection of American Press Books, 1968–1978," Grolier Club.
• Gary Frost, *The Tracts of Moses David* • *Artwords and Bookworks* fills LAICA's galleries. • *Umbrella* begins publication.

1979 Andrew Hoyem, *Moby-Dick*
• "Wayzgoose: A Symposium for Contemporary Bookmaking," independent conference, in San Francisco.
• "Book Makers, Center for Book Arts First Five Years."
• "Conference on Contemporary Press Books in the USA," at West Chester State College, Pennsylvania.
• Hedi Kyle, *April Diary*
• Ida Applebroog, *Look at Me* • Ulises Carrión, *Mirror Box* • Visual Studies Workshop conference, "Options in Independent Publishing," in Rochester, New York. Speakers include Ulises Carrión.

1980

1980 Harry Duncan, essay, "The Art of the Printed Book."
• "Seventy from the 1970s: A Decade of Fine Printing," at New York Public Library's Rare Book Room.
• *VIGILANCE: Artists' Books Exploring Strategies for Social Concern.* • Kevin Osborn, *Repro Memento*

1981 "The Art of the Printed Book," conference at The University of Nebraska– Omaha.

RESOURCES ON BOOK ART

The following collections comprise a small selection of the resources available to those interested in experiencing artists' books directly. (A complete directory of artist's book collections has never been compiled.) As such, this list is highly subjective and reflective of my particular experience. I suggest that it be used more as a guide to the kind of collections that an interested reader might contact within his or her area. Note that an early list (as of 1985) of collections specific to the multiple bookwork (along with an extensive bibliography) appears at the end of *Artists' Books: A Critical Anthology and Sourcebook,* edited by Joan Lyons.

In lieu of a full and updated directory of collections, interested readers have a number of options for locating artists' books. Many libraries now maintain collections of artists' books. Readers are encouraged to contact their local colleges, universities, and art colleges, keeping in mind that the kind of artist's book represented in a collection depends upon the audience served—that is, art colleges are more likely to collect multiple bookworks, while university rare books libraries are more likely to collect fine press books. Readers are also encouraged to contact museums at home or when traveling, since many collect artists' books. Note, however, that persistence may be necessary, since artists' books are often dispersed into different departments in a museum. For example, the Walker Art Center in Minneapolis maintains an extensive collection of multiple bookworks within its library, as well as deluxe books in its print department. The Minneapolis Institute of Arts maintains its deluxe books in its Prints and Drawings Room, its photographic multiple bookworks in the Photography Department, and a small number of multiple bookworks in the Library. Note, also, that a museum, college or university's artist's book holdings may be accessible through an on-line library index, thus allowing a visitor to begin his or her research from home.

Other resources can also provide an excellent introduction to current work. Those resources include book art journals, on-line lists, and mailings from book art organizations and independent artist-run offset presses.

I. COLLECTIONS OF ARTISTS' BOOKS

Burton Barr Public Library. Special Collections Department. Phoenix, Arizona

Getty Research Institute for the History of Art and the Humanities. Special Collections Library. Santa Monica, California

The Museum of Modern Art. Prints and Illustrated Books Department, Library. New York City

The New York Public Library. Spencer Collection, the Print Room

The Newberry Library, Chicago

Otis College of Art and Design, Los Angeles

Rhode Island School of Design.

Rochester Institute of Technology, The Cary Collection, New York

Ruth and Marvin Sackner Collection of Concrete and Visual Poetry. Miami Beach, Florida.

San Francisco Public Library

The School of the Art Institute of Chicago. Joan Flasch Artists' Books Collection. John M. Flaxman Library

Scripps College, Ella Strong Denison Library

University of California–Los Angeles (UCLA). The Charles E. Young Research Library, Department of Special Collections; the Williams Andrew Clark Memorial Library; the Judith Hoffberg Collection at the Arts Library.

University of Iowa–Iowa City

The University of Minnesota–Minneapolis. Rare Books and Special Collections Library

The University of San Francisco. The Gleeson Library

University of Wisconsin–Madison. Special Collections Library. Memorial Library

Virginia Commonwealth University Book Art Collection

Visual Studies Workshop. Independent Press Archive. Rochester, New York

Yale University, the Beinecke Rare Book and Manuscript Library, the Arts of the Book Collection in the Arts Library, and the Faber Birren Collection of Books on Color in the Arts Library

Afterimage. Bimonthly journal that often reviews multiple bookworks. Visual Studies Workshop. 31 Prince Street, Rochester, NY 14607. Email: afterimage@vsw.org.

Ampersand. Quarterly journal of the Pacific Center for the Book Arts. 300 DeHaro Street, San Francisco, CA 94103. On the web: www.pcbaonline.net.

Art on Paper. Monthly journal (except February and August) that carries the "Artist Book Beat" column by Nancy Princenthal, and "Photo Book Beat," by Jean Dykstra. 39 East 78th Street, New York, NY 10021. On the web: www.artonpaper.com.

Hand Papermaking. Twice-yearly journal, includes feature articles, reviews, etc. P.O. Box 77027, Washington, D.C. 20013-7027. On the web: handpapermaking@bookarts.com.

Parenthesis. Twice-yearly fine printing journal, Fine Press Book Association. North American Membership Secretary, Morva Gowans, 3235 West Tenth Avenue, Vancouver, British Columbia V6K 2L3. Email: FPBAmgowans@shaw.ca.

Umbrella. Journal of news and reviews on the arts, including artists' books and mail art, appearing three to four times yearly. In 2005 *Umbrella* plans to add an on-line information service to track deadlines and provide other time-sensitive information. Judith Hoffberg, editor. P.O. Box 3640, Santa Monica, CA 90408. Email: umbrella@ix.netcom.com.

On-line resources reflect the diversity of the field. Lists include the (now) venerable Book_Arts-list, in operation since 1995, whose web site (at http://www.philobiblon.com) includes links to book arts centers, programs, and educational organizations. The Book_Arts-list also includes links to other book art–related lists, such as the Letpress discussion list for letterpress printers, and Cyberscribes for calligraphers.

Another resource is SHARP, the Society for the History of Authorship, Reading, and Publishing, an interdisciplinary scholarly organization whose members explore topics such as the history of the book, publishing, printing, and the book arts. The organization maintains an on-line list (SHARP-L), and organizes an annual international conference.

Most of the organizations listed below offer broad programming that includes classes, exhibitions, visiting artists, lectures, etc. If a degree program is offered, that information is also indicated. Classes and lectures are increasingly available in most larger cities and smaller college towns. Further details on the programs listed below, as well as names of the many additional organizations and programs that are available throughout the United States and outside of the United States, can be found on the Book_Arts-list web site. Interested persons can search the archives of the Book_Arts-list or query the members on the list for resources particular to an area.

CENTER FOR BOOK ARTS
28 West 27th Street
Floor 3
New York, NY 10001
http://centerforbookarts.org/

COLUMBIA COLLEGE CHICAGO CENTER
FOR THE BOOK AND PAPER ARTS
218 South Wabash Avenue
Chicago, IL 60604-2316
http://bookandpaper.org
M. F. A. and M. A. Book and
Paper Arts Programs.

FRANKLIN FURNACE
http://www.franklinfurnace.org/

THE GROLIER CLUB
47 East 60th Street
New York, NY 10022
http://www.grolierclub.org/
The Club is private,
but its exhibitions are open to the public.

THE GUILD OF BOOK WORKERS
521 Fifth Avenue
New York, NY 10175
http://palimpsest.stanford.edu/byorg/gbw
Tours, exhibitions, workshops, and lectures.
Publishes bi-annual Journal and
bi-monthly Newsletter.

LOS ANGELES BOOK ARTS CENTER
http://www.labookarts.com/classes.html
A new organization that sponsors classes.

MILLS COLLEGE BOOK ARTS PROGRAM
5000 MacArthur Boulevard
Oakland, CA 94613
http://www.mills.edu/BART/bart.home.html
Students can pursue a book arts minor, in
which they can explore and create traditional
and contemporary book forms.

MINNESOTA CENTER FOR BOOK ARTS
1011 Washington Avenue
Suite 100
Minneapolis, MN 55415
http://www.mnbookarts.org

THE NEBRASKA BOOK ARTS CENTER
University of Nebraska at Omaha
College of Fine Arts
Department of Art and Art History
60th and Dodge Streets
Weber Fine Arts, Room 124
Omaha, NE 68182-0173

NEXUS PRESS
535 Means Street NW
Atlanta, GA 30318
http://www.thecontemporary.org/
pages/nexuspress/nexuspress.html
Nexus Press's residency, internship, and pro-
duction programming has been suspended
until further notice. Nexus Press is currently
being run by its volunteer advisory committee,
Friends of Nexus Press. The Friends of
Nexus Press are continuing to fulfill book
orders at this time. Please check the website
for further updates.

NORTH BENNET STREET SCHOOL
39 North Bennet Street
Boston, MA 02113
http://www.nbss.org/programs/
bookBinding.html
The only full-time bench bookbinding program
in North America. The two-year program
was started in 1986.

PAPER AND BOOK INTENSIVE (PBI)
http://www.paperbookintensive.org/
This volunteer-run organization offers a
spring/summer intensive of high-quality work-
shops in different regions of the United States.

PENLAND SCHOOL OF ARTS AND CRAFTS
PENLAND SCHOOL OF CRAFTS
P.O. Box 37
Penland, NC 2876
http://www.penland.org/
A national center for craft education located
in the Blue Ridge Mountains of Western
North Carolina, whose workshops include
those that deal with books and paper.

PRINTED MATTER
535 West 22nd Street, ground floor
New York, NY 10011
http://www.printedmatter.org/

PYRAMID ATLANTIC
8230 Georgia Avenue
Silver Spring, Maryland 20910
pyramidatlanticartcenter.org

THE RARE BOOK SCHOOL AT THE
UNIVERSITY OF VIRGINIA
http://www.virginia.edu/oldbooks/rbs/
Rare Book School (RBS) is an independent,
nonprofit, and tax-exempt institute
(since 1983) that supports the study of
the history of books and printing and
related subjects, governed by its own
board of directors. Each year, RBS offers
about forty five-day non-credit courses
for adults on topics concerning old
and rare books, manuscripts,
and special collections.

THE SAN FRANCISCO CENTER FOR THE BOOK
300 De Hare Street
San Francisco, CA 94103
http://www.sfcb.org/
Umbrella organization for the
Pacific Center for Book Arts and
The Hand Bookbinders of California

SCRIPPS COLLEGE PRESS
Kitty Maryatt, Director
1030 Columbia Avenue
Claremont, CA 91711
http://www.scrippscol.edu/~dept/art/press/
Offers class, Typography: The Art of the Book,
and sponsors lectures and workshops.

PURCHASE COLLEGE
STATE UNIVERSITY OF NEW YORK
SCHOOL OF ART + DESIGN
735 Anderson Hill Road
Purchase NY 10577-1400
http://www.purchase.edu/admissions/
adm_proginfo_artdesign.asp
B. F. A. Program offers a
four-year curriculum;
one area of concentration is in
printmaking/art of the book.

THE UNIVERSITY OF ALABAMA
BOOK ARTS PROGRAM
Box 870252
The University of Alabama
Tuscaloosa, AL 35487-0252
http://www.bookarts.ua.edu/
M. F. A. in the book arts

THE UNIVERSITY OF IOWA
CENTER FOR THE BOOK
216 North Hall
Iowa City, IA 52242
http://www.uiowa.edu/~ctrbook/
The UICB offers classes in book-related
topics, hosts lecturers, sponsors
conferences, publishes a newsletter,
and encourages the exchange of ideas
among individuals with interests in
the book. Associated faculty, staff,
and graduate students in the School of
Art and Art History, the School of Library
and Information Science, and in several
departments, represent a wide range of
perspectives on the book as an aesthetic,
cultural, and historical artifact.

UNIVERSITY OF THE ARTS
BOOK ARTS & PRINTMAKING
Broad and Pine Streets
Philadelphia, PA 19102
http://www.uarts.edu/gp/bap/index.cfm
M. F. A program in book arts and printmaking.

VISUAL STUDIES WORKSHOP
31 Prince Street
Rochester, NY 14607
http://www.vsw.org/
VSW offers an M. F. A. Program in Visual
Studies, in association with the Department of
Art and Performance at State University of
New York College at Brockport. The program
includes classes on artists' books.

WOMEN'S STUDIO WORKSHOP
P.O. Box 489
Rosendale, NY 12472
http://www.wsworkshop.org/
WSW offers classes and
workshops on artists' books.

BIBLIOGRAPHY
BOOKS & CATALOGUES

Ades, Dawn. *Photomontage.* London: Thames and Hudson, 1986.

Adrini, Gotz, ed. *The Books of Anselm Kiefer, 1969–1990.* Translated by Bruni Mayor. New York: George Braziller, Inc., 1991.

Album: Thirty Years at the Lower East Side Printshop, 1968–1998. New York: Lower East Side Printshop, Inc., 1998.

Alexander, Charles, ed. *Talking the Boundless Book: Art, Language and the Book Arts.* Minneapolis: Minnesota Center for Book Arts, 1995.

Allen, Lewis. *Printing with the Handpress.* New York: Van Nostrand Reinhold Company, 1969.

Allen, Lewis, and Dorothy Allen. *The Allen Press Bibliography, MCMLXXXI: Produced by Hand with Art Work, Sample Pages from Previous Editions.* Greenbrae, Calif.: The Allen Press, 1981.

American Prints and Printmaking: 1956–1981. New York: Pratt Graphics Center, 1981.

Andel, Jaroslav. *The Avant-Garde Book: 1900–1945.* New York: Franklin Furnace, 1989.

Anderson, Elliot, and Mary Kinzie, eds. *The Little Magazine in America: A Modern Documentary History.* Yonkers, New York: Pushcart Press, 1978.

Andrews, Benny and Rudolf Baranik, eds. *Attica Book,* by the Black Emergency Cultural Coalition and Artists and Writers Protest Against the War in Vietnam. South Hackensack, New Jersey: Custom Communications Systems, c. 1971.

Apollonio, Umbro, ed. *Futurist Manifestos.* New York: Viking Press, 1973.

Applebroog, Ida. *Look at Me.* 1979.

Archer, H. Richard, and Ward Ritchie. *Modern Fine Printing.* Los Angeles: William Andrews Clark Memorial Library, The University of California, 1968.

Artist/Author: Contemporary Artists' Books. New York: Distributed Art Publishers, Inc., and The American Federation of Arts, 1998.

Artists Book Works, A Decade in Illinois. September 7–October 29, 1993. Chicago: Artists Book Works, 1993.

Artists' Books. London: The Arts Council of Great Britain, 1976.

Artists' Books. Philadelphia: Moore College of Art, 1973.

Artists' Books: New Zealand Tour 1978. New York: Franklin Furnace Archive, 1978.

Artwords and Bookworks. Los Angeles: The Los Angeles Institute of Contemporary Art, 1978.

Atkinson, D. Scott, and Charlene S. Engel. *An American Pulse: The Lithographs of George Wesley Bellows.* San Diego: San Diego Museum of Art, 1999.

Bahr, Leonard, ed. *Printing in Privacy: A Review of Recent Activity Among American Private Presses.* Grosse Pointe Park, Mich.: Adagio Press, 1960.

Barrett, Timothy. *Japanese Papermaking: Traditions, Tools, and Techniques.* New York, Tokyo: Weatherhill, 1983.

Bartlett, Lee, ed. *William Everson, On Writing the Waterbirds and Other Presentations: Collected Forewords and Afterwords, 1935–1981.* Metchen, N.J.: Scarecrow Press, 1983.

____. *William Everson: The Life of Brother Antoninus.* New York: New Directions, 1988.

Baskin, Lisa Unger, comp. *The Gehenna Press: The Work of Fifty Years, 1942–1992.* Dallas: The Bridwell Library and the Gehenna Press, 1992.

Beat Culture and the New America. New York: The Whitney Museum of American Art, 1995.

Becker, Howard. *Art Worlds.* Berkeley, Los Angeles, London: The University of California Press, 1982.

Belanger, Terry, ed. *Proceedings of the Fine Printing Conference at Columbia University, Held May 19–22, 1982.* New York: School of Library Service, Columbia University, 1983.

Belting, Hans. *The End of the History of Art?* Translated by Christopher S. Wood. Chicago and London: The University of Chicago Press, 1987.

Benjamin, Walter. "The Work of Art in the Age of Reproduction," in *Illuminations.* Edited

by Hannah Arendt. New York: Schocken Books, 1968.

Bennett, Paul A., ed. *Books and Printing, a Treasury for Typophiles.* Savannah: Frederic C. Beil, Publisher, 1951.

Berger, Sidney E. *Printing and the Mind of Merker: A Bibliographical Study.* New York: The Grolier Club, 1997.

Bernstein, George, and Ralph E. Williams, eds. *Palimpsest: Editorial Theory in the Humanities.* Ann Arbor: University of Michigan Press, 1993.

Bernstein, Roberta. *Jasper Johns' Paintings and Sculptures, 1954–1974: "The Changing Focus of the Eye."* Ann Arbor, Mich.: U.M.I. Research Press, 1985.

Bigelow, Charles, Paul Hayden Duensing, and Linnea Gentry, eds. *Fine Print on Type: The Best of Fine Print Magazine on Type and Typography.* San Francisco: Fine Print and Bedford Arts, 1989.

Bindman, David. *Blake as an Artist.* Oxford, England: Phaidon; New York: E. P. Dutton, 1977.

___. *William Blake, His Art and Times.* New Haven: Yale Center for British Art; Toronto: Art Gallery of Ontario, 1982.

Binkley, Robert C. *Manual on Methods of Reproducing Research Materials.* Ann Arbor, Michigan: Edwards Brothers, Inc., 1936.

Bland, David. *A History of Book Illustration: The Illuminated Manuscript and the Printed Book.* London: Faber and Faber Ltd., 1969.

Bloch, Susi R. *The Book Stripped Bare: A Survey of Books by 20th Century Artists and Writers.* Hempstead, Long Island, N.Y.: The Emily Lowe Gallery and Hofstra University, 1973.

Blumenthal, Joseph. *Art of the Printed Book 1455–1955.* New York: The Pierpont Morgan Library; Boston: David R. Godine, 1973, 1989.

___. *The Printed Book in America.* Boston: David R. Godine, Dartmouth College Library, 1977.

___. *The Spiral Press: An Exhibition of Selected Books and Ephemera Designed and Printed at The Spiral Press in New York from 1926 to 1968.* New York: Joseph Blumenthal, 1968.

Bois, Yve Alain. *Edward Ruscha, Romance with Liquids: Paintings 1966–1969.* New York: Rizzoli and Gagosian Gallery, 1993.

Bolton, Richard, ed. *The Contest of Meaning: Critical Histories of Photography.* Cambridge, Mass., and London, England: The MIT Press, 1989.

The Book as Art. Washington, D.C.: Fendrick Gallery, 1976.

The Book as Art II. Washington, D.C.: Fendrick Gallery, 1977.

Book Makers: Center for Book Arts First Five Years. New York: Center for Book Arts, 1979.

Books as Art. Boca Raton, Florida: Boca Raton Museum of Art, 1991.

Books by Eugene Feldman. Philadelphia: Institute of Contemporary Art, University of Pennsylvania, 1977.

The Books of Antonio Frasconi. Purchase: Neuberger Museum of Art, State University of New York at Purchase, 1992.

The Books of Antonio Frasconi, A Selection 1945–1995. New York: The Grolier Club, 1996.

Bookworks. New York: The Museum of Modern Art, 1977.

Breton, André. *Nadja.* Translated by Richard Howard. New York City: Grove Press, Inc., 1960.

Marcel Broodthaers, Graphik und Bucher/Prints and Books/Gravures et Livres. Stuttgart: Sprengel Museum Hannover, 1996.

Brown, Andreas, comp. *Andy Warhol: His Early Works 1947–1959.* New York: Gotham Book Mart Gallery, 1971.

Brundage, Susan, ed. *Jasper Johns, 35 Years: Leo Castelli.* New York: Abrams, 1993.

Bürger, Peter. *Theory of the Avant-Garde.* Translated by Michael Shaw. Minneapolis: The University of Minnesota Press, 1984.

Burke, Clifford. *Printing It: A Guide to Graphic Techniques for the Impecunious.* New York: Ballantine Books, 1972.

___. *Printing Poetry: A Workbook in Typographic Reification.* San Francisco: Scarab Press, 1980.

Bury, Stephen. *Artists' Books: The Book as a Work of Art, 1963–1995.* London: Scolar Press, 1995.

Cabanne, Pierre. *Dialogues with Marcel Duchamp.* Translated by Ron Padgett. New York: Viking Press, 1971.

Carrión, Ulises. "The New Art of Making Books," in Lyons, Joan, ed. *Artists' Books: A Critical Anthology and Sourcebook.* 3d ed. Rochester, New York: Visual Studies Press, 1991.

___. *Quant aux livres* [On Books]. Texts assembled by Juan J. Agius. French translation by Thierry Dubois. Genève: Héros-Limite, 1997.

___. *Second Thoughts*. Amsterdam: VOID Distributors, 1975, 1980.

Castleman, Riva. *A Century of Artists Books.* New York: The Museum of Modern Art, 1994.

___. *Printed Art: A View of Two Decades.* New York: The Museum of Modern Art, 1980.

Cate, Phillip Dennis, and Sinclair Hitchings. *The Color Revolution: Color Lithography in France, 1890–1900.* Santa Barbara: P. Smith, 1978.

Cave, Roderick. *The Private Press.* 2d ed. New York and London: R. R. Bowker Company, 1983.

Center for Book Arts. *Conference Summary: Book Arts in the USA.* New York: Center for Book Arts, 1991.

Chappell, Warren. *A Short History of the Printed Word.* Boston: Nonpariel Books, 1980.

Clay, Steven, and Rodney Phillips. *A Secret Location on the Lower East Side. Adventures in Writing, 1960–1980.* New York: The New York Public Library and Granary Books, 1998.

___. eds. *When Will the Book Be Done? Granary's Books.* New York City: Granary Books, Inc., 2001.

Compton, Susan. *Russian Avant-Garde Books: 1917–34.* Cambridge, Massachusetts: The MIT Press, 1992.

___. *The World Backwards: Russian Futurist Books 1912–16.* London: The British Library, 1978.

Contemporary Art Museum, Houston. *American Narrative/Story Art 1967–1978.* Houston: Contemporary Art Museum, 1978.

Courtney, Cathy. *Speaking of Book Art: Interviews with British and American Book Artists.* Los Altos Hills, Calif.: Anderson-Lovelace Publishers, 1999.

Crane, Diana. *The Transformation of the Avant-Garde, The New York Art World, 1940–1985.* Chicago and London: The University of Chicago Press, 1987.

Crone, Rainer, ed. *Andy Warhol: A Picture Show by the Artist.* New York: Rizzoli, 1987.

Dada Artifacts. Iowa City: The University of Iowa Museum of Art, 1978.

Danky, James P., Jack A. Clarke, Sarah Z. Aslakson, eds. *Book Publishing in Wisconsin: Proceedings of the Conference on Book Publishing in Wisconsin, May 6, 1977.* Madison: The University of Wisconsin Library School, 1977.

Davids, Betsy and James Petrillo. "The Artist as Book Printer: Four Short Courses," in Joan Lyons, ed. *Artists' Books: A Critical Anthology and Sourcebook.* 3d ed. Rochester, New York: Visual Studies Press, 1991.

Drucker, Johanna. *The Century of Artists' Books.* New York City: Granary Books, 1995.

___. *Figuring the Word: Essays on Books, Writing, and Visual Poetics.* New York: Granary Books, 1998.

___. *The Visible Word: Experimental Typography and Modern Art, 1909–1923.* Chicago: The University of Chicago Press, 1994.

Duensing, Paul Hayden. "Metal Type: Whither Ten Years Hence?" (January 1985), in *Fine Print on Type: The Best of Fine Print Magazine on Type and Typography.* San Francisco: Fine Print and Bedford Arts, 1989.

Dugan, Thomas. *Photography Between Covers: Interviews with Photo-Bookmakers.* Rochester, N.Y.: Light Impressions, 1979.

Duncan, Harry. "The Art of the Printed Book," in *Doors of Perception: Essays in Book Typography.* Austin: W. Thomas Taylor, 1987.

___. "The Cummington Press," in *Doors of Perception: Essays in Book Typography.* Austin: W. Thomas Taylor, 1987.

___. *Doors of Perception: Essays in Book Typography.* Austin: W. Thomas Taylor, 1987.

___. "The Technology of Hand Printing," in *Doors of Perception: Essays in Book Typography.* Austin: W. Thomas Taylor, 1987.

Edwards, Hugh, comp. *Surrealism and its Affinities: The Mary Reynolds Collection.* Chicago: Art Institute of Chicago, 1973.

Eichenberg, Fritz. *The Art of the Print.* New York: Harry N. Abrams, Inc., Publishers, 1976.

Enyeart, James, ed. *Decade by Decade: Twentieth-Century American Photography from the Collection of the Center for Creative Photography.* Boston: Little, Brown; Tucson: published in association with The Center for Creative Photography, The University of Arizona, 1989.

Essick, Robert N. *William Blake, Printmaker.* Princeton: Princeton University Press, 1980.

Evans, Walker. *American Photographs.* New York: The Museum of Modern Art, 1938.

Farmer, Jane. *New American Paperworks.* San Francisco, California: The World Print Council, 1982.

___. *Paper as Medium.* Washington, D.C.: The Smithsonian Institution Traveling Exhibition Service, 1978.

___. "Prints and the Art of the Book in America," in *American Prints and Printmaking: 1956–1981.* New York City: Pratt Graphics Center, 1981.

Farrell, David. *Collegiate Book Arts Presses: A New Census of Printing Presses in American Colleges and Universities.* San Francisco: Fine Print, 1982.

Feldman, Eugene. *Doorway to Portuguese.* Philadelphia: The Falcon Press, 1957.

Fern, Alan. *Eugene Feldman, Prints.* Philadelphia: The Philadelphia Museum of Art Print Department and Falcon Press, 1966.

Fine, Ruth. *Claire Van Vliet — Paperwork.* Newark, Vt.: Janus Press, 1978.

___. *The Janus Press 1975–1980.* Burlington: The University of Vermont, 1982.

___. *The Janus Press 1981–1990.* Burlington: The University of Vermont Libraries, 1992.

Foirades/Fizzles: Echo and Illusion in the Art of Jasper Johns. Los Angeles: Grunwald Center for the Graphic Arts, in association with the Wight Art Gallery, The University of California, Los Angeles, 1987.

Frank, Peter. *Something Else Press, an Annotated Bibliography by Peter Frank.* Brattleboro, Vt.: McPherson and Company, 1983.

Franklin, Colin. *The Private Presses.* London: Studio Vista, 1969.

Freeman, Brad. *Offset: Artists' Books and Prints.* New York: Interplanetary Productions, 1993.

Garvey, Eleanor M., and Peter A. Wick. *The Arts of the French Book, 1900–1965.* Dallas: Southern Methodist University Press, 1967.

Gilmour, Pat. *Ken Tyler: Master Printer, and the American Print Renaissance.* New York: Hudson Hills Press, Inc., 1986.

Glier, Mike. *VIGILANCE: Artists' Books Exploring Strategies for Social Concern.* New York City: Franklin Furnace, 1978.

Goldstein, Ann. "Artists in the Exhibition," in *Reconsidering the Object of Art: 1965–1975.* Los Angeles: The Museum of Contemporary Art; Cambridge, Mass. and London, England: The MIT Press, 1995.

Goldwater, Marge, ed. *Marcel Broodthaers.* New York: Rizzoli; Minneapolis: Walker Art Center, 1989.

Gómez-Sicre, José, in *Eugene Feldman, Prints.* Philadelphia: The Philadelphia Museum of Art Print Department and Falcon Press, 1966.

Grabhorn, Edwin. "The Fine Art of Printing," in Paul A. Bennett, ed. *Books and Printing, a Treasury for Typophiles.* Savannah: Frederic C. Beil, Publisher, 1951.

Grabhorn, Jane, *The Colt Press.* Oral history interview with Ruth Teiser. 1966, Berkeley.

___. *The Compleat Jane Grabhorn. A Hodge-Podge of Typographic Ephemera, Three Complete Books, Broadsides, Invitations: Greetings, Place Cards, etc, etc.* San Francisco: Grabhorn-Hoyem, 1968.

Graham, Lanier. *The Spontaneous Gesture: Prints and Books of the Abstract Expressionist Era.* Canberra: Australian National Gallery, 1987.

Graphic Design in America: A Visual Language History. Minneapolis: Walker Art Center, 1989.

Guest, Tim, ed. *Books by Artists.* Toronto: Art Metropole, 1981.

Gutjahr, Paul C., and Megan L. Benton, eds. *Illuminating Letters: Typography and Literary Interpretation.* Boston: The University of Massachusetts Press, 2001.

Halbreich, Kathy. *Paper Forms, Handmade Paper Objects.* Cambridge, Mass.: Hayden Gallery, MIT, 1977.

Hamady, Walter. *Two Decades of Hamady and The Perishable Press Limited.* Mt. Horeb, Wis.: Perishable Press, 1984.

[WALTER SAMUEL HAATOUM HAMADY] Racine, Wis.: The Charles A. Wustum Museum of Fine Arts, 1991.

Hand Bookbinding Today, an International Art. An exhibition organized by the San Francisco Museum of Modern Art in cooperation with The Hand Bookbinders of California. San Francisco: San Francisco Museum of Modern Art, 1978.

Hart, James D. *Fine Printing: The San Francisco Tradition.* Washington, D.C.: The Library of Congress, 1985.

Harthan, John. *The History of the Illustrated Book: The Western Tradition.* London: Thames and Hudson, 1981.

Haum, Barbara. *"Women and the Artist's Book: The Hidden Dowry."* Ph.D. diss., New York: New York University, 1995.

Head, Heart and Hand: Elbert Hubbard and the Roycrofters. Rochester, N.Y.: University of Rochester Press, 1994.

Hershman, Lynn Lester. "Slices of Silence, Parcels of Time: The Book as a Portable Sculpture," in *Artists' Books.* Philadelphia: Moore College of Art, 1973.

Higgins, Dick. *A Dialectic of Centuries: Notes Towards a Theory of the New Arts.* New York and Barton, Vt.: Printed Editions, 1978.

___. *Horizons: the Poetics and Theory of the Intermedia.* Carbondale, Ill.: 1984.

Hofer, Philip, and Eleanor Garvey. *The Artist and the Book: 1860–1960 in Western Europe and the United States.* Boston: The Museum of Fine Arts; Cambridge: Harvard College Library, 1961, 1961.

Hoffberg, Judith. "The Museum is the Mailbox," in *Artwords and Bookworks.* Los Angeles: The Los Angeles Institute of Contemporary Art, 1978.

___., ed. *Umbrella: the Anthology.* Santa Monica, Calif.: Umbrella Editions, 1999.

Hoffman, Katherine. *Explorations: The Visual Arts Since 1945.* New York: HarperCollins Publishers, 1991.

Hogben, Carol, and Rowan Watson, eds. *From Manet to Hockney: Modern Artists' Illustrated Books.* London: Victoria and Albert Museum, 1985.

Hompson, Davi Det. *May I Have a Glass of Water with No Ice, Please?* 1976.

Hopps, Walter, conversation with Ed Ruscha, in Yve Alain Bois. *Edward Ruscha, Romance with Liquids: Paintings 1966–1969.* New York City: Rizzoli and Gagosian Gallery, 1993.

Houston, John Porter. *Patterns of Thought in Rimbaud and Mallarmé.* Lexington, Ky.: French Forum Publishers, 1986.

Hubert, Renée Riese. *Surrealism and the Book.* Berkeley, Los Angeles, Oxford: University of California Press, 1988.

Hubert, Renée Riese, and Judd D. Hubert. *The Cutting Edge of Reading: Artists' Books.* New York City: Granary Books, 1999.

Hugo, Joan. "Museum Without Walls," in *Artwords and Bookworks.* Los Angeles: The Los Angeles Institute of Contemporary Art, 1978.

Human Documents: Tom Phillips's Art of the Page. Philadelphia: The University of Pennsylvania, 1993.

Interplanetary Productions. *Offset.* New York: Interplanetary Productions, 1993.

Isselbacher, Audrey. "Iliazd and the Tradition of the 'Livre de Peintre.'" In *Iliazd and the Illustrated Book.* New York: The Museum of Modern Art, 1987.

Jay, Martin. *The Dialectical Imagination; a History of the Frankfurt School and the Institute of Social Research, 1923–1950.* Boston: Little, Brown, 1973.

Johnson, Una E. *American Prints and Printmakers.* Garden City, New York: Doubleday and Company, Inc., 1980.

Johnston, Alastair. *A Bibliography of the Auerhahn Press and Its Successor Dave Haselwood Books.* Berkeley: Poltroon Press, 1977.

___. *Bibliography of the White Rabbit Press.* Berkeley: Poltroon Press, 1985.

___. *Zephyrus Image: A Bibliography.* Berkeley: Poltroon Press, 2003.

Karginov, German. *Rodchenko.* London: Thames and Hudson, 1979.

Kelly, Mary. *Post-Partum Document.* 1973–1979.

Kinross, Robin. *Modern Typography, an Essay in Critical History.* London: Hyphen Press, 1992.

Kirshenbaum, Sandra, and Kenneth Karmiole, eds. *California Printing, a Selected List of Books which are Significant or Representative of a California Style of Printing.* 3 vols. San Francisco: The Book Club of California, 1980, 1984, 1987.

Kirstein, Lincoln, "Photographs of America: Walker Evans," in Walker Evans. *American Photographs.* New York City: The Museum of Modern Art, 1938.

Klima, Stefan. *Artists Books: A Critical Survey of the Literature.* New York: Granary Books, 1998.

Kostelanetz, Richard. "Book Art," in Lyons, Joan, ed. *Artists' Books: A Critical Anthology and Sourcebook.* 3d ed. Rochester, N.Y.: Visual Studies Press, 1991.

___. *Visual Literature Criticism: A New Collection.* Carbondale, Illinois: Southern Illinois University Press, 1979. Co-publication of *Precisely: Three Four Five*; and *West Coast Poetry Review* 5, no. 3, issue 19, Richard Kostelanetz and Stephen Scobie, eds.

___. *Wordsand.* Burnaby, British Columbia, Canada: The Simon Fraser Gallery, Simon

Fraser University, in cooperation with New York: RK Editions, 1978.

Kotz, Mary Lynn. *Rauschenberg, Art and Life.* New York: H. N. Abrams, 1990.

Kramer, Margia. *Essential Documents: the F.B.I. File on Jean Seberg.* c. 1979–[1980].

Krane, Susan. *Art at the Edge: Ida Applebroog.* Atlanta, Ga.: High Museum of Art, 1989.

Labrot, Syl. "The Invention of Color Photography," in *Pleasure Beach.* 1976.

___. *Pleasure Beach.* 1976.

Lacy, Suzanne. *Rape Is.* 1972, 1976 (2nd ed.).

Lange, Gerald. "The Emergence of Personal Bookmaking in the Eighties." In *A Southern California Decade: An Exhibition of Contemporary Books, 1980–1989.* Los Angeles: Alliance for Contemporary Book Arts, 1989.

___. *Printing digital type on the hand-operated flatbed cylinder press.* Marina del Rey: Bieler Press Monographs, 2001.

Lauf, Cornelia, and Clive Phillpot. *Artist/Author: Contemporary Artists' Books.* New York: Distributed Art Publishers, Inc. and the American Federation of Arts, 1998.

Lears, T. J. Jackson. *No Place of Grace: Antimodernism and the Transformation of American Culture, 1880–1920.* Chicago and London: The University of Chicago Press, 1994.

Lee, Marshall, ed. *Books for Our Time.* New York: The Oxford University Press, 1951.

Lehmann-Haupt, Helmut. *The Book in America: A History of the Making and Selling of Books in the United States,* New York: R. R. Bowker Company, 1951; 1st edition, 1939.

Lehrer, Ruth Fine. *The Janus Press: 1955–75.* Burlington, Vt.: The University of Vermont, The Robert Hull Fleming Museum, 1974.

Levin, Kim. *Lucas Samaras.* New York: H. N. Abrams, 1975.

Lewis, John C. *The Twentieth Century Book: Its Illustration and Design.* New York: Van Nostrand Reinhold, 1967, 1984.

Lewis, Roy Harley. *Fine Bookbinding in the Twentieth Century.* New York: Arco Publishing, Inc., 1985.

Lippard, Lucy. "Conspicuous Consumption: New Artists' Books," in Joan Lyons, ed., *Artists' Books: A Critical Anthology and Sourcebook.* 3d ed. Rochester, New York: Visual Studies Press, 1991.

___. "Escape Attempts," in *Reconsidering the Object of Art: 1965–1975.* Los Angeles: The Museum of Contemporary Art; Cambridge, Massachusetts and London, England: The MIT Press, 1995.

___. *From the Center: Feminist Essays on Women's Art.* New York: E. P. Dutton Paperback, 1976.

___. *Six Years: The Dematerialization of the Art Object from 1966 to 1972...* 2d ed. Berkeley, Los Angeles, London: University of California Press, 1997.

___. "The Structures, the Structures and the Wall Drawings, the Structures and the Wall Drawings and the Books." In *Sol LeWitt.* New York City: The Museum of Modern Art: 1978.

Lodder, Christina. *Russian Constructivism.* New Haven: Yale University Press, 1983.

Los Angeles Institute of Contemporary Art. *Artwords and Bookworks: An International Exhibition of Recent Artists' Books and Ephemera.* Los Angeles: Los Angeles Institute of Contemporary Art, 1978.

___. *The New Arts Space: Summary of Alternative Visual Arts Organizations.* Los Angeles: Los Angeles Institute of Contemporary Art, 1978.

Lovejoy, Margot. *Postmodern Currents: Art and Artists in the Age of Electronic Media.* Ann Arbor: U.M.I. Research Press, 1989.

Lyons, Joan, ed. *Artists' Books: A Critical Anthology and Sourcebook.* 3d ed. Rochester, N.Y.: Visual Studies Workshop Press, 1991.

Made in the Midwest: Walter Hamady's 6431 Students. Racine, Wis.: The Charles A. Wustum Museum of Fine Arts, 1993.

Mallarmé, Stéphane. *Stéphane Mallarmé, Selected Poetry and Prose.* Edited by Mary Ann Caws. New York: New Directions Books, 1982.

Martin, Henri-Jean. *The History and Power of Writing.* Translated by Lydia G. Cochrane. Chicago and London: The University of Chicago Press, 1994.

McClure, Michael. *Dark Brown.* San Francisco: Auerhahn Press, 1961.

McGann, Jerome J. *The Textual Condition.* Princeton: Princeton University Press, 1991.

McLuhan, Marshall. *The Gutenberg Galaxy: The Making of Typographic Man.* Toronto: The University of Toronto Press, 1962.

___. *The Mechanical Bride: Folklore of Industrial Man.* New York: Vanguard Press, 1951.

____. *Understanding Media: The Extensions of Man*. New York: McGraw-Hill, 1964.

McMurtrie, Douglas. *The Book: The Story of Printing and Bookmaking*. New York: Dorset Press, 1943.

McShine, Kynaston, ed. *Joseph Cornell*. New York: The Museum of Modern Art, and Munich: Presel Verlag, 1990.

Melot, Michel. *The Art of Illustration*. Translated by James Emmons. New York: Skira/Rizzoli, 1984.

Meyer, Ursula. *Conceptual Art*. New York City: E. P. Dutton, 1972.

Mitchell, Breon. *Beyond Illustration: the Livre d'Artiste in the Twentieth Century: an Exhibition*. Bloomington: Lilly Library, Indiana University, 1976.

Moeglin-Delcroix, Anne. *Esthétique du livre d'artiste, 1960–1980*. Paris: Éditions Jean-Michel Place and Bibliothèque nationale de France, 1997.

Morgan, Robert C. *Commentaries on the New Media Arts: Fluxus and Conceptual Art, Artists' Books, Correspondence Art, Audio and Video Art*. Pasadena: Umbrella Associates, 1992.

____. "Systemic Books by Artists." In *Artists' Books, A Critical Anthology and Source-book*. Edited by Joan Lyons. Rochester, N.Y.: Visual Studies Workshop Press, 1985.

Morison, Stanley. *First Principles of Typography*. New York: The Macmillan Company, 1936.

____. *Four Centuries of Fine Printing*. 2d ed. London: Ernest Benn Limited, 1949.

Morris, William. *On Art and Socialism: Essays and Lectures*. Selected by Holbrook Jackson. Paulton (Somerset) and London: John Lehmann, Ltd., 1947.

Motherwell, Robert, ed. *Dada Painters and Poets, An Anthology*. Cambridge, Mass. and London, England: The Belknap Press of Harvard University Press, 1989.

Museum of Contemporary Art. *Reconsidering the Object of Art: 1965–1975*. Los Angeles: The Museum of Contemporary Art; Cambridge, Mass., and London, England: The MIT Press, 1995.

The New Art Space. Los Angeles: Los Angeles Institute of Contemporary Art, 1978.

Newhall, Beaumont. *The History of Photography*. New York: The Museum of Modern Art, 1982.

The Object as Poet. Washington, D.C.: The Smithsonian Institute, 1977.

Pacey, Philip, ed. *Art Library Manual: A Guide to Resources and Practice*. New York City: Bowker Press, 1977.

Padon, Thomas. Interview with Martha Wilson, in Cornelia Lauf, and Clive Phillpot. *Artist/Author: Contemporary Artists' Books*. New York City: Distributed Art Publishers, Inc. and the American Federation of Arts, 1998.

Paper Art and Technology: The History and Methods of Fine Papermaking with a Gallery of Contemporary Art. San Francisco: The World Print Council, 1979.

Paschall, Jo Anne. "Nexus Press: A View From the Loading Dock," in *Talking the Boundless Book: Art, Language and the Book Arts*. Minneapolis: Minnesota Center for Book Arts, 1995.

Peich, Michael. *Carroll Coleman and the Prairie Press*. Tuscaloosa, Ala.: The University of Alabama Parallel Editions, 1991.

Perreault, John. "Some Thoughts on Books as Art," in *Artists' Books*. Philadelphia: Moore College of Art, 1973.

Perrée, Rob. *Cover to Cover: the Artist's Book in Perspective*. Rotterdam: De Beyerd Breda, 2002.

Peterson, William, ed. *The Ideal Book: Essays and Lectures on the Arts of the Book by William Morris*. Berkeley: The University of California Press, 1982.

____. *The Kelmscott Press: A History of William Morris's Typographical Adventure*. Berkeley: The University of California Press, 1991.

Petr, Mark. "Prints, Politics, Polemics" in *Hot Off the Press: Prints and Politics*. Tyler, Linda, and Barry Walker, eds. Albuquerque: The University of New Mexico, 1994.

Phillips, Christopher. "The Judgment Seat of Photography." In *The Contest of Meaning: Critical Histories of Photography*. Edited by Richard Bolton. Cambridge, Mass. and London, England: The MIT Press, 1989.

Phillips, Lisa. *Beat Culture and the New America: 1950–1965*. New York City: The Whitney Museum of American Art, 1995.

Tom Phillips: Works and Texts. Introduction by Huston Paschal. London: The Royal Academy of Arts, Stuttgart; London: Edition Hansjörg Mayer, 1992.

Phillpot, Clive, and Jon Hendricks. *Fluxus: Selections from the Gilbert and Lila Silverman Collection*. New York: The Museum of Modern Art, 1988.

Printed Matter, Books by Artists 1997/1998. New York: Printed Matter, 1998.

The Printers' Chappel of Santa Cruz. Santa Cruz, California: Printers' Chappel of Santa Cruz and Santa Cruz City Museum, 1986.

Rainwater, Robert. *The American Livre de Peintre.* New York: The Grolier Club, 1993.

___, ed. *Max Ernst, Beyond Surrealism: A Retrospective of the Artist's Books and Prints.* New York: The New York Public Library, 1986.

Ransom, Will, ed. *Kelmscott, Doves and Ashendene: The Private Press Credos with an Introduction by Will Ransom.* Typophile Chap Books: 27. Los Angeles: The Typophiles, 1952.

___. *Private Presses and Their Books.* New York: R. R. Bowker Company, 1929.

Ray, Gordon. *The Art of the French Illustrated Book.* 2 vols. New York: Pierpont Morgan Library, Cornell University Press, 1982.

Richman, Gary. *Offset: A Survey of Artists' Books.* Cambridge, Mass.: New England Foundation for the Arts, 1984.

Riddell, Alan, ed. *Typewriter Art.* London: London Magazine Editions, 1975.

Ritchie, Ward. *Fine Printing: The Los Angeles Tradition.* Washington, D.C.: The Library of Congress, 1987.

Robins, Corinne. *The Pluralistic Era: American Art, 1968–1981.* New York: Harper and Row, Publishers, 1984.

Rosenberg, Harold. *Artworks and Packages.* New York: Horizon Press, 1969.

Rossen, Susan F., ed. *Inland Printers: the Fine Press Movement in Chicago, 1920–45.* Introduction by Paul F. Gehl. Chicago: The Caxton Club of Chicago, 2003.

Roth, Dieter. *96 Piccadillies.* London: Eaton House Publishers Ltd., 1977.

___. *246 Little Clouds.* New York City: Something Else Press, 1968.

Dieter Roth: Chicago: Museum of Contemporary Art, 1984.

Dieter Roth: Printed Pressed Bound, 1949–1979. Cologne: Oktagon Publishing House, 1999.

Rothenberg, Jerome, and Steven Clay, eds. *A Book of the Book, Some Works and Projections about the Book and Writing.* New York: Granary Books, 2000.

Rothenberg, Jerome, and David Guss, eds. *The Book, Spiritual Instrument.* New York City: Granary Books, 1996. A reissue of *New Wilderness Letter* #11 from 1982.

Edward Ruscha. Minneapolis: Walker Art Center, 1999.

Sackner, Ruth and Marvin. *The Altered Page, Selections from the Ruth and Marvin Sackner Archive of Concrete and Visual Poetry.* New York: Center for Book Arts, 1988.

___, comps. *Ruth and Marvin Sackner Archive of Concrete and Visual Poetry.* Miami Beach: Ruth and Marvin Sackner, 1986.

Sandler, Irving. *American Art of the 1960s.* New York City: Harper and Row, Publishers, 1988.

Sayre, Henry M. *The Object of Performance: The American Avant-Garde Since 1970.* 2d ed. Chicago and London: The University of Chicago Press, 1992.

Schraenen, Guy, ed. *Ulises Carrión: "We have won! Haven't we?"* Amsterdam: Museum Fodor; Bremen: Neues Museum Weserburg, 1992.

Schwarz, Dieter. *Lawrence Weiner, Books 1968–1989: Catalogue Raisonné.* Cologne: Verlag der Buchhandlung W. Konig; Villeurbanne: Nouveau musee, 1989.

Seitz, William C. *The Art of Assemblage.* New York: The Museum of Modern Art, 1961.

Sischy, Ingrid. "If Marshall McLuhan Were a Gypsy and His Teacup the Art World, the Tea Leaves Would Be Artists' Books." In *National Arts Guide* 1 (January–February 1979): 2–3.

Smagula, Howard. *Currents, Contemporary Directions in the Visual Arts.* Englewood Cliffs, N.J.: Prentice-Hall, Inc., 1989.

Smith, Keith. *Structure of the Visual Book.* 2d ed., rev. Fairport, N.Y.: The Sigma Foundation, Inc., 1992.

___. *200 Books: An Annotated Bibliography.* Rochester, N.Y.: keith smith BOOKS, 2000.

Smith, Philip. *New Directions in Bookbinding.* London: Studio Vista, 1974.

Smithsonian Institution. *Robert Rauschenberg.* Washington, D.C.: The Smithsonian Institution, 1976.

Software: Information Technology: Its Meaning for Art. New York: The Jewish Museum, 1971.

Spector, Buzz. "The Book Alone: Object and Fetishism," in *Books as Art.* Boca Raton, Florida: Boca Raton Museum of Art, 1991.

___. *The Book Maker's Desire.* Pasadena: Umbrella Editions, 1995.

Spencer, Herbert, ed. *The Liberated Page.* San Francisco: Bedford Press, 1987.

___. *Pioneers of Modern Typography.* London: Lund Humphries, 1969.

Sperling, Louise, and Richard S. Field. *Offset Lithography*. Middletown, Connecticut: Davison Art Center, Wesleyan University, 1973.

Spies, Werner. "Take and Devour: The Book as Object." In *Focus on Art*. New York: Rizzoli, 1982.

The State of the Book World, 1980. Washington, D.C.: The Library of Congress, The Center for the Book, 1981.

Stein, Donna. *Cubist Prints/Cubist Books*. New York: Franklin Furnace, 1983.

Steinberg, S. H. *Five Hundred Years of Printing*. New York: Penguin Books Ltd., 1979.

Stewart, Susan. *On Longing: Narratives of the Miniature, the Gigantic, the Souvenir, the Collection*. Durham and London: Duke University Press, 1993.

Strachan, W. J. *The Artist and the Book in France*. London: Peter Owen; New York: Wittenborn, 1969.

Sweetman, Alex. "Photobookworks: the Critical Realist Tradition," In *Artists' Books, A Critical Anthology and Sourcebook*. Edited by Joan Lyons. Rochester, N.Y.: Visual Studies Workshop Press, 1985.

Symmes, Marilyn, "Other Languages, Other Signs," in *The Books of Antonio Frasconi*. Purchase: Neuberger Museum of Art, State University of New York at Purchase, 1992.

Talking the Boundless Book: Art, Language and the Book Arts. Minneapolis: Minnesota Center for Book Arts, 1995.

Tancock, John L. *Multiples of the First Decade*. Philadelphia: Philadelphia Museum of Art, 1971.

Tashjian, Dickran. *Joseph Cornell: Gifts of Desire*. Miami Beach: Grassfield Press, 1992.

Teiser, Ruth, comp. *Printing as a Performing Art*. Edited by Ruth Teiser and Catherine Harroun. San Francisco: Book Club of California, 1970.

Thomas, Lew. *Structural(ism) and Photography*. New York: Museum of Modern Art, 1978.

Thompson, Susan Otis. *American Book Design and William Morris*. New York, London: R. R. Bowker Company, 1977.

Tomkins, Calvin. *The Bride and the Bachelors: Five Masters of the Avant-Garde*. Rev. ed. New York: Viking Press, 1968.

___. *Off the Wall, Robert Rauschenberg and the Art World of Our Time*. New York: Penguin Books, 1980.

Tonelli, Edith A., ed. *Involvement: the Graphic Art of Antonio Frasconi*. Los Angeles: Wight Art Gallery, The University of California, 1987.

Traister, Daniel. *Human Documents: Tom Phillips's Art of the Page*. Philadelphia: University of Pennsylvania, 1993.

Trance and Recalcitrance: Twenty Years of Poltroon Press, The Private Voice in the Public Realm. San Francisco: Edizione Velocissime Faville: Pacific Center for the Book Arts in association with the Friends of the San Francisco Public Library, 1995.

Trepanier, Peter. *Artists' Books? A Definition and an Argument for their Inclusion in Library Collections*. Independent study paper for Dr. Hans Möller. Montreal: McGill University, Graduate School of Library Science, 1983.

Trissel, James. "Polymer Printing on the Letterpress." In *Off the Shelf and On-Line: Computers Move the Book Arts into Twenty-First Century Design*. Minneapolis: Minnesota Center for Book Arts, 1992.

Turner. Silvie, and Birgit Skiöld. *Handmade Paper Today: A Worldwide Survey of Mills, Papers, Techniques and Uses*. New York: Frederic C. Beil, 1983.

Tyler, Linda, and Barry Walker, eds. *Hot Off the Press: Prints and Politics*. Albuquerque: The University of New Mexico, 1994.

Vanderlip, Diane Perry. "Foreword," in *Artists' Books*. Philadelphia: Moore College of Art, 1973.

VIGILANCE: Artists' Books Exploring Strategies for Social Concern. New York: Franklin Furnace, 1978.

Viscomi, Joseph. *Blake and the Idea of the Book*. Princeton, N.J.: Princeton University Press, 1993.

Vollard, Ambroise. *Recollections of a Picture Dealer*. First English translation by Violet M. MacDonald, 1936. New York: Dover Publications, 1978.

Walker, Todd. *for nothing changes....* 1976.

___. *...one thing just sort of led to another...: the photographs of Todd Walker*. Tucson, Ariz.: Thumbprint Press, 1979.

Wall, Jeff. "'Marks of Indifference': Aspects of Photography in, or as, Conceptual Art," in *Reconsidering the Object of Art: 1965–1975*. Los Angeles: The Museum of Contemporary Art; Cambridge, Mass., and London, England: The MIT Press, 1995.

Wallis, Brian, ed. *Art after Modernism*. New York City: The New Museum of Contemporary Art, and Boston: David R. Godine, Publisher, Inc., 1984.

Warde, Beatrice. *The Crystal Goblet: Sixteen Essays on Typography*. London: The Sylvan Press, 1955.

Watrous, James. *A Century of American Printmaking, 1880–1980*. Madison, London: The University of Wisconsin Press, 1984.

Watson, Steve. *The Birth of the Beat Generation: Visionaries, Rebels, and Hipsters, 1944–1960*. New York: Pantheon Books, 1995.

___. *Strange Bedfellows*. New York, London, Paris: Abbeville Press Publishers, 1991.

Wheeler, Daniel. *Art Since Mid-Century: 1945 to the Present*. New York: The Vendome Press, 1991.

Wheeler, Monroe, ed. *Modern Painters and Sculptors as Illustrators*. New York: The Museum of Modern Art, 1936.

Whistler, James McNeill. *The Gentle Art of Making Enemies*. London: William Heineman, 1892. Republished, New York: Dover Publications, Inc., 1967.

Whitfield, Sarah. *Bonnard*. New York: The Museum of Modern Art, 1998.

Williams, Emmett, ed. *An Anthology of Concrete Poetry*. New York City: Something Else Press, 1967.

Wilson, Adrian. *The Design of Books*. 2d ed. Salt Lake City and Santa Barbara: Peregrine, Inc., 2nd edition, 1974, 1st edition, 1967.

Wilson, Martha. "Artists' Books as Alternative Space," in *The New Art Space*. Los Angeles: Los Angeles Institute of Contemporary Art, 1978.

Wingler, Hans M. *The Bauhaus: Weimar, Dessau, Berlin, Chicago*. Cambridge, Mass., and London, England: The MIT Press, 1969.

Winterich, John Tracy. *The Grolier Club, 1884–1950; An Informal History*. New York: The Grolier Club, 1950.

Women's Autobiographical Artists' Books. Milwaukee: The University of Wisconsin, Art Museum Fine Arts Galleries and the Conference Center of the Golda Meir Library, 1987.

Wye, Deborah. *Committed to Print: Social and Political Themes in Recent American Printed Art*. New York: The Museum of Modern Art, 1988.

Zeitlin, Jacob. *Small Renaissance: Southern California Style*. Los Angeles: California State University, 1972.

ARTICLES

Alloway, Lawrence. "Artists as Writers, Part Two: The Realm of Language." *Artforum* (April 1974): 30–35.

Alpers, Svetlana. "Is Art History?" *Daedalus* 106, no. 3 (1977): 1–13.

Amert, Kay, and Kim Merker. "A Checklist of Books Printed by Harry Duncan." *Fine Print* 4, no. 1 (January 1978): 9–10.

___. "Harry Duncan: Maker of Books." *Fine Print* 4, no. 1 (January 1978): 4–8.

Anania, Michael. "Of Living Belfry and Rampart: On American Literary Magazines Since 1950." *TriQuarterly* 43 (1978): 6–23.

Anderson, Alexandra. "Scrapbooks, Notebooks, Letters, Diaries—Artists' Books Come of Age." *Art News* 77, no. 3 (March 1978): 68–74.

Anon. Review of the "First North American Hand Papermakers Conference," in "Shoulder Notes," *Fine Print* 2, no. 2 (April 1976): 24–25.

Antonetti, Martin. "The Grolier Club, New York." *Bookways* (January 1992): 17–22.

Artists Proof 2, no. 1 (Issue no. 3, Spring 1962). Special issue: "The Contemporary Print and the Book."

Art-Rite, no. 14 (Winter 1976/1977). Special issue: Artists' books.

Atkins, Robert. "On Edge: Alternative Spaces Today." *Art in America* 86, no. 11 (November 1998): 57, 59, 61.

Austin, Gabriel. "The Illustrated Book." *The Print Collector's Newsletter* 1, no. 5 (November–December 1971): 101–2.

___. "The Modern Illustrated Book: A Neglected Field for Collectors." *The Print Collector's Newsletter* 4, no. 6 (1974): 130.

Baker, Elizabeth C. "Report from Kassel: Documenta VI." *Art in America* 65, no. 5 (September–October 1977): 44–5.

Baldessari, John. Statement. *Art-Rite* (No. 14, Winter 1976–1977): 6.

Baranik, Rudolf. "Is the Alternative Space a True Alternative?" *Studio International* 195, no. 9901 (1980): 69–74.

Barendse, Henri. "Ed Ruscha: An Interview." *Afterimage* (February 1981): 8–10.

Bass, Ruth. "Ordinary People." *ARTnews* (May 1988): 151–4.

Bentivoglio, Mirella. "The Reinvention of the Book in Italy." *The Print Collector's Newsletter* 24, no. 3 (July–August 1993): 93–96.

Benton, Megan, and Paul Benton. "Typographic Yawp: Leaves of Grass (1855–1992)." *Bookways* (October 1994–January 1995): 29.

Berger, Sidney E. "A History of Book Arts Programs in America." *Guild of Book Workers Journal* 33, no. 2 (Fall 1995): 28–44.

Blumenthal, Joseph. Untitled review of *Granite and Cypress. Fine Print* 2, no. 2 (April 1976): 27.

Bourdon, David. "Ruscha as Publisher [or All Booked Up]." *Art News* (April 1972): 32.

Brattinga, Peter. "Eugene Feldman's Creative Experiments in Photo-Offset Lithography." *Artist's Proof,* no. 4 (1962).

Braun, Barbara. "Artists' Books." *Small Press* 2, no. 1 (September–October 1984): 64–73.

Brody, Jacqueline. "'A Century of Artists Books': Between the Pages with Riva Castleman." *The Print Collector's Newsletter* 25, no. 5 (November–December 1994): 172–6.

———. "On and Off the Wall: Barton Lidicé Benes." *The Print Collector's Newsletter* 9, no. 6 (January–February 1979): 183–89.

———. "Peter Frank: A Case for Marginal Collectors." *The Print Collector's Newsletter* 9, no. 2 (May–June 1978): 40–46.

Bruckner, D. J. R. "With Art and Craftsmanship, Books Regain Former Glory." *The New York Times Magazine* (October 28, 1984): 49.

Bruns, Gerald L. "Mallarmé: The Transcendence of Language and the Aesthetics of the Book." *Journal of Typographic Research* 3, no. 3 (July 1969): 219–40.

Butler, Frances. "The Artist's Book in the Public Eye." *Fine Print* 12, no. 1 (January 1986): 18–19.

———. "Experiments in Superannuated Color Printing Techniques." *Fine Print* 6, no. 4 (October 1980): 108–12.

———. "New Demotic Typography: The Search for New Indices." *Visible Language* 29, no. 1.

———. "The Outsider, Inside and Out: A Discussion of the Process of Institutional Assimilation of the Marginal Arts such as Book Art." *AIGA Journal* (Summer 1995).

———. "Reading in Bed." *Ampersand* (Winter 1996): 4–5.

———. "Retarded Arts: The Failure of Fine Arts Education." *AIGA Journal* (Spring 1995).

———. "The Social Economy of the Book." *Fine Print* 11, no. 1 (January 1985): 23–5.

Calas, Nicholas. "Marcel Broodthaers' Throw of the Dice." *Artforum* 14, no. 9 (May 1976): 34–37.

Carrión, Ulises. "Bookworks Revisited." *The Print Collector's Newsletter* 11, no. 1 (March–April 1980): 6–9.

Clark, Cynthia. "An Industry Survey: Papermaking Revisited." *Print Collector's Newsletter* 10, no. 3 (July–August 1979): 80–86.

Clark, Jonathan. "Acquiring Handmade Paper: A Printer's View." *Fine Print* 2, no. 2 (April 1976): 21–23.

Coker, Gylbert. "'Apply Within' and 'Vigilance' at Franklin Furnace." *Art in America* 68, no. 7 (September 1980): 126.

Cole, William. "The Book and the Artist: Rethinking the Traditional Order." *Word and Image* 8, no. 4 (October–November 1992): 378–82.

Collins, James. "...'Artists' Books,' Pratt Graphics Center." *Artforum* 12, no. 4 (December 1973): 84–86.

Colsman-Freyberger, Heidi. "Robert Motherwell: Words and Images." *The Print Collector's Newsletter* 4, no. 6 (January–February 1974): 125–29.

Conroy, Tom. Untitled article. *Guild of Book Workers Journal* 28, nos. 1–2 (Spring–Fall 1990): 1–64.

Coplans, John. "Edward Ruscha Discusses His Perplexing Publications." *Artforum* 3, no. 5 (February 1965): 24–25.

Cornwell, Regina. "Michael Snow: Cover to Cover and Back..." *Studio International* 191, no. 980 (March/April 1976): 193–97.

Coron, Antoine. "The Plight of the French Illustrated Book Today." *The Print Collector's Newsletter* 17, no. 4 (September–October 1986): 131–33.

Dalberto, Janet. "Acquisition of Artists' Books." *ART Documentation* I, no. 6 (December 1982): 169–70.

___. "Collecting Artists' Books." *Drexel Library Quarterly* (1983): 78–90.

Davids, Betsy. "The Book Arts: A Look at Contemporary Fine Printing in the Bay Area." *A Special Supplement of the San Francisco Review of Books* (December 1977): VI–VII.

DeAk, Edit. "Printed Matter and Artists Books." *LAICA Journal,* no. 13 (January–February 1977): 28–30.

De Duve, Thierry. "Echoes of the Readymade: Critique of Pure Modernism." *October* 70 (Fall 1994): 77.

Douglas, Helen. "The Two I's Within the We: Why and How I Make Books." *JAB [Journal of Artists' Books]* 3 (Spring 1995): 8–10.

Drucker, Johanna. "Iliazd and the Book as a Form of Art." *The Journal of Decorative and Propaganda Arts* (Winter 1988): 36–51.

Dumb Ox, no. 4 (1977). Special issue: Artists' books.

Duncan, Harry. "Cross-Purposes." *Bookways,* No. 1 (October 1991): 13–18.

Dunn, Debra. Review of *Rape Is. Dumb Ox* (1977): 54.

Edgar, Anne. "A Conversation with Printed Matter." *Afterimage* 12, no. 6 (January 1985): 9–11.

___, "Franklin Furnace." *ART Documentation* 1, no. 6 (December 1982): 176.

Ellenport, Sam. "The Future of Hand Bookbinding." *Guild of Book Workers Journal* 31, 1–2 (Spring/Fall 1993): 36–49.

Esteve-Coll, Elizabeth. "The Art Book: The Idea and the Reality." *Art Libraries Journal* 17, no. 3 (1992): 4–6.

Everson, William. Untitled review of *Ode to Typography. Fine Print* 4, no. 3 (July 1978): 80.

Exposure 21, no. 3. (1983): n.p. Special issue: offset printing.

Farmer, Jane. "Poems of Land and Sky." *The Print Collector's Newsletter* 10, no. 3 (July–August 1979): 77–9.

Feldman, Eugene. Statement. *Exposure* 21, no. 3 (1983): n.p. Special issue.

Fine, Ruth. "Eugene Feldman (1921–1975): An Appreciation." *Exposure* 21:3 (1983).

Finkel, Candida. "Photography as Modern Art: The Influence of Nathan Lyons and John Szarkowski on the Public's Acceptance of Photography as Fine Art." *Exposure* 18, no. 2 (1981): 22–37.

Finkel, Candida., and Buzz Spector. "McLuhan's Mistake—The Book is Back." *New Art Examiner* 5 (March 1978): 6–7.

Frasconi, Antonio. "11 Graphic Artists Write." *The Tiger's Eye* 1, no. 8 (June 15, 1949): 59.

Freeman, Brad. Interview with Clifton Meador. *JAB* 7 (Spring 1997): 1–12.

___. Interview with Jo Anne Paschall. *JAB* 3 (Spring 1995): 2, 4–7.

___. Interview with Joan Lyons. *JAB* 4 (Fall 1995): 11–13.

Fulton, Deoch. "The Typophiles." *The New Colophon* 2, part 6 (June 1949): 143–62.

Gaskell, Philip. "The Bibliographical Press Movement." *Journal of the Printing Historical Society* I (1965): 1–11.

Gass, William H. "In Defense of the Book." *Harper's* 299, no. 1794 (November 1999): 45–51.

Gever, Martha. "Artists' Books: Alternative Space or Precious Object?" *Afterimage* 9, no. 10 (May 1982): 6–8.

Gilmour, Pat. "The Prints of Marcel Broodthaers." *The Print Collector's Newsletter* 7, no. 2 (May–June 1976): 44–47.

Godine, David. "The Small Fine Press as Business." *Fine Print* 7, no. 4 (October 1981): 118–120, 149–50.

Graham, Dan. "The Book As Object." *Arts Magazine* 41, no. 8 (Summer 1967): 23.

Grossman, Carol. "Arion Press, A Legacy of Literary Artistry." *Biblio* 2, no. 9 (September 1997): 30–37.

Guild of Book Workers Journal vol. 33, no. 1 (Spring 1995), and vol. 32, no. 2 (Fall 1995). Special issues on history of bookbinding in the U.S.

Gurney, Susan. "A Bibliography of Little Magazines in the Arts in the U.S.A." *Art Libraries Journal* 6, no. 3 (Autumn 1981): 12–55.

Harper, Glenn. "The Collaborative Spirit at Nexus." *Bookways* 8 (July 1993): 27–32.

Harris, Eugenia. "Artists' Books: Distribution is the Problem." *Afterimage* 4, no. 4 (1976): 3.

Harrison, John M. "A Confirmed Typomaniac: Carroll Coleman and the Prairie Press." *Books at Iowa,* no. 62 (April 1995): 68–69.

Higgins, Dick. "Intermedia." *Something Else Newsletter* 1, no. 1 (1966).

Hofer, Philip. "Book Illustration: An Essay." *The Print Collector's Newsletter* 5, no. 1 (March–April 1974): 16.

Hoffberg, Judith. "Distribution and Its Discontents." *Reflex* (May/June 1990): 10–12.

Hoyem, Andrew. "Working Together: Collaboration in the Book Arts." *Visible Language* 25, no. 2/3 (Spring 1991): 204.

Hubert, Renée Riese. "Readable-Visible: Reflections on the Illustrated Book." *Visible Language* 19, 4 (Autumn 1985): 519–38.

___, ed. "The Artist's Book: the Text and Its Rivals." *Visible Language* 25, 2/3 (Spring 1991).

Hugo, Joan. "Artists' Books: Primers of Visual Literacy." *The Dumb Ox,* no. 4 (Spring 1977): 22–23.

Hunter, Dard. "Peregrinations and Prospects." *The Colophon,* Part 7 (1931): n.p.

___. "A Revival of Handmade Paper Making in America." *The Colophon,* Part 4 (1930): n.p.

Johnston, Alastair. "Jack Werner Stauffacher, Typographer." *Fine Print* 5, no. 1 (January 1979): 1-6.

___. "Literary Small Presses Since World War II in Europe and America." *American Book Collector* [new series] 2, no. 3 (May–June 1981): 13–19.

Kelder, Diane. "Prints: Artists' Books." *Art in America* (January 1974): 112–13.

Kirshenbaum, Sandra. "Graduate Book Arts Education: Two Approaches." *Fine Print* 10, no. 2 (April 1984): 73.

Kostelanetz, Richard, and Stephen Scobie, eds. *Precisely: Three Four Five*

___. *West Coast Poetry Review* 5, no. 3, issue 19.

Lange, Gerald. "The Book of the Twenty-First Century." *Coranto: Journal of the Friends of the USC Libraries* 24 (1988).

___. "Edition Printing on the Cylinder Proof Press: A Historical Perspective." *Parenthesis,* no. 3 (May 1999): 22–23.

___. "From Where to Where?: Abbreviated Suspicions Concerning Postwar Book Arts Movements." *Bookways* (nos. 15 and 16, Summer 1995): 62–63.

Larson, Susan C. "A Booklover's Dream." *ARTnews* 77, no. 5 (May 1978): 144.

Lerner, Abe. "Assault on the Book: A Critique of Fine Printing at Private Presses in the U.S. Today." *Private Library* [3rd series] 1, no. 4 (Winter 1978): 148–70.

___. "Form and Content: The Books of the American Private Presses Today." *Private Library* [3rd series] 2, no. 3 (Autumn 1979): 95–100.

Lewis, Oscar. "The California School of Printing." *The Colophon,* part 3, no. 9 (1930): n.p.

Linker, Kate. "The Artist's Book as Alternative Space." *Studio International* 195, no. 9901 (1980): 75–79.

Lippard, Lucy. "The Artist's Book Goes Public." *Art in America* 65, no. 1 (January–February 1977): 40–41.

___. "Going over the Books." *Artweek,* October 30, 1976.

___. "Hanne Darboven: Deep in Numbers." *Artforum,* October 1973: 35–39.

___. "Making Book." *Art in America* 64, no. 3 (May–June 1976): 152.

___. "Surprises: An Anthological Introduction to Some Women Artists' Books," *Chrysalis,* no. 5 (1977): 73–74.

Lloyd, Gary. "A Talk with Ed Ruscha." *Dumb Ox,* no. 4 (1977): 6.

Loeffler, Carl. "Distribution: The New Heroics." *The New Art Examiner* (March 1978): 8–9.

___. "La Mamelle." *The Dumb Ox,* no. 4 (Spring 1977): 40–41.

Lydon, Mary. "The Book as the Trojan Horse of Art." *Visible Language* 25, no. 2/3 (Spring 1991): 159–60.

Lyons, Joan. "Book Conference 1990 Observations." Notes on previous conferences, distributed to organization representatives attending "Book Arts in the USA: 1st National Conference," at Center for Book Arts, New York City, March 30–April 1, 1990.

Markel, Kathryn. "Hey, Wanna Buy an Artists' Book?" "The State of the Book Arts," *Craft International* (October–November–December 1984): 27.

Marmer, Nancy. "Los Angeles." *Artforum* 13, no. 4 (January 1965): 11–12.

McCausland, Elizabeth. "Photographic Books." *The Complete Photographer* 8, no. 43 (November 20, 1942): 2783.

McFee, Michael. "'Reckless and Doomed', Jonathan Williams and Jargon." *Small Press* (September/October 1985): 101–106.

Meador, Clifton. "The Dungeon of the Temple." *JAB* [*Journal of Artists' Books*] 3 (Spring 1995): 1, 3.

Moore, Barbara, and Jon Hendricks. "The Page as Alternative Space: 1950–1969." *Flue* (December 1980): 1, 7–8.

Morgan, Robert. "Fables, Grids and Swimming Pools: Phototexts in Perspective." *LAICA Journal* (September 1979): 19–26.

Morris, Henry. Letter to editor concerning Richard Bigus's *Ode to Typography. Fine Print* 4, no. 3 (July 1978): 80.

Peich, Michael. "William Everson: Fine Printer." *Printing History* 18, no. 2 (1998): 36–48.

Peters, Lisa. "Print Clubs in America." *The Print Collector's Newsletter* 13, no. 3 (July–August 1982): 89.

Phillips, Deborah C. "Definitely Not Suitable for Framing." *Art News* (December 1981): 62–67.

Phillpot, Clive. "Books Bookworks Book Objects Artists' Books." *Artforum* 20, no. 9 (May 1982): 77–79.

___. "Feedback." *Studio International* 184, no. 947 (September 1971): 64.

___. "Feedback." *Studio International* 186, no. 957 (July–August 1973): 38.

___. "The Library of the Museum of Modern Art, New York." *Art Libraries Journal,* 10, no. 1 (Spring 1985): 29–36.

___. "Twentysix Gasoline Stations that Shook the World: The Rise and Fall of Cheap Booklets as Art." *Art Libraries Journal* 18, no. 1 (1993): 4–13.

___, ed. *Art Documentation, Bulletin of the Art Libraries Society of North America* 1, no. 6 (December 1982). Special issue: "An ABC of Artists' Books Collections."

Pindell, Howardena. "Alternative Space: Artists' Periodicals." *The Print Collector's Newsletter* (September–October 1977): 96–109, 120–21.

Piper, Adrian. Statement. *Art-Rite,* no. 14 (Winter 1976/1977): 8.

Platzker, David. Foreword. *Printed Matter, Books by Artists 1997/1998.*

Princenthal, Nancy. "Artist's Books Beat." Interview with Dick Higgins. *The Print Collector's Newsletter* 22, no. 4 (1991): 147.

___. "Numbers of Happiness: Richard Tuttle's Books." *The Print Collector's Newsletter* 24, no. 3 (July–August 1993): 82–86.

Quittner, Joshua. "An Eye on the Future." *Time,* December 27, 1999.

Richmond, Mary L. "The Cummington Press." *Books at Iowa* no. 7 (1967): 9–31.

___. "Harry Duncan and the Cummington Press." *Fine Print* 4, no. 1 (January 1978): 1–10.

Roth, Helen (Alm). "Women's Graphic Center." *The Dumb Ox* (1977): 38.

Roylance, Dale. "Gérard Charrière Bindings at the Princeton Graphic Arts Collection." *Fine Print* 6, no. 2 (April 1980): 60.

Sackner, Ruth. "The Avant-Garde Book: Precursor of Concrete and Visual Poetry and the Artist's Book." *The Journal of Decorative and Propaganda Arts* (Fall 1986): 60–77.

Schiller, Marlene. "The American Community of Hand Papermakers." *American Artist* 41, issue 421 (August 1977): 39–44.

Schwartz, Barbara. "An Interview with Lucas Samaras." *Craft Horizons* 32, no. 6 (December 1972): 41.

Schwarz, Dieter. "Look! Books in Plaster!" *October* 42 (Fall 1987): 57–66.

Shapiro, David. "A View of Kassel." *Artforum* 16, no. 1 (September 1977): 56–62.

Sherman, Stuart C. "Recent Press Books: The Arion Press." *Fine Print* 6, no. 2 (April 1980): 49–53.

Siegelaub, Seth. *Studio International* (London), vol. 78, no. 917 (December 1969): 202.

Spencer, Geoff. "Books as Books or Books as Things." *CBBAG Newsletter* [The Canadian Bookbinders and Book Artists Guild] (Summer 1991): 3–6.

Spitler, Pamela A. "Guild of Book Workers 1996: Vital at Ninety." *Guild of Book Workers Journal* 35, no. 1 (1998).

Steiner, George. "After the Book?" *Visible Language* 6:3 (Summer 1972): 199–210.

Stokes, Telfer. "The Why and How I Make Books." *JAB* [*Journal of Artists' Books*] 3 (Spring 1995): 11–12.

Stokes, Telfer, and Helen Douglas. "List of Publications 1972–90."

Storr, Anthony. "The Psychology of Collecting." *Connoisseur* 213, no. 856 (June 1983): 35–38.

Symonds, A. J. A. "An Unacknowledged Movement in Fine Printing, the Typography of the Eighteen-nineties." *The Fleuron* 7 (1930): 83–119.

Szarkowski, John. "A Different Kind of Art." *The New York Times Magazine* (April 13, 1975).

Tarshis, Jerome. "Bookbinding International." *Craft Horizons* 38, no. 3 (June 1978): 46–49.

Taylor, W. Thomas. "The Iowa Center for the Book." *American Craft* (June–July 1987): 26–33.

___. "The Relationship Between Fine Binding and Fine Printing." *Guild of Book Workers Journal* 33, no. 2 (Fall 1995): 57.

___. "A Survey of American Hand Papermakers." *Bookways,* no. 9 (October 1993): 35.

Thomas, Lew. Review of *Cover to Cover. Dumb Ox,* no. 4 (1977).

Tomkins, Calvin. "The Art World: Artists' Books, Art Books, and Books on Art." *The New Yorker* (January 25, 1982): 74–79.

____. "Profiles: The Moods of a Stone." *The New Yorker* 52, no. 16 (June 7, 1976): 42–76.

Trissel, Jim. "The Rise of the Book in the Wake of Rain." *JAB [The Journal of Artists' Books]* 5 (Spring 1996): 26–27.

Turner, Decherd. "A Perplexed Scene." *Bookways,* no. 3 (April 1992): 11–19.

Unsigned notice about the first Printed Matter catalogue. *The Print Collector's Newsletter* 8, no. 2 (May–June 1977): 46.

Unsigned review. "For and Against in Rochester," about the conference, "Options for Independent Art Publishing." *The Print Collector's Newsletter* 10, no. 5 (November–December 1979): 194–95.

Visible Language 25, nos. 2/3 (Spring 1991). Special issue: "The Artist's Book: The Text and Its Rivals."

Visible Language 26, nos. 1/2 (Winter/Spring 1992). Special issue: "Fluxus: A Conceptual Country."

Von Uchtrup, Michael. "Tony Zwicker, 1925–2000." *Umbrella* 23, no. 1 (April 2000): 3–4.

Walker, John. "John Latham: Books for Burning." *Studio International* (November 1987): 26.

Walkup, Kathleen, and Melody Sumner. "By Sovereign Maiden's Might: Notes on Women in Printing." *Fine Print* 11, no. 2 (April 1985): 100–104.

____. "The Mills College Program" in "Graduate Book Arts Education: Two Approaches." *Fine Print* 10, no. 2 (April 1984): 79–81.

Walkup, Kathy. "Recent Press Books." Review of Perishable Press books. *Fine Print* 5, no. 3 (July 1979): 77-79.

Wall, Jeff. "'Marks of Indifference': Aspects of Photography in, or as, Conceptual Art," in *Reconsidering the Object of Art: 1965–1975.* Los Angeles: The Museum of Contemporary Art; Cambridge, Mass., and London, England: The MIT Press, 1995.

Warde, Beatrice. "The Crystal Goblet." *I am a communicator. The Monotype Recorder* 44, no. 1 (Autumn 1970): 24.

Weldon, Kathleen. Discussion of conference "Options for Independent Art Publishing," in Center for Book Arts newsletter, nos. 3 and 4 (Fall 1979/Winter 1980), n.p.

Whitfield, Tony. "Vigilance: An Exhibition of Artists' Books Exploring the Strategy of Social Change." *Artforum* 19 (September 1980): 68–9.

Wilcox, Annie Tremmel. "The University of Iowa Center for the Book: A New Harvest." *Fine Print* 4, no. 1 (Summer 1989).

Wilson, Martha. "Artist's Book Beat." Interview with Nancy Princenthal. *The Print Collector's Newsletter* 22, no. 2 (May–June 1991): 61–64.

Wilson, Susan Spring. "Book Arts Reporter: University of Iowa." *Fine Print* 11, no. 3 (July 1985): 182–83.

Wirth, Karen. "In the Space of Blurred Boundaries." *JAB [Journal of Artists' Books]* 13 (Spring 2000): 12.

____. "Word and Image in *Foirades/Fizzles.*" Unpublished essay (Minneapolis, 1989).

Yalkut, Jud. "Towards an Intermedia Magazine." *Arts Magazine* (Summer 1968): 12–1.

INDEX

PHOTOGRAPHIC CREDITS

*In addition to the caption credits, the following photographers and agents
are gratefully acknowledged as the sources of the images, cited by artist and title.*

Eleanor Antin's *Blood of a Poet Box* courtesy Ronald Feldman Fine Arts, New York;
photo by Peter Moore. Ida Applebroog's *Look at Me* courtesy Ronald Feldman Fine
Arts, New York; photo by Peter Moore. John Baldessari's *Fable—A Sentence of Thirteen
Parts (with Twelve Alternate Verbs) Ending in FABLE* courtesy John Baldessari. Leonard
Baskin's *Auguries of Innocence* and *Capriccio* courtesy ©The Estate of Leonard Baskin,
and of MCBA; photo by Wilber Schilling. Barton Benes's *Censored Book* by Richard
Minsky for *Book Arts in the USA*. The Book Bus photo courtesy Joan Lyons. Louise
Bourgeois's *He Disappeared into Complete Silence* by Christopher Burke. Frances
Butler and Alastair Johnston's *Confracti Mundi Rudera* and *Logbook* courtesy the
artists. Betsy Davids and Jim Petrillo's *The Softness on the Other Side of the Hole* from
Cathy Courtney, *Speaking of Book Art*. Henrik Drescher's *Too Much Bliss* courtesy
Steven Clay, Granary Books. Harry Duncan's *Esthétique du Mal* and *Four Early Stories*
by Denise Brady. Timothy C. Ely's *The Open Hand Discovers* courtesy MCBA; photo by
Wilber Schilling. Conrad Gleber's *Chicago Skyline* courtesy the artist. Melissa Gurdus's
Electronic Variations courtesy Claire Van Vliet. Walter Hamady's *Reardon Poems*
courtesy the artist. Susan King's *Lessons from the South* courtesy MCBA; photo by
Wilber Schilling. Susan King's *Pacific Legend* courtesy the artist. Hedi Kyle's *April Diary*
courtesy the artist. Syl Labrot's *Pleasure Beach* courtesy the Estate of Syl Labrot.
Suzanne Lacy's *Rape Is* by Brad Freeman, for Johanna Drucker, *The Century of Artists'
Books*. Sol LeWitt's *Four Basic Kinds of Straight Lines and Their Combinations* and
Brick Wall courtesy MCBA; photo courtesy Walker Art Center. Richard Minsky's
Geography of Hunger courtesy MCBA; photo by Wilber Schilling. Richard Minsky's
Pettigrew's History of Egyptian Mummies and *Birds of North America* courtesy the
artist. William Morris's *Chaucer* and *Hand and Soul* courtesy MCBA; photo by
Wilber Schilling. Robin Price's *Ravaged with Joy* courtesy the artist. John Risseeuw's
The Politics of Underwear by Richard Minsky for *Book Arts in the USA*. Ed Ruscha's
Twentysix Gasoline Stations and *Every Building on the Sunset Strip* courtesy the
Gagosian Gallery. Clarissa Sligh's *Reading Dick and Jane with Me* courtesy MCBA;
photo by Wilber Schilling. Keith Smith and Sonia Sheridan's *Smithsonian* and Keith
Smith's *A Change in Dimension* courtesy Keith A. Smith. Philip Smith's *The Lord of the
Rings* courtesy the artist. Buzz Spector's *Library of Babel* courtesy the artist; photo by
the Art Institute of Chicago. Michelle Stuart's *Niagara II, Niagara Gorge* courtesy the
Walker Art Center, Minneapolis. McKnight Acquisition Fund and Art Center Acquisition
Fund, 1983. Richard Tuttle's *Story with Seven Characters* by Brad Freeman for Johanna
Drucker, *The Century of Artists' Books*. Twinrocker photo by Howard Clark for Claire
Van Vliet, *Landscape Papers*. Todd Walker's *for nothing changes...* courtesy Melanie
Walker. Karen Wirth and Robert Lawrence's *How to Make an Antique* courtesy Karen
Wirth; photo by Rik Sferra. Claire Van Vliet's *The Tower of Babel* and *A Country Doctor*
by John Somers. Gray Zeitz's *Sabbaths 1987* courtesy MCBA; photo by Wilber Schilling.

A NOTE ON THE TYPE

This book was set in 10.5 point HTF Hoefler Roman, scaled at 96%
and 3.5 points leaded, with its accompanying italic scaled at 103%.
The footnotes were set in 8 point FF Meta Normal, 3 points leaded.

DATE DUE

FE 18 '08			

Demco, Inc. 38-293